CONTEMPORARY **ART**

THE ESSENTIAL GUIDE TO 200 GROUNDBREAKING ARTISTS

CHARLOTTE BONHAM-CARTER & DAVID HODGE

Northamptonshire Libraries & Information Service KH

Askews & Holts	

CONTEMPORARY

THIS IS A GOODMAN BOOK

Text and design copyright © 2009, 2011 and 2013 Carlton Books Limited

This third edition published in 2013 by Goodman An imprint of the Carlton Publishing Group 20 Mortimer Street, London W1T 3JW

First published in 2009 under the title The Contemporary Art Book.

This book is sold subject to the condition that it shall not, by way of trade or otherwise, be lent, resold, hired out or otherwise circulated without the publisher's prior written consent in any form of cover or binding other than that in which it is published and without a similar condition including this condition, being imposed upon the subsequent purchaser.

All rights reserved.

A CIP catalogue record for this book is available from the British Library

ISBN 978 1 84796 058 0

Printed and bound in Hong Kong

CONTENTS

INTRODUCTION	6
ARTISTS A-Z	8
THEMES & MOVEMENTS	396
PICTURE CREDITS	398

INTRODUCTION

RICHARD CORK

A century ago, new art was galvanized by a surge of revolutionary turbulence. Rivalrous movements, each one convinced that it would command international attention, erupted with ever more startling force. Manifestoes were issued. proclaiming the ambitions of the young artists who delighted in signing them. Formed into aroups, they denounced the art of the immediate past and set out to define a singular direction for the future. One critic, enthralled by the spirit of rebellion, wrote many years later that the atmosphere in 1910 was tantamount to an "Art-Quake". Although adventurous movements were angrily condemned by conservative opinion, the old academic order was collapsing. And gangs of diehard insurgents competed to gain supremacy. Cubists, Expressionists, Fauvists, Futurists, Post-Impressionists and Vorticists all clamoured to place themselves at the centre of the experimental whirlpool. The excitement was feverish, and only an event as cataclysmic as the First World War could silence these noisy aesthetic combatants.

Today, by contrast, new art is no longer dominated by avant-garde movements asserting their militancy at every turn. Although artists often exhibit together and sometimes collaborate with each other, most of them prefer in the end to operate singly rather than in groups. Strident collective manifestoes are rarely published now, and "isms" have become hard to discern. Artists give little sign of wanting to dictate the course of the innovative momentum in art, and see no need to expend their valuable energy on reviling tradition. The principal emphasis, in the early years of the twenty-first century, rests on the individual. And we shy away from anyone who confidently predicts the future for art in an era now overshadowed by such alarming economic uncertainty.

Even so, the appetite for adventure running through art today is in many respects far more free-spirited than ever before. It no longer encounters vehement opposition from the kind of reactionary voices who condemned avant-garde audacity 100 years ago. Instead, museums of modern art are enjoying record attendances. More and more people have become eager to experience, at first hand, the most provocative work on offer. There is an ever-growing appetite for art that challenges, astounds, subverts and, ultimately, enlarges our ideas about what might be possible.

To leaf through the pages of this well-researched book is to realize, with a feeling of optimism, how unprecedentedly open art has now become. In the early twentieth century most modernist artists reacted against photography, pushing their own work away from realism and towards ever more abstract visions of the world. Yet now artists often use photography as a prime medium, and the advent of fastchanging digital technology has presented them with an exhilarating range of new possibilities. The young renegades active 100 years ago would be astonished by the way photographic avenues have multiplied, and they would feel still more amazed to see just how far film has grown from its silent, flickering, black-and-white origins to become a major resource for experimental art.

But nothing would astound the pre-1914 avant-garde more than the transformation in the status of women artists. Back then, only a few female practitioners succeeded in gaining prominence. Men dominated everything in art, and continued to do so far into the twentieth century. Even Louise Bourgeois was only given a large survey of her work, at the Museum of Modern Art in New York, as late as 1982 when she had already passed her 70th birthday. It was the first retrospective exhibition ever given to a woman by the Museum, whereas now female artists command just as much attention as their male counterparts.

Today, all the old hierarchies have definitively given way to a more flexible, open-ended and improvisatory dynamic. Painting is still a major medium, and yet artists often regard it as one resource among many worth deploying. Sculpture occupies a far more central position, using an ever-widening range of materials and working strategies. Almost anything can now be used if the sculptor proves capable of turning it to advantage. But an increasing number of artists no longer want to be seen as either painters or sculptors. They move, with supple and enquiring ease, between a range of disparate approaches, leaping from installations or performance to video, drawing and computer-based solutions. The choices available to artists who thrive on freewheeling attitudes are greater than ever before. And this dizzying richness of approaches defeats any facile attempt to summarize contemporary art. Defiantly multifarious, it is impossible to pin down.

Nor should we place any arbitrary and oppressive limits on the locations that artists are willing to explore. Although the classic white-walled gallery will continue to provide an ideal setting for a great deal of new work, an immense array of alternatives lie far beyond the gallery's confines. When Richard Long began his lonely walks through wild terrain back in the 1960s, he proved that artists could find stimulus in the most remote regions of the earth. Since then a fascinating range of diverse sites, both urban and rural, have been discovered by artists eager to extend the territorial boundaries of their work. The economic crash means that increasing numbers of artists are adopting extempore approaches, investigating hitherto overlooked areas of the world where art might flourish. But they also realise the dangers of imposing their work with destructive arrogance on vulnerable spaces. Haunted by fears of catastrophic global disintegration, artists are developing a more profound respect for our vulnerable planet before it is too late.

MARINA ABRAMOVIC

BORN Belgrade, Yugoslavia, 1946

Marina Abramovic studied at Belgrade's Academy of Fine Arts (1965–70) and the Academy of Fine Arts in Zagreb, Croatia (1970–72). She taught at the Academy of Fine Arts in Novi Sad, Yugoslavia (1973–75) and eventually moved to Amsterdam where she began an artistic and romantic relationship with the German artist Ulay. The pair ended their relationship in 1988 by spending almost three months walking toward each other from opposite ends of the Great Wall of China, Abramovic presented a major series of performances at the Solomon R. Guggenheim Museum, New York, entitled Seven Easy Pieces (2005), and in 2010 the Museum of Modern Art, New York hosted a major restrospective of her work.

SEE ALSO McCarthy, Performance Art

Marina Abramovic was instrumental in the genesis of Performance Art in the 1970s and is particularly known for addressing pain and bodily endurance. She both pioneered Performance Art and completely redefined it, collapsing its barrier with reality through genuine pain and bodily harm. In Lips of Thomas (1975), Abramovic underwent a series of acts of physical endurance including eating a kilogram of honey, carving a star into her own stomach, whipping herself and lying on a bed of ice. The whipping suggested the Christian practice of self-flagellation, and the star was a symbol of Communist Yugoslavia. Both Christianity and Communism were central to Abramovic's upbringing, and in Lips of Thomas she enacted their psychological torture on her body. Abramovic claimed that she whipped herself until the pain ended, as if it were a kind of emotional exorcism.

The brutal reality of this performance forced the audience into a clear position of responsibility, since their presence both instigated and endorsed Abramovic's acts of self-harm. Indeed the original performance finished when some of the audience went to the stage and physically removed her from her ice bed. As in Rhythm 0 (1974), in which Abramovic gave the audience weapons with the invitation to use them on her, in Lips of Thomas viewers were made to see their own ability to intervene in the situation and so realize that they could no longer remain passive. As much as we might question Abramovic's actions, she also deflects those questions back onto her viewers, forcing them to question themselves.

Lips of Thomas

Performance still from re-enactment at the Solomon R. Guggenheim Museum, New York, on 14 November 2005, as part of the *Seven Easy Pieces* series

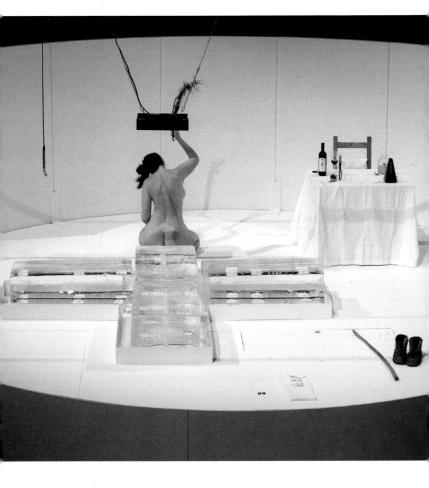

TOMMA ABTS

BORN Kiel, Germany, 1967

Tomma Abts studied visual communication at the Berlin University of the Arts. In 1995 she moved to London, where she had her first solo exhibition at Habitat. She won the Turner Prize (2006) for her exhibitions at greengrassi in London and Kuntsthalle Basel, Switzerland, and has since been exhibited in the Turner Prize Retrospective (2007). She had a major exhibition in New York, at the New Museum of Contemporary Art (2008). She continues to live and work in the United Kingdom.

SEE ALSO Abstract and Representational Art

The abstract paintings of Tomma Abts may seem rather out of place in the contemporary art scene, or even specifically opposed to prevailing trends. Her canvases are always the same small size, 48 x 38 cm (19 x 15 in), an exception to the current tendency toward large-scale works. The names of her paintings, which are always unusual German Christian names such as *Ert* (2003) and *Ebe* (2005), also seem to indicate an interest in making art on a human scale.

Another thing that sets Abts's work apart is its demand for close visual scrutiny. Although we might normally associate abstract art with flatness, the dimensions of Abts's paintings seem to be in a constant fluctuation that never really resolves itself. In Ert, contours overlap and destroy each other, leaving us unsure as to how its elements are related. In Ebe, there is a suggestion of shadows and the play of light, but these signs are contradictory and it is impossible to combine them into a consistent spatial arrangement. Abts is well known for the slowness of her process, but she also forces slowness on the part of the viewer. Hers is not the disposable aesthetic that we have become so used to in the successors of Pop Art, but a style that requires protracted concentration. Indeed, this demand for slowness is perhaps the most radical element of Abts's art, a rebellion against the fast pace of contemporary art and its market. Furthermore, while her antispectacular approach sets Abts apart from her contemporaries, it ultimately makes her work a highly effective critique of art's current problems.

Ert

2003 | Oil and acrylic on canvas 48 x 38 cm (19 x 15 in)

VITO ACCONCI

BORN New York City, NY, USA, 1940

Vito Acconci trained in English Literature, receiving a Bachelor of Arts degree from the College of the Holy Cross, Massachusetts in 1962, and a master's in English Literature and Poetry from the University of Iowa in 1964. He then began a career in poetry, but quickly changed to art. In the late 1960s he co-edited the journal 0 to 9. In 1969 he had his first solo show at the Rhode Island School of Design. His work featured in Information at the Museum of Modern Art, New York in 1970. Since the 1980s his work has predominantly been architectural.

SEE ALSO Graham, Nauman, Conceptual Art, Performance Art, Video Art

Unlike the often dry works of his contemporary Conceptual artists, Vito Acconci's work is charged with sexuality and playfulness. In *Remote Control* (1971), Acconci and a woman sat in boxes in separate rooms, but were displayed to each other by monitors and speakers. Acconci coaxed the woman to tie herself up with rope. Although he had no direct physical control, he still manipulated the woman into disempowering herself. While Remote Control is clearly gendered (a man manipulating a woman into helplessness), its implications are much broader. The monitors and the title reference the contemporary technologies that increasingly permeate our space. The implication is that violence is no longer the favoured method of power. Instead, we are manipulated into subduing ourselves by coercive media and omnipresent technologies.

Remote Control also comments on art itself. It demonstrates the power relations between a dominant artist and a viewer who is sensually and emotionally manipulated. Because of his inherent mistrust of art, Acconci has since turned to architecture, creating increasingly participatory spaces. With Steven Holl he co-designed a facade for the Storefront for Art and Architecture gallery in New York (1992-93). It pivots, removing any strict barrier between inside and outside and opening the gallery space beyond its narrow audience. This also removes strict institutional control, opening the space up to the logic of the city in general.

Acconci has acknowledged that all he can provide is choices within structures that remain concrete in their possibilities. However, as his work progresses, he increasingly moves from the simple, binary organization of *Remote Control* to the more fluid arrangement of works like the Storefront. The point is to move from a process of manipulation into one of collaboration.

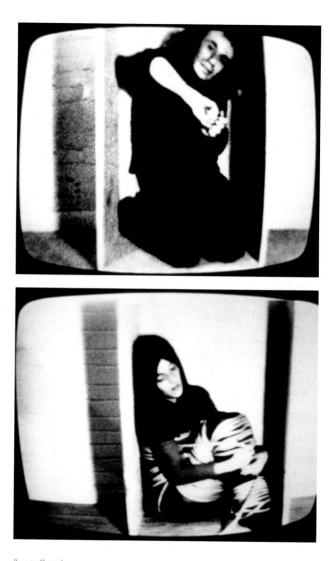

Remote Control 1971 | Video installation. Two simultaneous videotapes, black and white, sound, 62 min 30 sec 183 x 213 x 61 cm (72 x 84 x 24 in)

FRANZ ACKERMANN

BORN Neumarkt St Veit, Germany, 1963

Franz Ackermann studied at the Academy of Fine Arts in Munich (1984–88), and the University of Fine Arts in Hamburg (1989–91). He had his first solo show at the Galerie Komat in Braunschweig, Germany (1989). This was followed by a show called *Pacific* at the White Cube Gallery, London (1998). Ackermann's work was featured in the Venice Biennale (2003). He had a solo show at the Irish Museum of Modern Art, Dublin (2005).

SEE ALSO Genzken, Morris, Abstract and Representational Art, Installation Art

Franz Ackermann's work is an attempt at globalized painting. His "Mental Map" paintings have been executed in numerous places around the world, and they document his response to the locations, normally one of bewilderment. In *Mental Map: Evasion V* (1996), Ackermann mixes representative elements, such as architectural fragments and a section of coastline, with abstract, psychedelic forms. Sometimes these forms emanate from the representative elements, but they can also cut through them, fragmenting the images.

This spatial fragmentation is heightened by the imposing size of some of the works. In the installation *Terminal* (2008), for example, Ackermann's paintings covered all the walls of a room. We might assume some interconnection of parts in *Mental Map: Evasion V* because of its thin, snaking lines that resemble wires, but these bury themselves under the surface of the work and it is therefore impossible to trace the extent of their pervasion.

If confusion is Ackermann's key motif, perhaps this reflects how we are

ourselves confused by the intensity of the global environment. Both the size of the spaces we inhabit and our ability to travel across huge distances leave us unable to unify our experience. It is important that Ackermann's confusion is manifested in colours that we associate with Western popular art. Our authentic connection with the world is threatened by the intrusion of an all-pervasive hegemonic culture. Indeed the wires underlying Ackermann's torrent of kitsch imply that this confusion is produced by some uniform technology; the ordered production of complete disorder. Similarly, although these paintings are hugely seductive in their explosive exuberance, their sensual intensity is really just a sign of our total inability to function.

Terminal 2008 | Installation view Meyer Riegger, Karlsruhe

EIJA-LIISA AHTILA

BORN Hämeenlinna, Finland, 1959

Eija-Liisa Ahtila studied at Helsinki University (1980–85), the London College of Printing (1990–91) and the University of California, Los Angeles (1994–95). Her work was featured in the Venice Biennale (1999). She was the first artist to receive the Vincent van Gogh Award (2000). She has had a solo show at London's Tate Modern (2002) and at the Museum of Modern Art, New York (2006). She has taught at a number of institutions, including the Academy of Fine Arts, Helsinki.

SEE ALSO Video Art

Eija-Liisa Ahtila makes video installations consisting of highly sophisticated webs of overlapping and interpenetrating narratives. In Where is Where? (2008), an author is seen writing the story of two Algerian boys who murder a European friend as an act of defiance against the oppression of their compatriots. The author's life and her fictional narrative appear to be intimately bound up with each other. We see French men invading her house, capturing and eventually executing Algerians while she writes, as if she is producing the violence herself. This leads to a scene in which the

author speaks to a priest of her sense of responsibility for the fictional deaths. In another scene she speaks with Death, who demands that she should provide him with words, implying her complicity in his actions.

In House (2002) a woman flies above the ground, implying her disconnection from the reality that it represents. The relationship between fiction and reality is a constant theme in Ahtila's work and is emphasized in the construction of her

installations. When viewers arrive at her installations, the films are often halfway through, so the viewers are already disorientated. This disorientation is increased by the viewers' inability to see all the screens at once, meaning that they are only ever presented with a partial narrative. This narrative becomes personal because it is bound up with the viewers' own passage through the installation. By adding this personal plane to the collision of the real and the fictional, Ahtila acknowledges the equally ambiguous relationship between her own fictions and her viewers' realities. The viewers of her installations are integrated into her web, which denies the existence of any outside reality.

Where is Where? 2008 | Six-channel HD installation with eight-channel sound 53 min 43 sec

AI WEIWEI

BORN Beijing, China, 1957

Ai Weiwei enrolled at the Beijing Film Academy in 1978, before moving to New York in 1981, where he studied at the Parson's School of Desian for a short period of time. Ai Weiwei's work was included in the 48th Venice Biennale in Italy (1999), 1st Guanazhou Triennale in China (2002). The 2nd Guanazhou Triennial (2005), Busan Biennial in Korea (2006). The 5th Asia-Pacific Triennial of Contemporary Art in Australia (2006), Documenta 12 in Germany (2007), Liverpool Biennial International O8 in the UK (2008) and the 29th Sao Paulo Biennial in Brazil (2010). He also worked with Swiss architects Herzoa & de Meuron as the artistic consultant on the Beijing National Stadium for the Olympics in Beijing in 2008.

SEE ALSO Conceptual Art

One of the most well-known artists in China, in recent years Ai Weiwei has also emerged as one of the most influential artists in the world. Ai first began operating in the contemporary art world in 1978 as a member of "Stars", an early avant-garde art group. He studied briefly in China before moving to New York in 1981, where he lived until 1993. During this time, he created conceptual art that often involved the use of "readymades". After returning to China in 1993, Ai published three books, *Black Cover Book* (1994), *White Cover Book* (1995) and *Gray Cover Book* (1997), a project that helped bring conceptual art to a Chinese audience. In 1997, he also helped to set up China Art Archives and Warehouse (CAAW), an archive of work from China, and an experimental gallery.

A vocal critic against Chinese authority, Ai has been detained by the Chinese police on numerous occasions. He has made work and spoken out against the disaster of the Sichuan earthquake in 2008, a tragedy that was magnified by the fact that many schools collapsed because they failed to meet certain building regulations. The work, So Sorry, was exhibited as part of a major retrospective of Ai's work at the Haus der Kunst, Munich in 2009. Ai is also well known for his contribution to Documenta 12, in Kassel, Germany. In a work called Fairytale, Ai invited 1,001 people from China to Kassel, organized in five groups and for each to stay for eight days during the exhibition. Ai designed clothes for them and put them up in a temporary, communal-style dorm, as well as brought 1,001 Qing Dynasty chairs over from China for them. In 2010, Ai realized one of his biggest commissions to date at the Tate Modern. The work, titled Sunflower

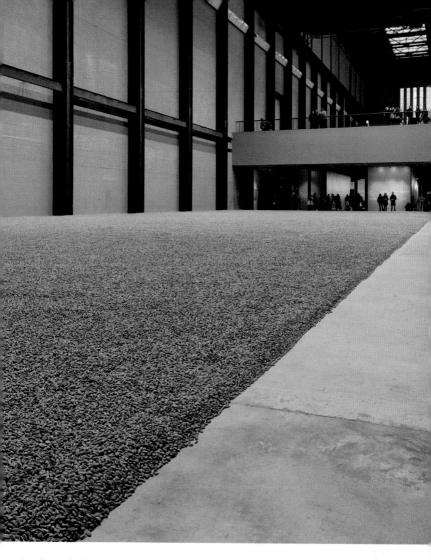

Seeds, involved hundreds of millions of sunflower seeds made from porcelain and hand-painted by artisans in a workshop in Jingdezhen, China. The piece reflected on the geo-politics of cultural exchange today.

Sunflower Seeds 12 October 2010 – 2 May 2011 Tate Modern Turbine Hall, London

DOUG AITKEN

BORN Redondo Beach, California, USA, 1968

Doug Aitken attended Marymount College in Palos Verdes, California (1986–87) and received a Bachelor of Fine Arts from the Art Center College of Design in Pasadena, California (1991). He had his first solo exhibition, entitled *Dawn*, at the AC Project Room in New York City (1993). In 1999 he was awarded the International Prize at the Venice Biennale for his work *Electric Earth* (1999). In 2007, jointly commissioned by the Museum of Modern Art and Creative Time, he became the first artist to make art on the exterior walls of MoMA. He lives and works in New York City and Los Angeles.

SEE ALSO McQueen, Wilson, Video Art

Doug Aitken's video installations absolutely absorb their viewers, occasionally even migrate into their space. In *Electric Earth* (1999), a dancer is heard to say that when dancing, "I become what surrounds me". This is equally descriptive of the viewer who is immersed within the large, sensual video installation. It also serves as an analogy for the way in which technology tends to encroach upon its

surroundings, restructuring the world around it. In *Electric Earth*, the dancer moves in synch with machines, such as car windows and traffic lights. He literally dances to the rhythm set by technology.

In sleepwalkers (2007), Aitken's film does not merely immerse its viewers, it also enters into their space and merges with its environment. Screened at the Museum of Modern Art in New York City, sleepwalkers consisted of eight moving images projected onto different parts

of the building's facade. The characters moved between the different images as if traversing the intermediate space. Therefore the viewer had to move around the building in order to fully experience the work, although they could never watch it all simultaneously. In this way, the images step into the viewer's space; not only representing an urban environment, but existing within it. While Aitken's works explore and depict urban spaces, they also manipulate and restructure them. Their sites are transformed into collections of moving images and can no longer retain any independence from the technologies that inhabit them. The films, meanwhile, are no longer merely films, since they have colonized reality and replaced it with their bright lights and moving pictures.

sleepwalkers

2007 | Installation view at MoMA, New York Six-channel video installation 12 min 57 sec Dimensions variable

PAWEL ALTHAMER

BORN Warsaw, Poland, 1967

Pawel Althamer studied sculpture at the Academy of Fine Arts in Warsaw (1988–93). He has exhibited widely at institutions around the world, including Tate Modern, London, and the National Gallery of Art, Warsaw. In addition to Sculpture Projects, Münster (2007), Althamer participated in Manifesta (2000); and the Carnegie International (2004). In 2004 he was awarded the Vincent van Gogh Award. Althamer lives and works in Warsaw.

SEE ALSO Conceptual Art, Installation Art, Performance Art, Video Art

Pawel Althamer makes Conceptual Art that is imbued with a strong sense of materiality. He works in a variety of media including video, sculpture and installation, and is also a Performance Artist. His art deals directly with the world around him and can be understood as a means of interpreting reality. His particular perspective is gained from having grown up in Poland (a former Eastern Bloc country) during the political transformations of the early 1990s.

Althamer's work investigates social issues and the relationships between people, particularly disenfranchised or impoverished people. In a well- known

piece entitled Dancers (1997), Althamer filmed a group of homeless people without clothes on, dancing in a circle. The absence of clothes makes it impossible to recognize the group as homeless. The piece explores human expression and interaction within an often stigmatized group of individuals.

In his artworks, Althamer questions everyday life by taking familiar objects and procedures out of context to elicit new interpretations. For Sculpture Projects

Münster 07, Althamer contributed a piece entitled *Path*, for which he created a cycle and footpath through the German city of Münster over meadows, fields and beyond. In one sense, visitors followed a path like any other of the many limitedaccess routes that run through a city – but in this case, the path actually ran directly through everything it was supposed to avoid. The project made people reconsider the movements and decisions they make everyday, while also harking back to childhood experiences of meandering through the countryside. Just short of 1 km (0.6 mile) in length, the path came to an abrupt end in the middle of a field. The cessation of the path forced its followers to make a quick decision about where to go and what to do next.

Path 2007 | Path near Münster, Germany Length: 1 km (0.6 mile)

FRANCIS Alÿs

BORN Antwerp, Belgium, 1959

Francis Aliys studied at the Institute of Architecture in Tournai, Belgium, and then at the Istituto Universitario di Architettura di Venezia, Italy. He has had a number of solo exhibitions, including Seven Walks, National Portrait Gallery, London (2005); Black Box: Francis Alijs, Hirshhorn Museum and Sculpture Garden, Washington DC (2006); A Story of Deception, Portikus, Frankfurt am Main (2006); A Story of Deception, Patagonia 2003-06, Museo de Arte Latinoamericano de Buenos Aires (2006); Politics of Rehearsal, Hammer Museum, Los Angeles (2007-08); and Bolero, Renaissance Society at the University of Chicago (2008). In 2010 Tate Modern, London, held a major retrospective of his work.

SEE ALSO Conceptual Art

Born in Belgium and based in Mexico City, Francis Alÿs makes interventions in his environment that are usually ephemeral, although often documented through video, photography, writing, painting or animation. His actions maintain a delicate balance between politics, poetics and philosophical meanderings. Alÿs moved to Mexico City in 1987, and he retains the acute

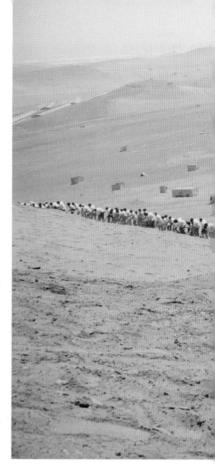

observational prowess of a foreigner, provoking, confronting and challenging mundane aspects of his urban surroundings. The work frequently operates within an absurd set of parameters that Alÿs establishes for himself; in a piece entitled *The Paradox of Praxis 1* (1997), a large block of ice was pushed through the streets of Mexico City until it melted. The fleeting nature of Alÿs's work, existing as much in the mind as it does in the moment, aligns his

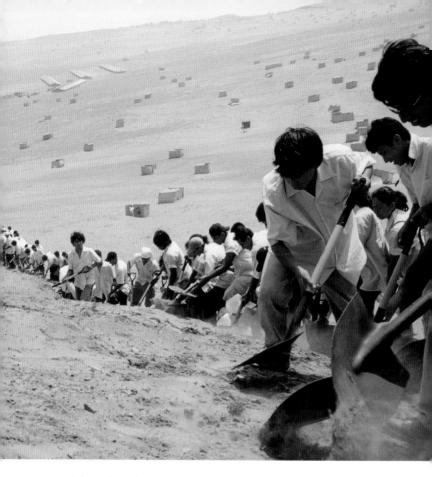

practice with the tradition of the Situationists, as well as the Fluxus movement.

On April 11, 2002, Alÿs recruited some five hundred volunteers to participate in perhaps his best-known work, *When Faith Moves Mountains*. In the surroundings of the city of Lima, Peru, Alÿs asked the volunteers – armed with shovels – to form a line and to move a large sand dune a small distance from its original position. Each volunteer moved one shovelful of sand one step at a time, from one side of the dune to the other. The actual displacement of the dune was only a few centimetres; however, the metaphorical resonance of the action, as well as the visual spectacle it created, was enormous.

When Faith Moves Mountains

2002 | Photographic documentation of an event, Lima, Peru 16mm film, colour, 36 minutes in collaboration with Cuauhtémoc Medina and Rafael Ortega

CARL ANDRE

BORN Quincy, Massachusetts, USA , 1935

Carl Andre studied art at the Phillips Academy in Andover 1951–53. Following a period in the army, he moved to New York in 1957 and soon began to work on sculptures. His first solo show was at the Tibor de Nagy Gallery in New York in 1965. In the 1960s he became associated with the term Minimalism and was included with other such artists in the 1966 exhibition *Primary Structures* at New York's Jewish Museum. In 1970 the Solomon R. Guggenheim Museum in New York put on a retrospective of his work.

SEE ALSO Abstract and Representative Art

Of all Minimalist Art, Carl Andre's is perhaps the most intensely sculptural. *Equivalent VIII* (1966) is from a series of configurations of 120 firebricks. Since we know that the works are made of equivalent materials and because of the simplicity of their arrangement, we are always aware of other possible alternatives. This leaves a trace of Andre's practice and declares the singularity of each work through its specific difference, both from the other works in the series and also the other approaches that Andre could have taken.

This singularity is in tension with the sculptures' mass-produced materials. We might think that the bricks could continue indefinitely and that the work is a presentation of objects, rather than the creation of a sculpture. However, what these works actually seem to signal is sculpture's reduction to its most fundamental level: the coordination of materials. Therefore Andre calls the viewer to pay closer attention to his practice rather than to jgnore it.

As well as stressing the artist's role, these works also radically incorporate the viewer. By using everyday materials, Andre declares his works' existence in our space. This is particularly clear in Venus Forge (1980), which viewers are invited to walk over. Our experience of the work is extended to the physical and even the aural, through the sound of our footsteps on the metal plates. So not only does Andre emphasize the essential nature of sculpture, but he also extends that nature beyond the merely visual to a more complete sensual experience. At the same time as drawing our attention to the work's singularity, he also reconciles it with our relation to the world in general.

Equivalent VIII 1966 | Firebricks 13 × 68.5 × 229 cm (5 × 27 × 90 in)

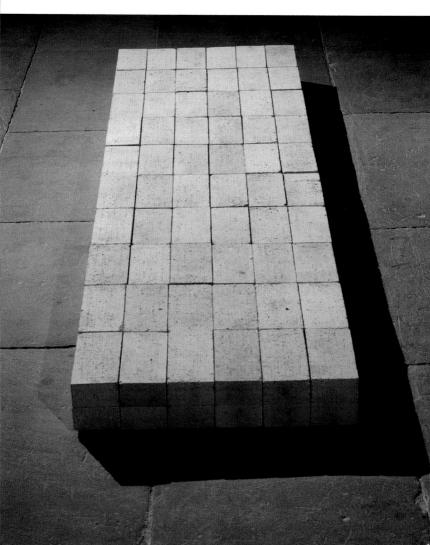

KENNETH ANGER

BORN Santa Monica, California, USA, 1927

Kenneth Anger made his first film, Who Has Been Rocking My Dreamboat (1941), at the age of fourteen. He published a book, Hollywood Babylon (1959), revealing a number of celebrity scandals. Due to funding difficulties several of his films, including Puce Moment (1949) and Kustom Kar Kommandos (1965), were never completed. Having stopped making films during the 1980s and the 1990s, he re-emerged with Don't Smoke That Cigarette! (2000). In 2009, the MoMA PS1 Contemporary Art Center in New York presented a major survey of his work. Anger has received a number of awards, including a Life Achievement Award from the American Film Institute.

SEE ALSO Warhol, Video Art

Kenneth Anger is a filmmaker who mixes the occult and the perversely sexual with the everyday. *Scorpio Rising* (1963) focuses on a day in the life of a biker. The opening scenes feature him working meticulously on his motorbike, intimating sexuality as he handles its metallic innards. He then relaxes, reading a comic. Despite the sexual undertones, these scenes are largely devoid of drama. The only signs of impending action are recurring images of James Dean, who famously rode motorcycles and was killed on the road, albeit while at the wheel of a car.

This introduction is followed by images of bikers putting on their leather gear. These images mix two key thematic interests that occur throughout Anger's work, homosexuality and the occult. The first is represented by Anger's voyeuristic gaze on male bodies and guasi-fetishistic clothes; the second by the almost ritualistic process of self-preparation undertaken by the bikers. Further clear allusions to homosexuality are made in Fireworks (1947), in which Anger is beaten and then has a milky, semen-like liquid poured over his face and chest. Invocation of My Demon Brother (1969), meanwhile, is entirely based on an occult ritual.

However, it is Anger's mixture of perversity and normality that has been most influential on other artists. *Scorpio Rising* emerges from its everyday pop-cultural references into full-blown acts of orgiastic violence and a catastrophic ending mirroring that of James Dean. Anger did not simply contrast normality with the far-fetched. Instead, he combined the two on a single plane, allowing the darkness underlying reality to burst through to the surface and assert itself in every moment.

Scorpio Rising 1963 | 28 min

DIANE ARBUS

BORN New York City, NY, USA, 1923 DIED New York City, NY, USA, 1971

Diane Arbus was born Diane Nemerov in 1923. At age 18 she married Allan Arbus and the two collaborated as fashion photographers until 1956 when Diane began to focus solely on her own work. This included photo-essays for magazines such as Esquire and Harper's Bazaar as well as the individual portraits for which she is best known today. The couple divorced in 1969. Arbus committed suicide in 1971. The Museum of Modern Art, New York, showed a retrospective of her work (1972), and in the same year she became the first photographer to be featured in the Venice Biennale, Diane Arbus Revelations - a major retrospective, oraanized by the San Francisco Museum of Modern Art, toured the United States and Europe between 2003 and 2006.

SEE ALSO Calle, Goldin

The photographer Diane Arbus is best known for works featuring giants, sideshow performers, and dwarves, as well as nudists, transvestites, the mentally disabled, and middle class families. *Triplets in Their Bedroom* (1963) is characteristic of those works in its intimate domestic feel. Although Arbus did sometimes work in outdoor spaces, the predominant use of interiors distinguishes her from most other photographers of her time. Arbus had a genuine intimacy with her subjects. She never took them outside their own space or arranged them, but came into their homes, integrated with them and arranged herself in order to capture them in their native environment. *Triplets*, for example, is clearly taken from close to the edge of the triplets' bed, inside their personal space.

Arbus's documentary approach contrasts with the more visually expressive style of many of her contemporaries in photography, and indeed painting, and it heavily influenced Conceptual Artists. Rather than merely documenting her subjects, her highly complex works consist of layers of generality and intimacy; they are in-depth engagements with individuals who are never named personally. As much as her images are of particular individuals. they also represent something much broader. Unlike her contemporaries, who either focused on the abnormal as a separate reality or on the common as a single entity, Arbus used instances of abnormality to represent life in general. By gaining intimacy with her subjects she reached beyond their social masks to reveal the differences that always lie behind them, and at the same time, in a broader sense, she pointed to what lies behind our own social masks.

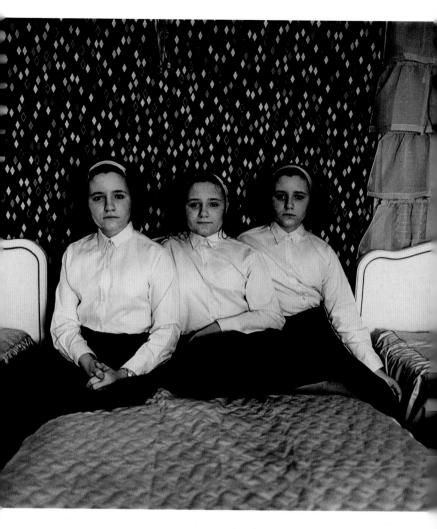

Triplets in their Bedroom, NJ, 1963 | Black and white photograph 40.5 x 51 cm (16 x 20 in)

MICHAEL ASHER

BORN L.A., California, USA, 1943 DIED L.A., California, USA, 2012

Michael Asher had work featured in the Venice Biennale (1976). His first public work in the United States was a granite drinking fountain on the campus of the University of California, San Diego (1991). In the same year he had a show at the Pompidou Centre, Paris. As well as being an artist he is a writer, notably of the collection *Writings: 1973–1983*, which was co-authored by art historian Benjamin Buchloh. Since the early 1970s Asher has taught at the California Institute of the Arts, Los Angeles.

SEE ALSO Broodthaers, Buren, Haacke, Fraser, Conceptual Art

Michael Asher is seen as a sculptor, but his primary material is art's institutional frame – his work explores the institutions that surround and constitute art, both in relation to the external world and in their effect on the works themselves. *Installation Münster* (Caravan) was first shown in 1977, but has been re-exhibited at Sculpture Projects Münster every 10 years. The work consists of an unmarked caravan that Asher moves around the city of Münster once a week. Although the caravan is displayed in official documentation, there is nothing around it to suggest its "art status" to passers-by. Asher marks a difference existing more between viewers than between objects: between those who are aware of the object's status and those who treat it like any other vehicle. This denies art objects any specificity; they exist through mutual agreement rather than any innate quality. Asher also incorporates context into the work, displaying how its reception changes as its context shifts.

This investigation of context is at the heart of Asher's work. In the late 1960s he divided up gallery spaces to improve awareness of both their physicality and their lack of spatial neutrality. In 1974 he removed a wall in the Claire Copley Gallery, Los Angeles, California, to reveal the administrative space of the gallery where its commercial activities took place. He thereby removed another assumption of neutrality by emphasizing art's place within the economy. The neat symbolism of this stripping away of the wall sums up Asher's practice. Artists usually create objects, but Asher manipulates both objects and spaces to peel away our assumptions and present a genealogy of artistic meaning.

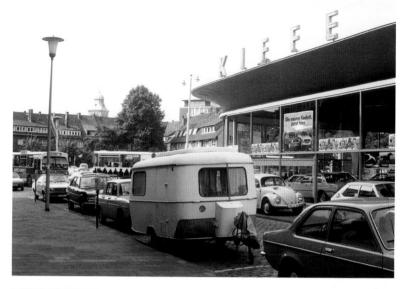

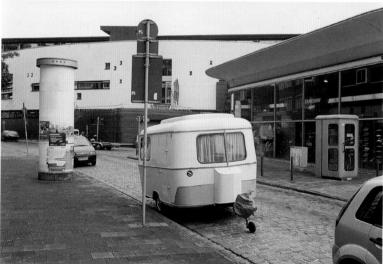

[Above]

1977 | Parking Position of Week 4, 25 July- 01 August, Alter Steinweg, opposite Kiffe Pavilion (on Parking Meter Nr 275 or 274) [Below] 2007 | Parking Position of Week 4, 09-15 July, Alter Steinweg, opposite Kiffe Pavilion

FRANK AUERBACH

BORN Berlin, Germany, 1931

Born to Jewish parents, in 1939 Frank Auerbach was sent to safety in England; his parents stayed behind and were killed by the Nazis. He attended St Martin's School of Art in London (1948–52), and then studied for three years at London's Royal College of Art. He had his first solo show at London's Beaux-Arts Gallery (1956). He had a retrospective at the Hayward Gallery, London (1978) and a solo show at the Venice Biennale (1986). The Royal Academy of Arts in London celebrated Auerbach's 70th birthday with a major retrospective (2001).

SEE ALSO Bacon, Freud, Abstract and Representational Art

Early in his career, Frank Auerbach's paintings were described by the critics as being more like sculpture, due to their thick layers of paint. We can see this in J.Y.M. Seated No. 1 (1981), a portrait composed from stabs and gashes that either loom off the canvas or dig within its ravines of paint. This play between absence and presence allows the paint to take on a physical weight, emphasizing its own volume and texture above any illusion of the sitter's.

So while his work might in some sense be sculptural, what it actually seems to reveal is the inherently sculptural aspects of painting itself. Auerbach also sets up a clear relationship between his paint and the canvas. In I.Y.M. Seated No. 1, the figure seems almost to be pulling itself out of the canvas, straining to separate itself. However, it ultimately fails, remaining lodged within its background. In this sense, Auerbach's apparently thick, bombastic paintings constantly play on a tension between coherent images and their collapse into disjointed forms. This internal dynamism, emphasized by Auerbach's diagonal slashes, retains a painterliness that clearly separates his work from sculpture. It also implies a process of evolution within the work – a vain attempt at emancipation from the canvas and from being pinned down to any particular medium. Therefore unlike Minimalist sculptors like Donald Judd, who collapse painting and sculpture into one another, Auerbach holds them in a constant state of conflict, lending a dynamic power to his work.

J.Y.M. Seated No. 1 1981 | Oil on board Support: 71 x 61 cm (28 x 24 in)

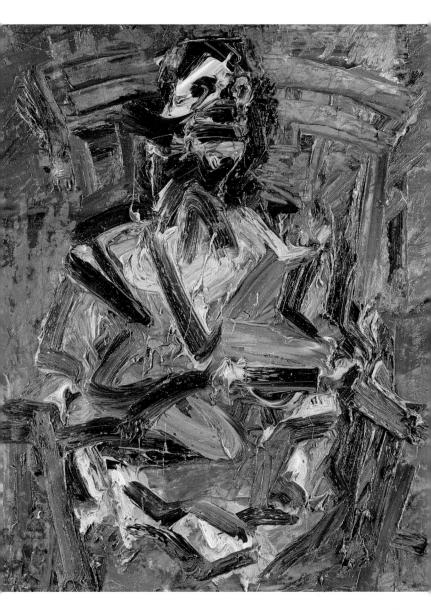

FRANCIS BACON

BORN Dublin, Ireland, 1909 DIED Madrid, Spain, 1992

In the late 1920s Francis Bacon began work as a designer of furniture and interiors, but by 1930 he had turned primarily to painting. He organized his first solo show at Sunderland House in London in 1934. He painted little for the next decade and later destroyed most of the works from this period. In the 1950s he developed into his mature style, for which he began to become well known. In 1955 the Institute of Contemporary Arts in London organized his first retrospective and another followed at the Tate Gallery in 1962. He died in Madrid in 1992. In celebration of the centenary of his birth, a major retrospective of Bacon's work took place at Tate Britain, London (2008–09).

SEE ALSO Auerbach, Freud, Hirst, Tuymans, Abstract and Representational Art

Although today Francis Bacon towers above most of his contemporaries, at the time of his emergence he was thought of as a wilfully incapable painter. Rather than the traditional approach of building up solid, stable bodies, Bacon smears and blurs his paint. In *Self-Portrait (Seated)*

(1970), Bacon's legs seem almost liquid, flowing into each other and down towards the floor. His face looks bruised and raw, as if Bacon has literally delved under the skin. Once his layer of protective flesh has been removed his body appears to crack apart, threatening to disintegrate. However, Bacon always used the unprimed side of the canvas, meaning that the paint soaks deep inside, its usual liquidity replaced by an almost chalky dryness. Therefore not only do his figures threaten to flow into an indistinct mass, but they also seem ready to return to ashes and dust.

In Three Studies for Figures at the Base

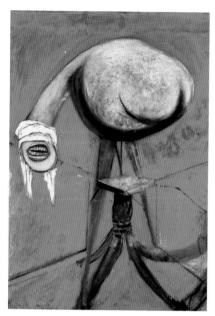

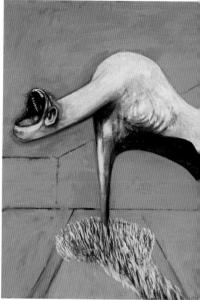

of a Crucifixion (circa 1944), this outward movement of the bodies expresses itself as a terrible anast. The figures strain against constraints that tie them down. As in his recurring use of cage-like squares to encompass his sitters, these are images of the body as a prison. If Bacon was wilfully incapable of maintaining the integrity that tradition demanded of him, he was supremely capable of tearing it apart, and dragging tradition down with it. Having turned from his early abstract paintings to predominantly figurative work, his figures are in constant danger of reverting to despairing abstractions, renouncing the pain of the body and the terror of the static.

Three Studies for Figures at the Base of a Crucifixion Circa 1944 | Oil on board Each support: 94 x 74 cm (37 x 29 in) Each frame: 116 x 96 x 8 cm (46³/4 x 38 x 3 in)

MIROSLAW BALKA

BORN Ottwock, Poland, 1958

Miroslaw Balkacontinues to live and work in Ottwock, Poland. His solo exhibitions include Museo Reina Sofia, Madrid (2010), Modern Art Oxford, Oxford and Tate Modern, London (2009), Museum of Contemporary Art, Rijeka and Irish Museum of Modern Art, Dublin (2007), K21 Kunstsammlung Nordrhein Westfalen, Düsseldorf (2006), Museum of Contemporary Art, Strasbourg (2004), Dundee Contemporary Arts, Scotland (2002) and Stedelijk Museum voor Actuele Kunst (SMAK), Gent (2001).

SEE ALSO Installation Art, Video Art

Working in sculpture, installation and video, Miroslaw Balka creates art that references the recent history of Poland. His works are made from distinct and evocative materials, including ash, felt, salt, hair and soap. Broadly, his work explores how subjective traumas become collective histories, however he often turns his attention to his native Poland, investigating the Nazi occupation during the Second World War and the experience of Jews during that time. Brought up as a Catholic in Poland, Balka's work explores the personal and collective experience of a complex national history. He also uses his own body as a starting point for many of his works, sometimes using materials as replacement for the body, or allowing the dimensions of his own body to influence the construction of the work.

In 2009, Balka realized a large-scale commission for Tate Modern's Turbine Hall. The work, *How It Is*, consisted of an enormous grey steel structure which participants walked into via a long dark ramp. Like much of Balka's work, the piece had clear connotations to the Holocaust; the ramp was reminiscent of the ramp into the ghetto in Warsaw and the dark container recalled the trucks that took Jews to Auschwitz. The experience of walking into a black chamber was, somewhat paradoxically, a highly sensory event yet one that was also deeply unsettling.

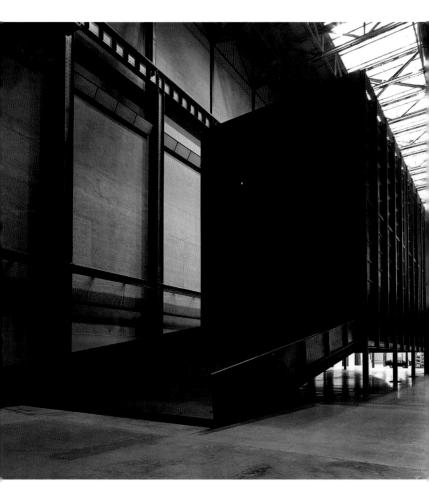

How It Is 13 October 2009 – Monday 5 April 2010 Tate Modern Turbine Hall, London

MATTHEW BARNEY

BORN San Francisco, California, USA, 1967

Matthew Barney moved to Boise, Idaho, at a young age. Though he grew up in Boise, he made frequent visits to New York City, where his mother lived. Barney has a Bachelor of Arts degree from Yale University. His work has been the subject of a number of solo exhibitions, including Matthew Barney: The Cremaster Cycle (2003), Solomon R. Guggenheim Museum, New York; Matthew Barney in the Living Art Museum (2005), Living Art Museum, Reykjavik; and Matthew Barney (2007), Serpentine Gallery, London. He won the Hugo Boss Prize in 1996.

SEE ALSO Abramovic, Acconci, Beuys, Nauman Performance Art, Video Art

Matthew Barney is one of the most influential American artists of his generation. A multimedia artist, he is well known for creating high-budget, visually extravagant films and working with a variety of unusual materials, including Vaseline. His most notable film series is *The Cremaster Cycle*, a five-part series created between 1995 and 2002. The series takes its name from the cremaster muscle in the male genitalia, which is responsible for raising and lowering the scrotum to regulate the temperature of the testes. The muscle provides a metaphorical basis for the films. Each of the five films takes place in a different setting, ranging from a football field in Barney's hometown of Boise, Idaho, to the Chrysler Building in Manhattan. Characters in the films, who include Barney himself, are worked into a densely layered and interconnected mixture of historical, autobiographical, mythological and phantasmagorical stories.

Many of Barney's works integrate his life interests in sport and art. In 1987, while still a student, Barney began the Drawing Restraint series. In the series, Barney investigates the idea that form is created out of a strugale against resistance. Barney's central proposition is that encumbrance can strengthen creative output, as resistance strengthens an athlete. In a number of works in the series, Barney creates drawings while working against self-imposed physical restraints. Some of Barney's performances show a close affinity to the tradition of Performance Art in the 1960s and 1970s. The centrepiece of the series is Drawing Restraint 9, a film about ritual and transformation, which takes place aboard the Nisshin Maru, a Japanese whaling ship, and features his partner, the Icelandic singer Björk.

CREMASTER 3 2002 | Production still

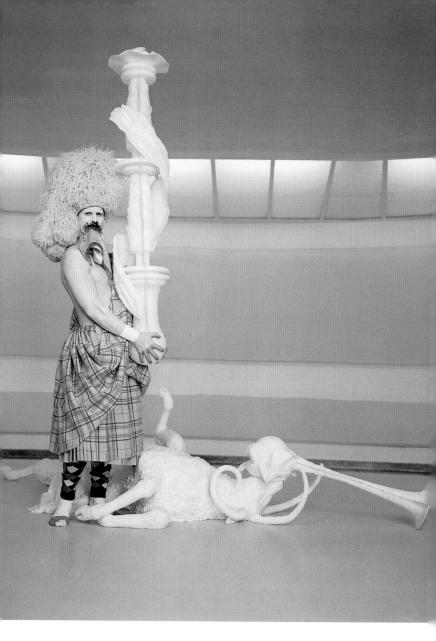

JEAN-MICHEL BASQUIAT

BORN New York City, NY, USA, 1960 DIED New York City, NY, USA, 1988

lean-Michel Basquiat left school in 1978, one year before graduating. His artistic career quickly gained momentum after he was praised in an article by the influential journalist, poet and critic Rene Ricard, Before reaching the age of 25, Basquiat was the subject of numerous solo exhibitions, before dying tragically of a drugs overdose. Julian Schnabel directed Basauiat (1996), a film about the artist's life and the 1980s Manhattan art scene. Since his death, Basquiat has been the subject of exhibitions around the world and in 2010 the Musée d'Art Moderne de la Ville de Paris held an enormous retrospective of his work.

SEE ALSO Clemente, Warhol, Identity Politics

Jean-Michel Basquiat was born to a Puerto Rican mother and a Haitian father. He grew up in Puerto Rico and New York, speaking French, Spanish and English. After leaving home at a young age and living with friends in New York, he gained some recognition as the artist SAMO, a self-created pseudonym under which Basquiat and his friend Al Diaz spraypainted pithy messages about the world around lower Manhattan. Although he disliked being called a graffiti artist, Basquiat maintained a close connection to the street art form in his paintings. In the 1980s he began to exhibit alongside Julian Schnabel, David Salle and Francesco Clemente, artists associated with Neo-Expressionism. Basquiat also maintained a close, if sometimes strained, relationship with Andy Warhol.

Basquiat's paintings are known for their rich symbolism and adept use of iconography, both of which engaged and delighted New York art critics. He used Afro-Caribbean imagery in his works, alongside seemingly disparate elements of mythology. Skeletons, skulls and masked figures make frequent appearances in the work and indicate a preoccupation with death. The work is frenzied and at times angry. Basquiat incorporated text into his paintings, but often the text is visibly scratched out, as though the painting is merely a work in progress, or a spontaneous creation. In the work Pyro (1984), the words "Big Pagoda" are written under what appears to be an unfinished portion of the painting. Underlying this spontaneity, Basquiat's paintings show a great mastery of composition, with bold use of strong, vibrant colours.

Pyro

1984 | Acrylic and mixed media on canvas 218.5 x 172 cm (86 x 67¾ in)

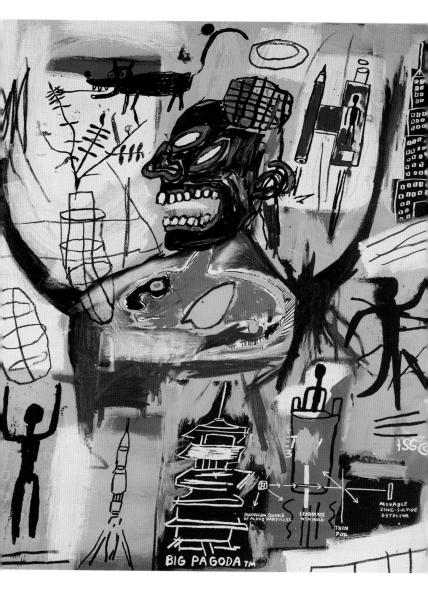

BERND & HILLER BECHER

BORN Bernd: Siegen, Germany, 1931; Hilla (née Wobeser): Potsdam, Germany, 1934 DIED Bernd: Rostock, Germany, 2007

The Bechers met while studying painting at the Kunstakademie in Düsseldorf in the late 1950s. They began to collaborate in 1959 and married in 1961. They won the Golden Lion at the Venice Biennale (1990). They have been hugely influential as teachers at the Kunstakademie Düsseldorf, and artists such as Andreas Gursky and Thomas Struth were once their students. They received the Hasselblad Foundation Award for the continued quality of their work and their influence as teachers in 2004.

SEE ALSO Gursky, Ruff, Schütte, Struth, Conceptual Art

During their collaboration of almost fifty years, Bernd and Hilla Becher photographically documented relics of industrial architecture. Their approach was largely uniform: grids of a certain type of building, such as pitheads and coal bunkers, all portrayed from the same angle and in black and white. This uniform approach abstracts the buildings from their social and technological importance, emphasizing their architectural and sculptural forms, in a move from historical context to purely visual context. Where we might usually disregard buildings such as these, we are invited to revel in the nuances of each design. The Bechers' detached, documentary approach was taken up by a number of Conceptual Artists in the 1970s.

However, this is a simplification of the buildings' relationship to history, which refuses to remain suppressed and resurfaces in a new form. In fact, the Bechers' works are an attempt to preserve the past, to safeguard it against destruction by the present. The artists insert historical images into the context of the present, forcing us to understand the sense in which our contemporary situation is very literally a product of the displayed objects. This is not a transportation into history, but a reassertion of history within the sphere of the present.

The Bechers focus on processes of production in an age that is increasingly dominated by images of consumption, as if the scars of the Industrial Revolution have been entirely patched over. The artists' point is that, although these industrial structures are disappearing, this is only because production is increasingly being dispersed across the world and out of our sight. Ultimately, these spectres of the past leave equally a gaping hole that is opening up in the present.

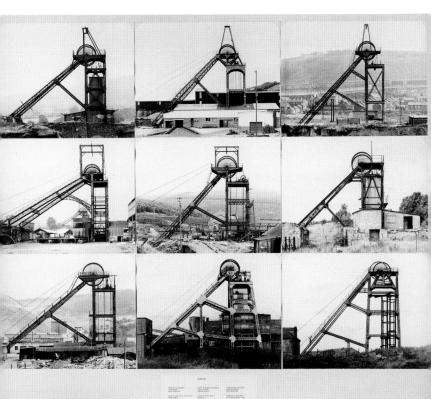

Pitheads
1974 Photograph on board

113 x 132 cm (44 x 52 in) (Approximate)

VANESSA BEECROFT

BORN Genoa, Italy, 1969

Vanessa Beecroft studied architecture at the Nicolo Barabino Civic Art School, Genoa (1983–87). She then studied painting (1987–88) and scenography (1988–93), both at the Brera Academy of Fine Art, Milan. She had her first solo show, VB 01, at the Inga-Pin Gallery, Milan (1993). She had work featured in the Venice Biennale (1997 and 2007). VB 55 was shown at the New National Gallery, Berlin (2005). VB 59 was performed at the National Gallery, London (2006).

SEE ALSO Feminism, Performance Art

Vanessa Beecroft is a Performance Artist, although she does not perform her works herself. VB 50 (2002) was performed in São Paulo, Brazil. Like all of her performances, it was acted by women, most of whom were largely nude. They stood or sat in tableaux, facing the audience but never making eye contact. They thus occupied an ambiguous middle ground between traditional, passive images of women and modern paintings, such as those of Manet, that feature sexually confrontational women. Beecroft's performers confront us in their reality but

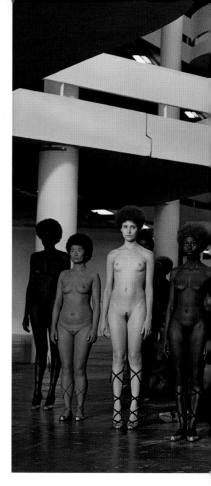

remain seemingly absent. Often, as in VB 50, their bodies are painted and they wear high heels, which Beecroft calls "pedestals". In this way, Beecroft presents us with actual women and the realities of our objectifying look, but we still find it impossible to cross the barrier implicit in her art.

This sense of distance is heightened by Beecroft's ordered tableaux, which more closely resemble paintings or photographs

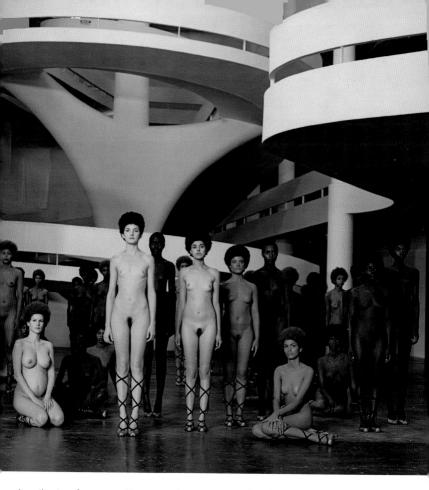

than "live" performances. The strict order of VB 50 is heightened by the women's three uniform skin tones and wigs. Their racial variety refers to São Paulo, the multicultural Brazilian site of VB 50, but it also seems rather artificial, a false multiculturalism. Although these women are apparently real, they seem too ideal to fit what we know of reality. Beecroft forces us to recognize the truth of our role as a viewer, but she also calls attention to her own role as constructor and organizer of the work. Her women are seductive but unattainable, and they exude a beauty that we cannot help but find false.

VB50.001.dr 2002 | VB 50 25th Bienal de São Paulo

JOSEPH BEUYS

BORN Krefeld, Germany, 1921 DIED Düsseldorf, Germany, 1986

During the Second World War Joseph Beuys served in the German air force. He later enrolled at the Kunstakademie Düsseldorf to study sculpture, graduating in 1952. He returned to the academy as a professor in 1961, although he was dismissed in 1972 for admitting students who had been rejected. In 1973 he set up the Free International University for Creativity and Interdisciplinary Research. He represented Germany in the Venice Biennale (1976 and 1980). There was a major retrospective of his work at the Solomon R. Guggenheim Museum, New York (1979).

SEE ALSO Broodthaers, Kippenberger, Conceptual Art, Installation Art

Joseph Beuys was one of the most influential artists of the modern period, a beacon for European contemporary art in an era of American cultural domination. In 1969 he simultaneously presented Goethe's play *Iphigenia* and Shakespeare's *Titus Andronicus*. As fragments of the works were played over loudspeakers, Beuys performed ritualistic actions, mimicking and interacting with a horse while it ate hay and stomped on an iron plank. The symbolism was clear: in art, nature and culture combine, and cultural products are adapted into a guasi-ritual. This combination of man-made forms with more primal or natural energies is central to Beuys's oeuvre. One of his most famous performances, I Like America and America Likes Me (1974) saw Beuys arrive in the United States, immediately enter an ambulance and proceed to spend three days in a room with a covote. Covotes were considered gods by the Native Americans, so we can read the work as Beuvs's communion with a primal America and his rejection of contemporary American society, which he criticized over the Vietnam War and its cultural monopolism. Beuys's approach was driven by a sociopolitical project. As in his social sculptures, such as 7000 Oaks (1982-87), in which he planted 7,000 trees around a German city to enrich the space and improve the environment, his work was alwavs designed to function within society. However, his art was also always haunted by the spectre of Germany's recent past, especially as he had fought for the Nazis himself. His notions of social rejuvenation were specifically intended to revive an ailing nation and prevent any recurrence of the Holocaust, which resulted from a will to social domination.

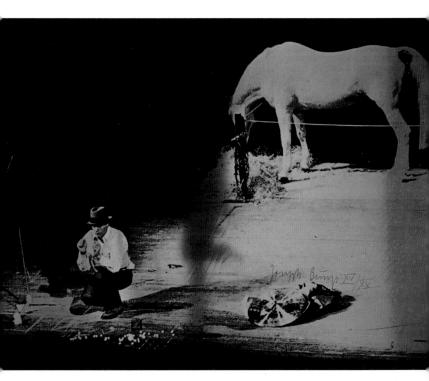

Iphigenia 1973 | Screenprint on plastic 41 × 56 cm (16 × 22 in) (Approximate)

CHRISTIAN BOLTANSKI

BORN Paris, France, 1944

The son of a Jewish father of Ukranian heritage and a Corsican mother, Christian Boltanski has been the subject of many solo exhibitions, most recently at MACRO Museo d'Arte Contemporanea Roma, Rome (2006) and Musée d'art et d'histoire du Judaïsme, Paris, organized by the Musée d'Art moderne de la Ville de Paris/ARC (2004). He has also participated in several Documenta exhibitions in Kassel, Germany.

SEE ALSO Andre, Kounellis, Installation Art

Christian Boltanski began his artistic career as a painter. However, in the late 1960s he made a number of successful short, avant-garde films and published a series of notebooks that documented parts of his personal history. Often in Boltanski's work, the line between fiction and reality is blurred. In the mid-1980s, Boltanski began to develop installations incorporating found photographs, projections, sculptures and a dramatic use of light. Boltanski's work is about coming to terms with the end of childhood and trying to understand memory and loss. In many instances the artist directly addresses the Holocaust, and the people who disappeared during the Nazi era. *Reserve* (1990), for example, consists of a room full of clothes, which recalls the warehouses used by Nazis to store the belongings of condemned individuals during the Holocaust. Although there is often a close connection between Boltanski's work and the history of the Holocaust, the work can also be understood more broadly as an investigation of the experience of death and loss.

In many ways, Boltanski's work is a form of memorializing, and the artist is particularly interested in the notion of archiving. In the late 1960s, Boltanski endeavoured to capture a trace of every moment of his passing life. Les archives de C.B. (1965–88) is an installation containing over 1,200 photographs and 800 documents collected from the artist's atelier. The objects are placed in biscuit tins that are stacked up to create a wall almost 3m (10 ft) high. The installation is a private collection of different fragments of the artist's life. Each of the tins exists in a different state of rust, pointing to the passage of time and processes of decay.

Reliquaire

1990 | Photographs, lamps, 6 metal drawers with grill tin biscuit boxes 213.5 x 169 x 43 cm (84 x 66½ x 17 in)

MONICA BONVICINI

BORN Venice, Italy, 1965

Monica Bonvicini has had solo exhibitions at the Magasin, Grenoble (2001–02); Museum of Modern Art, Oxford (2003); Sprengel Museum, Hannover (2004); SculptureCenter, New York City (2007); and Bonniers Konsthall, Stockholm (2007). She has also participated in the Venice Biennale (1999 and 2005) and the International Istanbul Biennial (2003). She lives and works in Berlin and Los Angeles.

SEE ALSO Andre, Asher, Graham, LeWitt, Feminism, Installation Art, Minimalism, Video Art

Monica Bonvicini explores the relationship between architecture, gender and the built environment. She questions the value of sleek Modernist surfaces by juxtaposing unusual materials, such as leather and velvet, with concrete and steel. In doing so, she renders the familiar as unfamiliar. Her work opens up principles of architecture and design to further interpretation, inviting the viewer to question the social structures that define these principles. She has made works that engage directly with the work of Minimalist artists such as Carl Andre and Sol LeWitt, as well as Dan Graham and

Michael Asher.

One of Bonvicini's best-known works with an explicit feminist agenda is *Destroy she said* (1998). The work is a twochannel video installation. Each screen presents scenes of women leaning against walls and presents them in a collage-like form. The footage is taken from films of the 1950s through to the 1970s by Jean-Luc Godard, Michelangelo Antonioni, Rainer Werner Fassbinder and others. The piece points out how women are represented in film as fragile and requiring the architectural support of walls, presumably

in lieu of male support.

Bonvicini's work also frequently incorporates the aesthetic and material language of fetish. However, in decontextualizing fetishistic objects, Bonvicini questions the value systems that give them meaning. Sometimes her methods of critique are aggressive, or even violent, and some projects have involved hammers and shattered glass. However, her considered approach to destruction and the often beautiful results suggest that her works are as much an act of homage as an act of critique. Destroy she said 1998 | Two-channel video installation onto two drywall screens 60 min Dimensions variable

LOUISE BOURGEOIS

BORN Paris, France, 1911 DIED New York City, NY, USA, 2010

Louise Bourgeois studied art at various schools there, including the École du Louvre, the Académie d'Espagnat and the École des Beaux-Arts. The first retrospective of her work was organized by the Museum of Modern Art, New York City (1982–83). Tate Modern, London organized a major retrospective in 2007, which travelled to Paris, New York, Los Angeles and Houston. In 1993 Bourgeois was selected to be the American representative to the Venice Biennale.

SEE ALSO Hesse, Nauman, Abstract and Representational Art, Ferninism

Louise Bourgeois is undoubtedly one of the world's most important artists. Throughout her illustrious career, which spanned nearly seven decades, she remained a groundbreaking and innovative figure, while participating in many of the key art movements of the twentieth century.

Bourgeois began her career as an artist making abstract drawings, prints and paintings, but from the 1940s onwards she concentrated on the making of threedimensional objects. In the mid-1960s, she

began to experiment with unusual materials such as plaster, latex, marble and bronze, placing her alongside artists who were making art in reaction to Minimalism. In her work, Bourgeois explored femininity, sexuality and alienation, as well as the notion of the home. Her ideas were drawn from personal life experiences and her art is largely autobiographical. Bourgeois grew up with a domineering and philandering father, and in her work she grappled with painful childhood memories and plumbs the depths of human emotions. Many of her works are understood to be extensions of psychic space, lying somewhere between abstraction and realism.

During the early years of her career, Bourgeois's works focused on the human body. Later on, she developed a number of recurring visual motifs. In the mid-1990s, for instance, Bourgeois began to use the spider as a complex representation of motherhood. The spider is fiercely protective and productive, as well as being a predatory creature. In Bourgeois's work, the spider appears simultaneously as threatening and vulnerable. In the work Spider (1997), the creature has ensnared a large cagelike structure, which represents another recurring motif in Bourgeois's work: the cell. Lending itself to numerous psychoanalytical interpretations, the cell is representative of imprisonment and repression, and yet it can also be understood as a quiet, solitary thinking space.

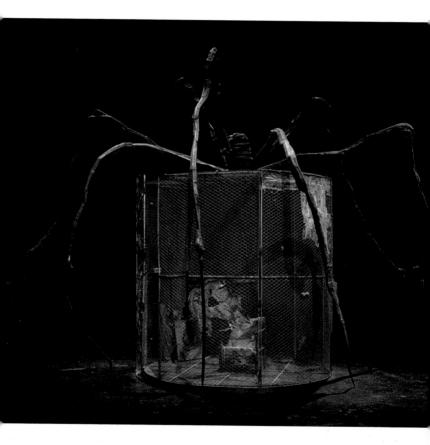

Spider 1997 | Steel and mixed media, including tapestry, gold and bone 444.5 x 665.5 x 518 cm (175 x 262 x 204 in)

FRANK BOWLING

BORN Bartica, Guyana, 1936

Frank Bowling moved to London in 1950, and won a scholarship to the Royal College of Art in 1959. He was awarded the Silver Medal for Painting upon araduation in 1962. His work is represented in many major museum collections around the world, including the Victoria and Albert Museum, London; the Walker Art Gallery, Liverpool; The Metropolitan Museum of Art. New York: The Museum of Modern Art, New York: and the Whitney Museum, New York, In 2005, Bowling became the first black artist to be elected a Royal Academician. and in 2008 he was appointed Officer of the Order of the British Empire (OBE).

SEE ALSO Abstract and Representational Art

Frank Bowling is a renowned painter. The Guyanese-born British artist graduated from the Royal College of Art in 1962 alongside other well-known alumni, including David Hockney. Although his early work was figurative, Bowling turned to abstraction in the mid 1960s, shortly after moving to New York and being introduced to the influential art critic Clement Greenberg. Abstraction enabled Bowling to liberate his work from representational and political concerns, and instead to focus on form and composition.

Working in a large studio in New York allowed Bowling to make paintings on a much bigger scale. By the mid 1970s Bowling's primary concern was colour, and he moved from the earthy tones of earlier work to experiment with a more vibrant palette. Around this time he developed a new technique which involved pouring or dripping paint directly onto the surface of the canvas. Bowling moved the canvas, at first pinned to the wall and later positioned on the floor or a specially designed tilting device, to direct the flow of paint down its surface. As a result Bowling's paintings are rich and textured, constituted by the accumulation of paint, and sometimes debris from the floor of his studio.

Over his long career, Bowling has maintained an enduring interest in colour and the material qualities of paint. He has experimented with chance in the creation of his work, as well as more deliberate and harder-worked compositions. He has maintained a workspace and developed a career on both sides of the Atlantic, in London and New York.

Julia 1975 | acrylic on canvas 234 x 119 cm

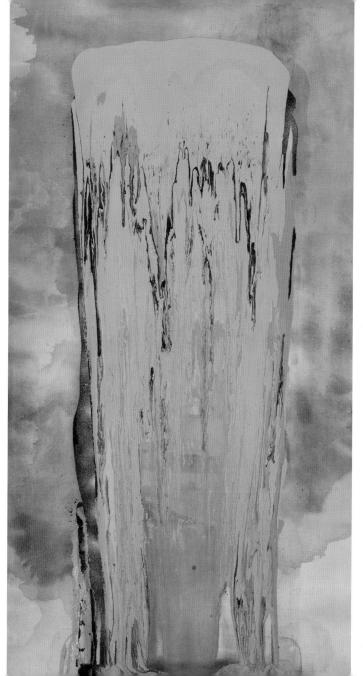

MARCEL BROODTHAERS

BORN Brussels, Belgium, 1924 **DIED** Cologne, Germany, 1976

Marcel Broodthaers began his career as a poet, with links to René Magritte. Throughout his life he also worked with film. In 1963 he became a visual artist and his first solo exhibition was held at the Galerie St Laurent, Brussels (1964). He had a show at the New National Gallery, Berlin (1975). A retrospective of his work was shown at the Tate Gallery, London (1980) and from thereon all around the world.

SEE ALSO Asher, Beuys, Buren, Deller, Dion, Haacke, Institutional Critique

Marcel Broodthaers's work is a comment on art and its institutions. In 1968 he opened a *Museum of Modern Art* in his house. The museum had a department displaying eagles of all kinds from all ages. The eagle has long been a symbol of imperial conquest from the Roman Empire to the Third Reich, and Broodthaers's eagles highlighted the museum's act of disguise. Artists frequently criticise art's neutralisation once it is torn from its original context, but Broodthaers reminds us of the other end of the spectrum – the aesthetic softening of atrocities.

What the museum most fundamentally highlighted was the role of context in the constitution of art. We can similarly understand his sculpture Casserole and Closed Mussels (1964) as symbolically referring to this problem of context through its mussels, which burst out of their enclosure. However, as in the museum where the institutional frame remains ever-present, the mussels are themselves closed, refusing to release their innards. So while Broodthaers's museum continues to define its contents - even if it defines them as non-art - his sculpture implies an infinite regression of contexts, which are themselves also contents. What this ultimately marks is an ambiguous relation to art and the museum. Broodthaers was an artist who challenged art's overdetermination of its objects through his own set of determinations. Although he was consistently critical of these practices, therefore, he accepted that to simply do away with them would be to renounce art itself.

Casserole and Closed Mussels 1964 | Mussel shells, pigment and polyester resin in painted iron pot 30.5 x 28 x 25 cm (12 x 11 x 10 in)

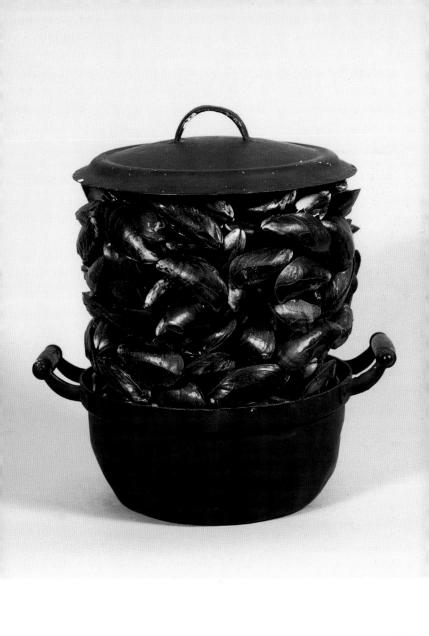

GLENN BROWN

BORN Hexham, England, 1966

Between 1984 and 1992 Glenn Brown studied at Norwich School of Art, Bath College of Higher Education and Goldsmiths College in London. His work has featured in *Sensation: Young British Artists from the Saatchi Collection* at the Royal Academy of Arts in London (1997) and elsewhere. He had his first solo exhibition at Patrick Painter Inc. in Santa Monica, California in 1998. He was nominated for the Turner Prize in 2000 and was also accused of plagiarism for his painting The Loves of Shepherds (2000), which resembles an illustration by Anthony Roberts.

SEE ALSO Auerbach, Peyton, Richter, Tuymans, Appropriation Art, Young British Artists

It is often said that Glenn Brown's paintings and sculptures mimic the work of others. Indeed, they are always linked to particular artworks, but Brown actually works from reproductions of these "originals" though he is guided more by discrepancy than by likeness. His most recent works, such as *Christina of Denmark* (2008), abstract their model (in this case a portrait by Holbein) far past the point of recognition. Brown's figure is full of life, sprouting leaves and defying the rigidity of Holbein's princess. This appears symbolic of the organic fluidity of Brown's own approach, which accepts the history of art as a process, through which given forms mutate via the intervention of new artists and techniques.

Shallow Deaths (2000) starts from a reproduction of a Renaissance painting of a saint. In Brown's version, the saint's blue, stretched skin resembles that of a corpse. His deathly visage represents our distance from the "original" work, which occurs because of historical and physical gaps. There is also a psychedelic quality to Shallow Deaths. However, its overly vivid colours, which elsewhere might imply divinity, here only imply a perceptual mediation between the work and us.

It is ironic that most viewers will only ever see a reproduction of Brown's work. One of the objects' most striking features is that despite having physical brush strokes, their surfaces are entirely flat as if they too were reproductions. This seems to add more distance, robbing us of any tactile experience of the works. Brown's thievery of our experience is absolutely central to his practice. He demands we reconsider our relationship not only with his art, but also with art in general.

Christina of Denmark 2008 | Oil on panel 165 x 119 cm (65 x 47 in)

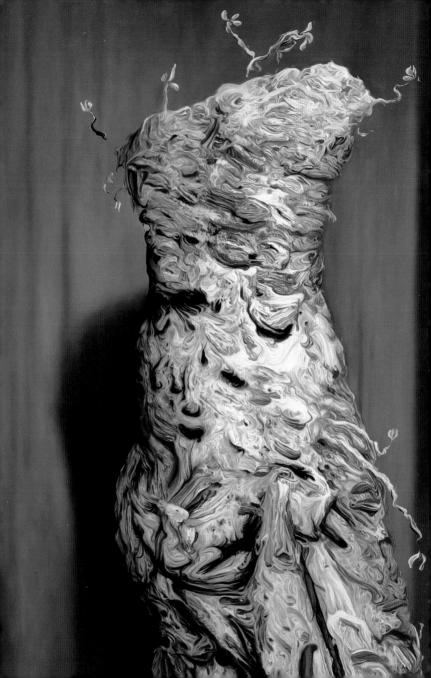

CHRISTOPH BÜCHEL

BORN Basel, Switzerland, 1966

Büchel has had numerous solo exhibitions around the world including *Shelter* at Haus der Kunst, Munich (2002); *Private Territories* at the Swiss Institute, New York (2004); *Hole* at Kunsthalle Basel (2005); *Superdome*, Palais de Tokyo, Paris (2008); and *Deutsche Grammatik* at Kunsthalle Fridericianum, Kassel (2008) for which the artist made an installation using the entire museum space.

SEE ALSO Hirshhorn, Schneider, Installation Art

Christoph Büchel works in a variety of media, including film, sculpture and printed materials. He is perhaps best known for his Conceptual projects and large-scale immersive installations. Büchel's constructed environments are created with meticulous attention to visual, auditory and olfactory details. When situated in an art gallery or museum, they can have the effect of obliterating all reference to their institutional setting. The installations usually convey the perspective of someone in a physically or psychologically demanding situation and sometimes involve the viewer in tight, cramped spaces. The installations

are so thorough in their construction, they often give the impression that the inhabitants have just left, and are therefore ripe with narrative potential.

In 2006–07, Büchel's installation Simply Botiful transformed a vast, empty building in London's East End into a makeshift itinerant workers' community, that appeared to sustain itself through various black market economies. Visitors entered the installation through an unmarked

entrance on the street. They were drawn first into an overflowing, decrepit hostel and then into a cluttered junkyard. Unexpectedly, the junkyard led to a tunnel, at the end of which an illegal excavation site of a mammoth was located, with two tusks emerging from the earth. Büchel's projects often show an explicit political awareness, and in this case the work drew attention to the abysmal living conditions of immigrant workers. For the 2005 Venice Biennale, Büchel collaborated with the artist Gianni Motti on *Guantánamo Initiative*, which consisted of the paper trail left by the artists' campaign to lease the site of Guantánamo Bay from the Cuban government.

Simply Botiful 2006 | Installation (detail) nstallation view at Hauser & Wirth Coppermill, London

DANIEL BUREN

BORN Boulogne-Billancourt, France, 1938

Daniel Buren graduated from the École Nationale Supérieure des Beaux-Arts, Paris in 1960. In the mid-1960s he made a name for himself as part of a group of painters called BMPT. In 1968 he had his first solo exhibition at the Apollinaire Gallery in Milan. In 1986 he won the Golden Lion at the Venice Biennale. In 2005 he had a solo show at the New York City's Solomon R. Guggenheim Museum entitled *The Eye of the Storm, works in situ by Daniel Buren.* He has also worked as a curator, including for a show of Sophie Calle's work at the Venice Biennale in 2007.

SEE ALSO Asher, Broodthaers, Calle, Fraser, Haacke, Institutional Critique, Site-Specificity

Daniel Buren's work rebels against the control which art institutions have over their contents. His early work consisted of canvases and posters adorned with painted blue stripes. These objects represented generic artworks and related specifically to their environment. In *Within and Beyond the Frame* (1973), Buren hung his paintings along the space

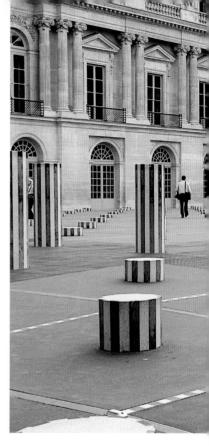

of a gallery and out of its window into the street. The artworks, which are clearly recognizable as such within the gallery, resemble washing hung out to dry once outside of it. The installation reveals the museum's role in transforming objects into works of art, which gives it authority over both its contents and its visitors. *Peinture-Sculpture* (Painting-Sculpture, 1971) attempted to reverse that relationship. It was a huge version of one of Buren's artworks, which dominated the centre of New York's Guggenheim Museum,

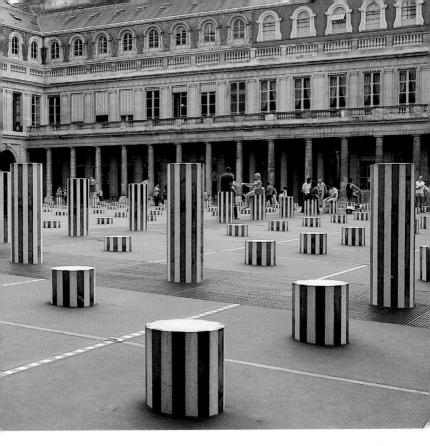

entering into a physical competition with the gallery. While the building's colossal scale can often eclipse its contents, Buren's work obscured the museum itself.

In Les Deux Plateaux (The Two Plateaus, 1985–1986), Buren's stripes adorn the front of columns in the courtyard of Paris's Royal Palace. The columns are of various heights, reflecting the varying elevation of an underground stream on which they stand. By piercing through the ground, they reveal Paris's hidden subterranean plane; its second plateau. Unlike his earlier works, *Les Deux Plateaux* takes Buren's acts of revelation beyond the confines of the art world. It is perhaps true to say that he has always been interested in the broader political implications of art and its institutions. Their logic of domination becomes equated with the artifice of society in general, suggesting that the two are instances of a single process.

Les Deux Plateaux

1985–1986 | Sculpture in situ, Courtyard of Palais-Royal, Paris. Detail

JEAN-MARC BUSTAMANTE

BORN Toulouse, France, 1952.

Jean-Marc Bustamante had his first solo show at the Château d'Eau Municipal Gallery, Toulouse (1977). Bustamante has also been important as a teacher, including at Amsterdam's Rijksakademie (1990–95) and at the École Nationale Supérieure des BeauxArts, Paris (1996). His work was included in Documenta 8 (1987), IX (1992) and X (1997) in Kassel, Germany. Tate Britain, London, put on a show of his work (1998). His work was featured in the French Pavilion at the Venice Biennale in 2003.

SEE ALSO Acconci, Arbus, Eggleston, Wall

Jean-Marc Bustamante works in several media, including painting, photography and sculpture. His photography is often highly enigmatic. Like his early *Tableaux* and *Landscapes* series of the late 1970s, *Something is Missing* (1995–97) is a series that never explicitly defines its content. In stark opposition to the contemporary trend of accompanying all works with plaques that direct our attention, Bustamante forces the viewer into guessing the significance and even the location of his subjects. The works are a kind of radical photo-documentary that refuses any single narrative, instead allowing multiple narratives to unfold through the images.

This indeterminacy is something that Bustamante carries over into all of his works. In his sculptural Sites (1991-92), he created sets of objects but allowed curators to decide their arrangement, thereby stripping away the artist's authority. However, unlike contemporaries such as Vito Acconci, who removed artistic authority in order to empower the viewer through their participation, Bustamante's viewers are also disempowered by their inability to ever grasp his work in its entirety. Lava (2003). for example, is a sculpture that appears to hover off the ground, with a surface that visibly alters as viewers move around it and which therefore refuses to reveal itself fully in any single aspect. This removal of our determining power is central to Bustamante's art and would be hypocritical if only applied on the side of the artist. The point is that Bustamante allows spaces, materials and objects to emerge in their individuality, refusing to force them into a position of generality.

[Above] *S.I.M* 4.97B 1997 | C-print 40 x 60 cm (15¾ x 23½ in)

[Below] *S.I.M 8.97B* 1997 | C-print 40 x 60 cm (15¾ x 23½ in)

CAI GUO-QIANG

BORN Fujian Province, China, 1957

Cai Guo-Qiana trained in stage design at the Shanahai Drama Institute (1981–85). He moved to Tokyo in 1986. His first solo show, entitled Cai Guo-Qiana's Painting, was held at the Office of the Foreign Correspondents' Club of Japan in Tokyo (1987). He has since had a number of major international shows, including at New York's Metropolitan Museum of Art (2006) and Solomon R. Guggenheim Museum (2008). He acted as Director of Visual and Special Effects for the opening and closing ceremonies of the Olympic Games in Beijing (2008). He has lived and worked in New York since 1995.

SEE ALSO Kabakov, Zhang (Huan), Installation Art

Cai Guo-Qiang's art is created on a large scale with constant reference to history. He is best known for using fireworks, which are central to Chinese heritage and enable spectacular displays. This exploration of China's history is always linked to China's present. *Dream* (2002) is an installation consisting of red lanterns hung from a ceiling. These recall the lanterns traditionally used in Chinese funerary rituals. The room is bathed in red light and its dream-like appearance is emphasized by billowing silk, resembling a mist on the ground. However, the dreaminess is complicated by the fact that the lanterns are shaped like consumer goods and weapons. The all-pervading red of the lanterns equates an ancient rite with a symbol of Communism, and the traditional rendering of ultra-modern images seems intended to imply their continuation of a cultural heritage.

In this way, the work reveals the contemporaneous coexistence of different ideologies, with one specifically contained within the other. Cai is often regarded as a purveyor of "Chineseness", presenting an Eastern "otherness" to a predominantly Western audience. While he certainly seems critical of the contemporary situation in China, his is a critique masked by pyrotechnics and extravagance. Ultimately the problems of his work reveal the problems of globalized art in general - the conflict between the national and the international, and the absorption and destruction of local cultures. Cai tries to intervene in the process by reappropriating his own cultural heritage, but in doing so he always accepts contemporary complications rather than just retaining his history.

[Right] Inopportune: Stage One 2004 | Eight cars and sequenced multi-channel light tubes Dimensions variable Installation view of exhibition copy at Solomon R. Guggenheim Museum, 2008

[Below] Dream 2002 | Silk lanterns, fans and electric lights Dimensions variable Installation view at Villa Manin Centre for Contemporary Art, Codroipo, Italy, 2008

SOPHIE CALLE

BORN Paris, France, 1953

Sophie Calle began working as an artist in the 1970s. Since the 1980s, her work has been shown in galleries and museums throughout the world, including the Whitney Museum of American Art, New York; Museum of Modern Art, New York and Tate Modern, London. She was the subject of a major retrospective at the Pompidou Centre (2003) and she represented France at the 52nd Venice Biennale in 2007.

SEE ALSO Buren, Wearing, Conceptual Art, Installation Art

Sophie Calle is a writer and photographer, as well as a Conceptual and Installation Artist. Her work is characterized by the playful use of self-imposed constraints. Conforming to a set of arbitrary but well-defined rules, Calle investigates issues of identity and intimacy. The subjects of her work are often complete strangers, and Calle develops clandestine techniques to "get to them", or at least to construct a portrait of them. In her controversial work *Address Book* (1983), for example, Calle interviewed people she found in a lost address book, asking questions about the male owner of the book. She presented her findings alongside photographs of the man's interests. Sometimes acting like a detective in her work, Calle produces art with a sociological meaning. Her means of documenting, archiving and exhibiting her findings have strong resonances with the lineage of Conceptual Artists before her.

Other works have been even more blatant acts of espionage, with Calle sometimes taking on the role of detective psychoanalyst. In *Prenez soin de vous* (Take Care of Yourself, 2007) Calle takes as a point of departure the last line of an email from her then-partner, telling her that she is dumped. The ensuing installation included photographs of 104 female professionals reading the line, as well as a variety of media enlisted to depict the women's analysis of the letter. The work is a form of therapy as well as art, and Calle often describes her art as a means of giving structure to her life.

"Take Care of Yourself Nathalie Dessay" 2007 | Video, screen, colour print, frame Print: 80 x 98 cm (31½ x 38½ in) Film: 106.5 cm (2 ft 18 in)

Take Care of Yourself

I received an email telling me it was over. I didn't know how to respond It was almost as if it hadn't been meant for me. It ended with the words, Take care of yourself. I followed this advice to the letter I asked 104 women (as well as two handpuppets and a parrot), chosen for their profession or skills, to interpret the letter. To analyse it, comment on it, dance it, sing it. Dissect it. Exhaust it. Understand it for me. Answer for me. It was a way of taking the time to break up A way to take care of myself.

ANTHONY CARO

BORN Surrey, England, 1924

Anthony Caro earned a degree in engineering from Christ's College, Cambridge, and later studied sculpture at Regent Street Polytechnic in 1946 as well as the Royal Academy of Art from 1947 to 1952. In the 1950s he worked as an assistant to the British sculptor Henry Moore. In the early 1960s the American sculptor David Smith influenced him to turn to abstract work. In 1963 he exhibited these new abstract sculptures at the Whitechapel Gallery in London. He has also been hugely important as a teacher, working at St Martin's College in London (1953–81).

SEE ALSO Andre, Flavin, Judd, Stella, Abstract and Representational Art, Minimalism

One of the foremost British sculptors of his generation, Anthony Caro has made abstract sculptures since the 1960s, using industrial materials and techniques. Many of his works are perhaps best suited to the term 'assembly' because they tend to be arrangements of parts rather than single objects. Some even use pre-formed parts, such as the girders of *Early One Morning* (1962). This technique of arranging rather than sculpting indicates something almost painterly about Caro's work. *Early One Morning* borders on a linear composition that could be transferred onto canvas. However, its existence in three dimensions draws our attention to the weight and materiality of these forms in a way that painting cannot.

His consistent refusal to use plinths in his work has had a profound effect on sculpture, allowing it direct access to the viewer's space. In the late 1960s Caro made a number of "table-pieces" - sculptural objects exhibited on tables. The relationship between the table and the object varies in each piece, with some objects even hanging over their table's edge. This varied approach seems to refuse any reading of the table as a neutral prop, implying that it must instead be part of the work. The objects, which are often assemblies of tool parts, seem almost to invite use and they therefore suggest their existence within the practical space of the viewer. The works break down all spatial boundaries; they are neither raised on a plinth nor resistant to our touch. Therefore while Caro might be the culmination of modern abstract sculpture, he is also the beginning of more recent trends towards Installation works that accept the viewer into their space.

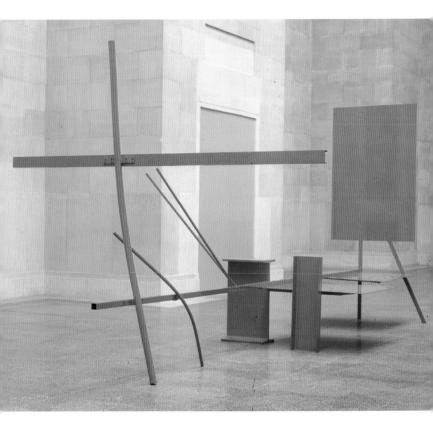

Early One Morning 1962 | Steel and aluminium, painted red 290 x 620 x 333 cm (114 x 244 x 143 in)

MAURIZIO CATTELAN

BORN Padua, Italy, 1960

Maurizio Cattelan did not attend art school but opted instead to teach himself. He began his artistic career by making furniture in the 1980s. His first solo show, entitled *Strategie*, was held at the Galerie Néon in Bologna, Italy (1990). Since 1995 he has produced a magazine with Dominique Gonzalez-Foerster entitled *Permanent Food*, which consists of pages from other magazines. He had a solo exhibition at the Museum of Modern Art, New York in 1998 and another at the Louvre, Paris, in 2004.

SEE ALSO Kelley, Appropriation Art, Installation Art, Institutional Critique, Performance Art

Maurizio Cattelan is often referred to as the joker of the art world. His work tends to involve a process of mockery; a belittling, which is literalized in his miniature works, such as these tiny replica elevators. While the elevators are in full working order, their Lilliputian scale makes them ridiculous and renders their function completely dysfunctional. His work *La Nona Ora* (The Ninth Hour, 1999) is a hyperrealistic sculpture of Pope John-Paul II being hit by a meteor. The title refers to the moment when the crucified Christ asked why his God had forsaken him, and here that moment seems to have been ironically replayed.

Initially, this seems like a fairly crude joke based on the irony of the Pope being struck down by an act of God. Some recent artists have invited controversy for the sake of self-promotion and to cover up the lack of quality in their work, but Cattelan only treads this path in order to reveal it. La Nona Ora is unashamedly staged; its theatrics are undercut with a foregrounding of the mechanics of theatricality itself. In The Real Rabbit (1995), Cattelan had a gallerist dress up in a giant pink rabbit suit for the duration of an exhibition. This presented the art world with an opportunity to expose itself to ridicule, which it took as eagerly as it might take any other opportunity for self-promotion and self-extension. Here, as in much of his work, Cattelan is less a joker than a catalyst for the art institution to enact its own self-mockery. This is a revelation of the art world's innately ridiculous nature and it takes only the slightest intervention on the part of Cattelan to turn it from profound statements to crude punchlines.

Untitled

2001 | Stainless steel, composition wood, electric motor, electric light, electric bell, computer Installation Triennale of Contemporary Art, Yokohama 2 parts: 30 x 12 x 12 cm (11¾ x 4¾ x 4¾ in)

VIJA CELMINS

BORN Riga, Latvia, 1938

When she was 10 years old, Vija Celmins and her family emigrated to the United States and settled in Indiana. She earned a Bachelor of Fine Arts degree from the Herron School of Art (1962) and a Master of Fine Arts degree from the University of California (1965). She had her first solo exhibition at the Dickinson Art Center in Los Angeles (1965) and was awarded a Guggenheim Fellowship (1980). A retrospective of her work travelled across the United States, including stops in New York, Washington DC and Los Angeles (1992–94).

SEE ALSO Abstract and Representational Art, Photorealism

Vija Celmins's art always borders on the abstract, despite being explicitly representational. This implication of abstraction is achieved through a number of techniques. The spaces and objects that she depicts are always entirely anonymous. Untitled (Ocean) (2000), for example, could be any section of the surface of any ocean, and as such any specificity of its subject is denied. There is also a lack of drama in these works – the ocean's waves are small, while the spider's web of *Web #8* (2004) contains no predator or prey.

All of Celmins's subjects tend to be treated in exactly the same way: with a moonlit palette of arevs and an intense level of detail. Her works can feel restrained or neutral since their subjects seem of little importance and their arev tones give no obvious emotional signs. This is in stark contrast with the generation of painters that came directly before her: the Abstract Expressionists, whose huge, smeared canvases tell of exaggerated gestures and existential angst. However, Celmins does share with those artists an interest in materials. On the one hand her depictions are hyperrealistic; on the other hand their absolute silence means that the play of the material itself is allowed predominance. It is also important to note that the flatness of her subjects – water, a spider's web - always returns our attention to the marks on the page. However, this interplay of the abstract and the representational in her work never amounts to a conceptual musing on the nature of depiction; it is simply a tool for the creation of an anonymous, silent beauty.

[Above] Untitled (Ocean) 1970 | Graphite pencil on paper 36 x 48 cm (14 x 19 in)

[Right] Web #8 2004 | Charcoal on paper 51.5 x 41.5 cm (201/2 x 161/2 in)

HELEN CHADWICK

BORN London, England, 1953

Helen Chadwick studied at Brighton Polytechnic (1973–76) and at Chelsea School of Art, London (1976–77). In 1987 she was nominated for the Turner Prize for her show *Of Mutability* at the Institute of Contemporary Arts, London (1986), and was the first woman to be nominated for that award. Her work featured in the Venice Biennale of 1995, and in the same year she had a show at New York's Museum of Modern Art, entitled *Helen Chadwick: Bad Blooms.* She died in 1996.

SEE ALSO Hesse, Lucas, Feminism, Identity Politics

Helen Chadwick's *Piss Flowers* (1991–92) juxtapose natural beauty and bodily fluids. Chadwick and her male partner created the sculptural flowers by urinating into snow and using the result as a cast. The stamens were created by Chadwick's more focused stream, while her partner made the more diffused impressions around the edges. In this way, the work involves a gender reversal, with female genitalia producing the form of male genitalia, and vice versa. As well as questioning gender difference, the work is symbolic of sexual

union. Flowers are unitary sexual organs, consisting of both male and female parts. So as well as taking a feminist position against the naturalization of gender stereotypes, the work documents a deeply intimate relationship between two lovers, one that is embodied in their combined act of urination.

This conjoining of the attractive and the repulsive is central to Chadwick's art. Just as in her series *Meat Abstract* (1989), abstract representations made from raw meat, in *Piss Flowers* Chadwick questions

art's sanitization of beauty. Flowers are traditionally seen as beautiful, but these flowers are tainted by their relation to bodily waste. And yet the allusion to sex equates urination with more pleasant bodily acts. So while *Piss Flowers* could lead to the flowers' debasement, it actually elevates bodily functions; romance is not lost, merely transplanted into an unlikely situation. The unashamed carnality and brutal honesty of Chadwick's art is the polar opposite of classical portraiture, which idealizes the body at the expense of genuine bodily experience. Her mixture of love, sex and urine confronts our naivety, asserting the facts of our physical existence.

Piss Flowers

1991–92 | Bronze and cellulose lacquer Up to 12 parts, each approximately 70 x 65 x 65 cm (27½ x 25½ x 25½ in)

JAKE & DINOS CHAPMAN

BORN Dinos Chapman: London, England, 1962; Jake Chapman: Cheltenham, England, 1966

The Chapman brothers both attended the Royal College of Art (1988–90), receiving master's degrees in fine art. They began to work together in 1992, marking their partnership with a solo show that year entitled *We Are Artists* at the Bluecoat Gallery, Liverpool and the Hales Gallery, London. They were prominent in the Young British Artists generation and were included in the show *Sensation* at the Royal Academy of Arts (1997). They were nominated for the Turner Prize (2003). Their show *When Humans Walked the Earth* was held at Tate Britain, London (2007).

SEE ALSO Hirst, Young British Artists

Jake and Dinos Chapman are widely seen as amongst the most shocking artists of our time. However, many who proclaim their shock at the Chapmans' work rarely consider exactly what they are reacting against. *Hell* (1999–2000) is a large sculptural representation of a battlefield populated by Nazis and genetically mutated monsters, all engaged in acts of brutality and torture. The figures are

constructed from modified toys, and the piece takes the shape of a swastika. The miniaturization of *Hell* seems to speak of art's inability to deal with such monumental issues as the Holocaust. The work shows that, in order to represent such things at all, artists always have to reduce their impact, or caricature them, as in the case of *Hell* 's mutants. Rather than representing war, *Hell* demonstrates the fundamental impossibility of such a task.

Undoubtedly the Chapman brothers can

be confrontational. Beginning in 1995, they made a series of sculptures of physically connected children with grotesque deformities, many including genitals and orifices where their faces should be. The children are always naked, except they sometimes wear branded pairs of trainers. The series debuted in England at a time of anxiety over paedophilia, and was specifically aimed to shock. However, it also traces the roots of that shock back to the use of children in advertising and the increasing social control of birth and other elements of life, which the Chapmans exaggerate into horrific genetic experimentation. While their work is certainly provocative, it raises the question of whether our anger should be aimed at the artists or the society that their work mirrors.

Hell 1999–2000 | Glass-fibre, plastic and mixed media (9 parts) Dimensions variable

CHRISTO & JEANNE-CLAUDE

BORN Christo: Gabravo, Bulgaria, 1935; Jeanne-Claude: Casablanca, Morocco, 1935. DIED Jeanne-Claude: New York City, NY, USA, 2009

Both born on 13 June 1935. Christo was admitted to the Academy of Fine Arts in Sofia (1953) and studied there and in Prague until he escaped the Communist bloc, fleeing to Austria (1957). In 1958 he met future wife Jeanne-Claude in Paris. They had their first solo show there (1962), which was overshadowed by their contemporaneous work *Wall of Oil Barrels/Iron Curtain*, involving the blocking of a road in Paris as an artistic comment on the Berlin Wall.

SEE ALSO Buren, Long, De Maria, Serra, Smithson, Land Art, Site-Specificity

Christo and Jeanne-Claude were a husband-and-wife collaborative team. They are primarily known for their interventions into spaces by wrapping objects, buildings or parts of the landscape.

In 1995 they wrapped the Reichstag (the German parliament building), although they considered this an extended project lasting from the conception of the idea in 1971 until the eventual unwrapping of the building. While their process was one of concealment, it also involved a kind of a revelation. Wrapped Reichstag was accompanied by documentation of the artists' efforts to obtain permission for the work, which was made difficult by the legal process involved. This accounts for the duration of the project and also raises questions about the status of the building, highlighting the private control that is exercised over this public place.

As well as urban sites, Christo and Jeanne-Claude wrapped natural objects. Wrapped Trees (1997–98) consists of a number of trees in Switzerland wrapped in thin fabric. While we might expect such a work to criticize man's intervention into nature, Wrapped Trees was actually very beautiful. We perhaps understand this better when told that the fabric of Wrapped Trees is used every winter in Japan to wrap trees for protection against the cold. The intervention represented here is therefore very different from the destruction that we might assume.

The work of Christo and Jeanne-Claude thus seems to reveal the truth of the present and also the potential of the future. Although their pieces are only temporary, they permanently transform their sites by forcing viewers to consider them in new ways.

Wrapped Reichstag 1971–95 | Berlin

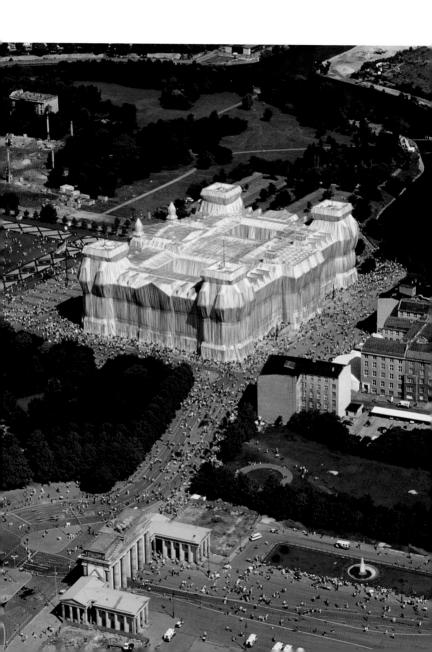

lygia clark

BORN Belo Horizonte, Brazil, 1920 **DIED** Rio de Janeiro, Brazil, 1988

In 1947 Lygia Clark moved to Rio de Janeiro to study with the architect Roberto Marx. She studied in Paris (1950–52), partly with the French painter Fernand Léger. She had her first solo show at the Institut Endoplastique, Paris (1952), and went on to co-found the Frente Group (1954). She participated in Brazil's National Concrete Art exhibition (1957), and became a member of the Neo-Concretist Group (1959). From the mid-1960s her work became increasingly participatory.

SEE ALSO Oiticica, Installation Art, Relational Aesthetics

Lygia Clark began her career as an abstract sculptor, and by the end of her life had fundamentally restructured our understanding of the relation between art and its viewers. Her last major work, *Structuring the self* (1976–82), was a series of therapy sessions in which she used relational objects to create sensual experiences that drew out the past experience of her subjects. The objects she used were relational in the sense that their significance lay in their specific connection to the individual involved. It is usual, in our experience of art, for many viewers to come to a single work imbued with a given meaning. In Structuring the self, however, the meaning of the work alters according to its participant. Furthermore, the artwork itself seems not to coincide with the objects but rather with the participant's experience. The object has no centre, and this leaves a gap in the middle of the artistic process to be filled by the individual.

This centrality of the participating individual is present throughout Clark's work. In the early 1960s she made *Animals*, a series of abstract sculptures with hinged components that invited reconfiguration by each viewer. In her *Sensorial Hood* (1967) series, she created a number of hoods with inward-facing mirrors over the eyes, coverings for the ears and a bag over the nose. Wearing a hood was therefore entirely an experience of self-awareness. As in *Structuring the self*, the hoods literally and metaphorically relocate the viewer inside art – art becomes the index of the viewer's experience.

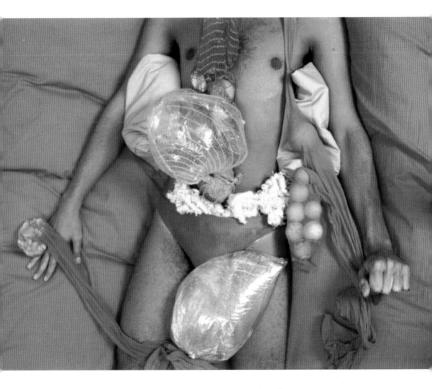

Structuring the self

FRANCESCO CLEMENTE

BORN Naples, Italy, 1952

Francesco Clemente went to study architecture at the University of Rome (1970), but left before finishing the course to focus on art. He had his first solo show at the Galleria Valle Giulia, Rome (1971). He travelled to India in 1973, and Indian art was to influence him greatly. A retrospective of Clemente's work on paper toured, including a stop at the Royal Academy of Arts, London (1993). He had a full retrospective at the Solomon R. Guggenheim Museum, New York (1999).

SEE ALSO Abstract and Representational Art

Francesco Clemente was central to painting's resurgence in the 1980s. His hugely sensual paintings oppose the barren materiality of both Arte Povera in his native Italy and international Conceptual Art. This sensuality is often centred on the body, although in Clemente's work the body is never a discrete unit; instead, it constantly merges into the flesh of the painting in general. In *Scissors and Butterflies* (1999), the women's eyelashes transform into antennae to mirror the butterflies, and the figures emerge from a collective mire of loosely defined forms. Although scissors normally suggest violence, here they complement the eroticism of the piece, which is conjured up using deep red tones and curving lines. Clemente's painting documents the confluence of individuals that occurs in sexual union, but also marks his general approach to the self. As well as the merging of individuals, there is a lack of definition between inside and outside, marked by the soft fleshiness of the figures and their blood-red hues. Clemente presents a human condition that is far removed from the radical individuality and pure surface assumed by Western society.

Clemente is also well known for his works on paper. These present the fragility of that medium by emphasizing its thinness, as well as representing equally thin, delicate subjects. Like Clemente's refusal of the discrete individual, this is in opposition to his experience of New York in the 1980s. In the place of that city's separateness and disposable, homogenized commodities, Clemente presented his subjects as interconnected, delicate and precious. Although his work appears to transcend its social situation, this is only out of a desire to reveal its inadequacies.

Scissors and Butterflies 1999 | Oil on linen 233.5 x 233.5 cm 92 x 92 in)

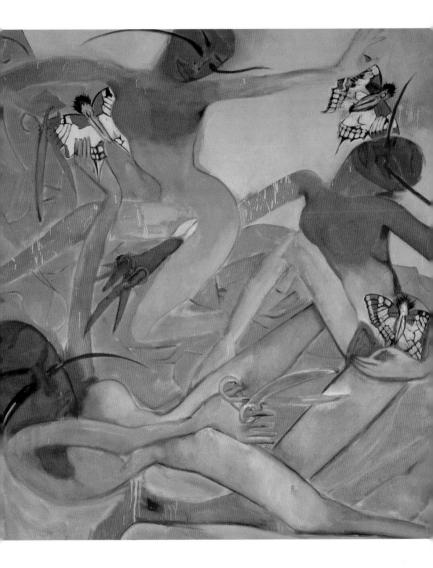

CHUCK CLOSE

BORN Monroe, Washington, USA, 1940

Chuck Closereceived a Bachelor of Fine Arts degree from the University of Washington (1962) and a Master of Fine Arts degree from Yale University (1964). He had his first solo show at the University of Massachusetts (1967), Close suffered a spinal artery collapse in 1988, leaving him partially paralyzed, but he continued to paint with a modified technique, using a brush strapped to his wrist. He has exhibited in group shows including Documenta 5 and 6 (1972 and 1977): the Whitney Biennial (1969, 1972, 1977, 1979, 1991); the Venice Biennale (1993, 1995, 2003); and Carnegie International (1995-6). He has had a number of solo shows, including a major touring retrospective that began at New York's Museum of Modern Art (1998), and another originating at the Walker Art Center, Minneapolis (2005).

SEE ALSO Photorealism

Chuck Close began his career in the 1960s as a Photorealist painter, making unnervingly realistic paintings at a time when representation of any kind was highly unfashionable. These early works, like all of his subsequent output, are close-ups of faces on a large scale. The approach has allowed him to achieve an intense level of detail and to delve deeply into the material of the human face.

Having excelled at illusionism, by the 1970s he was already beginning to deconstruct it. *Keith* (1972) maintains the accuracy of his earlier works, but also contains visible traces of his process. It displays the grid that Close used in the work's creation and which allowed him to work individually on small fragments of the print. At this stage of his career we can see a shift in his interest from result to process.

Close's more recent work, such as Lyle (2003), takes this technique even further. The individual units of the grid refuse to coalesce easily into a single image unless the viewer is at a great distance from the work; even then, the subject almost seems to be sitting behind frosted glass. But rather than detracting from the image, this approach gives it an added richness. It appears to shimmer and take on different appearances as the viewer moves around it. Such works extend Close's exploration of the image from the singularity of an illusion, to a multi-faceted process of visual oscillation. While his subjects have remained constant, his changing techniques have demonstrated the image's ability to extend itself, and its viewers, beyond mere representation.

Lyle 2003 | 149 colour silkscreen 166.5cm x 137cm (65½ x 54 in)

TONY CRAGG

BORN Liverpool, England, 1949

Tony Cragg began an art foundation course at Gloucestershire College of Art and Design, Cheltenham (1969), and then attended the Royal College of Art, London (1973–77). His first solo exhibition was held at the Lisson Gallery, London (1979). Cragg represented Britain at the Venice Biennale (1988) and was awarded the Turner Prize in the same year. He was made a Royal Academician in 1994. He had a retrospective at the Whitechapel Gallery, London (1997). He has lived and worked in Wuppertal, Germany, since 1977.

SEE ALSO Caro, Deacon, Long

Tony Cragg made sculptures in the late 1970s and early 1980s that tended to be constructed from an assortment of smaller objects. *Stack* (1975), for example, is a cube made up of a variety of materials, both synthetic and natural, ranging from traditional materials, such as wood, to the unusual, including plastic bottles. The objects are arranged into strata as if part of a geological formation. Given its mixture of the natural and the artificial, *Stack* seems to have invited reflection on the relationship between the two, at a time when environmental worries were just beginning to register.

In Britain Seen from the North (1981). the artist uses a similar technique, this time to create an image of Britain on its side, with a man (Cragg himself) viewing it from the north. Cragg was living in Germany by this time, and was viewing his country through the eyes of an outsider. Britain Seen from the North is comprised of a number of man-made objects and fragments gathered in the country, and is literally constructed from products of Britain. More pointedly, though, it is constructed from Britain's waste. This junk aesthetic seems fitting for the economic slump of the early 1980s, and implies links between industry, consumption and the wider picture of the national economy.

Both of these works are absolutely reliant on the relationship between the whole and its constituent parts, a sculptural technique that forces viewers to make connections between national politics and everyday life. Cragg therefore belongs within a history of modern artists who draw broad political statements from the debris of the commonplace.

Stack 1975 | Mixed media 200 x 200 x 200 cm (78¾ x 78¾ x 78¾ in)

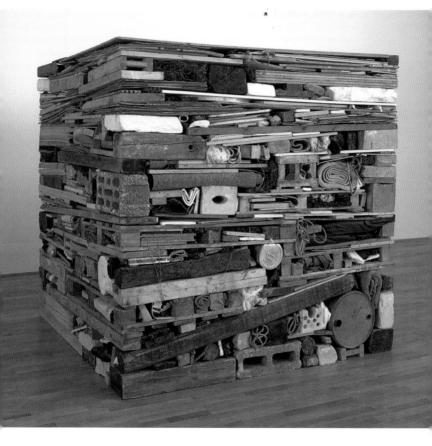

MICHAEL CRAIG-MARTIN

BORN Dublin, Ireland, 1941

Michael Craig-Martin was educated in the United States, studying Fine Art at Yale University (1961–66), where he received a master's degree in fine art. He moved to Britain in 1966, and had his first solo show at the Rowan Gallery, London (1969). Craig-Martin taught at London's Goldsmiths College (1974– 88), where he influenced a number of the Young British Artists. He had a retrospective at the Whitechapel Gallery, London (1989), and a solo show at the Pompidou Centre, Paris (1994).

SEE ALSO Creed, Nauman, Warhol, Conceptual Art, Young British Artists

In the 1970s, Michael Craig-Martin was a key exponent of Conceptual Art. An Oak Tree (1973) appears to be a glass of water on a shelf, but in an accompanying text Craig-Martin insists that it has become an oak tree. This requires a suspension of our disbelief, an acceptance that the object is more than it appears to be, and that the artist can do the extraordinary with the most ordinary of means. Whatever our reaction, the point is that the work should inform our understanding of art in general. What is it that sets artworks apart from other objects? What does an artist do that makes their products "art" while other objects are not art?

More recently, Craig-Martin has become better known as a painter. Eye of the Storm (2003) exemplifies his technique of painting everyday objects with matt colours and thick black lines. Craig-Martin's paintings seem to rephrase his earlier musings on ordinary and extraordinary objects, suggesting that perhaps it is the ordinary that is more suffused with meaning. The objects he paints always require completion by a human presence, or use, meaning that unlike artworks, they cannot be considered apart from their social function. For that reason, Craig-Martin is able to form these objects into a vocabulary, creating meaning within his work from the neglected significance of the everyday. His style, which actually seems designed to deny all stylistic content, allows his objects to speak without recourse to his intervention. Although his works might imply some presence for their completion, that presence is not the artist's but our own.

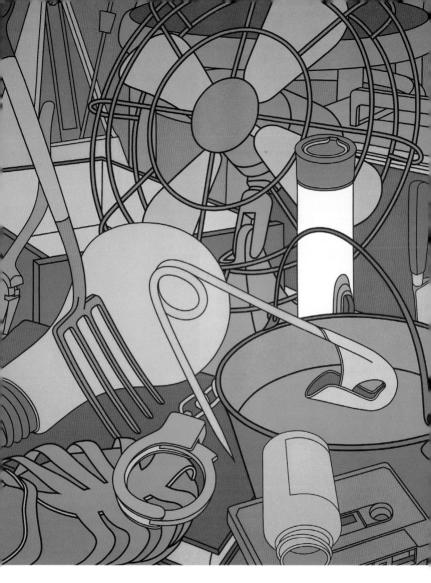

Eye of the Storm 2003 | Acrylic on canvas 335.5 x 279.5 cm (132 x 110 in)

MARTIN CREED

BORN Wakefield, England, 1968

Martin Creed attended the Slade School of Art in London (1986–90). He has had numerous solo exhibitions: at the Kunsthalle Bern, (2003); the Douglas Hyde Gallery, Dublin (2007); the Ikon Gallery, Birmingham (2008); the Duveen Galleries of Tate Britain (2008); *Feelings* at the Hessel Museum of Art and CCS Galleries, Bard College, Annandale-on-Hudson, New York; and the Hiroshima City Museum of Contemporary Art (2009). Creed currently lives and works in London.

SEE ALSO Friedman, Conceptual Art, Installation Art, Minimalism, Performance Art

Martin Creed uses the materials of everyday life to create cunning works that exude both humour and seriousness. Hailing from a tradition of Conceptual Art in the 1960s and '70s, Creed's Post-Conceptual practice often makes use of materials that are already in existence, such as light, air and words. *Work No.* 268: half the air in a given space (2001), for example, consists of balloons filled with the equivalent of one half of the volume of air in the room in which it is

exhibited. Like all of Creed's works, the piece has a place in the artist's numeric system – without regard to size or importance, every one of Creed's creations is given a number. Any description in the title is usually an entirely accurate elaboration of the work's form.

Creed won the Turner Prize in 2001 for a piece entitled Work No. 227: The lights going on and off (2000). Installed at Tate Modern, London, it included a device that periodically switched on and

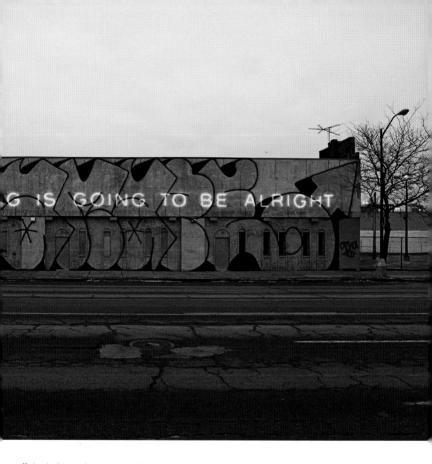

off the lights in the gallery. The work is characteristically minimal, yet rife with poeticism, surprise and even comic effect. Another well-known piece is *Work No.* 203: EVERYTHING IS GOING TO BE ALRIGHT (1999). This consists of neon lettering that is installed onto the host building's facade. The statement is both optimistic and enervating. On the one hand, the pithy remark is a light-hearted gesture of encouragement. On the other hand, the sign is reminiscent of the advertising industry's attempt to prey upon people's financial and emotional insecurities, as it makes a commodity of hope.

Work No. 790 EVERYTHING IS GOING TO BE ALRIGHT 2007 | Neon installation at the Museum of Contemporary Art Detroit Neon tubes: 251 x 81 x 15 cm (99 x 32 x 6 in)

JOHN CURRIN

BORN Boulder, Colorado, USA, 1962

John Currin received a Bachelor of Fine Arts from Carnegie Mellon University and a Master of Fine Arts from Yale University. He has been the subject of over twenty solo exhibitions. The Museum of Contemporary Art, Chicago, organized an exhibition of his paintings (2003) that travelled to the Serpentine Gallery, London; and the Whitney Museum of American Art, New York. The Des Moines Arts Center organized an exhibition of his drawings (2003), which travelled to the Aspen Art Museum and the Milwaukee Art Museum. The artist currently lives and works in New York.

SEE ALSO Peyton, Saville, Abstract and Representational Art

John Currin is an anomaly in the recent trajectory of contemporary art. Rising to prominence in the early 1990s, he entered an art world preoccupied by works with a political focus, usually in the form of video, installation and other mixed media. Yet Currin is a figurative painter rooted in the tradition of Old Master portraitists. His kind of practice evokes the work of Jenny Saville and Elizabeth Peyton, but relatively few other artists are comparable. Currin's technical skill and virtuosity as a painter are undeniable. His application of paint varies from soft and light, with invisible brushstrokes, to thick and grainy. His subject matter is people, and usually women. Alongside Renaissance oil paintings, Currin takes inspiration from a wide range of sources, including 1970s' *Playboy* adverts, issues of *Cosmopolitan* and mid-twentieth-century film.

Currin's distinctive style borders on the grotesque. The artist distorts and exaggerates particular features of the human body. At times, he acts like a caricaturist, making eyes bulge and bellies bloat. The result is both compelling and contentious. The women he depicts are varied, sometimes buxom young girls with toothy smiles, at other times older women with dull, lifeless skin. In The Cripple (1997) the girl appears unnaturally disproportionate because, characteristically, Currin has elongated her neck. The girl's mood is also typically hard to define. There is something slightly unnerving about her flowing hair, provocative neckline and slightly crazed smile. Currin's recent paintings have taken on as subject matter everything from eroticism and procreation, to mail-order porcelain.

The Cripple 1997 | Oil on canvas 112 x 91.5 cm (44 x 36 in)

RICHARD DEACON

BORN Bangor, Wales, 1949

Richard Deacon studied at St Martin's College of Art and the Royal College of Art. Having left the Royal College in 1977, he had his first one-man show at The Gallery in London in 1978. In 1987 he won the Turner Prize for his travelling show *For Those Who Have Eyes*. He has made a number of public works including *Between the Eyes*, made for the Yonge Square International Plaza in Toronto in 1990. In 1998 he was made a Royal Academician.

SEE ALSO Caro, Cragg, Gormley, Abstract and Representational Art

Richard Deacon is one of the principal British sculptors of his generation. Although his works are largely abstract, he tends to incorporate organic forms within them and some of his sculptures even resemble parts of the human body. This is the case with *Listening to Reason* (1986), which resembles a number of ears. Here, as in other examples, Deacon's bodily metaphors are particularly related to our perceptual organs. He seems to suggest that these objects are as receptive to us as we are to them, perhaps in the sense that they take on new meanings in response to

our perception and discussion of them.

Deacon's structures often resemble those of Anthony Caro and we can also find similarities in their approach. Like Caro, Deacon uses industrial techniques and as such he refers to himself as a "fabricator" rather than a sculptor. He also has a tendency to used unprocessed materials. *Listening to Reason* is made from

unprocessed wood on which we can still see rings and resin. This reminds us of the previous life of the material and alongside its organic form implies the ways in which we are connected with the work and with nature. We might also understand it as a testament to Deacon's professed interest in processes over finished pieces, since the surface of the work implies its origins. It is probably best to think of Deacon's oeuvre as a process of considering materials and spaces, rather than simply a series of discrete points.

listening to Reason 1986| Laminated wood 226 x 609 x 579 cm (88¾ x 239½ x 227¾ in)

tacita dean

BORN Canterbury, England, 1965

Tacita Dean studied at the Falmouth School of Art and at the Slade School of Fine Art. Dean has had solo exhibitions at many institutions including the Museu d'Art Contemporani de Barcelona (2001); ARC, Musée d'Art Moderne de la Ville de Paris (2003); Hugh Lane Gallery, Dublin (2007); Solomon R. Guggenheim Museum, New York (2007); and Dia:Beacon, New York (2008). She was nominated for the Turner Prize (1998) and was awarded the German DAAD Scholarship for a residency in Berlin (2000). She lives and works in Berlin.

Tacita Dean works in a variety of media including film, drawing, photography and sound. She has worked extensively with 1 6mm film, exploring the formal potential of the medium. Her films typically include long, slow shots, which often give the impression of stillness. In 2007 Dean made a film entitled Merce Cunningham performs STILLNESS (in three movements) to John Cage's composition 4'33" with Trevor Carlson, New York City, 28 April 2007 (six performances; six films). The work looks not only at silence but also at stasis. Dean's films frequently investigate anachronisms

and outdated systems of belief. They also explore the boundaries between fiction and reality and past and present. In 2006, Dean made a film, *Kodak*, about her medium of choice, 16mm film. The film explores the last factory in Europe producing black and white film for standard 16mm cameras. Since moving to Berlin, Dean has begun to look at architectural structures in her films, often as a means of understanding

certain cultural and political systems.

The sea, and its eighteenth-century interpretation as a representation of the sublime, is an enduring interest for Dean and is found in many of her works. *Disappearance at Sea* (1996) is inspired by the story of Donald Crowhurst, the English yachtsman who tried to fake a sailing journey around the world, but ended up committing suicide. She has also explored the imposing physical presence of trees in southeast England. *Majesty* (2006) features the oldest complete oak tree in England and consists of a largescale photograph covered in gouache.

Majesty 2006 | Gouache on fibre-based photograph mounted on paper 300 x 420 cm (118 x 165½ in)

JEREMY DELLER

BORN London, England, 1966

Jeremy Deller studied history of art at London's Courtauld Institute of Art (1985–88) and fine art at the University of Sussex (1991–92). His first solo show, *The Search For Bez*, was held at Weekenders in London (1994). He had a solo show at London's Tate Britain in 2001. He was awarded the Turner Prize in 2007 for a show called *Memory Bucket*, which was held at Artpace, San Antonio, United States (2003). Deller was made a trustee of the Tate Foundation in 2007.

SEE ALSO Dion, Conceptual Art, Performance Art

Jeremy Deller is an English artist who makes collaborative, community-led work. *The Battle of Orgreave* (2001) was a recreation of a 1984 clash between police and striking miners. Deller brought in historical re-enactment hobbyists alongside local people who were involved in the original confrontation. Deller himself is largely absent from the work, since it was based on the accounts of miners and police officers and directed by a re-enactment expert. The reason for the restaging was that the clash had already

been replayed through the media, which often twisted the events. Mike Figgis's accompanying movie even reveals that the BBC reversed film footage to imply that the miners struck first, when the opposite was the case. By allowing the original participants to shape their own retelling of the event, Deller facilitated a reclamation of this historical moment from its manipulation by Thatcher's government and its supporters.

The Folk Archive, which Deller began with Alan Kane in 1999, is a collection of works made by individuals outside the art world. It includes a mechanical elephant, documentation of a gurning championship and political banners. The work is clearly motivated by a dissatisfaction with mainstream culture and a wish to represent a broader spectrum of creation. Again, Deller himself is largely absent and acts more as a curator than an artist. Both of the above works seem to be attempts to bypass, and thereby criticize, the dominance of popular culture and the art world. If Deller is himself absent, it is to avoid channelling his subjects through yet another conduit.

The Battle of Orgreave 2001 | Commissioned and produced by Artangel

THOMAS DEMAND

BORN Munich, Germany, 1964

Thomas Demand began to study at the Academy of Fine Arts in Munich (1987), but switched to the Art Academy in Düsseldorf (1989). He had his first solo show at Galerie Tanit, Munich (1996). He received a Master of Fine Arts degree from Goldsmiths College, London (1994). Demand had a solo show at the Tate Gallery, London (1999). His work was included in *ArchiSkulptur* (2005) at the Museo Guggenheim Bilbao. He had an exhibition at the Taka Ishii Gallery, Tokyo, in 2007.

SEE ALSO Wall

Thomas Demand began his career as a sculptor of paper, but quickly turned to photography and film to document his sculptures in the gallery space. The sculptures, such as *Klause 3* (Tavern 3, 2006), are also modelled on photographs. Indeed, because of their intricacy, we might mistake Demand's documentations for being original photographs themselves. However, whether through their lack of textural detail or their oddly regular

shapes and colours, we eventually come to realize their artificiality.

The scenes represented by the sculptures are often highly significant. *Klause 3* depicts a room in a building in Germany where a kidnapped boy was murdered. Despite an initial sense of normality, areas of shadow – particularly the darkness showing through a crack in a door – imply the room's grim history. However, Demand's reconstruction of the scene implies the constructed nature of the original photograph. The work's injection of drama through artistic devices feeds our need to visualize the terror of the events that occurred at the original scene.

Demand's layering of reality and fiction is heightened in his series Yellowcake (2007). These works reconstruct photographs taken by Demand of the Nigerian Embassy in Rome, Italy. A burglary at this site led to the creation of forged documents that became central to the Bush administration's justification of its attack on Iraq. Here, not only are Demand's images fake, but the narrative they document is that of a forgery. Fiction and reality collapse, with neither the supposed original nor Demand's copy able to fully embody either. By creating fiction, Demand highlights the artificiality of what we call reality and brings into question all forms of representation and mediation.

Klause 3 2006 | C-print / diasec 199 x 258 cm (78½ x 101½ in)

RINEKE DIJKSTRA

BORN Sittard, the Netherlands, 1959

Rineke Dijkstra studied photography at the Gerrit Rietveld Academy in Amsterdam (1981–86). Since her first solo exhibition at de Moor in Amsterdam (1984), Dijkstra has shown at the Sprengel Museum Hannover (1998); Museu d'Art Contemporani de Barcelona (1999); and the Art Institute of Chicago (2001), amongst other venues. She has also exhibited widely in group shows, including the Venice Biennale (1997 and 2001); and *ICP Triennial of Photography and Video* at the International Center of Photography in New York City (2003). She lives in Amsterdam.

SEE ALSO Arbus

Rineke Dijkstra works primarily in photography and film. Her subjects are individuals, usually placed in front of a minimal background. Although she generally photographs one person in a frame, the individuals often constitute an identifiable group. In one series, Dijkstra photographed young women in uniform on their first day of mandatory service in the Israeli army. Despite the uniforms and the neutral white backdrop, each portrait is resoundingly distinct and each woman defiantly individual. Dijkstra's careful and compelling choice of subjects is an integral component of her work, inviting comparison with that of Diane Arbus. Other subject groups have included matadors immediately after a bullfight, mothers who have just given birth, awkward adolescents on the beach and boys in the Israeli army who have just fired a rifle.

Extending her mastery of the photographic portrait into the realm of video, Dijkstra made a 26-minute, split-screen video projection entitled The Buzzclub, Liverpool, UK / Mysteryworld, Zaandam, NL (1995). The video captures teenagers on a night out in each club. Once again placed against a plain white backdrop, the teenagers move into and out of the frame, sometimes posing, kissing or getting lost in their own world. Like many of the individuals Dijkstra documents, the teenagers appear vulnerable in front of the camera. Despite wearing the right clothes, moving to House music and, in some cases, feeling the effects of alcohol, cocaine and ecstasy, the subjects struggle with the intimacy of a private moment with the camera.

Kolobrzeg Poland 26 July 1992 | C-print 168 x 141.5 cm (66 x 55¾ in)

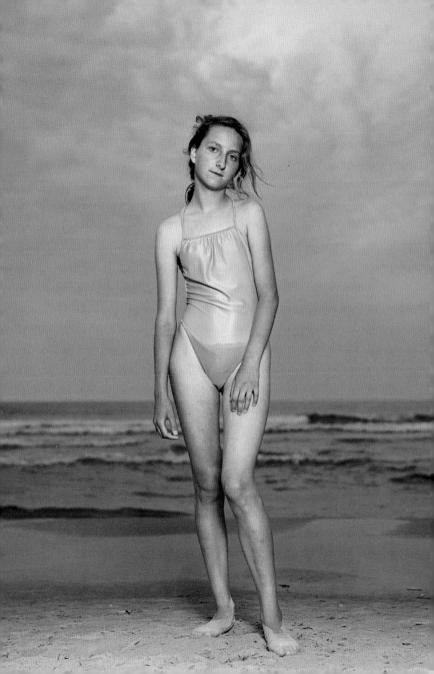

MARK DION

BORN New Bedford, Massachusetts, USA, 1961

Mark Dion studied at the University of Hartford School of Art, the School of Visual Arts, New York City and in the Independent Study Program at the Whitney Museum of American Art. He also holds an honorary doctorate from the University of Hartford School of Art. Dion has had exhibitions at Tate Britain, London (1999): Aldrich Museum of Contemporary Art, Ridgefield, Connecticut (2003); Museum of Modern Art, New York City (2004); South London Gallery (2005); and the Miami Art Museum (2006). He lives in Beach Lake, Pennsylvania, and works all around the world.

SEE ALSO Broodthaers

Mark Dion's work is concerned with notions of history and archaeology, and the understanding of history as archaeology. Seeking to disrupt distinctions between objective scientific methods and subjective artistic inquiries, Dion investigates the natural environment around him through a variety of creative means. Usually working collaboratively and frequently involving entire teams of volunteers or experts in the field under discussion, Dion often recategorizes objects and specimens in his work. Sometimes he places his finds in a curiosity cabinet, based upon the *Wunderkammer* of the sixteenth century. Dion's atypical methods of ordering objects follow in the tradition of Marcel Broodthaers's experiments with the *Museum of Modern Art, Department of Eagles* (1968). A particular interest for Dion is the investigation of "R-selected species", a category of living things that reproduce quickly in disturbed habitats.

One of Dion's most celebrated investigations is the Tate Thames Dia (1999). The work involved scouring the banks of the River Thames at two locations in London, Millbank and Bankside, near the Tate galleries. Over two weeks, some twenty-five volunteers employed a process of "field walking", an archaeological technique for gathering objects and artefacts. Dion consulted numerous ecologists, archaeologists and historians. A variety of objects were collected, ranging from a human shin bone to old shoes. The objects were later displayed in an old mahogany chest, one side representing objects from Millbank, and the other from Bankside. Loosely arranged according to object type, the display allowed antique objects and contemporary finds to sit together.

Tate Thames Dig 1999 | Mixed media 266 x 370 x 126 cm (104¾ x 145¾ x 49½ in)

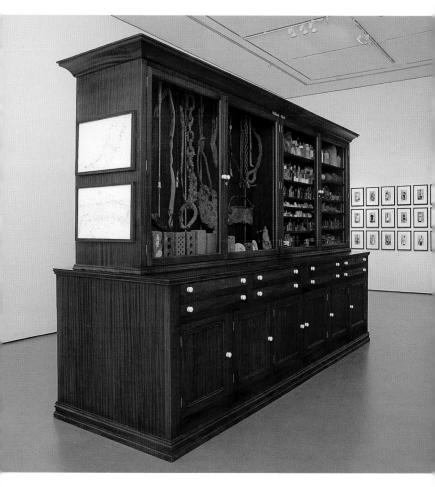

PETER DOIG

BORN Edinburgh, Scotland, 1959

Peter Doig moved with his family to Trinidad (1962), and then to Canada (1966). He then studied in London, England, at the Wimbledon School of Art, St Martins School of Art and finally Chelsea School of Art. He has had numerous solo exhibitions, with a major retrospective touring to Tate Britain, London; ARC/Musée d'Art moderne de la Ville de Paris; and Schirn Kunsthalle, Frankfurt am Main, Germany (2008–09). He currently lives and works in Trinidad.

SEE ALSO Abstract and Representational Art

Peter Doig is clearly one of the most important artists of his generation. He rose to recognition in the early 1990s with a distinctive approach to painting that combined figuration with abstraction. Doig's dreamy, large-scale canvases depict landscapes in oil paint. His works often reference natural scenes, and are frequently inhabited by one lone individual. In the early 1990s, Doig made a number of paintings featuring a cance, a use allegedly inspired by the film *Friday the 13th* (1980). The landscape in these paintings recalls the landscape of the

Canadian wilderness. Although Doig spent most of his childhood in Canada, many of these paintings were done in his studio in Kings Cross, London. Doig relies upon memory and photographs for his works, using as his sources both photographs he has taken himself and found photography.

Doig's paintings often reference familiar objects or settings, but are imbued with a sense of mystery, ambiguity and even magic. For these reasons, Doig's work is frequently compared to Magical Realism,

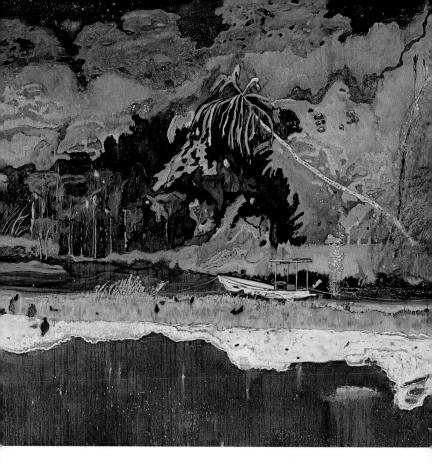

the literary movement in which unrealistic things happen in otherwise normal situations. Doig's exaggerated depictions of reflections in water, for instance, give his works a phantasmagorical quality. After painting a range of subjects throughout the middle of the 1990s, Doig returned to his investigation of the canoe in the late 1990s, this time with thinner paint applications, and increasingly dominant horizons. Doig visited Trinidad in 2000, taking photographs that he used in painting Grand Riviere (2000–01), his first work set on the island. Doig moved to Trinidad in 2002, and the island landscape is the subject of many of his recent paintings, including *Lapeyrouse Wall* (2004).

Grande Riviere 2001–02 | Oil on canvas 230 x 360 cm (90½ x 141½ in)

STAN DOUGLAS

BORN Vancouver, Canada, 1960

Stan Douglas studied at the Emily Carr College of Art and Design (1979-82). His first solo show was Onomatopoeia at the Western Front (1986). In the late 1980s he was on the board of the artist-run Or Gallery, Vancouver. A show he curated, Samuel Beckett: Teleplays, toured Canada, the United States, Australia, France and Italy (1988–91). He was in Documenta IX. X and Documenta 11. He co-curated the exhibition Beyond Cinema: The Art of Projection at the Hamburger Bahnhof, Berlin (2006). A survey of his work to date, Past Imperfect: Works 1986-2007. was mounted by the Württembergischer Kunstverein and the Staatsgalerie Stuttgart in 2007; and Klatsassin was shown at the Vancouver Art Gallery (2009).

SEE ALSO Installation Art, Video Art

Stan Douglas works primarily with film, using its inherent temporality to consider examples of historical change. *Win, Place or Show* (1998) involves an argument between two men. Douglas constructed their setting from plans of a Vancouver tower block that was never built, so the scene has an odd historical status: it is set in a past that never happened. This indeterminacy is replicated in the work's presentation - it is shown on two screens with a small gap between them. The film was made using a number of different takes, which each time it is played are reassembled by a computer. The narrative runs in broadly the same way at each showing, but it does vary slightly. Furthermore, the two screens can show two different takes at one time, so a character might leave one screen and not reappear on the other. In this way, the film seems to be constructed from a set of possibilities rather than a linear progression of events.

Douglas's realization of a past that never happened implies a present and a future that also do not happen. In the photograph Every Building on 100 West Hastings (2001), Douglas documented the negative impact that town planning has had on a poor area of Vancouver in Canada. As in Win, Place or Show, he considers how particular historical moments and processes have impacted, or could have impacted, upon subsequent situations. Douglas thus refuses to read the present as a fixed entity, but rather insists on its historical lineage as well as its consideration as future history.

Win, Place or Show 1998 | Two-channel video projection 204,023 variations with an average duration of 6 min each

MARLENE DUMAS

BORN Cape Town, South Africa, 1953

Marlene Dumas received a Bachelor of Arts dearee from Skone Kunsten, University of Cape Town, and later studied in the Netherlands. Her solo exhibitions have been held at Tate Gallery, London (1996); Museum für Moderne Kunst, Frankfurt am Main (1998): Camden Arts Centre, London (2000); Pompidou Centre, Paris (2001); New Museum, New York (2002); and the Museum of Contemporary Art, Los Anaeles (2008). A retrospective was held at the Museum of Modern Art. New York (2009). She represented the Netherlands at the Venice Biennale (1995).

SEE ALSO Tuymans

Marlene Dumas paints strikingly powerful scenes of ambiguous, intimate scenarios. Created primarily with oil on canvas, or ink and watercolour, Dumas's paintings are notable for their strength in simplicity. The artist depicts friends and lovers as well as popular figures. Unusually, she never works with sitters, but rather paints from images she gathers from newspapers, magazines and books, or which she has taken herself. Lucy (2004) – at once pained and strangely restful – is inspired by Caravaggio's painting Santa Lucia. Dumas frequently paints the female form, often in erotic or sexually suggestive postures. One work, (like al chambermaid (1999), is a beautiful representation of the curvature of the female form, balanced by the subject's simple black aarter belts. Sometimes it is difficult to tell whether Dumas is depicting scenes of abandoned sexual expression or simply creating pornography. Dumas seems to have an emotional uncertainty toward her subject matter. Children, who also appear frequently in Dumas's paintings, are portrayed as morose and innocent in equal measure. Unusually, Dumas often portrays children as something less than loveable, even as evil or slightly grotesque. At times, in Dumas's paintings, it is impossible to distinguish man from woman or one race from another. Dumas's brushstrokes are wide with soft edges, equalling the ambiguity of her subject matter. Her Neo-Expressionist style is similar to many drawing techniques. Dumas's paintings also reveal an acute awareness of the subtleties of human flesh tones, which she depicts with hues of blue, red and myriad other colours.

[Above] Lucy 2004 | Oil on canvas 110 x 130cm (43½ x 51 in)

[Below] (like a) chambermaid 1999 | Oil on canvas 40 x 50 cm (15¾ x 19¾ in)

JIMMIE DURHAM

BORN Washington, Arkansas, USA, 1940

Jimmie Durham studied at the École des Beaux-Arts in Geneva, Switzerland, In 1987 Durham moved to Cuernavaca. Mexico, and in 1994 moved to Europe. Solo exhibitions include the University of Texas Galleries, Austin (1965); Matt's Gallery, London (1988); Palais des Beaux-Arts, Brussels: Institute of Contemporary Arts, London (1993); Museo Nacional de Arte Contemporânea, Lisbon (1999); Galerie Nordenhake, Stockholm (2000); Centre for Contemporary Art, Kitakyushu, Japan (2000); Reg Vardy Gallery, University of Sunderland with Banff Centre, Canada; and Kunsthalle Basel (2006). He has participated in numerous international exhibitions, such as Documenta IX (1992) and the 50th Venice Biennale (2003) He now lives and works in Berlin.

SEE ALSO Rauschenberg, Identity Politics

Jimmie Durham is a writer, poet, performer, essayist, activist and artist. Working primarily in literature, theatre and performance in the 1960s and 1970s, Durham was also an active member of the American Civil Rights movement. Throughout the 1970s and into the early 1980s, Durham campaigned for the rights of Native Americans as part of the American Indian Movement (AIM). Of Cherokee descent, Durham is known for creating artworks that challenge Western representations of Native Americans.

Durham often uses found objects to create imaginative assemblages, such as the work Map of the Sky, including Betelgeuse and a Pecan (1993). Durham's art also investigates notions of the primitive and the idea of the native. His work nearly always assumes a pseudo-anthropological stance. Previous works include totem sculptures made of found junk. Durham gathers artefacts and materials to reveal satirical "facts" about the Native American population. In one of his best-known pieces, On Loan from the Museum of the American Indian (1985), Durham brings together for gallery display everyday objects such as a toothbrush and a family album. The objects are accompanied by captions that purport to explain their significance. The piece points to the American obsession with defining and exoticizing the Native American population. Durham's work is anti-hierarchical and increasingly challenges the idea of monumentalism in art. Recent works, such as Thinking of You (2008), tend to be sculptural in form, often emerging as beautiful and strange objects. Over the years, Durham's work made an important contribution to the discourse of post-colonial theory.

A Map of the Sky, including Betelgeuse and a Pecan 1993 | Oil on carvas mounted on board with additions (crab shell and pecan nut) 91.5 x 92 cm (unframed) (75½ x 36 in)

WILLIAM EGGLESTON

BORN Memphis, Tennessee, USA, 1939

William Eggleston was raised in Sumner, Mississippi. He attended Vanderbilt University in Nashville, Tennessee; Delta State College, Cleveland, Mississippi; and the University of Mississippi. He has mounted solo exhibitions at institutions around the world, including the Victoria and Albert Museum, London (1985); J. Paul Getty Museum, Los Angeles (1999); Fondation Cartier pour l'art contemporain, Paris (2001–02); Museum of Contemporary Art, Chicago (2003); and the Whitney Museum of American Art, New York (2008).

SEE ALSO Doig, Freud, Hodgkin, Abstract and Representative Art

An influential photographer, William Eggleston is often credited with establishing colour photography as an art form in its own right, deserving of display in museums, galleries and institutions. Eggleston grew up in the American South, and the southern environment continues to dominate his subject matter. His photographs capture mundane moments and everyday objects; he has a particular talent for finding inspiration in the sights that most people ignore or even avoid. Eggleston's large-format, richly coloured photographs monumentalize the most ordinary of subjects, facilitating a new way of looking. The detailed depiction of the everyday world in his images has affinities with the tradition of Photorealist painting that began to gain momentum just before his rise to prominence.

Initially inspired by photographers such as Robert Frank and Henri Cartier-Bresson. Eggleston switched from black and white photography to colour photography in 1965. He taught at Harvard University from 1973 to 1974, where he first discovered dye-transfer printing, a technique that allowed Eggleston to express subtleties and nuances within an image, as well as rich colours and hues. Dye-transfer printing is what gives Eggleston's images their characteristically intense colours. His best-known image, Untitled (Greenwood, Mississippi) (1973) - almost always referred to as The Red Ceiling - was created through dye-transfer. The image – a simple shot of a bare light bulb hanging from a friend's ceiling - is in an ineffable shade of red. Eggleston's groundbreaking 1976 exhibition at the Museum of Modern Art, New York, was entitled Color Photographs and was the first to bring colour photography from the world of advertising into the art gallery.

Untitled (Greenwood, Mississippi) 1973 | Dye-transfer print 40.5 x 51 cm (16 x 20 in)

OLAFUR ELIASSON

BORN Copenhagen, Denmark, 1967

Olafur Eliasson studied at the Royal Danish Academy of Fine Arts in Copenhagen (1989–95). He was commissioned to design the Serpentine Gallery Pavilion 2007, London, in collaboration with Kjetil Thorsen, and in 2008 was commissioned by the Public Art Fund to create a series of man-made waterfalls across New York City. He has had numerous solo exhibitions at institutions around the world, including the San Francisco Museum of Modern Art (2007–08) and the Museum of Modern Art, New York (2008). He lives in Copenhagen and Berlin.

SEE ALSO Installation Art, Site-Specificity

Olafur Eliasson is a multimedia artist who creates large-scale immersive installations, as well as working with sculpture and photography. Eliasson's work incorporates elements of science, art and the natural world. His art refers to light, temperature, air pressure, water, ice and other aspects of the physical environment. A progenitor of large-scale multi-sensory Installation Art, Eliasson often brings elements of the natural world, such as fog, mist and ice, into a gallery space or another unlikely environment, such as the city street. In doing so, Eliasson encourages the viewer to contemplate these phenomena with fresh insight, and to explore the relationship between viewer and stimulus. In many instances, the work has a participatory element. *One-way colour tunnel* (2007), for example, transformed the San Francisco Museum of Modern Art's steel skylight bridge. Starting from one side, the tunnel's triangular panels seem completely black; from the other end, a multicoloured spectrum shines through, changing as you walk by.

Eliasson's commission for London's Tate Modern Turbine Hall, The weather project (2003), drew more than two million visitors over the duration of its exhibition. The work involved a large, glowing, semicircular form that represented the sun. Inside the hall, Eliasson used humidifiers with a mixture of sugar and water to create a foggy effect. Finally, the ceiling of the hall was covered with a mirror, which reflected the visitors below. Taking as its point of departure the English propensity for discussing the weather, the project delved into deeper issues of experience and representation while creating a totally artificial immersive experience.

The weather project

2003 | Turbine Hall, Tate Modern, London (The Unilever Series)

Monofrequency lights, projection foil, haze machines, mirror foil, aluminium and scaffolding 26.7 x 22.3 x 155.4 m (87½ x 73 x 510 ft)

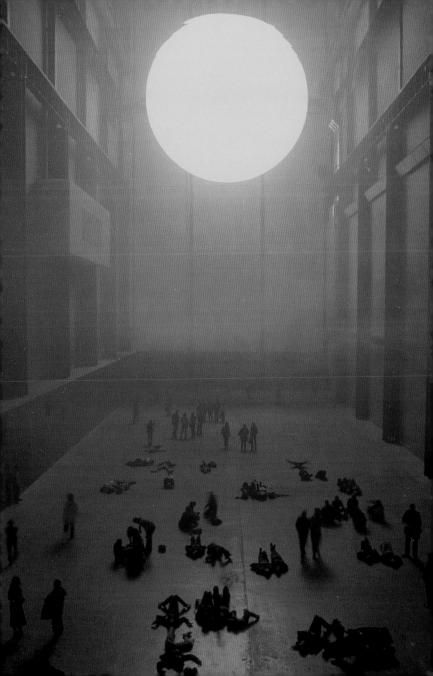

ELMGREEN & DRAGSET

BORN Michael Elmgreen: Copenhagen, Denmark, 1961; Ingar Dragset: Trondheim, Norway, 1969.

The artists have had numerous solo exhibitions at institutions around the world including Portikus, Frankfurt am Main (2001 and 2003); Tate Modern, London (2004); Serpentine Gallery, London (2006); The Power Plant, Toronto (2006); and Malmö Konsthall (2007). They also participated in the 49th and 50th Venice Biennale International Art Exhibitions (2001 and 2003), as well as Sculpture Projects Münster (2007). The artists live and work in Berlin.

SEE ALSO Institutional Critique, Minimalism, Performance Art

Michael Elmgreen and Ingar Dragset have been collaborating since 1995. Their work includes sculpture, performance and installation, and incorporates elements from architecture and design, as well as contemporary art. The pair first rose to prominence with an ongoing series of works entitled *Powerless Structures*. In these works, the artists challenge conventional notions of the "white cube" gallery space. Stemming from the lineage of Institutional

Critique, Elmgreen and Dragset redefine and re-inscribe meaning onto the gallery space. Works in the *Powerless Structures* series include an undulating wave constructed over the gallery floor, turning the linear Modernist design of the gallery into a sensual and emotive surface; a "white cube" exhibition space created in an area of a park popular for homosexual cruising; and a performance in which the artists repeatedly paint the walls of the gallery white. The series confronts the notion that it is not only space that

mediates behaviour, but also behaviour that mediates space.

In recent works, the artists have moved on from questioning structures of display in the art world to larger social, political and economic structures. In 2005, Elmgreen and Dragset completed *Prada Marfa*. Situated near Marfa, Texas, the town made famous by Donald Judd's large-scale Minimalist experiments, *Prada Marfa* is an exact replication of a Prada store, replete with shoes from the 2005 autumn collection. Looking more than a little out of place on an open expanse of desert landscape, the store has no entrance and no exit, and is being left to decay over the years. The work critiques how capitalism alleges to make luxury goods available to all, when in actuality the products are accessible to very few.

Prada Marfa

2005 | Mixed media, Prada shoes and bags 7.6 x 4.7 x 4.8 m (25 x 15½ x 15¾ ft)

TRACEY EMIN

BORN London, England, 1963

Tracey Emin studied at Maidstone College of Art, and later received a masters degree in painting from the Royal College of Art, London. She has had solo exhibitions at South London Gallery, London (1997); Stedelijk Museum, Amsterdam (2002); Modern Art Oxford (2002); and the Scottish National Gallery of Modern Art, Edinburgh (2008), amongst others. Emin represented Britain at the 52nd Venice Biennale (2007). She lives and works in London.

SEE ALSO Lucas, Young British Artists

Tracey Emin's art is almost always a form of self-disclosure, revealing intimate details of her private life and past. She works in a variety of media, including paint, sculpture, photography, fabric, found objects and installation. In the early 1990s, Emin set up a shop with fellow artist Sarah Lucas, called simply "The Shop". The pair sold T-shirts, ashtrays and small works of art from a space in London's East End. In 1994, Emin had her first solo exhibition at White Cube Gallery, one of London's most prominent contemporary art spaces. Despite gaining notoriety for sometimes controversial encounters with

the media, Emin has come to define the generation of artists in Britain who rose to prominence in the 1990s and became known as the Young British Artists (YBA).

Emin's work was included in the groundbreaking exhibition *Sensation*, at the Royal Academy of Arts, London, in 1997. The exhibition was drawn from the collection of Charles Saatchi and included works by the likes of Damien Hirst, Sarah Lucas, Marc Quinn and others. Emin's contribution to

Sensation was typically autobiographical. The piece, entitled Everyone I Have Ever Slept With 1963–1995, consisted of a large tent displaying the names of everyone with whom Emin had ever had sexual relations. Sadly, the work was destroyed in a fire that ravaged an art storage warehouse in 2004. In 1999, Emin was nominated for the Turner Prize for another controversial work, My Bed. The work exemplified the YBA generation's affinity for unusual materials, and consisted of the artist's bed, transplanted into the gallery space. Unmade and littered with soiled underwear, condoms and empty cigarette packets, the bed was supposedly left in the state in which it existed after the artist suffered a bout of depression.

Everyone I Have Ever Slept With 1963-1995 1995 | Appliquéd tent, mattress and light 122 x 245 x 215 cm (48 x 96½ x 84½ in)

FISCHLI/WEISS

BORN Peter Fischli: Zürich, Switzerland, 1952; David Weiss: Zürich, Switzerland, 1946 DIED Weiss: Zürich, Switzerland, 2012

Peter Fischli was educated at Academia di Belle Arti, Urbino, Italy, and then at Academia di Bella Arti, Bologna. David Weiss studied at Kunstgewerbeschule, Zürich and Kunstgewerbeschule, Basel. The artists have exhibited at institutions around the world including San Francisco Museum of Modern Art (1997); Museo d'Arte Contemporanea/ Castello di Rivoli, Turin (2000); Museum Ludwig, Cologne (2002); and Kunsthaus Zürich (2007). There was a major retrospective of their work at Tate Modern, London (2006–07). Fischli and Weiss live and work in Zürich.

SEE ALSO Doig, Freud, Hodgkin, Abstract and Representative Art

Since their first collaboration in 1979, Fischli and Weiss have found countless ways of making the familiar seem strange and the strange familiar. Their first collaborative work was *The Sausage Photographs* (1979), a series of images of sausages ingeniously manipulated to take part in fantasy worlds. Fischli and Weiss bring childlike inventiveness, wit and humour to the creation of their photographs, films, sculptures and installations. In the early 1980s the artists made a number of films that featured Fischli and Weiss engaging with one another and the world around them while attired in ridiculous rat and bear costumes. Often, their gestures work like acts of alchemy on their subjects. In Airports (1987–2006), the duo present what are usually frantic locations in a series of serene and strangely beautiful images. The subjects, unexpected for this purpose, include lone aircraft waiting on runways at dusk and baggage handlers going about their business under romantically murky skies.

Similar to the artists' use of auotidian objects in the creation of phantasmagorical worlds is their employment of low-fi methods in the production of spectacular scenarios. In The Way Things Go (1986-87), for example, a variety of objects ranging from kitchen utensils to chairs are used to create a chain reaction of events, with balls rolling, water flowing and explosions being set off. In an equally exploratory vein, Equilibres / Quiet Afternoon (1984–5) is a series of photographs depicting objects precariously, and seemingly miraculously, balanced one on top of another, supposedly captured in the instant they existed before succumbing to gravity.

Untitled (Tokyo) 1990 | C-print 124 x 190 cm (48¾ x 74¾ in)

dan flavin

BORN New York City, NY, USA, 1933 DIED New York City, NY, USA, 1996

Dan Flavin attended the Hans Hofmann School of Fine Arts and studied art history at the New School for Social Research (1956). He attended painting and drawing classes at Columbia University (1959) and had his first show at the Judson Gallery, New York (1961). He had a show entitled *some light* at the Kaymar Gallery, New York (1964); this was the first exhibition of his light sculptures. By 1968 he was creating room-sized light installations, as demonstrated at Documenta 4 in Kassel, Germany, that year.

SEE ALSO Andre, Judd, LeWitt, Nauman, Stella, Minimalism

From the early 1960s, Dan Flavin created "light sculptures" through the arrangement of fluorescent lights. His light sculpture *Pink out of a Corner – To Jasper Johns* (1963), is designed to be displayed in a corner. Flavin specifically references this position in the title, as if asking us to consider the work in relation to the gallery space. Furthermore, through its emanation of light the work is literally projected outside itself and into its surroundings. As well as its physical borders, it dissolves borders between media. Flavin did not sculpt this object, but merely bought and placed it. Its linearity and its emphasis on colour seem to place him as much within the history of painting or drawing as that of sculpture.

Flavin's early works are absolutely frank. When they were originally exhibited, their electrical cords were always visible. Certainly there is a sensuous element to Flavin's sculptures, and this is especially evident in his later works, which fill whole rooms with light. The light-sculpture experience is always rooted in an awareness of how it is produced by everyday electric lights, as well as its situation within a particular space. Where traditional works of art function as windows onto a separate space, Flavin's explicitly reach out to us. They create an aesthetic experience within which we can actively participate. Flavin often referred to his works as icons, but this might well have been ironic. In fact, they seem to reduce the iconic status of the work itself, dispersing its form throughout the gallery space and inviting us to become part of its composition.

"Monument" for V. Tatlin 1 1964 | Fluorescent lights and metal fixtures 244 x 59 x 11 cm (96 x 231/4 x 41/4 in)

ANDREA FRASER

BORN Billings, Montana, USA, 1965

Andrea Fraser attended New York University and the Whitney Museum of American Art's Independent Study Program and School of Visual Arts, New York. She has had solo exhibitions and given individual performances at institutions around the world, including the Kunsthalle Bern (1998); Kunstverein, Hamburg (2003); Dia:Chelsea, New York; Museum Moderner Kunst, Vienna (2005); Wexner Center for the Arts (2006); and the Pompidou Centre (2009).

SEE ALSO Feminism, Institutional Critique, Performance Art

Andrea Fraser is a progenitor of Institutional Critique. Working with video, performance and sculpture, since the 1990s she has developed a critical stance regarding the modern-day art museum, and the politics, power structures and systems of commerce that surround it. Often using humour and satire to investigate the very institutions in which her work is exhibited, Fraser also deals closely with the female body, and particularly her own body. In this way she follows in a lineage of female Performance Artists before her, such as Carolee Schneemann and Hannah Wilke. In Untitled (2003), Fraser offered her own body as the object of a work of art, and found a collector willing to pay the stated price for it. The ending result is a video piece of a sexual encounter between the collector and the artist.

Fraser is perhaps best known for her performances, in which she adopts the role of a museum tour guide. In Museum Highlights (1989), her first performance, she poses as a guide in the Philadelphia Museum of Art and describes the institution in elaborate detail, vet focusing on features such as the museum's cafeteria and water fountains. In 2001, Fraser reversed roles and made a video in the role of a museum visitor listening to an audio guide at the Museo Guggenheim Bilbao. In this piece, Little Frank and His Carp, Fraser takes everything the guide says literally. At one point she is asked to caress the building's "sensual curves", which she does in a fanciful and sexually suggestive way.

[Above] Untitled 2003 | DVD 60 min

[Below] Museum Highlights: A Gallery Talk 1989 | DVD 29 min

lucian freud

BORN Berlin, Germany, 1922 DIED London, England, 2011

After Hitler was appointed German Chancellor, Lucian Freud's family, who were of Jewish descent, fled to London, England. Freud studied art in a number of places, notably London's Goldsmiths College (1942–43). He was shortlisted for the Turner Prize (1988 and 1989). He had a major retrospective at Tate Britain, London (2002). There was an exhibition of his etchings at the Museum of Modern Art, New York (2007).

SEE ALSO Auerbach, Bacon, Saville, Abstract and Representational Art

After a Surrealist period in the 1940s, Lucian Freud, a grandson of the psychoanalyst Sigmund Freud, began primarily to paint portraits. His painting *Francis Bacon* (1952) is an early and unformed example of the intensely material approach that marks Freud as arguably the foremost painter of his generation. While Bacon himself is renowned for delving under the flesh of his subjects, Freud's paintings draw their interest from flesh itself. And while Bacon is thought of as a painter of meat, he cannot match Freud for unadulterated carnality.

In Benefits Supervisor Sleeping (1995),

the overweight woman sleeping on a sofa's inelegant pose and rough, uneven skin contrast with the sofa's smooth, pale base and with the classical model of beauty as provided by marble sculpture. As usual Freud makes no effort to flatter. But while this could indicate a detached approach to human representation, there remains a tension between what we might normally call ugliness and a visceral sexuality. The raw textures of this woman's body are intensely sexual, inviting the gaze and especially the touch. Although hardly delicate in its application, the painting evokes a moment of intimacy and complicates our usual approach to the body.

Freud's material approach also emphasizes a barrier between the viewer and the subject, with the latter reduced either to flesh or simply to paint. In Double Portrait (1985–86), depicting a woman and a dog, the woman's covered eyes are characteristic of this barrier, which distinguishes between painting's material plenitude and its inability to approach the psychological adequately. Although Freud's work is often hailed as a return to figuration, it continues to question the illusions of painting that were thought to be dispelled by Modernist abstraction. By addressing painting's inabilities alongside a rich understanding of its potential, Freud created a multi-faceted oeuvre that simultaneously approaches all of modern art history and the pure material experience of the moment.

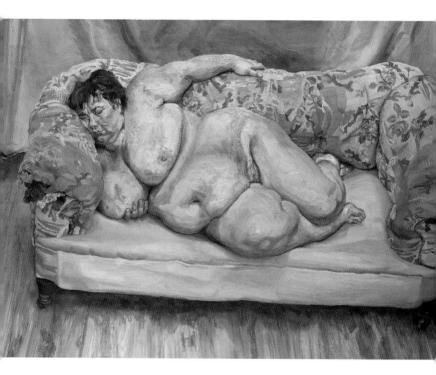

Benefits Supervisor Sleeping 1995 | Oil on canvas 151.5 x 219 cm (59¾ x 86¼ in)

tom friedman

BORN St. Louis, Missouri, USA, 1965

Tom Friedman has a Bachelor in Fine Arts from Washington University, St. Louis, and a Master of Fine Arts from the University of Illinois, Chicago. He has had numerous exhibitions at institutions around the world, including Museum of Contemporary Art, Chicago and Yerba Buena Center for the Arts, San Francisco (2000); Fondazione Prada, Milan (2002); New Museum of Contemporary Art, New York (2001–02); South London Gallery, London (2004); and Gagosian Gallery, London (2008). He lives in Northampton, Massachusetts.

SEE ALSO Conceptual Art

Tom Friedman is a Conceptual Artist who uses everyday materials in unusual ways, often imbuing mundane objects with new significance, such as toilet paper, chewed gum and spaghetti. In some instances, Friedman's work is fleeting, ephemeral or visually unspectacular, and it is often executed on a small scale – in one case the size of an aspirin pill, into which the artist carved his self-portrait. Friedman has executed a number of unusual self-portraits throughout his career. One untitled work from 2000, made from construction paper, imagines what the artist would look like after a motorcycle crash.

There is often a humorous element to Friedman's work, which is usually connected to the moment when the viewer realizes what he is actually looking at. In an untitled work from 1999, for example, what appears to be a small, intricately carved ivory sculpture turns out, on closer inspection, to be a pubic hair delicately forming a spiral on a bar of soap. In another work, Untitled, Toothpicks (1995), what looks like an exquisite, otherworldly object is actually a painstaking conglomeration of toothpicks. Friedman's works are sometimes accompanied by a kind of mythical backstory that adds gravity to their material presence. Hot Balls (1992), for example, is a pyramid made from brightly coloured balls and marbles, stolen by the artist from shops over a period of two years. As in many of Friedman's works, the materials in the piece are closely connected to the artist's life.

Untitled (toothpicks) 1995 | A starburst construction made with thousands of toothpicks 66 x 76 x 58.5 cm (26 x 30 x 23 in)

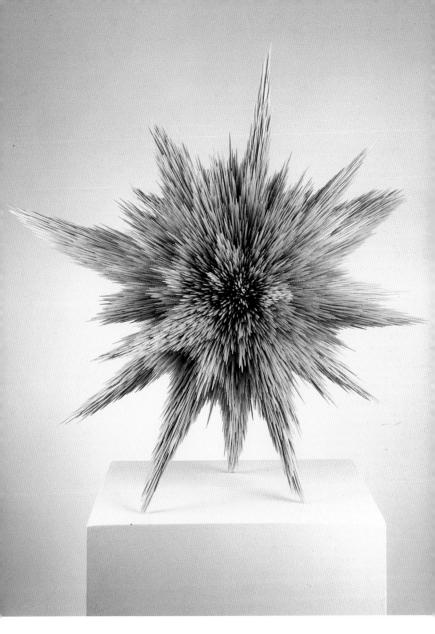

THEASTER GATES

BORN Chicago, Illinois, USA, 1973

Theaster Gates currently lives and works in Chicago. He has degrees in Urban Planning, Fine Art and Religious Studies. He has had numerous solo exhibitions at institutions including the Seattle Art Museum (2011-12); Museum of Contemporary Art, Los Angeles (2011-12); the Milwaukee Art Museum (2010) and the Museum of Contemporary Art, Chicago (2009). He was included in the Whitney Biennial in New York in 2010.

Theaster Gates occupies a unique position in the contemporary art world. His work involves not only object making, but also social practice—the transformation of space and critical engagement with the public. With a background in urban planning, Gates stretches our understanding of what constitutes art, often working with communities to revitalise urban space. *Dorchester Projects* involved the acquisition and renovation of a group of derelict buildings in Chicago's South Side neighbourhood. Over a number of years, Gates transformed the buildings from neglect and decay into a vibrant community hub. After living for a period of time in one of the buildings, Gates acquired further buildings for use as a library, archive and soul food kitchen. In one of the houses he set up a 'listening room', which facilitated access to the collection of a former record store in a nearby neighbourhood. He also established a library, including stock from a local bookstore that had shut down and glass slides from the University of Chicago's Art History Department.

Working as an artist and a social activist, Gates explores questions of race as well as cultural heritage and politics. In a number of recent works, Gates has addressed the ongoing campaign for civil rights, and the history of the struggle for civil rights in America. In the work Raising Goliath (2012). Gates displays hundreds of issues of African American publications, such as Ebony. As part of dOCUMENTA 13, in Kassel, Gates contributed 12 Ballads for Huguenot House (2012), which involved the complete transformation of an old building to a place where people could enjoy music, food, programmed talks and conversation. Gates often works with reclaimed and re-purposed materials to create a particular aesthetic for his renovation projects.

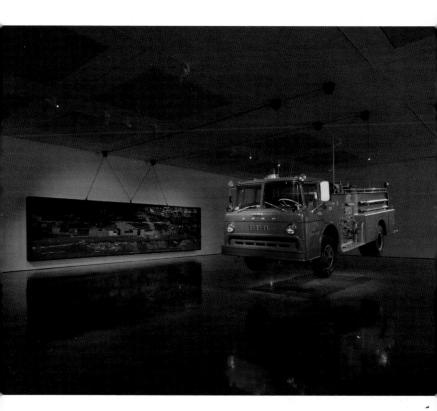

Presentism 2005 | Installation View Corvi-Mora, London

ISA Genzken

BORN Bad Oldesloe, Germany, 1948

She studied at the University of Visual Arts in Hamburg (1969–71), the University of Visual Arts in Berlin (1971–73) and the Kunstakademie in Düsseldorf (1973–77). Her first solo exhibition was held at the Konrad Fischer Gallery in Düsseldorf (1976). Although primarily considered a sculptor, she has worked in other media: amongst her films is *Chicago Drive* (1992). She represented Germany in the Venice Biennale in 2007. Since 1996 she has lived and worked in Berlin.

SEE ALSO Ackermann, Kelley, Installation Art

Since the 1970s, Isa Genzken has continually overhauled her artistic practice, always rejecting that which has gone before. Indeed, her most recent work has brought impermanence and the transitory into the foreground, perhaps in acceptance of its central role in her oeuvre. Untitled (2007), an installation for that year's Sculpture Projects Münster, consisted of a selection of toys and umbrellas that suggested their impermanence through their tatty state. Her installation *Oil* (2007) made a theme of the transitory through its

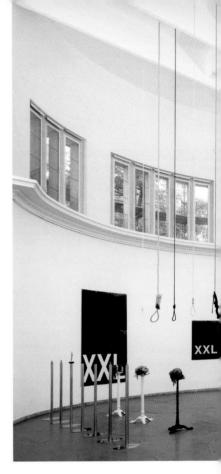

symbolic use of suitcases. As well as self-reference, this constant insistence on transition seems to mirror art's globalization. The specificity of a space is removed and it is treated merely as a way station and never as a final destination.

Genzken's assemblages of kitsch objects coalesce into a grotesque PostPop aesthetic in which the commercial mixes with the deathly. *Oil* contained a room of kitsch skulls, some wearing glitzy Venetian masks

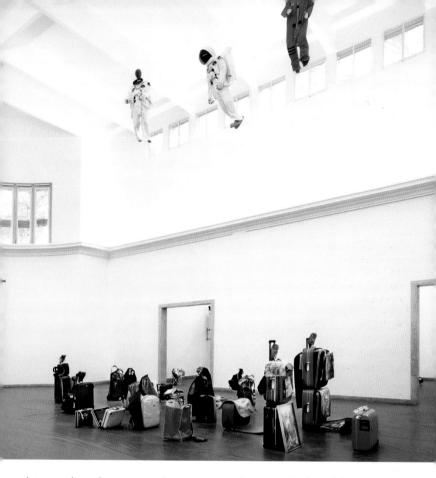

that seemed to make associations between death, glamour and consumption. This scattergun approach refuses precision, opting for playful combination rather than strict formal modelling. Genzken's sculptures act as a site within which cultural objects can create new meanings and reveal old ones. However, her work never functions as transparent political mapping; although the objects often have specific symbolic functions (as with the suitcases), their combination produces a wealth of possibilities but also a lack of definitive answers. These cultural way-stations seem to cater to the transient viewer, and refuse to offer a false finality in a world where there is only impermanence.

Oil Installation view German Pavilion, Venice Biennale 2007 Mixed media

GILBERT & George

BORN Gilbert: San Martin de Tor, Dolomites, Italy, 1943; George: Plymouth, England, 1942

The pair met while students at St Martin's School of Art, London, and have lived and worked together since 1968. Gilbert & George have had major exhibitions at the Stedelijk van Abbemuseum, Eindhoven (1980); Hayward Gallery, London (1987); and Tate Modern (2007), amongst many others. They were invited to participate in Documenta 5, 6 and 7 in Kassel (1972, 1977 and 1982). The duo won the Turner Prize (1986) and represented the United Kingdom at the Venice Biennale (2005).

SEE ALSO Performance Art

Now two of the most recognisable artists today, Gilbert & George established their reputation in 1969 with *The Singing Sculpture*, a work that features the artists dancing and singing Flanagan and Allen's *Underneath the Arches* (a 1930s British hit, steeped in the traditions of musical hall). In their art and their daily lives, Gilbert & George have adopted the identity of "living sculptures", becoming the art itself. They are always seen impeccably dressed in tailored suits they call

"Responsibility Suits". The artists have lived in London's East End since the 1960s, and almost all of the images they use are sourced from their immediate surroundings, though their subject range is vast and profound. *Fates* (2005), for example, includes pictures of young Asian men in urban wear, reflecting the cultural diversity of the neighbourhood. The work also includes text elements. Since the mid-1970s much of Gilbert & George's art has consisted of their trademark pictures, which

are often framed in large grid structures. They are visionary artists, whose aim is to create "Art for All".

LIAM GILLICK

BORN Aylesbury, England, 1964

Liam Gillick graduated from Goldsmiths College with a Bachelor of Fine Art degree (1987). He had his first show, entitled 84 Diagrams, at Karsten Schubert Ltd, London (1989). He had a major exhibition called The Wood Way at the Whitechapel Gallery, London (2002), and was nominated for the Turner Prize for that exhibition in the same year. He has written a number of books that run within and alonaside his other projects. From 2008-2010, a retrospective exhibition of his work Iwas shown at the Museum of Contemporary Art, Chicago; the Witte de With, Rotterdam; Kunsthalle, Zürich; and Kunstverein, Munich.

SEE ALSO Gonzalez-Torres, Höller, Graham, Tiravanija, Conceptual Art, Installation Art, Relational Aesthetics

Throughout his career, Liam Gillick has worked in a variety of media, each of which interact with each other. Similarly, his works themselves tend to be fluid, refusing to rest in any one object and sometimes even in any one place or time. In *Presentism* (2005), a number of short texts were hung from the ceiling of a

gallery. These objects sit between text and sculpture, demonstrating the spatial nature of the texts. As implied by a sign which says "reorganising the signage again", as we move round the gallery the texts appear to alter, merging with one another and forming different structures. This incorporates our actions into the syntax of the work, but also emphasises time, with the work constantly shifting through the course of its exhibition.

In other installations, Gillick often crafts the entire space of galleries, altering our

use of them through what he calls "discussion platforms", structures that loom either over our head or behind our backs and encourage particular types of interaction between participants. While these works do require our involvement for their completion, we are always aware that our participation is being manipulated by the objects and therefore by Gillick himself. In realising this and coming to critically analyse the spaces themselves, we begin to read them textually. This fluid approach, a continuation of Conceptual Art's attempts to rethink the status of artworks, produces art that is diffused throughout time and space, and so enters into a broader dialogue with the world and its inhabitants.

Presentism 2005 Installation View Corvi-Mora, London

ROBERT GOBER

BORN Wallingford, Connecticut, USA, 1954

He attended Middlebury College in Vermont (1972–76), studying Literature and Fine Arts. He moved to New York (1976), and his first solo show was held at the Paula Cooper Gallery, New York (1984), where he exhibited *Slides of a Changing Painting* (1982–83). Soon afterward he turned to making primarily three-dimensional works. Gober has had a number of retrospectives, notably at the Galerie Nationale du Jeu de Paume in Paris (1991) and the Museum of Contemporary Art in Los Angeles (1997). He represented the United States at the Venice Biennale in 2001.

SEE ALSO Cattelan, Kelley

Robert Gober is a sculptor of objects that unsettle the viewer through strange combinations, absences or deformities. *Untitled (Leg)* (1989–90) appears to be the lower quarter of a man's leg, complete with trousers, shoes and even hair. The leg sits against a wall and we wonder whether the man has been crushed under a great weight, or whether this part has been severed. Of course the leg is artificial, but Gober's great craftsmanship and attention to detail make it seem worryingly real.

Untitled (Leg) resembles the work of the Surrealists in its perversion of reality. Unlike the Surrealists, though, Gober creates highly realistic objects in real space. The subjects of his sculptures are always familiar items, such as this leg with its very average attire. It is because his objects are so close to mundane reality that their diversion from the usual is so disquieting. While earlier artists used found objects as sculptures, playing on our expectation of traditional art, Gober depends on our expectation of found objects. His apparently real objects actually evade reality, referring instead to the dream-like and the disturbing.

Robert Gober is a craftsman at a time when craft is highly unfashionable. In the 1980s his contemporaries re-presented commercial objects or used teams of assistants to physically create their pieces. Gober, meanwhile, personally made his works by hand, providing a radical alternative to the mass production of identical goods, rather than merely a comment on it. Both of these techniques tread a path between the banal and the fantastic, but only Gober's approach allows us to connect objects with fantasy without slipping into the vagaries of irony or the blind fascination of kitsch.

Untitled Leg 1989–90 | Beeswax, cotton, wood, leather, human hair $29 \times 20 \times 51$ cm ($111/_2 \times 734 \times 20$ in)

NAN GOLDIN

BORN Washington DC, USA, 1953

She had her first solo show at Project, Inc in Boston (1973). She received a Bachelor of Fine Arts degree from Tufts University, near Boston (1977). Goldin moved to New York in 1978 and quickly got involved with the New Wave scene. She first became known for her series *The Ballad of Sexual Dependency* (1980–86), particularly because some of its photographs were included in the Whitney Biennial (1985). The Whitney Museum of American Art, New York, later held a retrospective of her work (1996).

SEE ALSO Arbus, Bustamante, Sherman, Identity Politics

Nan Goldin's photography documents her life and the lives of those around her. It is absolutely frank, as exemplified by *Nan* one month after being battered (1984), which is a self-portrait taken a month after Nan was beaten by an ex-boyfriend. While her early work is sometimes glamorously hedonistic, by the 1990s she was mostly documenting the negative aspects of drug abuse and the deaths of friends from AIDS. This honesty contrasts with the arch irony that pervaded much American art in the 1980s, and is enhanced by the intimacy common to all of her works, a result of her practice of photographing only close friends.

She has frequently photographed cross-dressers. Sometimes such as in Misty and Jimmy Paulette in a taxi, NYC (1991), they are in full dress; and sometimes, such as in Jimmy Paulette and Taboo! Undressing, NYC (1991). they are in the process of dressing or undressing. These works imply the construction and performance of different self-identities. Similarly, in Nan one month after being battered, Goldin presents her own identity's construction by the actions of those ground her. Unlike traditional portraits, in which the artist tries to draw out something from inside the sitter, Goldin represents her external definition.

If her art is primarily characterized by intimacy, this intimacy is complicated by our masking and reconstruction of the self. Since Goldin represents the evolution of her subjects over time, her work documents the shifting of relationships; she refuses to capture moments only, preferring instead to document the process that is life.

Misty and Jimmy Paulette in a taxi, NYC

FELIX GONZALEZ-TORRES

BORN Guáimaro, Cuba, 1957 DIED Miami, Florida, USA, 1996

Felix Gonzalez-Torreslived in Puerto Rico before moving to New York City. He earned a Bachelor of Fine Arts in photography from Pratt Institute in Brooklyn, New York, and a Master of Fine Arts from the International Center of Photography, New York University, His work has been exhibited at the Solomon R. Guggenheim Museum (1995); Museum of Contemporary Art in Los Angeles (1994); Sprengel Museum, Hannover (1997); Museu de Arte Moderna, São Paulo (2001); and Hamburger Bahnhof, Museum für Gegenwartskunst, Berlin (2006). Gonzalez-Torres represented the United States in the 52nd Venice Biennale (2007).

SEE ALSO Meireles, Tiravanija, West, Minimalism

Felix Gonzalez-Torres's practice directly engages many of the principles of Minimalism set out by artists a generation before him. Working with a variety of materials, he develops and challenges Minimalist notions of presence and absence. While Minimalism sought to affirm the viewer's awareness of his physical presence in relation to an object. Gonzalez-Torres's works allude to presence through the threat of absence. Many of his works are fragile, unstable or even open to consumption by the audience - attributes reinstating qualities downplayed in Minimalist Art. By metaphorical extension, the works engage with the nearness of death. As a gay man living for many years with AIDS, and losing his long-term partner to the virus before succumbing himself, Gonzalez-Torres was acutely aware of death looming in life.One of Gonzalez-Torres's best-known works is "Untitled" (Go-Go Dancing Platform) (1991). The work consists of a platform with a string of bare light bulbs, upon which a go-go dancer performs for five minutes daily. The dancer listens to music on a Walkman. which the audience cannot hear. The piece draws a distinct line between performer and audience, and public versus private. Of course, when the dancer is not there, and only the platform exists, there is a notable absence. After Gonzalez-Torres lost his partner, many of his works dealt with presence realized through absence. The work "Untitled" (1991) consisted of a photograph of an empty bed with traces of two bodies on the sheets: the work existed as a billboard throughout New York City.

"Untitled" (Go-Go Dancing Platform) 1991 | Wood, lightbulbs, acrylic paint and Go-Go dancer in silver lame bathing suit, sneakers and Walkman. Overall dimensions vary with installation.

DOUGLAS GORDON

BORN Glasgow, Scotland, 1966

Douglas Gordon studied at Glasgow School of Art (1984–88) and then attended the Slade School of Art, London, until 1990. He had his first solo show at the Musée d'Art Moderne de la Ville de Paris (1993). He won the Turner Prize (1996) and represented Britain in the Venice Biennale (1997), at which he was awarded the Premio 2000. The Solomon R. Guggenheim Museum, New York, held a show of his work entitled *Moving Pictures* (2002), and he had a show at New York's Museum of Modern Art called *Timeline* (2006).

SEE ALSO Huyghe, Parreno, Viola, Video Art

Douglas Gordon is a filmmaker and photographer whose work is often a deconstruction, as much as a construction, of images. Zidane, a 21st Century Portrait (2006), which Gordon co-directed with Philippe Parreno, documents a football match but focuses solely on Zinédine Zidane. The film initially seems to exalt Zidane, isolating him and emphasizing his quasi-heroic concentration. At the same time, we are made aware that we are viewing an image and not a man. The film's quality is so high that it almost seems unreal, but at several points Zidane's image is entirely pixelated, which emphasizes his mediation by cameras, editing equipment and a screen – he is being reconstructed for the eyes of the viewer.

In 24 Hour Psycho (1993), Gordon takes a ready-made – the work of another (in this case Alfred Hitchcock's film *Psycho*) – and re-exhibits it. Gordon slows down the film and makes it run over a whole day. Its temporality is thereby extended to the point of collapse. Its narrative is disrupted and it loses any flow, becoming a series of stills. Gordon's intervention into Hitchcock's work seems both to reduce it to its essentials and completely destroy it.

Both works emphasize a tension between subject and medium, between film as presenting a narrative or a figure, and film as a mediating practice, the combination and editing of footage. Zidane, a 21st Century Portrait is as much a portrait of Gordon's own intervention, and 24 Hour Psycho is less a homage to Hitchcock than the complete annihilation of his work. Ultimately, each work calls its background, its technical apparatus, into the foreground, and in so doing calls the original content into question.

Zidane, a 21st Century Portrait 2006 | Film by Douglas Gordon and Philippe Parreno

ANTONY GORMLEY

BORN London, England, 1950.

Antony Gormley was awarded a degree in archaeology, anthropology and art history by Cambridge University (1971). After learning about Buddhism in India and Sri Lanka for three years, he studied fine art at Goldsmiths College (1974– 77) and sculpture at the Slade School of Art (1977–79), both in London. He had his first solo show at London's Whitechapel Gallery (1981). He won the Turner Prize (1994). Gormley is best known for creating *The Angel of the North* (1998), which stands outside Gateshead, England.

SEE ALSO Andre, Caro, Deacon, Flavin, Serra

Antony Gormley's sculptures and installations always take their viewers' bodies as their point of departure. *Blind Light* (2007) is a glass chamber filled with steam. Visitors who enter it are blinded by the steam and so they stumble around, unable to get their bearings. In opposition to the notion of "visual" art, Gormley bases this work around invisibility and privileges a perception which has to include the body.

Lost Horizon I (2008) also presents a bodily interpretation of space. It contains

32 life-size casts of the artist, standing at a number of angles around the gallery. The work transforms the otherwise anonymous space into a function of human presence. However it is also somewhat antagonistic: blank bodies which represent the latent presence of the artist, but refuse any direct social contact.

Field (American) (1991) is a mass of clay sculptures resembling human figures, constructed by a family of brick-makers in

Mexico. It is part of a series, all of which have been created by various communities across the globe. While elsewhere Gormley incorporates his viewers' bodies into the work, here he incorporates absent sculptors, who are often a great distance away. Although this is an act of inclusion, for the viewer it appears as an invasion. The figures physically confront us and deny us passage through the gallery space. Therefore while *Field (American)* is founded on global integration, Gormley also acknowledges its problems and asks his viewers to negotiate them. Like all of his work, the installation hinges on our reaction and forces us to question our own response.

Blind Light

 $2007 \mid Fluorescent light, toughened low iron glass, ultrasonic humidifiers, aluminium, water \\ 320 \times 978.5 \times 856.5 \ cm (126 \times 385! 4 \times 337 \ in)$

dan graham

BORN Urbana, Illinois, USA, 1942

He ran the John Daniels Gallery in New York in 1964 but left in 1965 to concentrate on his own art; he had his first solo show at that gallery in 1969. He was included in the *Information* exhibition at the Museum of Modern Art, New York (1970). In 2009 a major survey of his work travelled from the Whitney Museum of American Art, New York, to the Walker Art Center, Minneapolis and the Museum of Contemporary Art, Los Angeles. Graham is also a prolific author of art criticism and theory.

SEE ALSO Gillick, Serra, Conceptual Art, Installation Art

In the late 1960s and early 1970s, Dan Graham was a pioneer of Conceptual Art. His work has generally tended toward the theme of architecture, emphasizing the relationship between individuals and their surroundings. In *Two-way Mirror and Hedge Labyrinth* (1989), Graham created a pavilion from ornamental hedges and panes of two-way mirror glass. The transparency of the glass varies with light conditions; sometimes the outside is reflective while the inside is transparent, and sometimes both sides are transparent. This flux between the opaque and the transparent reveals the mirrors' differing effect on relationships between viewers. We come to realize that at some points we can be seen by an unseen viewer. It is in this way that the work reveals the strategies of vision employed in contemporary society, where a select few are given both the literal and the metaphorical ability to view the activity of others.

Graham's use of hedges compares these strategies with more traditional means of physical exclusion. People use hedges to demarcate their property relations, but hedges blend into natural surroundings and seem natural themselves. Similarly, two-way mirror glass reflects its surroundings, blending into the space around it and avoids implication as an exclusionary device. In comparing the hedges and glass, Graham refers to a history of architectural exclusion and reveals the politics that have long been inherent in space. We are denied access to private spaces, but their inhabitants simultaneously inhabit public spaces, visually penetrating them and transforming them into the negative of their own designs. Ultimately, Graham's art strips away the apparent neutrality of space, revealing its role in social control.

Twoway Mirror and Hedge Labyrinth 1989 | Zinc sprayed steel, twoway mirror, clear glass and Blue Cypress trees 220 x 600 x 900 cm (861/2 x 2361/4 x 3541/4 in) Installation recreated for *Like Nothing Else in Tennessee*, Serpentine Gallery, London, 1992

SUBODH GUPTA

BORN Bihar, India, 1964

Subodh Gupta received a BFA Painting from the College of Arts and Crafts, Patna, in 1988, and moved to New Delhi, where he currently lives and works, in 1990. Gupta has had a number of solo exhibitions, including *Take off your shoes and wash your hands* at Tramway, Glasgow in 2010; *Et tu Duchamp?* at KÖR am Kunsthalle Wien project space, Vienna, Austria and *I Go Home Every Single Day* at the Showroom in London.

SEE ALSO Installation Art, Photorealism

In 2007, The Guardian newspaper called Subodh Gupta the "Damien Hirst of Delhi". The artist has certainly come to represent a new generation of artists working in India whose practices reflect a country that is rapidly changing, culturally and economically. Originally trained as a painter, Gupta works in a variety of media such as steel, bronze, marble and paint. Most of his works include everyday objects that are relocated as artworks within the piece. Playing with Marcel Duchamp's notion of the "readymade", Gupta chooses objects that are well known in India – such as the steel tiffin boxes used to carry lunch, thali pans and bicycles – to create monumental installations. His choice of objects is considered; he selects items that are familiar to everyone in India, but also have certain aesthetic qualities. In some works, he incorporates materials that are specific to rural India, such as cow dung. Like many of his contemporaries, Gupta tries to capture the pulse of a nation on the move. He is also concerned with issues of migration, and some of his works deal with the idea of "returning home".

In 2009, Gupta exhibited Line of Control (2008) at the Tate Triennial. The work consists of a giant, exploding mushroom cloud made of hundreds of stainless-steel kitchen utensils. The piece symbolizes an uneasy pressure point a kettle about to boil, a contested political border or a country in the midst of modernization. The work questions consumer desires and the relationship between the western world and the developing economies it deals with. Many of Subodh's paintings also feature kitchen utensils. Photorealist paintings of utensils suspended in flight are quiet meditations on the material quality of stainless steel and, like Gupta's installations, an illustration of the everyday elevated to grandeur.

Line of Control

2008 | Stainless steel and steel structure, stainlesssteel utensils. 1000 x 1000 cm (394 x 394 x 394 in).

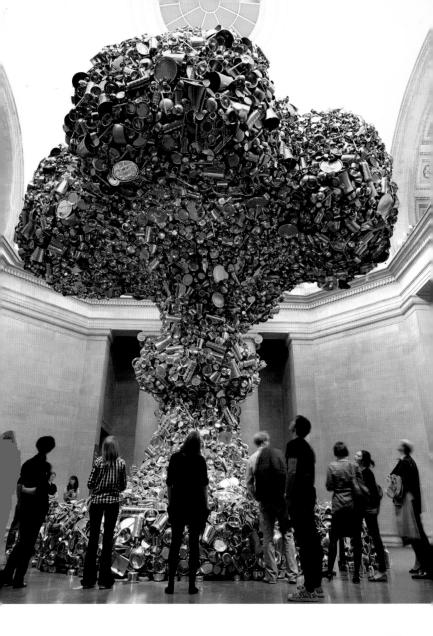

ANDREAS GURSKY

BORN Leipzig, Germany, 1955

Andreas Gursky studied at the Folkwangschule, Essen, and at the Kunstakademie, Düsseldorf. His work has been exhibited at institutions worldwide. including Museum of Modern Art, New York (2001); Haus der Kunst, Munich (2007); Kunstmuseum Basel (2007); Kunstmuseen Krefeld, Haus Lanae und Haus Esters (2008): Moderna Museet. Stockholm; and Vancouver Art Gallery (both 2009). He participated in the Venice Biennale (1990) and the Biennale of Sydney (1996 and 2000). Gursky has won several awards, amongst them the Citibank Private Bank Photography Prize (1998) and the Kaiserring der Stadt Goslar (2008). He now lives and works in Düsseldorf

SEE ALSO Becher, Ruff, Struth

Andreas Gursky is one of the best known photographers of his generation. His panoramic pictures are frequently enormous, enlarged to 3m (10 ft) tall or more. His images are rich and brightly coloured, and often enhanced by digital techniques. Gursky began his career by taking images of local tourism and leisure activities, but soon moved on to capture

fast-moving, high-tech environments including factories and the trading floors of international stock exchanges. In his photograph *Chicago Board of Trade II* (1999) the frantic energy on the floor is intensified by Gursky's digital tweaking of colours to an almost hallucinatory effect. Educated in Düsseldorf, Germany, Gursky was heavily influenced by his teachers Bernd and Hilla Becher, the well known husband-and-wife team of photographers in the Conceptual and Minimalist art movements. He has since travelled the world taking photographs, visiting Hong

Kong, Cairo, New York, Brasília, Tokyo, Stockholm, Chicago, Athens, Singapore, Paris and Los Angeles.

Gursky's images often take a bird'seye view of large gatherings of people. Individuals are lost amongst the crowd, and in this way his photographs suggest the anonymity of people living in urban societies. In one chromogenic colour print, *Mayday IV* (2000), Gursky depicts a crowd of people dancing and revelling. Although no one particular individual can be discerned amongst the crowd, the photograph has a strong emotive effect, conveying the intensity of a large gathering. Frequently, Gursky's images transform man-made environments and interiors into captivating abstract compositions. In this way, his photographs inspire new ways of looking at the built environment.

Chicago Board of Trade II 1999 | C-print 205 x 335 x 6 cm (80¾ x 131¾ x 2½ in)

HANS HAACKE

BORN Cologne, Germany, 1936

Hans Haacke studied at the State Academy for Fine Arts, Kassel (1956– 60), and at Tyler School of Art at the Temple University, Philadelphia (1961– 62). He then taught at Cooper Union, New York City (1967–2002). He has had a number of solo shows including at the Tate Gallery, London (1984); the Pompidou Centre, Paris (1989); and the Academy of Art, Berlin (2006). He jointly won the Golden Lion at the Venice Biennale (1993) with Nam June Paik.

SEE ALSO Asher, Broodthaers, Buren, Fraser, LeWitt, Conceptual Art, Institutional Critique, Minimalism

Hans Haacke was a pioneer of Conceptual Art in the 1960s and 1970s. However, his work was never entirely bound by Conceptualism because it always traced connections between concepts and form. *Condensation Cube* (1963–65) resembles the Minimalist cubes of artists such as Robert Morris. It is a sealed Plexiglass box containing a small amount of water. When the room is warm, the water turns to gas; as it cools, the water condenses on the Plexiglass and returns to liquid. It is a sealed physical system, but it is also visually altered by its surroundings. There is a tension between its individuality and its dependence on the world around it. This is symbolic of art in general – works exist in their own right, but are conditioned in both their production and reception by things beyond themselves.

Haacke has since moved from physical to political systems. MOMA Poll (1970) asked the following question: "Would the fact that Governor Rockefeller has not denounced President Nixon's Indochina Policy be a reason for you not voting for him in November?" Viewers were asked to cast votes in one transparent box for yes, or another for no. Again, this meant that the work's form was externally defined. Rockefeller was a trustee of the museum in which the work was shown, and therefore Haacke's work highlighted its relationship with its viewers, the museum and a broader political sphere. Yet it always retained its own internal artistic logic, as set by the parameters within which Haacke created it.

Condensation Cube

1963–65 | Clear Plexiglass and distilled water 30.5 x 30.5 x 30.5 cm (12 x 12 x 12 in)

RICHARD HAMILTON

BORN London, England, 1922 DIED UK, 2011

Having worked as a designer, Richard Hamilton enrolled at the Royal Academy of Art (1946), but was expelled for "not profiting from the instruction". He then studied at the Slade College of Art (1948-51). His first exhibition, consisting of engravings, was held at Gimpel Fils, London (1950). In 1952 he co-founded the Independent Group, a pioneering group of Pop Artists, with Eduardo Paolozzi as well as other painters, architects and writers. He has had a number of major retrospectives, including two at the Tate Gallery, London (1970 and 1992) and the Serpentine Gallery, London (2010).

SEE ALSO Lichtenstein, Warhol, Pop Art

Richard Hamilton's *Swingeing London* series (1967–72) consists of a number of paintings and prints of Mick Jagger and Hamilton's agent, Robert Fraser, just after being arrested for the possession of heroin. Hamilton derived the image from a photograph taken at the time of the event and circulated in the media. His work, therefore, is actually an image of an image and not of an event. Hamilton's technique in these paintings and prints seems to emphasize their distance from reality. Although they are formally identical, each uses a different range of tones. The tonal differences mean that some of the images look more realistic than others. The non-reality suggested by some must also indicate the non-reality of them all, as they are all produced in the same way. Hamilton thereby emphasizes that all of these images are mediated – by a photographer, a painter and perhaps also a journalist.

Hamilton was amongst the pioneers of Pop Art in the 1960s. As such, given his critical stance in the 1970s, it might seem ironic that his work was vital for the entry of popular imagery into high art. However, there is also a sense in which this introduction of the popular into the sphere of art allowed for criticism such as that levelled at *Swingeing London*. Although Hamilton paved the way for the glamourization of the popular through art, he also allowed art to become a tool for questioning its role in our lives.

[Above] Stage Proof 18 1972 | Screenprint on paper Image: 68 x 86 cm (26½ x 34 in)

[Below] Stage Proof 17 1972 | Screenprint on paper Image: 68 x 86 cm (26½ x 34 in)

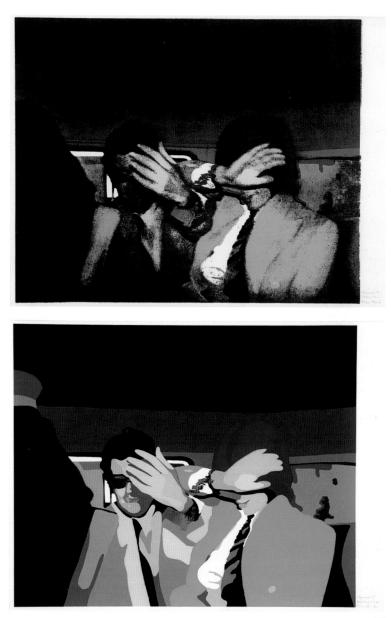

KEITH HARING

BORN Reading, Pennsylvania, USA, 1958 DIED New York city, NY, USA, 1990

Keith Haring enrolled in a commercial art course at the Ivy School of Professional Art, Pittsburgh (1976), but quickly dropped out. Having continued to teach himself, Haring had his first solo show at the Pittsburgh Arts and Crafts Center (1978). In the same year he enrolled in New York's School of Visual Arts and got involved in the city's graffiti scene. In 1986 he opened Pop Shop, a retail store selling items bearing his images.

SEE ALSO Basquiat, Warhol, Pop Art

Keith Haring's work mixed Pop Art with graffiti and Expressionism. His best known paintings include figures that appear to radiate energy and imply a primal world of constant rhythm and dance. *Tree of Life* (1985) relates this technique to naturalism through its merging of human figures and tree branches, implying that primal energy stems from our natural roots. In works containing his radiant baby motif, a baby is seen projecting thick black lines; this representation of its natural energy is ambiguously mixed with contemporary fears over nuclear war, radiation and their impact on humans and nature alike.

In 1980 Haring began his artistic career by producing chalk drawings on the New York subway, and he continued to make throughout his life. They were executed in the spaces left by removed advertisements, which would soon be covered by new ones. The point was to make his work accessible beyond the confines of the art world. In opposition to the increasing commercial control of public space and art, Haring favoured a doityourself approach, and this is clearly represented by his appropriation of space intended for advertising.

Haring wanted to distribute his work within the city, and we can see that its energy stems perhaps more from a proximity to life than a fear of its obliteration. However, fear and joy mix evenly in Haring to produce work that is in constant motion, both in the context of the city and across the canvas. If it internalizes the tension of its times, then it also converts the tension into a positive energy, a dance in the face of death.

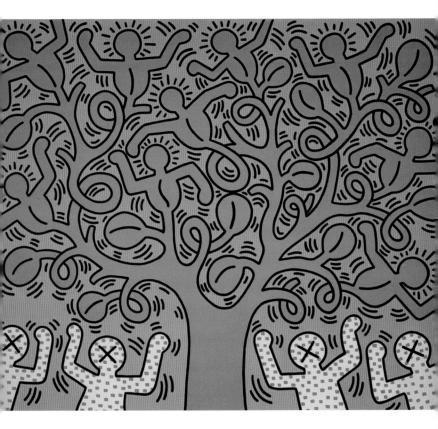

Tree of Life 1985 | Acrylic on canvas 305 x 366 cm (120 x 144 in)

MONA HATOUM

BORN Beirut, Lebanon, 1952

Mong Hatoum studied at Beirut University College, and then in London at the Byam Shaw School of Art and the Slade School of Art. She was shortlisted for the Turner Prize (1995). Solo exhibitions include the Pompidou Centre, Paris (1994); Museum of Contemporary Art Chicago (1997); New Museum of Contemporary Art, New York City (1998); Castello di Rivoli, Turin (1999); Tate Britain, London (2000); Magasin 3, Stockholm (2004); Kunstmuseum Bonn (2004); Hamburger Kunsthalle (2004); and the Museum of Contemporary Art, Sydney (2005). She participated in the Venice Biennale (1995 and 2005) and the Biennale of Sydney (2006). She lives and works in London.

SEE ALSO Abramovic, Salcedo, Post-Colonialism

Mona Hatoum's work addresses violence and oppression in the world. Born to a Palestinian family, she was forced into exile in the United Kingdom in 1975 after the outbreak of civil war in Beirut, Lebanon. The experience of political turmoil and conflict pervades Hatoum's work. She began making Performance Art in the 1980s, focusing her work on the

body and its threshold for pain, and exploring the power dynamics between perpetrators and victims of violence. Hatoum continues to examine the individual in relation to the potential destructiveness of the institution.

In the 1990s she began to explore more widely a variety of media, including installation, sculpture, video and photography. Hatoum often chooses to work with everyday, domestic items, transforming them into threatening objects

with the capacity to inflict pain. Doormat (1996), for example, is a welcome mat made from upturned stainless-steel pins. The sculpture has a Surrealist quality in that it merges one identity with another. Hatoum's works are witty conglomerations, yet somehow the humour disappears in the confluence of intrigue and fear.

Hatoum uses a variety of materials, ranging from found objects to stainless steel, rubber and sand. *Light Sentence* (1992) is an installation using wire-mesh lockers arranged to create a U-shape. The structure is lit by one light bulb within the enclosure. The single bulb causes the mesh to cast stark shadows around the entire room, causing it to resemble a cage. The intricate lacework of the mesh is at once beautiful and startling.

Light Sentence

1992 | Edition of two wire mesh lockers with slowmoving motorized light bulb 198 x 185 x 490 cm (78 x 72 3 x 193 in)

EVA HESSE

BORN Hamburg, Germany, 1936 DIED New York City, NY, USA, 1970

Eva Hesse's family moved to the United States three years after her birth. She studied art at Cooper Union in New York (1954–57) and under Josef Albers at Yale University School of Art, Connecticut (1957-9). Her first solo show was held at the Allan Stone Gallery, New York (1963). The first major retrospective of her work was held at New York's Solomon R. Guggenheim Museum (1972). The Tate Modern in London also held another large retrospective of her art in 2002.

SEE ALSO Chadwick, Minimalism

Eva Hesse is known primarily as a sculptor whose work questions strict oppositions between media, forms and genders. *Repetition Nineteen III* (1968) is a collection of sculptures made of resin, all resembling bottomless buckets. The work links with Minimalism in its use of repeated forms, but while the Minimalist sculptors repeated identical parts, the elements of *Repetition Nineteen III* are all slightly different. Furthermore, unlike the mathematical and regular grids that were employed by the Minimalists, there is no set arrangement for the sculptures. Hesse uses organic materials and her sculptures resemble natural objects; their form, perhaps symbolizing female genitalia, links them to the human body. Unlike Minimalist sculptures. Hesse's works are imbued with irregularity, sexuality and humanity. While Repetition Nineteen III is clearly sculptural, not all of Hesse's works are so straightforward in their approach to media. Hesse made a number of rope sculptures whose composition is entirely linear. Often presented flat against a wall, they seem to blur the line between her sculpture and drawing. In other works she uses objects to collapse our assumptions about gender. Accretion (1965-70) consists of a number of rods leaning against a wall. These phallic forms require physical support, and Hesse seems to be mocking the supposed strength and self-sufficiency of masculinity.

If Hesse's work defies easy categorization, it is because she reveals the inadequacy of categories intended to encompass humans and objects alike. Refusing the simple, material encounters that we have with Minimalist objects, she implies the existence of her objects within a broader and more intimately human field.

Repetition Nineteen III 1968 | Fibreglass, polyester resin Installation variable, 19 units

SUSAN HILLER

BORN Tallahassee, Florida, USA, 1940

Susan Hiller originally worked as an anthropologist, receiving her bachelor's degree from Smith College in Massachusetts (1961) and completing a doctorate (1965). She moved to London in 1969 and began a second career as an artist in the 1970s. She has had retrospective shows at the Institute of Contemporary Arts, London (1986) and the Tate Gallery, Liverpool (1996). Hiller curated a travelling show entitled *Dream Machines* (2000–01). She had |a solo show and a major survey at Tate Britain, London (2011).

SEE ALSO Viola, Installation Art

Since the 1970s Susan Hiller has very consciously acted as a square peg in the round hole of both the art world and society in general. Her installation *Witness* (2000) is located in a dark room, actually a disused chapel, with many loudspeakers hanging from its ceiling. From the speakers, which are lit to resemble stars floating in the air, witness accounts of UFO sightings can be heard. Viewers can hold speakers to their ears and pick out individual accounts, but otherwise the monologues mesh together to form a single insistent drone.

Hiller concentrates on experiences that transcend our understanding. Clinic (2004) is an installation that includes recordings of accounts of near-death experiences. For Sisters of Menon (1972), a number of artists working long distances apart created images and then compared them for similarities, much as in certain paranormal practices. Rather than merely affirming these extraordinary experiences, though, Hiller focuses on their collision with rational society. In Witness most of the accounts centre on an experience of light. The work's setting in the ex-chapel suggests a link with traditional religious and mystic experiences, as if UFO sightings are part of an updated religion, with angels and demons swapped for aliens. Although Witness neither asserts nor rejects the truth of UFOs, it suggests that the efforts of science to comprehend the world around us are really no different from those of religion or myth; a theoretical framework is created that is rarely adequate to the matter of our experience. Therefore, in works like Witness Hiller transforms these frameworks back into a sensual experience, thus refuting the cold, logical approach of Conceptual Art and affirming an open-ended relation to the world.

Witness

2000 | Mixed media installation at The Chapel, 92 Golborne Road, London Commissioned and produced by Artangel

THOMAS HIRSCHHORN

BORN Bern, Switzerland, 1957

Thomas Hirschhorn has exhibited widely: solo exhibitions include Museu d'Art Contemporani de Barcelona (2001); Pompidou Centre, Paris (2001); Schirn Kunsthalle, Frankfurt am Main (2003); Foksal Gallery Foundation, Warsaw (2004); Institute of Contemporary Art, Boston (2005); Kestner Gesellschaft, Hannover (2006); and Stephen Friedman Gallery, London (2007). He has received numerous awards for his work including the Marcel Duchamp Prize (2000–01) and the Joseph Beuys Prize (2004). He now lives and works in Paris.

SEE ALSO Installation Art

Thomas Hirschhorn makes large sculptures and installations out of everyday materials including duct tape, cardboard, paper, foil and plastic wrap. Constructed with temporary, flimsy and low-budget resources, his works often appear to have been made in a mad flourish of energy and enthusiasm. Importantly, this "thrown-together" aesthetic makes visible the process of construction behind each piece. Hirschhorn's installations usually contain a deluge of information, and draw upon the visual language and

imagery of protesters and picketers. Hirschhorn's art also makes explicit reference to a number of philosophers and thinkers, and the relationship between philosophy and art is an important and long-standing investigation in his work. Borrowed philosophical texts often appear in his installations and sculptures, and many of his most important works take their title from particular philosophers. There is an astute political awareness in Hirschhorn's work, which has addressed issues such as

the war in Iraq and the pursuit of democracy in the West.

Like many of Hirschhorn's works, Substitution 2 (2007) is made from disposable, mass produced materials. Hirschhorn borrowed text from sensationalist headlines found in newspapers and on the Internet, and incorporated them into a self-constructed island of mannequins and flat, life-sized standees of soldiers. The latter are called "Flat Daddies" and are a kind of reminder for children whose fathers have been sent to fight in Iraq. As such, Substitution 2 explores the different levels of representation present in contemporary society and media. The work also features graphic images of war, voicing the senselessness and horror of conflict.

Substitution 2 (The Unforgettable) 2007 | Mixed media Installation view at Stephen Friedman Gallery 2007 Overall: 3.25 x 5.6 x 9.4 m (10 fr 6 in x 18 fr 3 in x 30 fr 9 in)

DAMIAN HIRST

BORN Bristol, England, 1965

Damien Hirst graduated from Goldsmiths College, London in 1989. He has had solo exhibitions at institutions around the world, including Southampton City Art Gallery (1998); Archaeological Museum, Naples (2004); Astrup Fearnley Museet for Moderne Kunst, Oslo (2005); Museum of Fine Arts, Boston (2005); and Rijksmuseum, Amsterdam (2008). He was awarded a DAAD residency in Berlin (1993–4) and won the Turner Prize (1995). Hirst's work is included in numerous public and private collections. He lives and works in London and Devon.

SEE ALSO Bacon, Koons, Quinn, Appropriation Art, Young British Artists

Damien Hirst is undoubtedly one of the most important artists of recent times. Throughout the 1990s, as a leading member of the Young British Artists (YBA) group, Hirst changed the perception and direction of art in Britain. While still a student at Goldsmiths University, Hirst organized *Freeze* (1988), an exhibition in a run-down area of London's Docklands that kick-started a new era of art making. Since then Hirst has become a superstar of

the international art world, continuing to evolve while pushing the boundaries of contemporary art. He first became notorious for his shocking use of materials, which included dead animals suspended in formaldehyde. Known as his "natural history series", and demonstrated in such works as In His Infinite Wisdom (2003), sharks, sheep and cows all came to be preserved in Hirst's formaldehyde tanks. Like much of Hirst's work, the series examines death and its proximity to life. Hirst's unusual choice of materials offers a powerful means of communicating the fragility of existence. His work questions a number of social paradigms, including reason and faith, and ultimately seeks to understand what it is that separates life from death. In his "pharmaceutical works" - a series of cabinets, walls and installations displaying pharmaceutical products - Hirst seems to point out the inefficiency or uselessness of medicine in curing long-term ailments of the body and mind. In one of his most poetic series, Hirst adheres real butterfly bodies to the canvas with paint, again pointing out the beauty, and vulnerability, of life. Other well-known series of paintings include his meticulously rendered spot paintings, and his chance-determined spin paintings, created using centrifugal force.

Beautiful Osiris Euphoria Painting 2007 | Household gloss paint on canvas 244 x 213.5 cm (96 x 84 in)

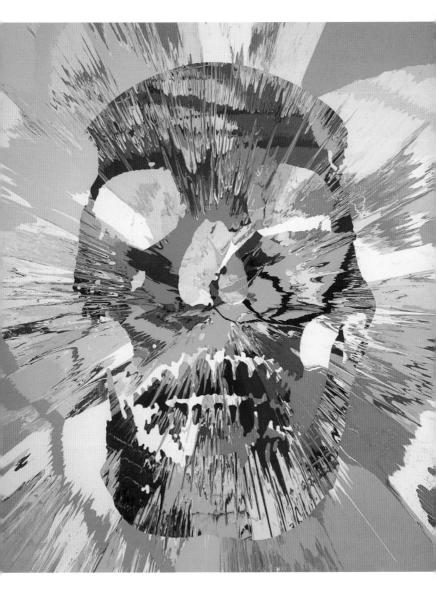

DAVID HOCKNEY

BORN Bradford, UK, 1937

Hockney studied art at Bradford College (1953–57) and at the Royal College of Art, London (1959–62). He had his first solo show at the Kasmin Gallery, London (1963), and moved to the United States in the same year. He had a show at New York's Museum of Modern Art (1968). A retrospective of his work was shown at the Los Angeles County Museum of Art, the Metropolitan Museum of Art, New York and the Tate Gallery, London (1988).

SEE ALSO Doig, Freud, Hodgkin, Abstract and Representative Art

David Hockney is often thought of as a Pop Artist, but this is a mistake. He is an English painter and photographer whose work focuses mostly on the United States, but his style is less that of popular culture than that of the great modern painters. A Bigger Splash (1967) puts a modern European aesthetic through the lens of 1960s America. As in many abstracted European works, it is mostly composed of geometric forms and flat planes and its colours are simplified into broad matt areas. However, Hockney's tones have a great richness that is not often found in that style. Hockney has referred to the light of Los Angeles as one of the main factors that drew him there, and here we can certainly see a magnificent light suffusing with life what might otherwise be an indifferent image.

Very different, but actually still in a Modernist mode, is Nichols Canyon (1980). It is composed from sinuous curves and lurid colours, much in Matisse's early style. Nichols Canyon seems to present a different view of America from the cool, composed one in his paintings of the 1960s. This is a reflection of the diversity within America, but perhaps more interestingly of the diversity within the Modernist style, which is often taken to be rigid.

While his contemporaries were increasingly looking to new media and conceptual approaches to push the boundaries of art, Hockney was intent on suggesting the continued potential of tradition. He has both maintained and extended the tradition of Modernism, implying both its flexibility and its continued relevance.

A Bigger Splash

1967 | Acrylic on Canvas, 242.5 x 244 x 3 cm (95½ x 96 x 1 in)

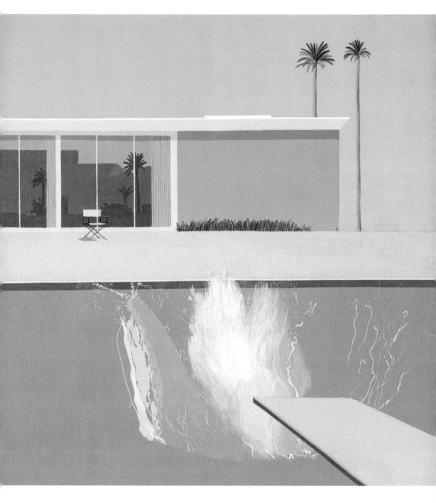

HOWARD HODGKIN

BORN London, England, 1932

Hodgkin studied at the Camberwell School of Art, London (1949–50) and the Bath Academy of Art (1950–54). His first solo show was held at Arthur Toot and Sons, London (1962). He won the Turner Prize (1985). He was knighted in 1992. He had a retrospective show at the Metropolitan Museum of Art, New York (1995). A major touring retrospective of his work went to London's Tate Britain, the Irish Museum of Modern Art, Dublin, and other museums (2006).

SEE ALSO Hockney, Stella, Abstract and Representational Art

Howard Hodgkin is a highly renowned English painter. His works are distillations of personal experiences, including representative elements as well as Abstract Expression. The viewer's immediate reaction is often an attempt to decode the relationship between these two elements. In *Red Bermudas* (1978–80), a waterfall, the trunk of a tree and round pieces of fruit

can be made out. However, Hodgkin's thick daubs of paint reveal themselves and their origins more quickly than they suggest anything else. Furthermore, he goes to lengths to emphasize these marks as marks. The work's frame is painted over, and the painting is thus extended beyond its normal confines and declared as the equivalent of all other objects, such as its frame and the wall on which it hangs. Although more famous as a painter, Hodgkin is also a highly accomplished printmaker. Painting's physicality appeals to him, but printmaking lends more possibilities to his layered technique. Again, through close attention to the properties of the medium, Hodakin emphasizes its physical nature. In Bleeding (1982), thick lines around the work seem to echo and thus emphasize the work's edge, refusing to allow its object status to disappear. These lines also represent a window through which a scene is viewed. Hodakin therefore integrates his approaches to abstraction and representation, presenting the two as inherently linked.

Red Bermudas 1978–80 | Oil on wood 70.5 x 70.5 cm (27¾ x 27¾ in)

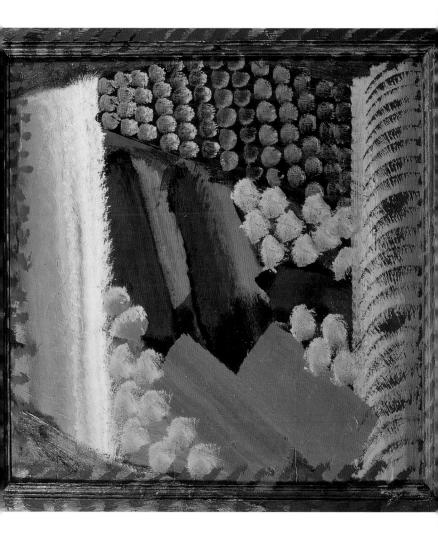

CARSTEN HÖLLER

BORN Brussels, Belgium, 1961

Carsten Höller studied agronomy and received his doctorate in biology (1993), before starting to make art. He has exhibited widely in Europe, Asia and America. He has had major solo exhibitions at the Prada Foundation. Milan (2000): Institute of Contemporary Art, Boston (2003): Musée d'Art Contemporain, Marseille (2004); and Kunsthaus Bregenz (2008). He was invited, with Miriam Bäckström, to exhibit in the Swedish Pavilion at the Venice Biennale (2005). He exhibited at Documenta X in Kassel, in collaboration with Rosemarie Trockel (1997). He now lives and works in Stockholm, Sweden.

SEE ALSO Huyghe, Parreno, Tiravanija, Relational Aesthetics

Carsten Höller creates art that tests human perception and physiological reactions. With a doctorate in biology, he manipulates, alters and stimulates sensory perception. In one work, *Upside-Down Mushroom Room* (2000), Höller filled a corridor with large inverted revolving mushrooms. The upside-down mushrooms reflected the way that images of the world actually appear on the retina, before the brain processes the information. Most of Höller's works require the participation of the viewer. For instance, *Upside-Down Goggles* (1994–2001) consists of a pair of spectacles that create an inverted view of the world. Many of Höller's works create sensations that are experienced individually within the body – frequently a collective experience of his work is impossible. In altering our perception, Höller facilitates understanding and awareness of normal sensory perception.

Höller is interested in slides as physical sculptures and as a viable means of transport, and he has worked with them for a number of years. He has also investigated the emotional effects of going down slides, focusing on how they change our perception of the world before, during and after the thrilling experience. In a project called *Test Site* (2006), he created five slides for Tate Modern's Turbine Hall in London. The project was a large-scale experiment to explore how slides could be used in public spaces and urban environs.

Upside-Down Mushroom Room

2000 | Mixed media including polystrol and electric motors

Room: $12.3 \times 7.3 \times 4.8$ m (40 x 24 x 15% ft) Length of mushrooms: 0.6–3 m (2–10 ft) Hat diameter: 0.6–2.9 m (2–9½ ft)

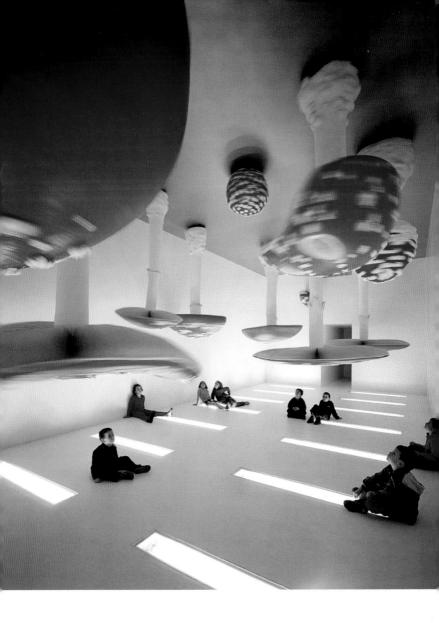

JENNY Holzer

BORN Gallipolis, Ohio in 1950.

Jenny Holzer received a Bachelor of Fine Arts degree from Ohio University (1972) and a Master of Fine Arts degree from Rhode Island School of Design (1977). In the same year she enrolled in the Independent Study Program of the Whitney Museum, New York. Her publications have included *Truisms and Essays* (1983). She received the Golden Lion for the best pavilion at the Venice Biennale (1990) and had a show at New York's Solomon R. Guggenheim Museum in the same year.

SEE ALSO Kruger, Appropriation Art, Conceptual Art

Since the late 1970s Jenny Holzer has been working primarily with text, but often not in her own voice. *Truisms* (1977–) consists of a number of one-liners that can seem loaded with meaning, but are later revealed to be meaningless. The statements are always presented in huge numbers, completely overwhelming the potency of any single one. There are also contradictions between them: for example, "Children are the most cruel of all" and "Children are the hope of the future". These contradictions demonstrate that we cannot

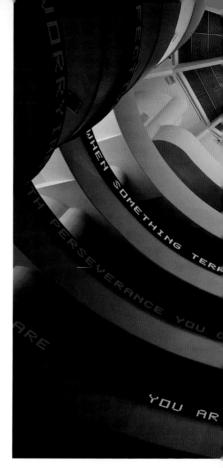

take the truisms at their word. By emptying them of content, Holzer encourages us to be more critical in our approach toward language and demonstrates how easily we can be manipulated.

Although consistently working with text, Holzer has varied the mode of its presentation in order to gain access to different audiences and intervene in different spaces. She has often used neon signs and billboards to mimic advertising. In some

instances her work is shown in a gallery, but she has also placed signs in public spaces in order to disguise them as genuine advertisements, thereby assimilating her acts of manipulation into the context of the commercial manipulation of the public. More recently, in the ongoing series *Projections* (begun in 1996), she has projected her text pieces onto various public buildings. These sites are implicated within Holzer's suggested system of manipulation, and are also reclaimed as tools for political action. This demonstrates the potential of Holzer's work to prescribe as well as diagnose.

Untitled (Selections from Truisms, Inflammatory Essays, The Living Series, The Survival Series, Under a Rock, Laments, and Child Text)

1989 | Extended helical tricolour L.E.D. electronicdisplay signboard, site-specific dimensions

REBECCA HORN

BORN Michelstadt, Germany in 1944.

Rebecca Horn studied at the University of Fine Arts, Hamburg. Solo exhibitions of her work have been shown at the Staatliche Kunsthalle, Baden-Baden (1981); Museum of Contemporary Art, Los Angeles (1990); Solomon R. Guggenheim Museum, New York (1993); New National Gallery, Berlin (1994); Serpentine Gallery, London (1994); Tate Gallery London (1994); Musée d'art contemporain, Nimes (2000); and the Hayward Gallery, London (2005); and Martin-Gropius Bau, Berlin (2006). Horn lives in Berlin and Paris.

SEE ALSO Beuys, Installation Art, Performance Art

Rebecca Horn's artworks have included drawings, small sculptures, large installations, kinetic machines, performances and films. Her work investigates the intersections of nature, culture and technology. In many instances, her constructions are extensions of particular parts of the body, but rather than acting as surrogate limbs, her prosthetic enhancements enable hypersensual experiences. In the 1972 work, *Weißer Körperfächer* (White Body Fan) Horn straps herself into a huge, white set of wings that hide and reveal her body as she moves her

arms. Einhorn (Unicorn 1970) is a sculpture that was worn by a friend as she moved through a field of wheat in the early morning. Horn's work often privileges the sense of touch over the sense of sight. As part of an early series of works called Berlin Exercises (1974–75), Horn made a pair of elongated gloves that enabled the wearer to touch the walls of the surrounding room, thus allowing orientation in the space through the sense of touch alone. Horn's appendages are often clumsy and at times robotic. There is a tension between sensuality and technology, as her works explore the synthesis of human and machine. Later works explore kissing, touching, caressing and other erotic gestures between machines.

Performance has always been an important element in Horn's work, and human interaction is almost always a vital component. At first Horn used film only to document her performances, but she soon began to see the medium as an artistic end in itself. Again, most of her films explore issues around the body and its physical and sensual properties. Horn's fascination with the body developed in part after she suffered lung poisoning as a student working with glass fibre. She was forced to spend a considerable period of time in a sanatorium, and this experience may have contributed to her exploration of loneliness and isolation in later works.

Einhorn 1970 | Fabric, metal construction Dimensions variable

roni horn

BORN New York City, NY, USA, 1955

She received a Bachelor of Fine Arts from the Rhode Island School of Design and was awarded a master's degree in fine arts from Yale University (1978). She had her first solo exhibition outside Yale at the Kunstraum, Munich, Germany (1980). She is a frequent visitor to Iceland, which has been huaely influential on her work, and in 1990 she began a series of books named To Place, which consider her relationship with that country. In 2009 a major retrospective of her work was exhibited at the Whitney Museum of American Art, New York; the Museum of Contemporary Art, Chicago; and Fondation Beyeler, Basel-Riehen Switzerland Horn still lives in New York City.

SEE ALSO Installation Art

Roni Horn's art can be seen as a meeting point for spaces, images, texts and individuals. VATNASAFN/LIBRARY OF WATER (2007) is a former library in lceland that Horn has transformed into a space combining installations, archives and a community centre. Inside is an installation entitled Water, Selected, which consists of large tubes filled with water collected from

underground glaciers. Horn calls this work an archive, implying that such a thing will soon be necessary given the increasing scarcity of clean water. Since the water archive is placed within the community centre, the water itself is integrated into the activities of that space and so nature asserts itself alongside the human inhabitants. The building also contains an ongoing archive of accounts about the weather, called *Weather Reports You*.

The title implies that we are

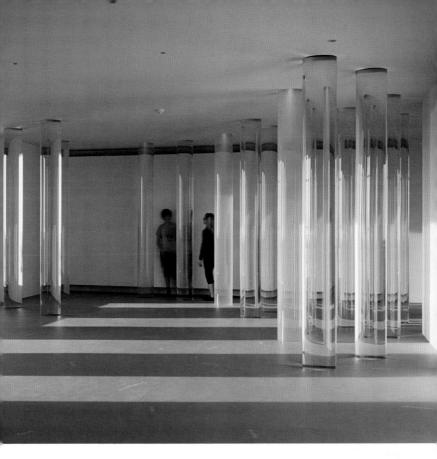

conditioned by the weather, and therefore also by nature, denying any possibility of our being separate from either. Water has been a consistent theme throughout Horn's work. *Still Water (The River Thames, for Example*) (1999) is a series of photographs of the River Thames, each footnoted with thoughts and quotations. The series explores the links between the verbal and the visual, attempting to find words for the reactions solicited by pictures and places. Much like Horn's combination of the verbal and the visual in her earlier work, *Library of Water* attempts to suggest the inherent connection of two apparently distinct entities. It suggests that any barrier that exists between humans and nature is fully permeable – we cannot consider the environment's survival without contemplating our own.

VATNASAFN/UBRARY OF WATER 2007 | Commissioned and produced by Artangel

HUANG YONG PING

BORN Xiamen, Fujian Province, China, 1954

Huang graduated from the Fine Arts Academy Zhejiang in 1982. In 1989 he moved to Paris, where he continues to live and work. His travelling retrospective, *House of Oracles*, was shown at the Walker Art Center, Minneapolis, and the Massachusetts Museum of Contemporary Art (2005–06); the Vancouver Art Gallery (2007); and the Ullens Center for Contemporary Art, Beijing (2008). Huang participated in Manifesta 1 (1996) and in Skulptur Projekte Münster (1997).

SEE ALSO Doig, Freud, Hodgkin, Abstract and Representative Art

Huang Yong Ping is one of China's preeminent contemporary artists. Though Huang left China in 1989 and settled in Paris, his work continues to draw upon Chinese language and tradition, alongside Western culture. A well-known piece, 100 Arms of Guan-yin (1997), for example, draws inspiration from the image of the Bodhisattva of compassion in Buddhism, whereas Colosseum (2007) is inspired by the iconic Roman form. Often in Huang's work, there is a blending of Eastern and Western ideas. In The History of Chinese Painting and the History of Modern Western Art Washed in a Washina Machine for Two Minutes (1987/1993), Huang creates a pile of pulp out of two important history of art texts. The work does not pit one cultural belief system against another, but instead instigates their collision, and eventual destruction. In many ways, Huana's work is anti-establishment, often concerned with the questioning and breaking down of knowledge hierarchies, particularly Ancient and Modern as well as Eastern and Western. Throughout his work, there is continually the suggestion of paired but opposing entities, similar to the Chinese notion of Yin and Yang.

Huana first rose to prominence in China in the 1980s, as a founding member of the Xiamen Dada group, a collective which staged radical happenings heavily influenced by Dadaist principles. Now, most of his works are installations or sculptures, which are often executed in very large proportions. In 2002, Huang's Bat Project 2 was banned from the Guangzhou Triennial. One of a series of works on the same subject matter, the piece consists of a reconstruction of a segment of an American spy plane that collided with a Chinese jet fighter in 2001, killing the Chinese pilot. The plane is filled with taxidermy bats.

Colosseum 2007 | Ceramic, soil, and plants 226 x 556 x 758 cm (89 x 217 x 298½ in)

PIERRE HUYGHE

BORN Paris, France, 1962

Huyghe studied at the École Nationale Supérieure des Arts Décoratifs, Paris (1982–85). Huyghe has received multiple awards, including *Beaux-Arts Magazine's* prize for best French artist (2005) and the Jury of the Venice Biennale's Special Award (2001). He has had major solo exhibitions at the Dia Center for the Arts, New York (2003); Castello di Rivoli, Turin (2004); Moderna Museet, Stockholm (2005); and Tate Modern, London (2006).

SEE ALSO Höller, Parreno, Tiravanija, Relational Aesthetics

Pierre Huyghe works within a variety of formats and media, and rarely in traditional modes of artistic expression. Often his works are ephemeral in nature, and can sometimes be understood as events. There is a playful, fanciful and at times childlike quality to Huyghe's experiments, which comes from a desire for art to shake up our everyday lives, rituals and social constrictions. In this way, while Huyghe's works pay great attention to aesthetics, they are not devoid of political import. Huyghe is part of a shift in contemporary art that occurred in the 1990s, sometimes called Relational Aesthetics, when artists

moved away from emphatic explanatory gestures and instead began to make open-ended works that offered subtle commentaries on mundane events. Huyghe's experiments have included collaborations with other artists, temporary interventions in public space and even the proposal of a new public holiday.

For Huyghe, the narrative, or the story around the work, is often an integral part of the piece. Huyghe collaborated with Phillipe Parreno on a well-known work

entitled No Ghost Just a Shell (2000–03). In this work, Parreno and Huyghe bought the rights to Annlee, a Manga character. The project took on many different permutations as the character moved from one narrative to another. Huyghe is also interested in the relationship between truth and fiction and the notion of constructed realities, and his works often play on the boundaries of fantasy and reality. A Journey that wasn't (2005), for example, is a film about a search for a mythical white penguin. The film is shot partly in Antarctica and partly in Central Park, New York City. In Central Park, the film set is barely disguised, exposing the artifice of the journey but at the same time inviting the suspension of disbelief.

A Journey that wasn't 2005 | Super 16mm film and HD video transferred to HD video, colour, sound 21 min 41 sec

JASPER JOHNS

BORN Augusta, Georgia, 1930

Jasper Johns briefly studied at the University of South Carolina before moving to New York City in 1949. In the early 1950s he befriended a number of prominent artists and musicians including Robert Rauschenberg and John Cage. He had his first solo show at the Leo Castelli Gallery, New York (1958). He had a retrospective at the Pasadena Art Museum, California (1965). A show of his work, entitled Past Things and Present: Jasper Johns since 1983 (2003–05), toured a number of galleries including the Walker Art Center, Minneapolis.

SEE ALSO Rauschenberg, Reinhardt

Jasper Johns is a painter and printmaker whose work provided an alternative to the dead end of Modernism in the 1950s. Many of his early works, such as *Target with Four Faces* (1955), feature common images such as targets and flags, so Johns is often credited with reintroducing representation into painting. However, his simple images always resemble abstract patterns. Johns's technique can be described as presentation as representation, since nothing seems to distinguish the target in *Target with Four Faces* from a real target. The work is less a simple progression from abstraction to representation than the collapse of these two terms into a third term: "object".

Johns's work tends to be highly impersonal. In *Target with Four Faces*, the faces – the only sign of humanity – have their eyes covered to prevent any personal interaction. *The Seasons* (*Spring*) (1987) is similarly impersonal; its figures are presented as silhouettes. This, too, is ambiguous. The silhouettes are accompanied by optical illusions, images that never resolve themselves into any one form but rather demand to be viewed in their duality. Another example of ambiguity in Johns's work is *False Start* (1959). Johns labelled the colours in this abstract painting, but often labelled them incorrectly.

Although Johns is often credited with art's simplification, he actually complicated art by refusing unitary meanings, or even definition by single words such as "red", "yellow", "abstract" or "representational". If his work seems deeply impersonal, then this highlights another contradiction: that he reconnects with people through simple images and a complete withdrawal from humanism. It is fitting that, in escaping definition, Johns redefined art and presented alternatives beyond the single path of abstract painting.

Target with Four Faces 1955 | Mixed media Canvas: 66 x 66 cm (26 x 26 in) Box closed: 9.5 x 66 x 9 cm (3³4 x 26 x 3¹/₂ in)

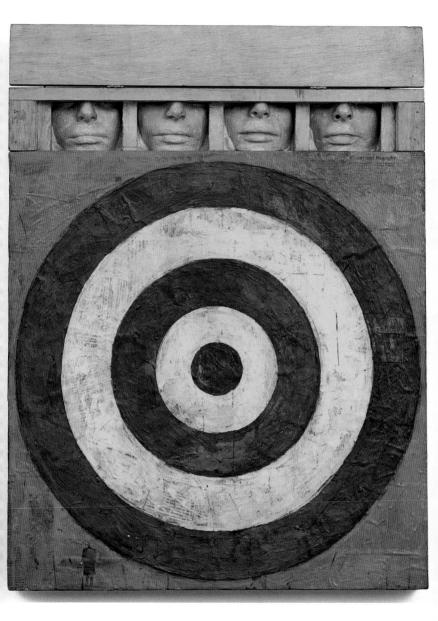

DONALD JUDD

BORN Excelsior Springs, Missouri in 1928. DIED New York City, NY, USA, 1994

Judd studied philosophy and then art history at Columbia University, New York. He had major exhibitions of his work at the Whitney Museum of American Art, New York (1968 and 1988); Stedelijk van Abbemuseum, Eindhoven, Netherlands (1987); and the St Louis Art Museum (1991). More recently, his work has been shown at the Museum of Modern Art, Saitama, Japan (1999); Walker Art Center, Minneapolis (2001); and Tate Modern, London (2004).

SEE ALSO Andre, Flavin, LeWitt, Minimalism

Donald Judd is undoubtedly one of the most significant artists of the post-war generation. His work changed the course of contemporary art and propelled Minimalism to the forefront of avant-garde practices. Although it was a term he always deplored, Minimalism is inextricably linked to Judd and the work he made from the 1960s onward. Judd's career as an artist began as a painter in the 1940s, but by the late 1950s he was already challenging the accepted axioms of the time, arguing for a method of painting that was not restricted to a representation of the real world. In the early 1960s he began to make geometric, three-dimensional objects with the same intent – he wanted to make things that did not aspire to represent other things, but could rather exist as independent and autonomous objects.

ludd was also a talented, prolific and influential art critic and writer. In 1964 he wrote an important essay entitled "Specific Objects", a term also used by Judd for his purposefully built three-dimensional objects. Judd's "specific objects" are focused on the relationship between the object, the viewer and his environment. The meaning of the object is thus phenomenologically determined. In the creation of these forms, ludd used industrial materials such as aluminium, stainless steel, brass, copper and Plexiglass. Untitled (1973) is made from copper, a material that diminishes any trace of the artist's hand; the work is also made in precisely uniform proportions. ludd also made individual works that exist as part of a series. In 1971 he moved to Marfa, Texas, where, in an open desert landscape, he made works to a larae scale and in numerous series.

Untitled

1990 | Sculpture, Anodized aluminium, steel and acrylic Overall display, Dimensions variable

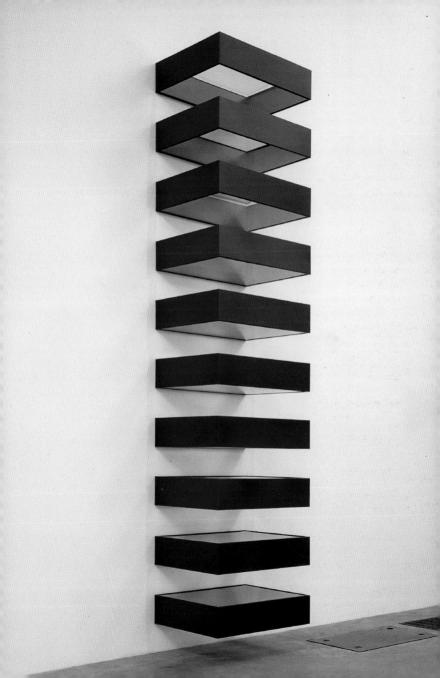

ilya kabakov

BORN Dnepropetrovsk, Ukraine, 1933

Ilya Kabakov graduated from Moscow Art School in 1951 and enrolled in the Moscow Surikov Art Institute. From then until the 1980s he specialized in book illustration. Although he was exhibiting his Conceptual work as early as 1965, he did not have his first solo exhibition until 1985 at the Dina Vierny Gallery, Paris. He emigrated to Austria in 1987 and thereafter remained in the West. He became the first living Russian artist to have a solo exhibition at the State Hermitage Museum in St Petersburg (2004).

SEE ALSO Cai, Installation Art

Ilya Kabakov is a leading Conceptual Artist, originally from the Soviet Union. Until emigrating to the West in the late 1980s, his work consistently dealt with Soviet society. *The man who flew into space from his apartment* (1984–88) was an installation that ironically illustrated freedom from totalitarianism through a fictional man who catapulted himself from restricted Soviet Russia into the infinity of space. We can only view the man's room through cracks in its door, which is boarded up to stop us from contemplating his escape. However, as much as Kabakov indicts totalitarianism, he also mocks naive escapism.

Since Kabakov's own escape, through emigration, his work has often focused on lost histories and incompatible cultures. *School # 6* (1993) recreated an abandoned Soviet school in Texas. While its contents would have been useful to the school's inhabitants, today they are relics. The work visualizes this difference through accumulated dust and general neglect. As well as commenting on the distance between East and West in Kabakov himself, it questions whether art can ever allow us to cross time and space or whether curatorial practices will always turn living objects into artefacts.

Kabakov's approach to curatorship is ambiguous. The same problematic theme reappears in The Palace of Projects (1995–98). With this building, which contains absurd proposals for selfimprovement techniques, Kabakov mocks the supposed role of museums in social development. While he rejects escapism and distance, the "total installation", which is his own auasi-curatorial approach, is a complete experience that disallows curatorial mediation by turning the entire structure of the installation into the artist's product. Kabakov merges the roles of artist and curator, at the same time emphasizing the antagonisms within this relationship and transforming it into something entirely different.

The man who flew into space from his apartment 1984–88

ANISH KAPOOR

BORN Mumbai (Bombay), India, 1954

Anish Kapoor moved to London, England, in the early 70s and studied at the Hornsey College of Art and then at the Chelsea School of Art and Design. He represented Britain at the Venice Biennale (1990), and won the Turner Prize the following year. He has had solo shows at Haus der Kunst, Munich (2007); the Institute of Contemporary Art, Boston (2008); and the Royal Academy of Arts, London (2009). He participated in Documenta IX (1992). Kapoor continues to live and work in London.

SEE ALSO Serra

Anish Kapoor is a masterful sculptor known for creating soft, sensuous works that sometimes resemble the curves of the human body, or other natural forms, and often on a massive scale. Some of his sculptures contain vast, dark cavities. These abysses provoke both awe and contemplation. Kapoor is interested in dualities, real and imagined. His works offer a careful balance of polarities: positive and negative space, absorbing and reflecting materials, equilibrium and precariousness of composition.

Kapoor first gained public recognition in the 1980s. His early works usually involved pure powdered piament, piled up in mounds and carefully sculpted, or covering an object and the floor around it. Raised in India, Kapoor found inspiration for these works in the spices and piaments found in the country's markets and temples. His work is shown in museums and galleries as well as outside in public commissions, though the large-scale work is not limited to outdoor sites. Marsyas (2002) was a piece Kapoor completed for Tate Modern's Turbine Hall. The work consisted of a single span of PVC membrane, stretched over three steel rings and encompassing nearly the entire length of the Turbine Hall. Like many of Kapoor's works, the piece was a rich monochrome, in this instance a deep red. Other works have involved shiny industrial materials. manipulated into sumptuous curves. Cloud Gate (2004) in Chicago's Millennium Park is a large, bean-shaped structure. Made from highly polished stainless steel, the sculpture reflects and distorts Chicago's dramatic skyline, at the same time dwarfing and exalting the city's architectural feats.

Marsyas 2002 | PVC and steel

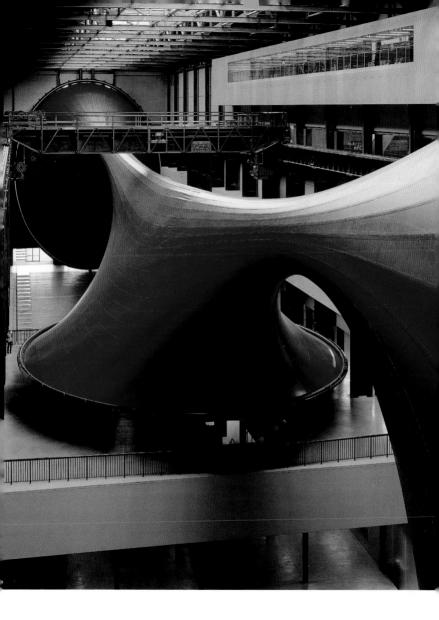

ALEX KATZ

BORN Brooklyn, New York, 1927

Alex Katz studied at The Cooper Union and later at Skowhegan School of Painting and Sculpture, Maine, He has exhibited widely at institutions across the world, including the Whitney Museum of American Art. New York (1974. 1986, 2002); Brooklyn Museum of Art. New York (1988): Staatliche Kunsthalle. Baden-Baden (1995); Instituto Valenciano de Arte Moderno, Valencia (1996): Galleria Civica di Arte Contemporanea, Trento (1999); Kunst und Ausstellungshalle der Bundesrepublik Deutschland, Bonn (2002); and the Irish Museum of Modern Art, Dublin (2007). The artist lives and works in New York

SEE ALSO Abstract and Representational Art, Pop Art

Alex Katz is one of the best-known painters in the United States and has a distinctly recognizable style. A figural painter, he usually works with bright colours against flat backgrounds and shows strong influences of Pop Art. Katz's unique depiction of the world is sometimes called Modern Realism, and his work maintains a stylized proximity to representation of the real world.

Katz works only from observation, never from photographs. His paintings usually consist of neatly compartmentalized applications of colour; the brushstrokes are nigh invisible. He paints individual portraits, group compositions and landscapes. Katz's paintings are simple, without being reductive. The artist pays particular attention to how his images are cropped, creating intensely focused portraits by framing his subjects in particular ways. He often represents subjects in conversation or other kinds of social interaction.

Most of Katz's subjects are family members and friends, many of whom are artists, writers, critics and other cultural

figures in New York. In 1957, Katz made his first painting of his wife, Ada, and he has continued to paint her ever since. Ada has soft, American-European looks, which Katz renders as a timeless beauty. He has painted her in any number of scenarios and attire, from bathing caps and sunglasses to formal dress. Despite the numerous representations of Ada, Katz's paintings maintain an enduring reticence about his subject. It is perhaps this continuing intrigue that fuels Katz's ongoing drive to paint her. Grey Day (1990), one of many representations of Ada Katz, demonstrates the way in which Katz's use of a bold cropping device brings his subjects to life.

Grey Day 1990 | Oil on linen 101 x 330 cm (40 x 130 in)

MIKE KELLEY

BORN Detroit, Michigan, USA, 1954

Mike Kellev araduated from the University of Michigan with a Bachelor of Fine Arts degree (1976). He then moved to Los Angeles and studied at the California Institute of the Arts under Douglas Huebler. During this period he staged a number of public performances, including My Space (1978). His first video work was The Banana Man (1983). A retrospective of his work organized by the Whitney Museum of American Art (1993) travelled to Los Angeles County Museum of Art (1994) and Haus der Kunst, Munich (1995). He has had solo shows at the Louvre, Paris (2006) and Tate Liverpool (2004). Kelley has collaborated with a number of artists including Paul McCarthy and Tony Oursler.

SEE ALSO Cattelan, Gober, McCarthy, Oursler, Performance Art

Mike Kelley is primarily known for his trashy Pop aesthetic, but his work always situates scraps of pop culture in relation to human individuals. *Frankenstein* (1989), one of several works made from soft toys, consists of two objects made from soft toys sewn together, with the implements left on display. The title, a reference to Mary

Shelley's eponymous novel, relates this process of combination to that of constructing a human from various parts. For further emphasis, *Frankenstein* is scaled to the size of Kelley's body, as if it were a model. The childhood toys forming the work take on a new implication as childhood experiences, amalgamated into a more "complete" mature subject that nonetheless remains a composite. The different parts of *Frankenstein* might create a single form but its surface never resolves into a whole, instead remaining a jumble of different elements.

This jumbled look is characteristic of Kelley's work. Categorical Imperative and Morgue (1999) is a large collection of leftovers from Kelley's studio grouped according to type, but which otherwise suggest no clear connections. As in Frankenstein, meaning is denied to any part and may be found only within the whole – the complete collection of toys or the whole of Kelley's practice. While Kelley's amalgamations deny a singular meaning, they simultaneously reinvest their components with human significance. The works are either presented as an image of humanity or as human products that take on particularl meanings in how they are used. In his re-examination of the object, Kelley rejects all simplicity and refuses to allw the object's predominance over its human creators.

Frankenstein

1989 | Sewn stuffed cloth animals, basket with thread, pincushion, felt

32 x 190.5 x 71 cm (121/2 x 75 x 28 in)

MARY KELLY

BORN Fort Dodge, Iowa, USA, 1941

Mary Kelly studied at the Pius XII Institute in Florence, Italy (1963-65) where she was awarded a master's degree in fine arts. In 1968 she moved to London where she studied at St Martin's School of Art. Her first solo show was held at the Institute of Contemporary Arts, London (1976) featuring elements of her Post-Partum Document project. She has since had a mumber of solo exhibitions including at the New Museum of Contemporary Art, New York (1990) and again at the Institute of Contemporary Arts, London (1993). She participated in documenta 12. Since 1996 she has lectured in Art and Critical Theory at the University of California, Los Angeles.

SEE ALSO Goldin, Simpson, Conceptual Art

Mary Kelly engages with a number of recent artistic trends, particularly mediating between Conceptual Art and a more intimately human approach. *Post-Partum Document* (1973–79) is a process-based work involving the documentation of the first six years of her son's life. This documentation includes objects with both a personal connection and a more theoretical significance. For example, an item of her son's clothing is adorned with a psychoanalytic diagram depicting inter-subjective relationships, and a table of information is shown covered by the boy's scribbles.

This connection of the theoretical and the personal is evident throughout Kelly's work. *Gloria Patri* (1992) is an archive of found material from the time of the first Gulf War. It investigates relations between large and small-scale events, questioning whether international violence affects or is affected by individual lives. Therefore we can understand Kelly's work as a bridge between Conceptual Art's interest in broad theoretical structures, such as language, and the more intimate interests of artists of the 1980s such as Nan Goldin or Lorna Simpson.

Kelly also continues Conceptual Art's deconstruction of the artwork by revealing each object as part of a wider artistic and social process. This is clearest in the stone tablets from *Post-Partum Document*, which resemble both milestones and headstones – markers along a path and also memorials to lost moments. Untypical of Conceptual Art, however, this process takes the form of a personal narrative. As in her personalization of theory, Kelly also grounds the deconstruction of art in the personal, collapsing art into life.

Post-Partum Document: Documentation VI, Pre-writing Alphabet, Exergue and Diary (detail) 1978 | Perspex unit, white card, resin, slate 1 of the 15 units 20 x 25.5 cm each (7¾ x 10 in)

Post-Partum Document: Introduction 1973 | Perspex unit, white card, wool vests, pencil, ink 1 of the 4 units 20 x 25.5 cm each (7% x 10 in)

WILLIAM KENTRIDGE

BORN Johannesburg, South Africa, 1955

William Kentridge studied Politics and African Studies at the University of Witwatersrand, Johannesburg (1973-76). Fine Art at Iohannesburg Art Foundation (1976–78) and drama at École Jacques LeCoq, Paris (1981-82). He had a major exhibition at the Hirshhorn Museum and Sculpture Garden, Washington DC (2001) and a survey of his work toured from the San Francisco Museum of Modern Art to the Museum of Modern Art, New York in 2010. Kentridge participated in Documenta X (1997) and Documenta 11 (2002) in Kassel, Germany; the Bienal de São Paulo (1998); the Venice Biennale (1999): the Bienal de la Habana, Havana (2000); and the Biennale of Sydney (2008). Kentridge was awarded the Carneaie Medal (1999) and the Kaiserring der Stadt Goslar (2003). He continues to live and work in Johannesburg.

SEE ALSO Abstract and Representational Art, Post-Colonialism

William Kentridge is one of the best known South African artists working today. Born seven years after the 1948 election that instituted the apartheid system in South Africa, Kentridge has consistently made the political and social structure of South Africa the subject of his work. The artist makes etchings, lithographs, silkscreens and tapestries, but is primarily known for his drawings and films. With the relatively simple means of charcoal and a rubber, Kentridge makes pictures that feature epic narratives and well-developed characters.

Kentridge studied both theatre and mime, so was a natural progression for him to move on to the creation of films In the making of his films, Kentridge erases and redraws elements of his drawings, filming each new frame to create the sense of motion. Johannesburg, 2nd Greatest City after Paris (1989) is Kentridge's first animated film. His characters are the greedy, suited businessman Soho Eckstein and the naked, romantic Felix Teitelbaum, and the film explores the pair's conflicting aims, as well as class struggles in South Africa. History of the Main Complaint (1996) is the sixth film in the series titled Drawings for Projection. It takes place in the derelict lands south of Johannesburg that have been destroyed by years of mining. Kentridge's process of making the continual erasing and reworking of material - is a reflection of the processes of memory and reconstruction in South Africa's recent history. The erasure also represents South Africa's spoilt and scarred landscape.

History of the Main Complaint 1996 | Animation film installation

MARTIN KIPPENBERGER

BORN Dortmund, Germany, 1953

In 1971 Kippenberger moved to Hamburg, living in a string of communes. He began to study at the Hamburg Art Academy (1972), but he left before completing his course. He had his first solo show at the Petersen Gallery in Hamburg (1977), and co-founded a gallery called Kippenberger's Office (1978). He had work featured in the Venice Biennale (1988), a solo show at the San Francisco Museum of Modern Art (1991), and a major retrospective at Tate Modern, London (2006). He died in Vienna in 1997.

SEE ALSO Beuys, Polke, Warhol

Ironically, Martin Kippenberger's insistent self-mockery has founded a cult of personality, which surpasses that of most other contemporary artists. *The Happy End of Franz Kafka's "Amerika"* (1994) is based on an unfinished Kafka novel. It is an installation of sets of tables and chairs, arranged for interviews. It is set on a sports field, with a green floor adorned by demarcating lines. This implies a competition, but also spectatorship. If we are the spectators, and therefore the interviewers, then Kippenberger and his

contemporaries must be the competitors, battling for our preference. However this apparently rigid set-up is undercut by the mixture of high Modernist furniture with surreal objects, such as a fried-egg shaped table. As in Kafka's literature, the situation devolves into absurdity.

A 1988 self-portrait sees Kippenberger dressed in white underwear, covering his face with a balloon. His bloated body displays the results of an excessive lifestyle. Initially this seems like a frank self-

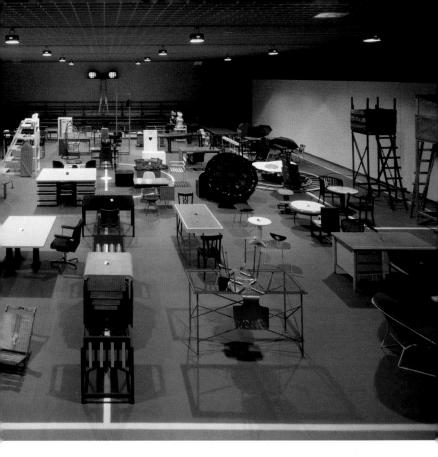

revelation, but it also involves concealment. The balloon that Kippenberger hides behind symbolises his "party animal" reputation. Similarly, his underpants resemble a pair worn by Picasso in a famous photograph. This comparison could be mere self-promotion, or perhaps a further concealment; the man buried by his "great artist" status. It implies that the Kippenberger whom we claim to know - whom we claim to engage in the reciprocal process of an "interview" – is actually our own projection. Like the empty seats of *The Happy End of Franz Kafka's "Amerika"*, Kippenberger's paintings become a blank canvas for our own assumptions, but these are always denounced in their falsehood and defied in their attempts at solidification.

The Happy End of Franz Kafka's "Amerika" 1994 | Mixed media (chairs, tables, etc), electricity, green carpet painted with white lines, two bleachers Dimensions variable

PER KIRKEBY

BORN Copenhagen, Denmark, 1938

Per Kirkeby studied at Copenhagen's Experimental Art School, experimenting with a variety of media (1962-64). Durina the 1960s he was a member of the Fluxus aroup. He had his first solo exhibition in Cologne (1964). An art historian as well as an artist, he has published a book of essays on artists including Manet and Picasso (1988), as well as poetic and literary books that include Copyright (1965) and 2,15 (1966). In 1973 he executed the first of many brick sculptures. He has been awarded a number of prizes, notably including the Herbert-Boeckl prize for lifetime achievement (2003). He had a solo show at Tate Modern, London (2009).

SEE ALSO Abstract and Representational Art

Per Kirkeby has worked in a variety of media, but is best known as a painter. In his works, such as *Untitled* (2005), Kirkeby always seems to take the landscape as a reference point and yet never depicts it directly. Despite remaining defiantly abstract, as emphasized by its non-committal title (or lack of one), *Untitled* seems to suggest rocks through its thick, craggy volumes of paint. Kirkeby received an early education in geology, an interest that recurs throughout his work. Indeed, not only does this work seem to depict rocks, but its construction represents a geological process. The paint is thickly layered, suggesting the strata of sedimentary rock formations.

However, this reading of Kirkeby's painting as being primarily within the genre of landscape may be deflated by the abstract marks that he often hatches across the surfaces of his works. Untitled. for example, has an upper layer of spidery black lines. We can perhaps read the tension between these two elements of Kirkeby's painting - the tactile and the linear, the representational and the purely abstract – as the revelation of a tension inherent to painting in general. There is a dichotomy at work here between painting as representation and paint as a material substance. While a lesser artist might seek some way of resolving this tension, Kirkeby draws energy from it. Never fully answering the questions posed by his work, he is always coming up with fresh possibilities.

Untitled 2005 | Oil on canvas 200 x 110 cm (78¾ x 43 in)

JEFF KOONS

BORN York, Pennsylvania, USA, 1955

leff Koons obtained a Bachelor of Fine Arts from the Maryland Institute College of Art in Baltimore, and also studied at the School of the Art Institute of Chicago. The San Francisco Museum of Modern Art and the Stedelijk Museum, Amsterdam, have organized major retrospectives of his work (1992). He has exhibited widely at institutions across Europe and America, including the Museo Guggenheim Bilbao (1997); the Astrup Fearnley Museet for Moderne Kunst, Oslo (2004); the Museum of Contemporary Art, Chicago (2008); and the Serpentine Gallery, London (2009). He currently lives and works in New York and York, Pennsylvania.

SEE ALSO Warhol, Pop Art

Rising to super stardom in the 1980s, Jeff Koons remains one of the world's most influential contemporary artists. Before fully devoting his time to art, Koons worked for six years as a commodity broker on Wall Street, New York, and his work demonstrates a continuing keen sense of consumer practices and desires. Taking inspiration from both high and low forms of culture, his artworks challenge common distinctions between kitsch and high art. Sometimes his sculptures are playfully deceptive, appearing to be weightless while being made of heavy materials such as stainless steel. Koons often borrows from the language of advertising and marketing as he investigates how perfection is sold to us. In the late 1970s, Koons began a series of works that presented the latest consumer products as artworks. Elevating everyday objects to the position of high art, the series highlighted the sleek design and desirable qualities of mass-produced objects in the United States.

At the end of the 1980s, Koons's work took a new direction. He began to display images and sculptures of his former wife – ex-porn star and member of Italian parliament, Ilona Staller – and himself engaged in intimate, often sexual, acts. The works demolish boundaries between public and private, and art and life, while demonstrating art as a means of exploring desire. Koons's sculptures often have a reflective quality to them. Viewers find their image mirrored in the surface of the work, and so their desires are reflected back at them.

Rabbit 1986 | Stainless steel 104 x 48.5 x 30.5 cm (41 x 19 x 12 in)

JANNIS KOUNELLIS

BORN Piraeus, Greece, 1936

He studied at an art college in Athens until moving to Rome in 1956, when he enrolled in the Academy of Fine Arts. He had his first solo show at La Tartaruga , Rome (1960). In 1967 he joined the Arte Povera movement. He had a solo exhibition at the Museum of Contemporary Art, Chicago (1986). He had a retrospective show at both the Karsten Greve Gallery in Cologne, Germany, and the National Museum of Visual Arts in Montevideo, Uruguay (2001).

SEE ALSO Penone, Pistoletto, Arte Povera

Jannis Kounellis is best known for his involvement with the Arte Povera movement, which sought to reconnect art with life by using everyday objects and materials. *Untitled* (2006) is constructed from battered old shoes and other found items. The shoes imply human use, but appear to have no users. Therefore *Untitled* simultaneously evokes and denies a human presence that is left hanging in the air. The work seems almost mournful, bearing the memory of a lost time that we cannot share. This effect is emphasized by the iron

girder, which is wrapped in a black shroud and lies on a wire bed, as if in a funeral procession. The objects, seemingly longing to be used, appear as a critique of art, which tries in vain to cross the barrier that separates itself from the living.

The same motif runs throughout Kounellis's work. Jaffa Port (2007) is an installation featuring unused tables and chairs, with bright lights that cast long, dark shadows across the floor. In the middle of one ring of chairs is a chalk outline of a body – another human

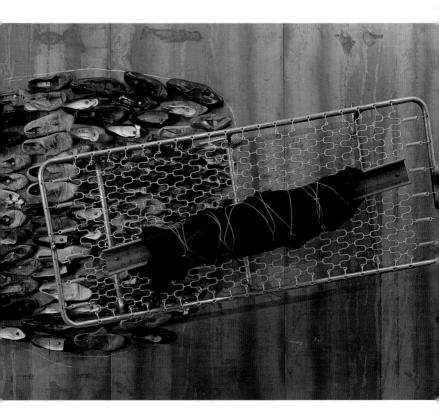

absence that the closed circle of chairs prevents us from filling. Untitled (1979), meanwhile, is a simple wall drawing of an industrial town. The only signs of life are two stuffed birds, which have been attached to the wall and pierced with arrows. A last vestige of life, the birds have been preserved in the moment of their obliteration for all to see. Like all of Kounellis's work, Untitled rails at the poverty of this preserved existence. The death that it mourns is really its own; the petrification of life into its static opposite.

Untitled

2006 | Iron plates, shoes, bed frame, steel hooks, I-beam, coat, wire 200 x 360 cm (78 34 x 141 34 in)

BARBARA KRUGER

BORN Newark, New Jersey, USA, 1945

Kruger studied at Syracuse University, New York, and the Parsons School of Design, New York City, After working in advertising, she began to exhibit as an artist. She has had major solo shows at numerous institutions, including the Institute of Contemporary Arts, London (1983); Museum of Contemporary Art in Los Angeles (2000); South London Gallery (2001): Kestner Gesellschaft, Hannover (2006): and Moderna Museet Stockholm (2008). She also participated in Documenta 7 (1982), Documenta 8 (1987) and the Whitney Biennale (1973, 1983, 1985, 1987). She received the Golden Lion for Lifetime Achievement at the 51st Venice Biennale (2005) She now lives in New York and Los Anaeles.

SEE ALSO Conceptual Art, Feminism

Barbara Kruger is a Conceptual Artist who works with film, video and installation but is best known for making photo-collages inspired by the aesthetics of advertising. Using images sourced from mass-media outlets such as newsprint and television,

Kruger borrows the language of advertising to criticize its effects. The collages usually consist of black and white images that Kruger has overlaid with text. The text, either black or white, is frequently set against a red background and relays pithy messages about societal relationships and power structures. Through these messages, Kruger challenges propagation by the media of stereotypes, misogyny and outdated notions of gender roles. The images she sources are often enlarged to unrealistic proportions. Like advertising campaigns, her works convey their ideas clearly, concisely and emphatically. Kruger's work has appeared in public spaces and on billboards, as well as in museums and galleries.

Throughout her career, Kruger has developed a number of slogans that reappear in her work, such as I shop therefore I am, which addresses issues of consumerism, classism and feminism. Another popular slogan is Your body is a battleground, which was designed as a poster for a pro-choice march in Washington DC, on 9 April 1989. In this work, a black and white image of a woman's face is divided in half, highlighting the idea that symmetry is a prerequisite for stereotypical feminine beauty. At the same time, the work addresses the political furore centred on a woman's right to have an abortion.

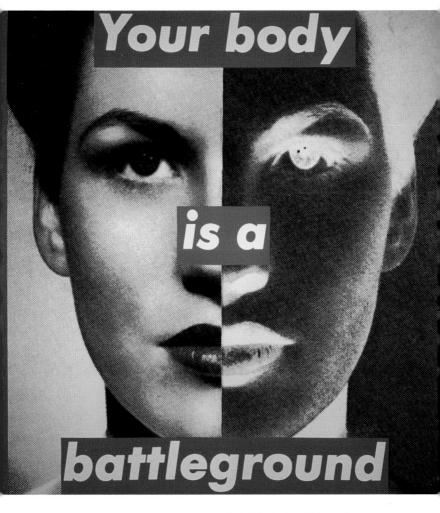

Untitled (Your body is a battleground) 1989| Photographic silkscreen/vinyl 280 x 280 cm (112 x 112 in)

YAYOI KUSAMA

BORN Matsumoto, Nagano Prefecture, Japan, 1929

She had her first solo show there at the First Community Centre (1952). She went to the United States to study at the Art Students League (1957), and moved there in the following year. Having been primarily a painter, she now mixed painting with performance. Her "Happenings" were recorded in the film Self-Obliteration (1968). Kusama returned to Japan in 1973. A retrospective of her work was shown at several galleries, including the Museum of Modern Art, New York City and the Museum of Contemporary Art, Tokyo (1998–99); and a solo show entitled Yavoi Kusama: Mirrored Years was shown at the Museum of Contemporary Art, Sydney (2009). She is the recipient of a number of international honorary awards.

SEE ALSO Feminism, Identity Politics, Installation Art

Since the 1950s, Yayoi Kusama has been creating patterns with obsessively repeated forms. Many of her works are abstract paintings, covered in dots. She has also used these dots as the basis for a number of installations, including *Dots Obsession – Infinity Mirrored Room* (2008). The dots are

derived from her hallucinations, and the paintings thus have a therapeutic function, transferring her experience onto canvas. The installations, meanwhile, reconstruct that experience in real space. Indeed, these spaces are highly hallucinatory; *Dots Obsession – Infinity Mirrored Room* consists of a number of bright yellow bubbles, floating in the air or being squashed onto the ground.

Kusama invites viewers to share her experience, drawing them into her hallucinatory world. The shift from painting to installation is thus key – a shift from

the documentation of experience to its realization in space. Her work is often given certain artistic labels, such as Pop, because of her use of repetition, or Surrealist, because of her externalization of the internal. However, her work is highly personal and she fights most vehemently against any such categorization. Kusama has lived intermittently in a mental institution and has also been labelled with various mental disorders. However, she presents her mental state as inseparable from her experience and refuses her doctors' labels through her practice. She allows us to share in her experience, opening a door between our worlds and transforming the gallery space into a common frame of reference. Ultimately her project is the facilitation of commonality and communication; she offers a means of inclusion that opposes the distinctions and exclusions through which we are all constantly herded.

Dots Obsession – Infinity Mirrored Room 2008 | Mixed media Dimensions variable; balloon diameters 2m, 3m, 4m, 6m

SHERRIE LEVINE

BORN Hazleton, Pennsylvania in 1947.

Sherrie Levine received a master's degree in fine arts from the University of Wisconsin (1973). She had her first solo show at the De Saisset Art Museum, California (1974). Her work was first introduced to a broader audience through the show *Pictures* (1977), curated by art historian Douglas Crimp and held at the Artists Space in New York City. She has had numerous solo shows including San Francisco Museum of Modern Art (1991) and Museum of Contemporary Art in Los Angeles (1995).

SEE ALSO Kruger, Prince, Appropriation Art, Institutional Critique

Sherrie Levine has been a pioneer of Appropriation Art since the 1980s. Her series After Walker Evans (1981) is characteristic of that style. It consists of photographs that Levine took of photographs by Walker Evans and which are therefore visually identical to his works. Levine's intervention forces us outside the image, forcing recognition of Walker Evans himself and his own intervention. When questioning what it means for Levine to re-photograph Evans's "original", we are also forced to ask what it meant for Evans to photograph his subjects of poor farmers.

Levine's work enacts the collapse of traditional artistic authorship and is a rejection of authorial ownership. Her constant use of the prefix "After..." refers to the art-historical tradition of copying works and suggests that no work of art is original in a pure sense because artists are always influenced by each other. She also collapses our usual definition of artistic practice and even art itself. Fountain (After Marcel Duchamp) (1991) is a version of Duchamp's work of the same name, but unlike the original, which was a real urinal, Levine's is cast in bronze. So, while Duchamp's work was intended to drag artworks down to the level of ordinary objects, Levine's use of a precious and traditional artistic material criticizes Fountain's entry into art's canon for its complicity with the very system that it opposed. This approach can appear as a purely negative practice of collapse, but it is actually a positive act that includes all the aspects of artistic production, even those that are usually left outside the frame. Her work is therefore a continuation of the Institutional Critique of the 1970s, but its emphasis shifts to the institutional function of the artwork itself.

Fountain (After Marcel Duchamp) 1991 | Bronze 38 x 63 x 38 cm (15 x 25 x 15 in)

SOL LEWITT

BORN Hartford, Connecticut, USA, 1928 DIED New York City, NY, USA. 2007

LeWitt studied at Syracuse University, New York (1945–49), receiving a bachelor's dearee in fine arts. He had work shown in the Primary Structures exhibition at New York's lewish Museum (1966), perhaps the most important exhibition of Minimalist art. His article "Paragraphs on Conceptual Art" (1967) is widely regarded as among the most important primary texts on that subject. He had shows at the Institute of Contemporary Arts, and Tate Gallery, both London (1986) and a travelling retrospective, organized by San Francisco Museum of Modern Art (2000). Massachusetts Museum of Contemporary Art, North Adams is showing A Wall Drawing Retrospective (2008-2033).

SEE ALSO Buren, Weiner, Conceptual Art, Minimalism

In the late 1960s Sol LeWitt was a pioneer of Conceptual Art. He declared the primacy of the concept over the finished work and therefore created art mathematically, leaving the actual

execution of objects and drawings to assistants. This approach is visually present in his earlier works, such as *Five Open Geometric Structures* (1979), which consists of plain white, starkly mathematical sculptures that echo their theoretical formulation.

Although LeWitt favoured the conceptual over the sensual, the latter always remains active in his work. The role of his assistants is hugely important because their execution of his instructions enables the transmission of LeWitt's concepts. This is particularly clear in recent works, such as Wall Drawing #1055 (2002), that

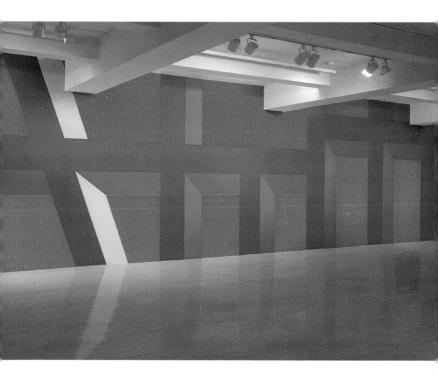

deviate from his earlier mathematical style and imply a gap between his theoretical instructions and the resulting physical product. Even if LeWitt sees the concept as primary, it remains the case that we can only reach his concepts sensually, and so there is always a sense in which the "finished" works take precedence.

A finished LeWitt artwork is not so much removed as de-centred; it is revealed as part of a broader process that incorporates the artist, the assistants and the viewer. Although Conceptual Art is born in LeWitt's work, it immediately begins to unravel itself. In fact, this very process of unravelling is the core of LeWitt's approach. His experiments with mathematics and visual form were simultaneously an experiment with the very concept of art, a demand that we should look beyond the purely visual and into the furthest reaches of artistic production.

Wall Drawing #1055 (PW), Wall B 2002 | Bars of colour, acrylic paint, red background 3,89 m x 17.78 m (12 ft 9 in x 58 ft 4 in)

ROY LICHTENSTEIN

BORN New York City, NY, USA, 1923 DIED New York City, NY, USA, 1997

Roy Lichtenstein received a bachelor's degree at Ohio State University (1946) and went on to teach and do further research, whilst practising various fine and applied arts including painting, lithography, jewellery-making and sculpture. He had his first solo exhibition at the Carlebach Gallery in New York (1951). By the late 1950s he was painting in an Abstract Expressionist style. In1956 he made his first work of Pop Art, a lithograph called Ten Dollar Bill, and in 1961 Look Mickey was his first work to incorporate Ben Day dots, his reproduction of the printing process. He had his first solo show of Pop Art at the Castelli Gallery, New York (1962).

SEE ALSO Hamilton, Kruger, Murakami, Oldenburg, Polke, Warhol, High Art and Low Art, Pop Art

Roy Lichtenstein was a pioneer of Pop Art. In works such as *Blam!* (1962), he took images from popular culture (in this case a comic) and introduced them into high art. This act opened up high art to an engagement with popular imagery and thus with popular culture in general. But if we look at Lichtenstein's art as a whole, we can see it as a broader consideration of the nature of the image and the complex relations between the popular and the avant-garde.

In his work *Brushstroke* (1965), Lichtenstein reproduced a commercial image of a brushstroke. Its emphasis on mass reproducibility contrasts starkly with the Abstract Expressionists' emphasis on painting's potential for individual expression. This work is partly a comment on high art's pretension in using material means to embody the immaterial, but it also implies the appropriation and destruction of high art techniques by commercial artists. The brushstroke might be descended from a principle of high art, but that descent has involved a removal of all of its meaningful content.

Lichtenstein investigated a number of other avant-garde movements in this way, particularly Cubism, as in the Greene Street Mural (1983), a 90-foot-long mural on the wall of Castelli's gallery space. In every example, each style is viewed afresh through a Pop lens. The point is that Lichtenstein demonstrates the complete submersion of all styles into a single unifying system. Regardless of stylistic differences, he shows all artistic methods as intermingling in their support of consumer society, as represented by his Pop aesthetic. So while his work undoubtedly hailed the entrance of a commercial style into high art, it also documented the absorption of high art into the commercial.

Blam 1962 | Oil on canvas 172.5 x 203 cm (68 x 80 in)

LIU XIAODONG

BORN Liaoning Province, China, 1963

Liu Xiaodong graduated from the Beijing Central Academy of Fine Arts with a bachelor's degree and a master's dearee (1995) and returned there as a lecturer after studying for a master's at the University of Compultense, Madrid, He has been active in the Chinese art world since the late 1980s, beginning with the group show Chinese Avant-garde at the China Art Gallery, Beijina (1989). From the 1990s; and especially since 2003, his work has also become popular in the West. He had a major exhibition of The Three Gorges Project at the Asian Art Museum of San Francisco. California (2006)

SEE ALSO Rauch, Yue, Zhang (Xiaogang), Abstract and Representational Art

Liu Xiaodong walks on thin ice as a political artist in a totalitarian society. He mimics the form of state propaganda in order to criticize the state, but does not include specific critical references. In this way, Liu's paintings reframe the images of prosperity and pleasure that China presents to its population and to the world.

The woman in QiQi (2007) resembles the prostitutes painted by French Realists of the nineteenth century, especially Courbet. But while Courbet's women tended to sit within some obvious social context. Liu's subject lies on a mattress in abstract space, suggested by splashes of paint. Her bed seaues into its surroundings, as if to mask the realities of her seedy position. QiQi depicts a sexually confrontational woman, but another work, Massage (1996), avoids all confrontation and instead presents an image of a man being massaged - only the hands of the masseuse are visible. Again, there is a sense that the subject has been taken out of context.

On the evidence of Massage alone, we might think that censorship prevents the sensual act of massaging from being fully depicted in Communist China. Yet QiQi proves that this cannot be the case. since Liu does not attempt to conceal that painting's sexual content. Instead, it seems that his careful framing of these images is intended to draw as much attention to what is left outside as to what is actually depicted. His refusal to display the masseuse leaves us wondering why she herself is of so little interest, and the lack of any context for the prostitute makes us look beyond the empty sexual fantasy of her work toward those whose needs she serves.

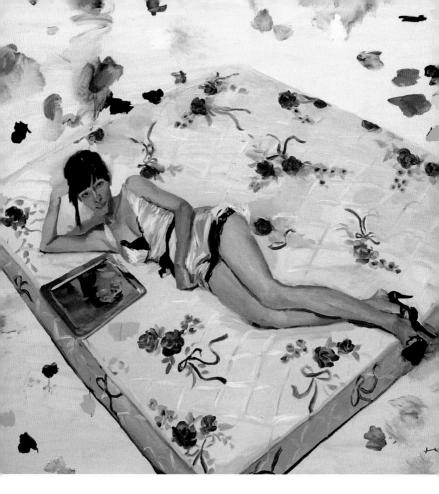

QiQi 2007 | Oil on canvas 200 x 200 cm (78¾ x 78¾ in)

richard Long

BORN Bristol, England, 1945

He studied at West of England College of Art, Bristol and St Martin's School of Art, London. He has been the subject of many solo exhibitions, including the Museo Guggenheim Bilbao (2000); San Francisco Museum of Modern Art (2006); the Scottish National Gallery of Modern Art, Edinburgh (2007); and Tate Britain, London (2009). He represented Britain at the Venice Biennale (1976). He won the Turner Prize in 1989. Long lives and works in Bristol and continues to travel the world in his work.

SEE ALSO Christo and Jeanne-Claude, De Maria, Smithson, Land Art, Minimalism

Richard Long made his first "walking piece" in 1967. The work is a photograph of a trampled path in an English field, made by the artist walking in a straight line. As a student in the 1960s, Long entered an art world dominated by Minimalism and large, abstract and often industrial sculptures. Working with nature as a medium, he makes subtle gestures in the outdoor landscape that are often translated into the gallery space as only a simple line of text or a photograph. Long's

practice is, in part, a reaction to Minimalism's cool, emotionless, industrial aesthetic. However, in privileging lines, circles, spirals and, above all, simplicity as formal devices, Long's work is perhaps not as divergent as it first appears.

Berlin Circle (1996) features many small slabs of sedimentary rock set on edge and configured into a ring. The piece is a part of the landscape from

which it was lifted, as well as a simple geometric form.

Long begins a piece by setting himself an objective to fulfil: he has returned a drop of water from the mouth of a river to its source, walked for 25 days across Nepal, turned 207 stones to face the wind during a 15-day walk in Lapland and followed a straight line arbitrarily drawn onto a map across the wilderness. His most common method of working first involves taking a walk. Over the years, Long has found different ways of representing in the gallery his walks and actions in the wilderness.

Berlin Circle 1996 | Installation view Hamburger Bahnhof Museum für Gegenwart, Berlin

SARAH LUCAS

BORN London, England, 1962

Sarah Lucas graduated from Goldsmiths College, London (1987). Her work was included in *Freeze* (1988), the exhibition primarily organized by Damien Hirst that secured the ascent of the Young British Artist generation, of which Lucas was a part. Her first solo show, entitled *The Whole Joke*, was held at 8 Kingly Street, London (1992). She participated in *Sensation*, another major exhibition of the Young British Artists at the Royal Academy of Arts, London (1997). Lucas also had a retrospective show at Tate Liverpool (2005–06).

SEE ALSO Chadwick, Emin, Feminism, Young British Artists

Sarah Lucas's art focuses on the underside of sex and gender relations through everyday objects and images. The title of *Pauline Bunny* (1997) refers to the seductive image of the Playboy bunny. The work itself is less than seductive, however. It is a cheaply made sculpture draped limply on a chair, its legs splayed in a vulgar position. Its limpness suggests a post-coital posture and the emphasis on flesh and genitalia, without the inclusion of a face, presents this female figure purely as a sexual object. This viewpoint is emphasized further in *Bunny Gets Snookered #2 [Unwrapped]* (1997), in which Lucas's bunny is displayed in parts resembling pieces of meat.

Lucas is well known for her androgynous self-portraits, in which her femininity is obscured by her short hair, constant smoking and masculine posture. This stance is partly an attack on the naturalization of gender roles, but it also implies a complication in her work, since she comes to occupy the laddish male position that such works as Pauline Bunny are designed to critique. Perhaps we can say that this is Lucas's alter ego: an irreverent, masculine other to the feminist critic that her work often implies her to be. The point of this opposition is that Lucas probably wants us to fall somewhere in the middle. We cannot help but laugh at her rude jokes, regardless of our shock at her raw presentation of the female body. Ultimately, Lucas refuses strict definition, instead opting for a revelation of the ambiguities of gender and sexuality within her art, herself and her viewers.

Pauline Bunny 1997 | Mixed media 95 x 64 x 90 cm (37½ x 25 x 35½ in)

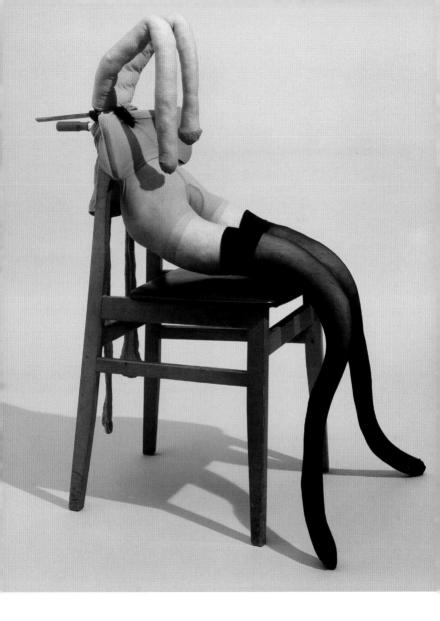

ROBERT MAPPLETHORPE

BORN Floral Park, NY, USA, 1946. **DIED** Boston, Massachusetts, USA, 1989

He studied painting, drawing and sculpture at the Pratt Institute of Art, Brooklyn (1963–70). He had his first important solo show at The Kitchen, New York (1977). Both the Stedelijk Museum, Amsterdam, and the Whitney Museum of American Art, New York, organized major exhibitions of his work in 1988. Mapplethorpe has had numerous other solo shows, including at the Institute of Contemporary Art, Philadelphia (1989) and a retrospective at the Tokyo Metropolitan Art Museum (1992). Mapplethorpe died from AIDS in 1989.

SEE ALSO Identity Politics

Robert Mapplethorpe was drawn to an exploration of the social underground. Having grown up in a quintessential American suburb on Long Island, New York, Mapplethorpe moved to Manhattan to study art. He began to take pictures with a Polaroid camera in the early 1970s, and over time his practice shifted from the assemblage of other people's images to the creation of his own photographic works. In his photography, Mapplethorpe captured sexual subcultures and edgy communities of artists living in Manhattan in the1970s and 1980s. A participant in these circles, he took images of things that most people had only heard about, such as gay sadomasochistic sex practices, which he depicted graphically.

Despite gaining some notoriety for the subject matter of his photographs, Mapplethorpe is consistently recognized for the formal composition of his photography, which emphasized balance and cohesion. During the 1980s, he focused increasingly on the naked human body, looking at its physical stature, and finding perfection in its structure. Thomas (1987) is a classical depiction of the beauty of the human form. Mapplethorpe constantly pushed the boundaries of photography, experimenting with different formats including colour Polaroids, Cibachromes and dye-transfer colour prints, as well as his now well-known black and white gelatine silver prints.

Alongside pornography stars and figures from the underground, Mapplethorpe's photographs also depict important cultural figures and socialites. At a young age, Mapplethorpe met the then struggling artist, writer and poet, Patti Smith. The two forged an enduring emotional partnership and Smith features in many of Mapplethorpe's most famous images.

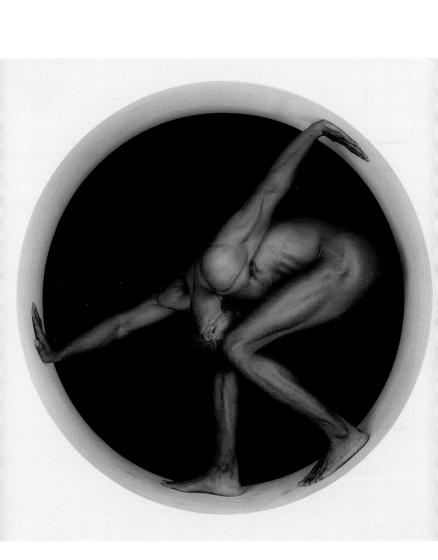

Thomas 1987 | Gelatin silver print 48 x 48 cm (19 x 19 in)

WALTER DE MARIA

BORN Albany, California, USA, 1935

He earned a master's degree in fine arts at the University of California, Berkeley (1953–59). In 1960 he moved to New York, where he wrote on art and, despite his training as a painter, got involved in Happenings and other projects. His first solo sculpture show (1963) was at the 9 Great Jones Street Gallery, New York, which he co-owned with the artist Robert Whitman. His international shows include Kunsthaus Zürich (1992, 1999); Fondazione Prada, Milan (1999); and Chichu Art Museum, Naoshima, (2000, 2004). A number of his sculptural installations remain on continuous view.

SEE ALSO Long, Smithson, Land Art

Walter De Maria's work marks a transition between Minimalism and land art and a confrontation between man and nature. *The Lightning Field* (1977) is a grid of poles measuring one mile by one kilometre, situated in a remote part of New Mexico in the United States. Viewers spend 24 hours within the work, experiencing different effects of light on the poles and their surroundings. The work is so-named because it is designed to attract lightning, offering the powerful experience of being surrounded by bolts of electricity. The poles stand within the natural environment and their colour blends them into their surroundings. But despite this apparently harmonious relationship the rods are still an intervention, capturing lightning and manipulating light.

A constant characteristic of De Maria's work is his use of mathematics. Like The Lightning Field, his sculptures The Vertical Earth Kilometer (1977) and The Broken Kilometer (1979) are designed to exact measurements. Similarly The New York Earth Room (1977) is described according to its dimensions – 250 cubic vards of earth, 3,600 square feet of floor space (335 square metres). In Earth Room we again see nature's seizure by humanity, or conversely its eruption into human space. Mathematics offers another means of bridging this threshold - cold, human logic, which nonetheless also occurs in the natural world. De Maria forces us to acknowledge our place within nature, which, despite its destruction by human hands, continues to exert a force over us both from the outside and the inside. De Maria's interventions into nature and his eruption of the natural into the human thus refer to a single procedure. He forces the two together and in so doing integrates nature back into the apparently cold aesthetic of Minimalism and the logic of Conceptual Art.

Lightning Field (New Mexico)

1977 | a permanent earth sculpture, 400 stainless steel poles arranged in a grid array measuring one mile by one kilometer, average pole height 20 feet 7 inches, pole tips form an even plane

GORDON MATTA-CLARK

BORN New York City, NY, USA, 1943 DIED New York City, NY, USA, 1978

Before his death at a young age from cancer, Gordon Matta-Clark had solo exhibitions at the Museo de Bellas Artes in Santiago, Chile (1971); Musée d'Art moderne de la Ville de Paris (1974); Neue Galerie der Stadt in Aachen, Germany (1974); and the Museum of Contemporary Art Chicago (1978), among others. He has been the subject of numerous exhibitions around the world.

SEE ALSO Whiteread, Institutional Critique, Site-specificity

Gordon Matta-Clark made his name by altering the structure of derelict buildings, but not one of his original site-specific interventions in the built environment exists today. For years Matta-Clark perplexed curators and exhibition makers who had to rely upon drawings, plans, reconstructions and scant photographic documentation to illustrate the artist's actions in the urban environment. A trained architect, Matta-Clark was familiar with the materials of construction as well as the sometimes fraught pedagogy of architectural institutions. Turning to the built environment, Matta-Clark's goal was to critique the social iniquities of the urban landscape and to investigate the plight of the disenfranchised or dispossessed. By surreptitious means such as photographing through the punched-out windows of abandoned buildings, Matta-Clark questioned the strategies of urban renewal in 1970s' New York. In 1971 he cofounded Food, a restaurant run and staffed by artists who considered the act of cooking an art form.

Throughout the 1970s, Matta-Clark worked in derelict buildings and empty suburban houses. He worked with a power saw, literally cutting, splitting and carving up empty houses, a technique that became known as "building cuts". In 1974 he took part in a group exhibition in New York entitled Anarchitecture, a term later used in reference to many of Matta-Clark's ideas about architecture. and also, for a while, to a loose collection of his friends and collaborators. For Conical Intersect (1975), made for the Paris Biennale, Matta-Clark cut a large, cone-shaped hole into two seventeenthcentury townhouses that were scheduled for demolition. This was to become one of his most iconic works.

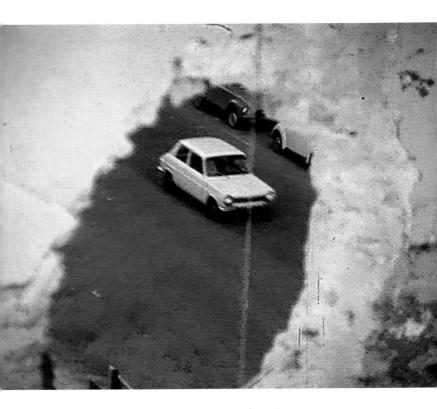

Conical Intersect 1975 | Courtesy Electronic Arts Intermix (EAI), New York

PAUL MCCARTHY

BORN Salt Lake City, Utah, USA, 1965

McCarthy received a Bachelor of Fine Arts from the University of Utah (1969), and a Master of Fine Arts, specializing in film, from the University of Southern California (1973). Although beginning his career as a painter, in the 1970s he turned to performance. He had his first solo exhibition, entitled Contemporary Cure-All and Deadening, at the Los Angeles Institute of Contemporary Exhibitions (1979). A travelling retrospective of his work was shown at the Los Angeles Museum of Contemporary Art (2000) and Tate Liverpool (2001). Paul McCarthy - Head Shop/Shop Head was shown at Moderna Museet. Stockholm (2006); ARoS Aarhus Museum of Art, Aarhus; and S.M.A.K. Stedelijk Museum voor Actuele Kunst, Gent (2007).

SEE ALSO Kelley, Performance Art, Video Art

Paul McCarthy's art is messy, unpleasant and often highly amusing. In the 1960s he explored the boundaries between painting and performance, using his body to apply paint to canvas. In the 1970s he replaced paint with other substances, including saliva and ketchup, with the latter becoming an ever-present motif in his work. McCarthy's use of ketchup as a comic substitute for blood in his violent and often genuinely dangerous performances indicates the way in which his practice links popular entertainment with the grotesque. By acting as both clown and butcher, he exposes the violence latent in many icons of Western society.

Caribbean Pirates (2001–05) takes inspiration from Disneyland's "Pirates of the Caribbean" ride. Unlike the children's ride. however, McCarthy's work stresses the reality of pirates as violent and terrifying. A boat covered in ketchup suggests the aftermath of a battle, while a video screen displays acts of rape and mutilation carried out by pirates with oversized plastic heads. This combination of a plastic, cartoon aesthetic with brutal images questions our acceptance of Hollywood violence and especially its relationship with actual violence - it does not seem far-fetched to relate his marauding pirates to the Western invaders of Iraq or the atrocities at Abu Ghraib prison. In fact, McCarthy seems to present his installation as a more honest alternative to Disney's sanitized depiction of history. If we are disgusted by what we see, it is as much because of its closeness to reality as because of its vulgarity.

Caribbean Pirates

In collaboration with Damon McCarthy | 2001–05 Performance, video, installation, photographs

STEVE MCQUEEN

BORN London, England, 1969

He studied at London's Goldsmiths College and earned a bachelor's degree in fine art (1993). His first major film exhibition was of the work *Bear* at the Royal College of Art (1994). He won the Turner Prize for an exhibition at the Institute of Contemporary Arts, London (1999). He had work featured in the Venice Biennale (2007) and was invited to represent the United Kingdom in 2009. His film *Hunger* (2008) won the Caméra d'Or and the International Federation of Film Critics' award at the 2008 Cannes Film Festival.

SEE ALSO Aitken, Wilson, Video Art

Steve McQueen makes films that drastically renegotiate the language of cinema. In *Bear* (1993), two naked men circle and square up to each other. They lock together, their bodies straining one against the other. This violence quickly succumbs to tenderness. Their intertwined legs are shown in slow motion, as if they are dancing rather than fighting. They smile and caress, but quickly return to aggression. McQueen refuses to privilege either extreme, implying that they are entirely bound up with each other. The crude moral distinctions that we usually find in mainstream cinema are therefore denied.

In Deadpan (1997) he reconstructs a famous Buster Keaton sequence. McQueen stands under a falling wall, and is only saved by the lucky positioning of a window over his head. The film is projected across a whole wall and is reflected in the room's floor. Viewers are thus invited to step into the work and experience the dramatic moment for themselves. While Keaton's performance was a comedic routine that we could enjoy from a distance, here we are immersed in it and the work becomes a test of our endurance, with the wall repeatedly crashing down around us.

Both works question our relationship with film, contrasting its distanced presentation of bodily experience with reality, which always contains the possibility of desire and trauma. Films normally separate us from ourselves, denying any physical relation to their imaginary space. However, McQueen demands a bodily reaction, and in doing so he emphasizes the limitations of conventional films. And as much as his works provide a new direction for film, they also produce a hunger for reality and awareness that film can never provide.

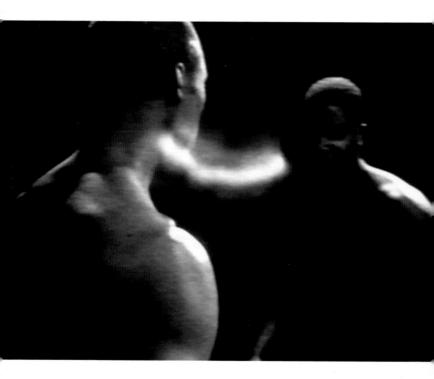

Bear 1993 | 16mm black and white film transferred to video 10 min 25 sec

JONATHAN MEESE

BORN Tokyo, Japan, 1970

Meese attended the Hochschule für bildende Künste in Hamburg, Germany, but left before completing his studies. He has had numerous solo exhibitions at institutions across Europe, including Kestner Gesellschaft, Hannover (2002): Schirn Kunsthalle, Frankfurt am Main (2004); MAGASIN Centre National d'Art Contemporain, Grenoble (2006); Deichtorhallen, Hamburg (2006); De Appel Centre for Contemporary Arts, Amsterdam (2007): and Fondació "la Caixa", Barcelona (2008), He participated in the Berlin Biennial (1998), the Reykjavík Arts Festival (2005) and the Yokohama Triennale (2008). Meese lives and works in Berlin and Hamburg.

SEE ALSO Kippenberger, Installation Art, Performance Art

Jonathan Meese is one of the most important artists to emerge from the Berlin art scene in the last decade. He is an Installation Artist, painter, sculptor and Performance Artist. The reckless, abandoned aesthetic of his work seems to reflect the zeitgeist of Berlin in recent times. Meese's installations resemble squatters' guarters, packed with recycled goods, urban debris and general clutter. His collages, drawings and paintings are similarly frantic, energized and ultimately chaotic. He has collaborated with other artists, such as lörg Immendorff, Albert Oehlen, Daniel Richter and Tal R. In all of Meese's works there are references to a myriad of cultural, historical, popular and mythological characters. Notorious tyrants such as Hitler, Mussolini and Stalin make frequent appearances. Meese has also designed theatre sets, and he wrote and starred in the play De Frau: Dr. Poundaddylein – Dr. Ezodysseusszeusuzur, which was staged at the Volksbühne theatre, Berlin, in 2007.

In 2006 Meese performed Noël Coward Is Back – Dr. Humpty Dumpty vs. Fra No-Finger in the Turbine Hall of Tate Modern, London. The cacophonous performance, most of which occurred in a boxing ring, involved numerous Nazi salutes alongside references to the Marquis de Sade, Richard Wagner, Stanley Kubrick and, one of Meese's favourites, Noël Coward. Like most of Meese's work, the performance mixed pop and historical iconography, resulting in a new kind of cutand-paste collage of symbolic meaning.

Noel Coward is back – Dr. Humpty-Dumpty vs. Fra No-Finger

Performance at the Tate Modern on 25 February 2006, London, UK

JULIE MEHRETU

BORN Addis Ababa, Ethiopia, 1970

Mehretu grew up in Michigan in the United States. She studied at the University Cheik Anta Diop in Dakar, Senegal (1990–91), was awarded a Bachelor of Fine Arts from Kalamazoo College, Michigan (1992) and received a Master of Fine Arts degree from the Rhode Island School of Design (1997). Her first solo show, entitled Ancestral Reflections, was shown at the Archive Gallery, New York (1995). She had a solo exhibition at the White Cube Gallery, London (2002). Mehretu lives and works in New York.

SEE ALSO Abstract and Representational Art

Although Julie Mehretu's paintings and drawings look abstract, they always include representational elements. The base layer of her layered compositions consists of diagrammatic images such as architectural schematics and maps. On top of this, Mehretu applies chaotic abstract marks that deny any possibility of easily deciphering the diagrams underneath.*Renegade Delirium* (2002) resembles an explosion, as if the matter of the urban schemata underlying the work is being dispersed across the

canvas, or perhaps suggesting that we are unable to perceive the depicted space correctly. This is an attack on the legibility of diagrams that purport to depict reality in a world where borders are constantly being redrawn.

Mehretu's approach to abstraction tends to include particular elements of Modernist abstract art. Her use of different views of buildings echoes the Cubists' use of multiple angles. Also, her use of different layers in the creation of pictorial space is something that we can see in the

work of the Russian Constructivists. One way of reading this appropriation of abstract techniques is to consider it as a display of signs of the abstract, to contrast with the representational elements of the paintings' base layers. Mehretu reveals the illusion of representation by comparing it with abstraction – that which is supposedly less "true to life". Her paintings consist of a collision of their methods and their contents; they attempt to reveal that the relationship between the two is not as simple as we might think.

Renegade Delirium 2002 | Acrylic on canvas 228.5 x 366 cm (90 x 144 in)

CILDO MEIRELES

BORN Rio de Janeiro, Brazil, 1948

Moving to Brasilia, he studied a number of subjects including visual arts and film at the Centro Integrado de Ensino Médio. His first solo show was held at the Museu de Arte Moderna, Salvador, Bahia (1967). In 1969 he was due to have work exhibited at the Paris Biennale, but the show was cancelled by Brazil's military government. His important exhibitions outside Brazil include *Projects* at the Museum of Modern Art, New York (1990) and a major retrospective at Tate Modern, London (2008–9).

SEE ALSO Smithson, Conceptual Art, Installation Art

The Brazilian Cildo Meireles is often considered to be a Conceptual artist, but his work always has an explicitly sensory side. In *Eureka/Blindhotland* (1970–75) a large area is surrounded by black netting and littered with black rubber balls. At the centre of the space is a pair of scales, which are given a looming presence by the dramatic lighting. The scales are perfectly balanced, despite the fact that they seem to contain uneven loads. Similarly the balls, which viewers are encouraged to handle, are of radically different weights despite being the same size. There is also an audible element to the work: a recording of the balls being dropped and a voice stating their weight and distance from the microphone. This work questions the truth of the visual while still encouraging sensual interaction. Viewers become empirical testers, discovering the work's oddities and inequalities for themselves.

This anti-authoritarian stance might represent an alternative to the military dictatorship in Meireles's home country, Brazil, at that time. Indeed, we can read Eureka/Blindhotland as covertly opposing the regime through its call to look beyond appearances. Furthermore, the oddly balanced scales seem like a thinly veiled reference to the uneven weightings that can underlie what is apparently just. That Meireles's statements are never definitive or explicit might partly reflect the repressive atmosphere surrounding the work's production. However, the work also seems to confirm the artist's more fundamental opposition to absolute authority, presenting political discourse as a process of collaborative discovery rather than a one-way transfer of thought.

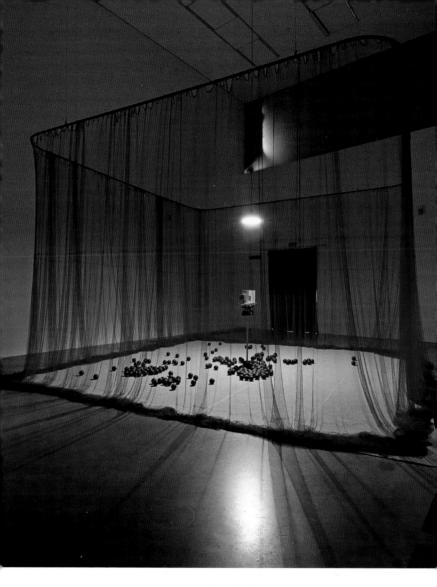

Eureka/Blindhotland 1970–75 | Installation rubber, lead, cork, textile, metal, paper and audio. Display dimensions variable.

ANNETTE MESSAGER

BORN Berck-sur-Mer, France, 1943

Messager studied at the École Nationale Supérieure des Arts Décoratifs in Paris (1962–66). She has had solo shows since 1973, including exhibitions at San Francisco Museum of Modern Art (1981); Bonner Kunstverein in Bonn, Germany (1990): the Museum of Modern Art in New York (1995): Museo de Arte Moderno in Buenos Aires (1999), Musée d'Art moderne de la Ville de Paris (2004); and the Hayward Gallery (2009). Messager participated in Documenta 6 and Documenta 11(1977 and 2002); Biennale of Sydney (1979, 1984 and 1990); Venice Biennale (1980, 2003 and 2005 recipient of the Golden Lion award); and Biennale d'Art Contemporain de Lyon (2000). The artist currently lives and works in Malakoff, a suburb of Paris.

SEE ALSO Feminism, High Art and Low Art, Installation Art

Annette Messager is one of France's leading contemporary artists. Using a variety of media, Messager works from a distinctly feminine perspective and sometimes with an explicitly feminist

agenda. Through a panoply of increasingly complex means, including elaborate and large-scale installations, Messager questions the role of women as defined by men and society. In a well-known work entitled My Collection of *Proverbs* (1974), Messager embroidered onto cloth famous French proverbs belittling women. The proverbs included statements such as "Women are wise except when they begin to think" and "A woman is like an egg; she is better when beaten". In appropriating these denigrating adages into her work, and representing them in a

traditionally feminine craft, Messager brings them under her control. Like many of her works, the piece also confounds traditional distinctions between high and low art. Messager rejects the label of "photographer" and challenges simplistic categorisation by mixing photography with painting, drawing and other media. She was awarded the Golden Lion Award in 2005 for her exhibition *Casino* at the French Pavilion at the Venice Biennale. The exhibition (an installation occupying the entire pavilion) took as its point of departure the story of Pinocchio and is conceived in three stages across three rooms, like an elaborate set design. Its culmination is a large, undulating piece of red fabric that floats in the air, before falling slowly to the floor. The installation plays upon the tension between immortality and death, while exploring duplicity, a theme that runs throughout Messager's work.

Casino

2005 | French Pavilion, 51st International Exhibition of the Venice Biennial 2005 400 x 160 x 120 cm (13 x 5 x 4 ft)

GUSTAV METZGER

BORN Nuremberg, Germany, 1926

After his evacuation to England, Metzger studied woodwork at O.R.T. Technical College in Leeds, and from 1946 attended art courses at the Cambridge School of Art and later in London. The Oxford Museum of Modern Art organized the first retrospective exhibition of his work (1998), and he had a solo exhibition at the Generali Foundation, Vienna (2005) and the Serpentine Gallery, London (2009). Metzger participated in Documenta 5 (1972), the Lyon and Venice Biennale (2003) and the Skulptur Projekte Münster (2007). Metzger lives and works in London.

SEE ALSO Reinhardt, Performance Art

Gustav Metzger takes as his subject matter the political, social and environmental disasters of his lifetime. It is difficult not to read his work within the context of his life. Born into a Jewish-Polish family in Germany, he was evacuated in 1939 to England as part of the Refugee Children's Movement or Kindertransport. Most of his family were killed by the Nazis. Twenty years after arriving in England, in 1959, Metzger wrote his "Auto-destructive Art" manifesto, which drew parallels between

acts of creation and acts of destruction. Utilizing various "ready-made" objects, items that could be viewed as the debris of a wasteful, capitalist society, Metzger used destruction to demonstrate the perilous state of a world under constant threat of nuclear warfare or the outbreak of violence on a calamitous scale. However, critics challenged the ability of his art to change the thing it mimicked.

Experimenting with various processes of destruction, Metzger devised what he

called an "aesthetics of revulsion". In 1961 he performed a now well-known performance on London's South Bank, using hydrochloric acid to destroy a nylon canvas. Pouring, painting and flinging the acid onto the nylon, he corroded the material within seconds. Metzger's interest in creating out of destruction, albeit momentarily, was also a means of subverting elements within the art world that existed only for financial gain. In 1966 Metzger organized the Destruction in Art Symposium, a forum for discussion attended by art-world luminaries such as Yoko Ono, John Latham and Hermann Nitsch. The meeting aimed to identify ways in which destruction in art could curtail destruction in social, political and environmental spheres.

Auto Destructive Art 1961

TRACY MOFFATT

BORN Brisbane, Australia, 1960

She studied visual communications at the Queensland College of Art. Her first feature film, *Bedevil* (1993), was shown at the 1993 Cannes Film Festival. She has had numerous solo exhibitions including at Fundació "la Caixa", Barcelona (1999); the Institute of Contemporary Art, Boston (1999); the Museum of Contemporary Art, Sydney (2003). Moffatt lives and works in Sydney.

SEE ALSO Identity Politics, Video Art

Tracey Moffat is one of Australia's most influential artists. Working primarily in photography and video, Moffat makes artworks in the style of Hollywood B-grade movies. She first caught the attention of the art world in her native Australia, with a series of nine photographs entitled *Something More* (1989), a title that suggests the existence of an underlying story behind the imagery. The potential narrative is an important aspect of her work and is further explored in *Scarred for* Life (1994), a series of photographs depicting people in everyday situations with each image accompanied by a caption implying a racist, sexist or homophobic reading of the image. Later works, such as *Up in the Sky* (1998), address the displacement of marginalized societies, particularly Aboriginal communities, and their depiction in the popular media. She consistently challenges the reliability of the photographic medium as a means of representation. In taking photographs of blatantly constructed scenes, Moffat exposes the possibility of manipulating reality in photography.

Moffat's imagery also addresses celebrity status, and how it can be created by the media. A series of images entitled Fourth (2001), which captures Olympic athletes who have just finished in the undesirable position of fourth place, examines the exact moment when celebrity status is not attained. In her video works Artist (2000) and Lip (1999). Moffat uses clips from TV programmes and popular movies to examine how entertainment media can encourage stereotypes. Moffat's adeptness at handling popular media to probe serious social and political situations ensures her position as a critical contribution to the artistic practice of her generation.

Tracey Moffatt

Useless, 1974 Her father's nickname for her was 'useless'.

Useless, 1974 1994 | Offset print, From the series Scarred for Life 80 \times 60 cm (31½ \times 23½ in)

MARIKO MORI

BORN Tokyo, Japan, 1967

Mariko Mori studied at Bunka Fashion College in Tokyo (1986–88) and also worked as a fashion model. She then moved to London, studying at the Byam Shaw School of Art (1988–89) and the Chelsea School of Art and Design (1989–92). She participated in the Independent Study Program of the Whitney Museum of American Art (1992–93). A solo exhibition entitled *Close-up* was held at the Project Room, New York (1993). Her first major exhibition in Japan, entitled *Mariko Mori Pure Land*, was held at the Museum of Contemporary Art, Tokyo (2002).

SEE ALSO Morimura, Installation Art, Video Art

Mariko Mori's works imply there is an increasing mediation of all experience and, despite being aesthetically futuristic, her art displays a present in which technology has already come to dominate the way that we relate to the world. Mori's *Link* (1995–2000) is a four-channel video installation with screens showing images of different geographic locations, both old and new.

Their only common feature is a futuristic, bubble-like form containing a horizontal figure. The hugely differing environments make the figure seem like a time traveller, appearing mysteriously in locations throughout time and space. Via the installation, the viewer is also transported to these places, despite actually remaining still. Indeed, it seems that we have already stepped into the future, but that in so doing we have lost any concrete connection with space or time. *Link's* virtual reality mimics our relationship with the world and dissolves reality's limitations by replacing it with images.

If Link shows how technology affects our experience of the world, Wave UFO (1999-2003) shows how it affects our interpersonal relationships. It looks like a futuristic sculpture, but inside it there is a video installation. The video is a visualization of viewers' brainwaves. picked up by electrodes and combined into a single sequence. In a sense then, the work is produced collaboratively by all those present. Although this activity might seem to draw the participants together. they are actually wedged apart; they are physically separated within the structure, and they rely solely on the screens around them for their perception of each other. Rather than this being a true community, it is a number of separate individuals artificially joined together.

Wave UFO 1999–2003 49.3 x 113.4 x 52.8 m (161 ft 3 in x 372 ft 3 in x 173 ft 3 in)

YASUMASA MORIMURA

BORN Osaka, Japan, 1951

Morimura received a Bachelor of Fine Arts degree from Kyoto City University of Art (1978). He had his first solo show at Galerie Marronier, Kvoto (1983). Work of his was featured in the Venice Biennale (1988, 1993 and 2007). His first solo show outside Japan was held at the Nicola Jacobs Gallery. London (1990). He had a touring show organized by the Museum of Contemporary Art, Chicago (1992). Solo shows include White Cube London (1999) and the Contemporary Arts Museum Houston (2003). He was nominated for the Hugo Boss Prize (1996).

SEE ALSO Mori, Sherman, Yue

Yasumasa Morimura's oeuvre consists entirely of self-portraits, but in all of these works Morimura is in disguise. In Self-portrait (actress)/Red Marilyn (1996), Morimura re-made a photograph of Monroe, posing himself in her place. As with all of his Actress series the resemblance is strong, but Morimura's masculine, Japanese face gives him away. In earlier works he inserted his image into famous paintings, such as in *Daughter of Art History (Princess A)* (1990), where he masqueraded as a young princess in a Velázquez portrait. In the works that mimic paintings, Morimura spreads lacquer over parts of their surfaces to look like brushstrokes. By mixing this technique with direct appropriation and digital manipulation, Morimura forces confusion over which areas are original and which are not.

That this mimicry of predominantly Western stars and artworks appears to be Morimura's only means of self-expression implies a clash between contemporary Eastern artists and the global art market. In Self-portrait (actress)/Red Marilyn, a battle between reality and fiction is fought on several levels. Morimura presents himself, but only through the lens of Monroe and the original image. Of course, Monroe was herself an actress and, as in the case of Warhol's famous prints, her image came to be diffused throughout Western culture, confusing the real Monroe with her projected image, even when she was supposedly not acting. So while there always appear to be elements of Morimura poking through his disguises, we must wonder how far these are part of yet another act.

Self-portrait (actress)/Red Marilyn 1996 | Ekta Ultra Color II 220 x 167 cm (86½ x 65¾ in)

SARAH MORRIS

BORN Kent, England, 1967

Sarah Morris grew up on Rhode Island in the United States. She received a bachelor's degree from Brown University, Rhode Island (1989), after studying for a year at Cambridge University (1987– 88). She participated in the Whitney Independent Study Program, New York (1989–90). Her first solo show, called *Citizens*, was shown at the New York Kunsthalle (1992). An exhibition of her films was shown at the New York Kunsthalle (1992). An exhibition of her films was shown at the Hirshhorn Gallery, Washington DC (2002). Morris's work was included in the Bienal de São Paulo (2002) and the Tate Triennial (2003).

SEE ALSO Ackermann, LeWitt, Abstract and Representational Art

Sarah Morris's paintings defy the medium's usual scale and thus function more like architecture. *Endeavor* [*Los Angeles*] (2005), spanned a large wall in the Palais de Tokyo, Paris, incorporating its doors and steps. It is hard to know how to approach a painting of this size and almost impossible to apprehend it as a whole. This difficulty is heightened by Morris's style, which involves complex abstract patterns of overlapping lines and

shapes that leave us with little to grasp in terms of an overall structure. The paintings are also made quite impersonal by their refusal to give away any trace of Morris's craft, bereft as they are of brushstrokes.

Endeavor [Los Angeles] followed on from her film Los Angeles (2004), which involves rapidly changing images from around the city, with swift cuts between celebrities, architecture and cosmetic surgery. The references to celebrity and cosmetic surgery might relate to Morris's glossy, impersonal technique, while

the architectural images relate to her architectural use of painting. Although both film and painting consist of parts that overlap and imply interconnection, these parts always defy being combined into a whole. Indeed, that can be said of a comparison between the two works; they have points of convergence, but these never define any clear statement. Maybe we can take this as a comment on Los Angeles, a city of overlapping elements that are both interdependent and conflicting. More generally, Morris's approach seems defined by a will to avoid strict structures and absolute legibility. While we usually think of art as a process of defining and balancing form, Morris's work bursts through all formal boundaries and refuses any precise apprehension.

Endeavor [los Angeles] 2005 | Palais de Tokyo Wall painting 6.8 x 37.2 m (22 ft 3 in x 122 ft)

JUAN MUÑOZ

BORN Madrid, Spain in 1953. DIED Ibiza, Spain, 2001

Muñoz studied at the Central School of Art and Design in London. His exhibitions throughout Europe and the United States included *Possible Worlds*, Institute of Contemporary Arts, London (1990); Documenta IX, Kassel (1992); *A Place Called Abroad*, Dia Center for the Arts, New York (1996); and the Venice Biennale (1997). Muñoz was the subject of a major retrospective that toured to Tate Modern, London; Museo Guggenheim Bilbao; Museu Serralves, Porto; and Museo Nacional Centro de Arte Reina Sofia, Madrid (2008–9).

SEE ALSO Gormley, Yue, Abstract and Representational Art, Installation Art

Juan Muñoz is known for his elusive, and sometimes unsettling, sculptures of life-like human figures. He rose to prominence in the mid-1980s with a series of works featuring a single human figure within an architectural setting. At a time when many artists eschewed figuration, Muñoz embraced it. Often situating his sculptures on balconies above eye-level, or employing optical tricks, such as the use of patterned

linoleum floors, to create the illusion of perspective, Muñoz was interested in the way a viewer encountered his work. His practice built upon the legacy of Minimalism and the viewer's dynamic relationship with the object and the space around it.

Muñoz also relied upon a number of recurring visual motifs to draw the viewer into a relationship with his sculptures. Among these motifs was the dwarf, which he used to insinuate a ubiquitous

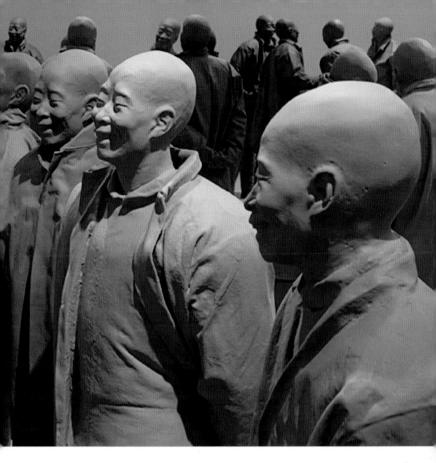

sense of "otherness". In the mid-1990s, Muñoz began to make his now wellknown "Conversation Pieces", sculptural installations that appeared to freeze a group of people in mid-conversation.

Muñoz's last great commission, made for the Turbine Hall of Tate Modern, London, was *Double Bind* (2001), which featured two lifts that moved through the gallery space and provided the viewer with different vantage points of an installation that was partly based upon illusion. Considered one of the great sculpture and installation artists of his generation, Muñoz described himself in an interview with James Lingwood simply as a "storyteller", a perception that highlights the narrative potential of his intriguing configurations.

Many Times (detail) 1999 | Polyester and resin Dimensions variable

TAKASHI MURAKAMI

BORN Tokyo, Japan, 1962

Murakami received his BFA, MFA and PhD from Tokyo National University of Fine Arts and Music. He is the founder of Kaikai Kiki Co., Ltd., now a large-scale art production company. Murakami has participated in solo exhibitions at leading institutions such as Museum of Contemporary Art, Tokyo (2001); Museum of Fine Arts, Boston (2001): Fondation Cartier pour l'Art Contemporain, Paris and the Serpentine Gallery, London (2002). Murakami is also the subject of a large-scale retrospective installation entitled ©MURAKAMI, touring at Museum of Contemporary Art, Los Angeles (2007); Brooklyn Museum, New York (2008): Museum für Moderne Kunst. Frankfurt am Main (2008); and the Museo Guggenheim Bilbao (2009). In 2010 he had an exhibition at the Palace of Versailles, France.

SEE ALSO Warhol, High Art and Low Art, Pop Art

Bright colours, psychedelic shapes and outlandish cartoon-like figures are the defining features of Takashi Murakami's imaginative oeuvre. Sometimes hailed as the Andy Warhol of his generation, Murakami is a master of blending elements of high and low culture in his art. Borrowing from genres of art history such as traditional Japanese landscape painting, Murakami is equally influenced by pop culture, particularly Japanese anime and manga. TIME - camouflage moss green (2009) is a painting from the Time Bokan series, which Murakami began in 1993. The series takes its name from a 1970s Japanese TV anime series. Working in collaboration with his studio, the international corporation Kaikai Kiki Co., Ltd., Murakami makes paintings, sketches, videos and sculptures, as well as T-shirts, key chains, mouse pads, and even limited edition Louis Vuitton handbags. Murakami embraces technological and computer processes, often achieving the super polished, high-gloss aesthetic of mass-produced goods.

There are a number of recurring characters in Murakami's work. Figures such as DOB and Mr Pointy frequently make appearances in different forms, establishing individual works as part of a larger body of work. Unlike his Pop predecessors, such as Roy Lichtenstein, who also adopted from the world of comics and cartoons, Murakami invents his own characters. Despite the immediate childlike charm of much of Murakami's work, there is also a sinister edge to it. Tan Tan Bo Puking – a.k.a. Gero Tan (2002), portrays a black-toothed monster

ejecting and excreting bodily fluids. The figure is set against a brilliant blue background. The colours of the multi-panel painting are so vivid they recall playful, fictional worlds and video game graphics. Most of Murakami's paintings are arranged to give the illusion that they lack depth, a characteristic he calls "superflat". TIME – camouflage moss green 2009 | Acrylic on canvas mounted on aluminum frame 300 x 300 x 5 cm (118 x 118 x 2 in)

WANGECHI MUTU

BORN Nairobi, Kenya, 1972

In the 1990s Wangechi Mutu moved to New York to study art and anthropology, receiving a bachelor's degree from Cooper Union (1996) and a master's degree in sculpture from Yale University (2000). Her first solo exhibition, entitled *Pagan Poetry*, was shown at the Susanne Vielmetter Los Angeles Projects (2003). A solo show of her work, called *The Chief Lair's a Holy Mess*, was shown at the San Francisco Museum of Modern Art (2005–06). She was awarded the Deutsche Bank Artist of the Year award in 2010.

SEE ALSO Ofili, Quinn, Shonibare, Simpson Abstract and Representational Art, Identity Politics, Post-colonialism

One of the most pre-eminent African artists now working in New York, Mutu draws on her experiences and observations to contrast Western and African cultures. Her collages often focus on the body, representing its inner ambiguities and external determinations. In "*This you call Civilization?*" (2008), one figure has its flesh stripped away and its muscle exposed while the other's organs are on display. With their protective layers removed, these figures appear to have been physically mutilated or ravaged by disease. The reference to "civilization" suggests that this situation is man-made. The figure on the right appears to emerge from inside a plant and we can only take this unnatural state of affairs as resulting from human intervention into nature. Mutu's use of collage emphasizes the ruptures within her figures and also demonstrates that these bodies, which threaten to disintegrate or collapse at any moment, are externally constructed.

The reason for these mutilations becomes clear in Mask (2006) an erotic photograph of a black woman, pasted over a photograph of an African sculpture. Its mixture of exotic pleasures and dark horrors embodies the duality of Western images of Africa. The dark voodoo mask lurks behind the seductive woman, but also pokes its nose and teeth through. The images thus merge, demonstrating the Western projection of "otherness" onto Africans and women. This process is a metaphorical deformation of bodies, helping us to understand the more literal physical mutilations that Mutu represents elsewhere.

"This you call Civilization?"

2008 | Mixed media, ink, collage, contact paper on Mylar 249 x 132 cm (98 x 52 in)

BRUCE NAUMAN

BORN Fort Wayne, Indiana, USA, 1941

He studied mathematics, physics and art and received a master's degree in fine artsfrom the University of California (1966). Giving up painting in 1964, he focused instead on sculpture, performance and film. He had his first solo show at the Nicholas Wilder Gallery, San Francisco (1966). Nauman has had a number of major retrospectives, including one organized by the Walker Art Center, Minneapolis, United States, which toured a number of countries (1993-95) and a large-scale survey at the Hamburger Bahnhof. Berlin (2010), Nauman lives and works in New Mexico. He was chosen to represent the USA in the 53rd Venice Biennale

SEE ALSO Graham, Conceptual Art, Performance Art, Video Art

Bruce Nauman's The true artist helps the world by revealing mystic truths (1967) is a neon sign bearing that phrase. Nauman's use of neon ridicules the statement, comparing it with advertisements and implying its role in art's self-promotion. The work is also highly ambiguous. Its circular shape mirrors the circularity of the statement itself – do artists become "true" by revealing truths, or do they define the truth by their own status as "true"? This ambiguity also seems to be present in our own conception of art. If we find Nauman's statement ridiculous, then on what grounds can we take art seriously? What value can art have if it is not a revelation of truth? And if not, does this imply that it is somehow deceitful?

This work is only certain in its uncertainty. It ridicules our silent assumptions by writing them in large neon letters and vet forces us to confront them through the same medium that we are supposed to be questioning. By displaying his own uncertainty, Nauman destroys any possibility of revealing a "mystic truth" since all truth is refused. This approach is characteristic of his work, as in Eating my words (1966–67), which is centred around a pun that destroys the singularity of meaning by displaying the duality of that phrase. This transfers artistic control from the act of creating to the act of reading, which is the process that ultimately defines the work. Although it might seem that Nauman mocks us by tearing down our most basic assumptions about art and language, he actually allows us an active role in its constitution rather than just a passive role in its acceptance. Art's mysticism is thus removed and we are allowed to become part of the discursive process that is itself the production of "truth".

The true artist helps the world by revealing mystic truths (Window or wall sign) 1967 | Fluorescent tubes 150 x 139.5 x 5 cm (59 x 55 x 2 in)

SHIRIN NESHAT

BORN Qazvin, Iran, 1957

Shirin Neshat moved to the United States in 1974 and received a Bachelor's of Fine Arts degree from the University of California, Berkeley (1983). She then moved to New York but did not make any art until a trip back to Iran in 1993. In that year she had her first solo show at Franklin Furnace, New York. She had work featured in the Venice Biennale (1995 and 1999) and was awarded the Grand International Prize for the latter show. She had a solo show at the Whitney Museum of American Art, New York (1998–99).

SEE ALSO Identity Politics, Video Art

Shirin Neshat is an Iranian artist who was educated in New York and still lives there today. Her art deals with both this separation from her Iranian roots and Iran's transformation since the revolution in 1979, which she was shocked to see upon her return. *Rebellious Silence* (1994) displays an Iranian woman with Arabic writing on her face and a gun in her hands. The gun appears to separate her into two halves: one half is cast in shadow, while the other is much brighter. This contrast is echoed by the image's black and white tones. The work's visual duality reflects how many Westerners might perceive this image of a Middle Eastern woman. We cannot be sure whether she holds the gun for defence or aggression, or whether she is a victim or an instigator of violence. Neshat ambiguously combines both in a single image and thus negates them, demanding recognition of a broader network of oppression and freedom, violence and revolution.

More recently. Neshat has concentrated on film. In Possessed (2001). a mad woman removes her veil and goes out in public. While some harangue her, others think that she should be left alone, as if her madness exempts her from censure. Neshat is implying that madness brings freedom, since it crosses all borders laid down by power. But Possessed is less a romanticization of madness than a criticism of domination, and, like Rebellious Silence, it raises ambiguities: defence or aggression, freedom or automatism. Both works expose the simplifications that uphold these supposed oppositions and point to the complexity of contemporary politics.

Rebellious Silence 1994 | RC print and ink 118.5 x 79 cm (46½ x 31 in)

ERNESTO NETO

BORN Rio de Janeiro, Brazil, 1964

Neto was educated at the Escola de Artes Visuais Pargua Lage and the Museu de Arte Moderna, both in Rio de Janeiro. He has participated in numerous international exhibitions, including the Bienal de São Paulo (1988): the Biennale of Sydney (1998); the Liverpool Biennial (2000 and 2002); and the Venice Biennale (2001 and 2003). He has had solo exhibitions at museums and aalleries around the world, including the Institute of Contemporary Arts, London (2000); Museum of Contemporary Art, Sydney (2002); Malmö Konsthall, Sweden (2006); Museo d'Arte Contemporanea Roma (2008-09); and the Hayward Gallery, London (2010). Neto lives and works in Rio de Janeiro.

SEE ALSO Clark, Kapoor, Oiticica, Relational Aesthetics

Ernesto Neto's distinctive fabric sculptures and participatory environments continually push the boundaries of art, architecture and the sensorial experience. Emphasizing the importance of the viewer's active participation in his work, Neto follows in the tradition of Brazilian Conceptual artists Hélio Oiticica and Lygia Clark. Their work

in the 1960s sought to expand the aesthetic experience beyond the purely visual, encouraging visitors to touch, smell and walk inside the artworks. By the early 1990s, Neto had developed a unique sculptural repertoire involving organic shapes made by filling Lycra with lead or Styrofoam pellets. The sculptures usually hang from the ceiling, creating a maze of soft, amoeba-like forms. The thin, malleable Lycra acts like a skin. Sometimes Neto shapes the Lycra by filling it with aromatic ground spices such as pepper, cumin, cloves and ginger.

Neto's É ô Bicho! (2001), shown at the Venice Biennale exemplifies the kind of spatial labyrinth that he creates with his unusual shapes. In this work, Neto plays with the idea of sinking and stretching, creating a sculptural form that is at once sensuous and grotesque. In the late 1990s, Neto began to make truly immersive environments, in which the visitor is invited to enter the work. Made from large amounts of material with soft textures and muffling qualities, his environments encourage an intimate, almost spiritual relationship between the viewer and the artwork. At

times the sensuous qualities of the work take on sexual connotations, as the artworks explore the spaces between ourselves and others, and inside our own bodies.

É ô Bicho!

2001 | Lycra tulle, poliamid tubes, hooks, tumeric, black pepper, and clove Dimensions variable Installation view Exhibition Arsenalle 49, Esposizione Internazionale d'Arte, Venice Biennale

CHRIS OFILI

BORN Manchester, England, 1968

Chris Ofili studied in London at the Chelsea School of Art and the Royal College of Art. Ofili has had solo exhibitions at numerous institutions, including the Southampton City Art Gallery, England (1998); the Serpentine Gallery, London (1998); the Studio Museum in Harlem, New York (2005); Kestner Gesellschaft, Hannover (2006); and Tate Britain, London (2010) among others. He served as a Trustee/Council Member to the Tate Gallery, London (2000–05).

SEE ALSO Hirst, Mutu, Post-Colonialism, Young British Artists

Chris Ofili is one of the best-recognized painters of his generation. He makes large, colourful canvases that combine oil paint with unconventional materials such as glitter, resin and elephant dung. Paint is applied traditionally and in bead-like dots. There is a conscious flattening of the picture plane, and bold applications of colour in careful layers. Elephant dung is usually varnished and applied directly to the surface of the painting in mounds, or used to support the canvas on the floor, as in the work *Afro* Apparition (2002–3). Ofili frequently turns to biblical themes in his work, often juxtaposing them with elements inspired by popular culture, such as comics from the 1970s. Born in the United Kingdom but of Nigerian heritage, Ofili also explores issues of black culture and history. His work sometimes includes references to rap music and blaxploitation films, as well as aspects of traditional African art. Recently, Ofili has begun to explore sculpture in more depth, while continuing to explore his habitual subject matter.

Ofili rose to prominence in the early1990s. His work was collected by Charles Saatchi, and featured in the influential Young British Artists exhibition, Sensation (1997). Ofili was chosen to represent Britain at the Venice Biennale in 2003. His exhibition Within Reach at the Biennale was housed in an architectural environment conceived in collaboration with the architect David Adjaye. The Upper Room (1999–2002), an installation in the Tate collection, includes thirteen paintings on canvas in a specially designed, chapel-like environment also conceived in collaboration with Adjave. The work raises questions about reliaion, civilization and nature.

Afro Apparition

2002–2003 | Acrylic paint, oil paint, polyester resin, glitter, map pins and elephant dung on linen, with two elephant dung supports 275×214 cm (10814×8414 in)

HÉLIO OITICICA

BORN Rio de Janeiro, Brazil, 1937 DIED Rio de Janeiro, Brazil, 1980

From 1954 he studied with the abstract painter Ivan Serpa, later becoming a member of the Frente Group, which Serpa founded. He co-founded the "Neo-Concretist Group" (1959), which rejected the strict doctrines of abstract art in favour of a more experimental approach. He had his first solo show at the Museum of Modern Art in Rio de laneiro. In the 1960s he began to focus on sculpture, although he increasingly blurred the lines between different media. A major retrospective of his work was held at Tate Modern, London, and the Museum of Fine Arts in Houston (2007).

SEE ALSO Caro, Clark, Installation Art, Relational Aesthetics

Although Hélio Oiticica began his career as an abstract painter, he quickly rejected this approach as overly specific. His subsequent work can be seen as a process of integrating his early style into a more general engagement with space. *Grand Nucleus* (1960–66) has a pivotal position in this process. His earlier work can broadly be designated as either sculpture or painting, but his later work completely abandons such categories, instead utilizing non-artistic objects. *Grand Nucleus*, meanwhile, sits somewhere in between the two – it clearly contains painterly, sculptural and even architectural elements and yet it transcends all three.

Grand Nucleus consists of a number of pieces of wood hung from a ceiling. It resembles a three-dimensional rendering of Oiticica's earliest abstract paintings, but this three-dimensionality aives it a sculptural element. Furthermore, the work seems architectural in that viewers are invited to walk in and around it as they would a building. Grand Nucleus could be taken as a final realization of Oiticica's early work, and that process of realization reveals the problems that were already inherent in his abstract paintings. By attaching the work to any single medium we disallow it from merely functioning as an engagement with space in general - only through the dissolution of the medium could art come into full and explicit contact with its environment, rather than giving the appearance of inwardness. Grand Nucleus is thus a revelation of both art's potential and of its shortcominas. with the implication that only through an understanding of the latter can we hope to fulfil the former

Grand Nucleus

1960–66 | Oil and resin on wood fibreboard 670 x 975 cm (263½ x 383¼ in)

CLAES OLDENBURG

BORN Stockholm, Sweden, 1929

He and his family moved to the United States (1936), where he studied literature and art history at Yale University (1946-50), and then art at the Art Institute of Chicago (until 1954). In the late 1950s he became known for producina "Happenings", an early form of Performance Art. From the mid-1960s onwards he has focused on large public sculpture, often collaborating with Coosje van Bruggen. He has had a number of major shows, including a retrospective organized by the National Gallery of Art in Washington DC and the Solomon R. Guagenheim Museum. New York (1995).

SEE ALSO Dine, Lichtenstein, Oldenburg, Warhol, High Art and Low Art, Pop Art

Claes Oldenburg is among the most literal of Pop Artists, creating artworks in which those two terms violently collide. *Floor Burger* (1962) is one of his well known 'soft-sculptures': enlarged commercial objects, assembled from painted canvasses. While the materials are those

of high art, its form is that of by a popular image. The sculptures' softness thus implies high art's deflation, but also makes the burger appear to disintegrate or rot. This mutual dearadation is also at work in his earlier installation The Store (1961). The Store was a studio which also functioned as a shop from which Oldenburg sold artworks. These works were versions of everyday objects, made from muslin and covered in thick quasi-Expressionist paint. Again, Oldenburg produced objects as a confrontation of academic art and consumer society, except that in The Store he did so as a direct representation of that society and its logic of profit.

While his early works maintained a parodic link to high art, his more recent sculptures have become absolutely dominated by commercial images. perhaps reflecting their increasing cultural supremacy. These sculptures, such as Binoculars (1991) are colossal, dominating people and buildings alike. They invade public spaces, like B-movie monsters come to crush traditional public sculpture. However their overblown size also makes them function as self-parody; by calling attention to his objects' act of domination, Oldenburg always undermines them. As in his soft sculptures then, he only creates these commercial images so that we can watch them wither away.

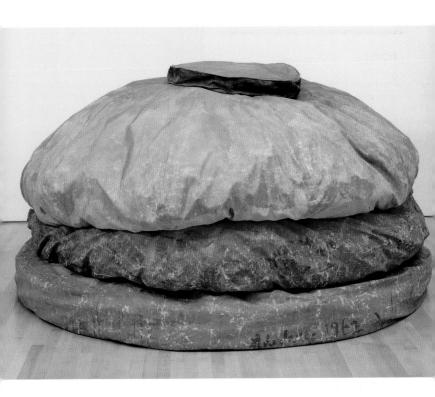

Floor Burger 1962 | Acrylic on canvas filled with foam rubber and cardboard boxes 132 x 213.5 cm (52 x 84 in)

GABRIEL OROZCO

BORN Jalapa, Mexico, 1962

Gabriel Orozco studied at the Escuela Nacional de Artes Plásticas in Mexico City (1981–84) and at the Círculo de Bellas Artes, Madrid (1986-87), He was awarded the DAAD Artists in Residence Fellowship (1995) and worked in Berlin for a year. He had had numerous solo shows including at New York's Museum of Modern Art (1993): Museum of Contemporary Art, Los Angeles (2001); Hirshhorn Museum, Washington DC and Serpentine Gallery, London (both 2004); and Tate Modern, London (2011). He participated in Documenta 11, Kassel (2002) and Venice Biennale (2003 and 2005).

SEE ALSO Conceptual Art, Installation Art

Gabriel Orozco uses various media to set up and record the poetry of transitory moments. *Mis Manos Son Mi Corazón* (My Hands Are My Heart, 1991) is a pair of self-portraits. In the first, Orozco squeezes a ball of clay in his hands, and in the second, he opens them, revealing the now heart-shaped clay in front of his chest. The work symbolizes artistic activity – an encounter between Orozco and his

material that lays bare his heart. A similar encounter takes place in the work *Corner Face* (1993), which is an imprint of Orozco's face. The work resembles the suggestive inkblots used in the Rorschach psychometric test in that the viewer is invited to interpret the imprinted face. With *Corner Face* it is our encounter with the material object that reveals something hidden inside us.

Ping Pond Table (1998) consists of the four halves of two ping-pong tables arranged in the shape of a cross around a

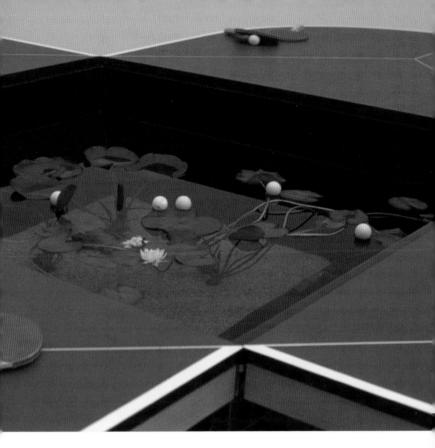

small, square lily pond. Orozco gives no instructions on how to negotiate the tables, instead providing bats and balls and allowing them to be used freely. As with *Corner Face*, he sets up an encounter and allows it to play out in his absence. In both it is the participation of the viewer that activates the work, turning it from an inert object into a dynamic process. The process is both acted out and embedded within the object, which is reconfigured as both a space for interaction and the embodiment of an exchange between individuals. While Orozco continues the recent trend toward participatory art, he retains the art object as an integral component, as the poetic distillation of a personal exchange.

Ping Pond Table 1998 | Modified ping pong table, water lilies, soil, stones and water 76 x 426 x 426 cm (30 x 167³/4 x 167³/4 in)

DAMIÁN ORTEGA

BORN Mexico City, Mexico, 1967

Damián Ortega' still lives and works in Mexico City. He started his artistic career as a political cartoonist. He had his first solo exhibition, entitled Fuerza Viva, at the Galería Etnia, Mexico City (1991). Among the prizes he has been awarded is the Torino Prize from the Fondazione Sandretto Re Rebaudengo per L'Arte, Turin, Italy. He represented Mexico at the Venice Biennale (2003). The Beetle Triloav and Other Works was a collaborative show with the Museum of Contemporary Art, Los Angeles (2005–6). He had an exhibition entitled Nine Types of Terrain at the White Cube Gallery, London (2007).

SEE ALSO Sierra, Installation Art

Damián Ortega's *The Beetle Trilogy* consists of three works, all involving a Volkswagen Beetle. In *Cosmic Thing* (2002), Ortega separated the car into its constituent parts and then hung them individually from the gallery's ceiling. This presented the vehicle as a mechanical system, but also hinted at its systematic production. Although of German design, the car was assembled in Ortega's native Mexico. The separation of the car comes

280

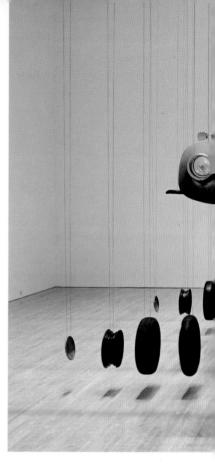

to represent the dispersal of industry and wealth across the globe. This relation between the object and its place of production is further emphasized in the third part of the trilogy, a film called *Beetle '83, Escarabajo* (2005), in which the car is driven to its possible place of manufacture at the North American Volkswagen factory in Puebla, Mexico.

The second part of the trilogy, *Moby Dick* (2004–5), is a performance involving

a tug of war between Ortega and the Beetle in which he tries to physically manoeuvre the car using ropes and pulleys. This seems to satirize the clichéd notion of a battle between man and machine. Ortega's comment on the car's relationship to the Mexican economy seems defused by his attempts to pull it. The point is perhaps a refusal of art's polemical force. By using the format of the trilogy, Ortega is able in the same work both to present a point and to undercut it entirely. The result is that viewers are allowed to find their own way into the ideas raised by Ortega, rather than merely following in his wake.

Cosmic Thing 2002 | Disassembled 1989 Volkswagen Beetle | C-print 673 x 701 x 752 cm (265 x 276 x 296 in)

TONY OURSLER

BORN New York City, NY, USA, 1957

He received his bachelor's degree in fine arts from the California Institute for the Arts. He has had solo exhibitions at Walker Art Center, Minneapolis (1982); Pompidou Centre, Paris (1986); Kunstwerke, Berlin (1993); Magasin 3, Stockholm (2002); Museo D'Arte Contemporanea Roma (2002): Aarhus Kunsthaus, Aarhus (2003); and Galerie National du Jeu de Paume, Paris (2005), amongst others. Massachusetts Museum of Contemporary Art (Mass MoCA) organized a mid-career survey of Oursler's work (1999) that travelled to a number of venues across the United States. The artist continues to live and work in New York.

SEE ALSO Kelley, Paik, Installation Art, Video Art

Tony Oursler is well known for pushing the boundaries of video as a medium. In the 1980s he began to think of different ways in which an image could be detached from a screen. At the time, installation art was becoming increasingly prevalent, but projectors were still cumbersome, unwieldy and technically limited. Artists such as Nam June Paik had already used the television as an object in an artwork. Oursler started to experiment with different ways of working with the image as a projection of light, such as reflecting it in glass, mirrors or water. In the late 1980s, LCD (liquid crystal display) mini video projectors became more widely available and, in the early 1990s, Oursler began to use this technology to project images directly onto objects, and often onto blank dummy faces, as in Autochthonous AAAAHHHH (1995). The process of projecting onto something suggests the psychological phenomenon of a subject projecting his or her internal thoughts onto an external subject. Oursler's use of projection also reflects his interest in different forms of representation in the mass media.

Oursler's projections have taken many forms. In addition to projecting faces, he has frequently worked with eyes. Having filmed a human eye for an extended period of time, he projects the result onto a spherical shape. The technique enables a prolonged, unnaturally close-up analysis of the eye. Sometimes Oursler's projections are accompanied by a voice interjecting comments or an entire narrative. The conjunction of human qualities and innate objects is unsettling and often startling.

Autochthonous AAAAHHHH

1995 | Installation, Video and mixed media 200 x 150 x 150 cm (78¾ x 59 x 59 in) (Approximately) Duration: 16 min 33 sec

NAM JUNE PAIK

BORN Seoul, Korea, 1932 DIED Miami, Florida, 2006

Paik studied at the University of Tokyo, and then Munich University, Germany. He exhibited widely throughout his life, with major retrospective exhibitions at the Whitney Museum of American Art, New York (1982) and the Solomon R. Guggenheim Museum, New York (2000).

SEE ALSO Beuys, Installation Art, Video Art

Nam lune Paik is considered to be the world's first video artist, and an astute cultural commentator on the advent of new technologies. By his own account, Paik was the first person to use the phrase "information superhighway", as early as 1974. Born in Korea, Paik was trained as a classical pianist and studied composition in Tokyo, before travelling to Germany, where he met the avant-garde composer John Cage, and the founder of the Fluxus movement George Maciunas. Paik was soon invited to join the movement. Paik had his first solo exhibition, Exposition of Music-Electronic Television (1963), at the Galerie Parnass in Wuppertal, Germany. The exhibition featured an arrangement of televisions that

Paik had adjusted to achieve distorted reception. Visitors to the exhibition could further distort the images on the televisions with the use of a magnet. Inviting viewers to interact with the piece in this way was revolutionary for the time, and subsequently influenced the way viewers interact with both art and technology.

Paik was committed to finding ways in which he could develop video and the moving image as an art medium. In 1971, he and his frequent performance

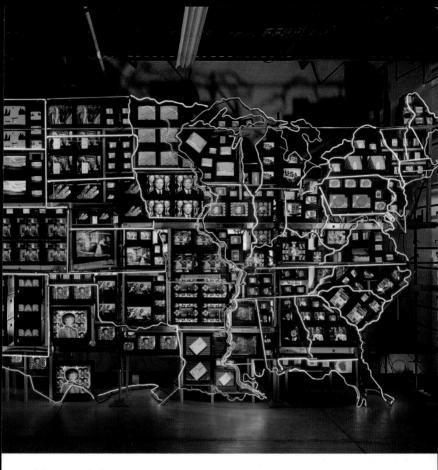

collaborator, Charlotte Moorman, combined video, music and performance in a piece entitled *TV Cello*, which consisted of several televisions stacked to form the shape of a cello, "played" by Moorman while the televisions displayed images of her and other cellists. After decades of experimenting with the use of the electronic image in art, Paik moved, in his later years, towards an investigation of the laser as a new form of sculptural art and installation. [Electronic Superhighway: Continental U.S. 1995 | Video installation 49-channel closed circuit video installation, neon, steel and electronic components 4.57 x 122.2 x 1.2 m (15 x 401 x 4 ft) (Approximately)

CORNELIA PARKER

BORN Cheshire, England, 1956

Parker studied art at Gloucestershire College of Art and Design and Wolverhampton Polytechnic before receiving her MFA from Reading University (1982). She was shortlisted for the Turner Prize (1997). She has had solo exhibitions at the Serpentine Gallery, London (1998); Institute for Contemporary Art, Boston (2000); and Galleria Civica d'Arte Moderna, Turin (2001), among others. The Victoria and Albert Museum in London commissioned a permanent installation of her work in 2001, and pieces are included in the collections of museums and galleries such as Tate Modern, London, and the Museum of Modern Art, New York.

SEE ALSO Installation Art, Young British Artists

In her large-scale installations and suspended sculptures, Cornelia Parker transforms destructive energy into poetic moments. In earlier works she has steamrolled, shot at and exploded different objects. The actions in her work recall the kind of destruction that takes place in cartoons, with the emphasis on big bangs and improbable annihilations. In its orchestration, representation and containment of uncontrollable forces, Parker's work harnesses the volatile, unpredictable and dangerous.

In a now well-known technique. Parker suspends fragments of supposedly exploded objects to create a vague reconstruction of the object in the midst of the explosion. Cold Dark Matter: An Exploded View (1991) is an exploded garden shed. A symbol of British culture, the shed was first exhibited, prior to destruction, at Chisenhale Gallery, in London's East End. A few months later it returned to the gallery as thousands of fragments suspended from the ceiling. In the centre of the piece is a single light bulb, which looks like the source of the explosion. The light from it creates large dark shadows on the walls of the gallery. Parker's shed was blown up with the assistance of the British Army. In soliciting the help of the army in this way, she suggests the institution's capacity for destruction, as well as protection. Cold Dark Matter: An Exploded View addresses modern-day fears of bombs, explosions and terrorist activity in everyday life. In recent works. Parker has turned toward the investigation of issues such as alobalization and the influence of mass media.

Cold Dark Matter: An Exploded View 1991 | Mixed media 400 x 500 x 500 cm (157½ x 196¾ x 196¾ in) (Approximately)

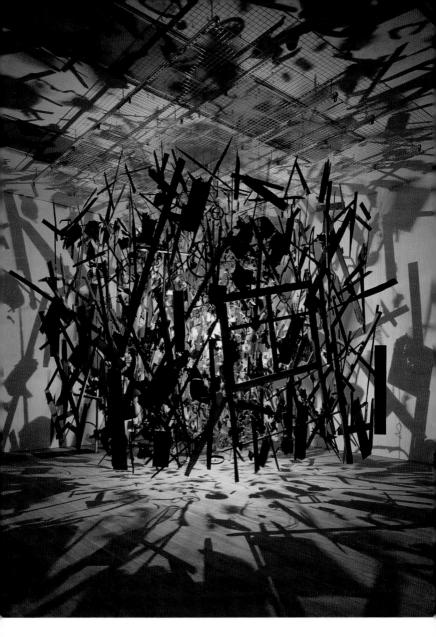

PHILIPPE PARRENO

BORN Oran, Algeria, 1964

He studied at the École des Beaux-Arts de Grenoble and the Institut des Hautes Études en Arts Plastiques, Palais de Tokyo, Paris. He has had solo shows at the Moderna Museet, Stockholm (2001); ARC, Musée d'Art moderne de la Ville de Paris (2002); Portikus, Frankfurt (2002); Kunstverein München (2002); Museum of Modern Art in San Francisco (2002–03); CCA Kitakyushu, Japan (2003); Kunsthalle Zürich (2006); Pompidou Centre, Paris (2009); and the Serpentine Gallery, London (2010). Parreno lives and works in Paris.

SEE ALSO Höller, Huyghe, Tiravanija, Relational Aesthetics

Philippe Parreno works across a variety of media and has collaborated with filmmakers, architects, curators, ventriloquists, artists, writers and playwrights, amongst others. His practice is primarily concerned with deconstructing and reinventing the various layers that constitute our complex reality, but his investigations can take many trajectories. In the work *Speech Bubbles* (2007), an ominous cloud of balloons in the shape of cartoon speech bubbles occupy a room.

In this instance, the visitor becomes a collaborator as he or she projects her own ideas of what thoughts and words are encased in the black balloons.

In his projects, Parreno frequently works with pre-existing material and manipulates it or creates a new narrative structure around it, raising questions of authorship and authenticity in the process. For the work *No Ghost Just a Shell* (2000–03), made in collaboration with French artist Pierre Huyghe, the artists acquired the

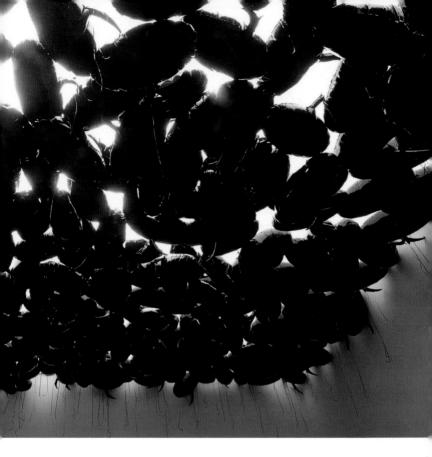

copyright to a Japanese manga character named Annlee. Parreno and Huyghe used the Annlee computer file as a point of departure for an extended artwork in which several artists were invited to bring the character to life through a variety of means, including animation, posters, paintings and books. The work playfully calls into question the distinction between reality and fiction, while forging new collaborative structures among artists.

Parreno also frequently works with

film, an obvious vehicle for fantasy and constructed reality. *The Boy from Mars* (2003), one of Parreno's best known films, is the story of a mysterious piece of architecture in a Thai field. As in most of Parreno's work, the conundrum of separating reality from fiction is never truly resolved.

Speech Bubbles 2007 | Black Mylar Balloons Dimensions variable

GIUSEPPE PENONE

BORN Garessio, Italy, 1947

Giuseppe Penone received a diploma in sculpture from the Academy of Fine Arts, Turin (1970). He had his first solo show at the Contemporary Art Deposit, Turin (1968). His work has been included at the Venice Biennale (including 1978 and 1996), and he was chosen to represent Italy there (2007). He had a solo show at the Museum of Contemporary Art, Chicago (1983). He won the Schock Prize for the Visual Arts (2001). Penone had a solo show at the Pompidou Centre, Paris (2004).

SEE ALSO Kounellis, Pistoletto, Arte Povera

Giuseppe Penone is primarily thought of as a sculptor, but from late 1960s until the present day he has worked in many media, also including installation, photography and film. Despite this variety of media, his work is unified by its focus on the relation between humanity and nature. His series *Light Traps* (1995) consists of a number of works that compare human eyes with leaves in that both are receivers of light. In one example, a photograph of the artist's eyes is placed in a bare tree as if the eyes were its

leaves. The staring eyes, while apparently active in their gaze, are also shown to be passive in their reception of light and illuminated objects. Rejecting a one-sided view of man exploiting nature or bending it to his will, Penone presents man and nature in balance, with each acting upon and receiving the other.

Some of Penone's works nevertheless deal specifically with the traces that we

leave in nature. In his performance series Maritime Alps (1968), Penone left nail marks in the bark of a tree, forever scarring it with the imprint of his act. However, in To Turn One's Eyes Inside Out (1970) he photographed himself wearing mirrored contact lenses; by presenting the image that reached his eyes as the content of his work, he removed his own mediation. Maritime Alps equates human intervention with violence, while To Turn One's Eyes Inside Out presents our equivalence with the world around us. By refusing to separate humanity from nature, Penone is ultimately warning us that violence against nature is violence against ourselves.

Trappole di Luce (Light Traps) 1995 | Photo, porcelain, tree Dimensions variable

GRAYSON PERRY

BORN Chelmsford, England, 1960

Grayson Perry studied at Braintree College of Further Education and at Portsmouth Polytechnic. He has had solo exhibitions at the Stedelijk Museum, Amsterdam (2002); Andy Warhol Museum, Pittsburgh (2006); and Mudam, Luxembourg (2008). He has participated in group exhibitions around the world, at institutions including Whitechapel Gallery (2000); Tate Liverpool (2004); and the Museum of Modern Art, New York (2006). He was awarded the Turner Prize (2003). He curated Unpopular Culture (2008-10), an Arts Council touring exhibition that began at De La Warr Pavilion, Bexhill. Perry lives and works in London.

SEE ALSO Identity Politics

Grayson Perry's media of choice are ceramics, embroidery, textiles, cast iron and printmaking and he often makes use of photographic imagery in his work.. After working in performance and film in the 1980s, the artist gained international acclaim when he turned his attention to pottery. Perry's ceramic creations include autobiographical images of himself, as well as depictions of his assumed alter ego, "Claire". The artist frequently appears in public dressed as Claire, and is now commonly referred to as "the transvestite potter". The ornate, colourful surfaces of Perry's ceramic vases belie his dark subject matter and pointed social critiques. He uses the curved surface of the vase to develop narratives through figurative imagery, incorporating art history, politics and consumer culture as well as sex scenes and allusions to violence.

Perry's work is also an exploration of the perceived second-rate status of embroidery and pottery, which are often considered craft but not high art, and are pejoratively dismissed as "women's work". Subverting our expectations of these media, he includes in the repeated patterns of his tapestries images of ejaculating penises, jet aircraft, hypodermic needles and other unsettling subjects. Subverting our expectations of these media, he includes in the repeated patterns of his tapestries images of ejaculating penises, jet aircraft, hypodermic needles and other unsettling subjects. Attracted to Suffering (2005) depicts a number of faces bearing expressions of agony. The faces are arranged into innocuous flower shapes. As a spherical object, the surface of the vase can never be viewed all at once. and Perry's intricate renderings encourage a slow and close inspection.

[Above] Self Portrait with Eyes Poked Out 2004 | Glazed ceramic 55 x 34 cm (21¾ x 13½ in)

[Above] Attracted to Suffering 2005 | Glazed ceramic 75 x 50cm (29½ x 19¾ in)

RAYMOND PETTIBON

BORN Tucson, Arizona, 1957

Raymond Pettibon earned a degree in Economics from the University of California, Los Angeles (1977). He has been the subject of numerous exhibitions, including the Museu d'Art Contemporani de Barcelona (2002); Museo d'arte moderna e contemporanea, Bolzano (2003); Whitney Museum of American Art, New York (2005); and Kunsthalle, Vienna (2006). Pettibon was included in the Whitney Biennial (2004), where he was the recipient of the Whitney Museum's Bucksbaum Award. Pettibon lives in Venice, California.

SEE ALSO Doig, Freud, Hodgkin, Abstract and Representative Art

Raymond Pettibon is known for his prolific output of drawings in comic-book style. Before gaining international recognition as a contemporary artist, Pettibon made a name for himself in the Los Angeles punk rock scene. Throughout the 1970s and into the mid-1980s, he created pamphlets, fanzines and album covers for Black Flag, the influential punk band started by his brother, Greg Ginn. His drawings maintain the same kind of highly energized, iconoclastic aesthetic as his early DIY productions. For many years Pettibon worked primarily with pen on paper. More recently he has engaged with other formats, including video, animation and painting. In the work *No Title (It is a)* (2000), Pettibon drew directly on the walls of the gallery. He occasionally uses watercolour and crayon to add colour to his drawings. His more recent works include wide brushstrokes, usually alongside pen markings. *No Title* (*I must tell*) (2002) illustrates the conjunction of the two materials.

Pettibon's witty, cryptic and at times, caustic captions are an integral part of his drawings. The captions are inspired by a variety of sources, including Charles Baudelaire, Henry James, Charles Manson, William Faulkner, Daniel Defoe, Marcel Proust, Samuel Beckett and Mickey Spillane. At times the combination of cartoon-like drawinas and philosophical musings is bewildering and even humorous. The captions tend to correlate intuitively rather than obviously with the drawings. The subject matter of Pettibon's work is just as varied, incorporating elements of popular culture, art history, religion, sports and sexuality. Increasingly, Pettibon also represents and tackles political issues, including contemporary conflicts such as the war in Iraq.

No Title (I must tell) 2002 | Ink and watercolour on paper 57 x 76 cm (22½ x 30 in)

ELIZABETH PEYTON

BORN Danbury, Connecticut, USA, 1965

Peyton received a bachelor's degree in fine arts from New York's School of Visual Arts (1987); she had her first solo show at the Althea Viafora Gallery in the same year. A show of her work was held in a room of New York's famous Chelsea Hotel (1993). She had shows at Gallery Side 2 in Tokyo, Japan (1997); at London's Royal Academy of Arts (2002); and was invited to show at the 2004 Whitney Biennial, New York. She had a major solo exhibition at New York's New Museum (2008–9).

SEE ALSO Brown, Currin, Hockney, Polke, Richter, Zhang (Xiaogang)

Elizabeth Peyton's drawings and paintings delicately balance intimacy with an unsurpassable emotional distance from their subject. Peyton often depicts celebrities, taking their images from photographs. In her painting entitled *Kurt* (1995), rock star Kurt Cobain stares vacantly, the dark rings around his eyes contrasting sharply with his deathly pale skin. His image is cropped, making it appear as if we are physically close to him, and this closeness is emphasized by his completely unguarded expression. Although Cobain appears to be quite indifferent to our presence, we feel absolutely as if we are sharing an intimate moment with him.

Peyton's stylized approach – epitomized by her characteristic use of thick, bright-red lipstick – reminds us that this confrontation is thoroughly indirect. *Kurt* is a painting of an individual whom Peyton, like ourselves, will never meet. In *Queen Mum's Funeral* (2002), in which we observe a funeral procession from above, we experience a similar realization of impersonality. This awareness emphasizes our lack of physical presence, and by extension our lack of truly personal engagement with a scene that should elicit emotion.

The other side of this scale is represented by works such as *Julian* (2004), which depicts the lead singer of The Strokes bathed in red and yellow light. The scene's theatricality belies any direct engagement that we might have with the singer. In this context, the use of his forename appears almost ironic. Peyton does not seem to adopt such a cynical posture, however; instead, she integrates these distances into the melancholy of her works. Like the portrait of Cobain, they lay themselves bare and back away in the same moment, as if our gaze might tear them apart.

Kurt 1995 | Oil on masonite 25.5 x 20.5 cm (10 x 8 in)

MICHELANGELO PISTOLETTO

BORN Biella, Italy, 1933

Michelangelo Pistoletto began his artistic career as a figurative painter in the 1950s. He had his first solo show at the Galleria Galatea. Turin (1960), and his first solo show in the United States at the Walker Art Center Minneapolis (1966), From the mid-1960s he began to use performance in his art, co-founding and working with Zoo Group (1968-70). In 1968 he withdrew from the Venice Biennale in response to the student riots in Italy and elsewhere. He has won the Venice Biennale's Golden Lion for Lifelong Achievement (2003) and the 2006/7 Wolf Prize in the Arts (Painting and Sculpture).

SEE ALSO Kounellis, Penone, Arte Povera

Michelangelo Pistoletto's work has been described as *Arte Povera*, or "poor art", a category of Italian art in the 1960s that dealt with art's relation to the everyday and used only cheap, readily available

materials. Pistoletto's Venus of the Rags (1967) is primarily constructed from a clash of symbols – a classical statue of the Roman goddess of beauty and love standing before a messy pile of rags. While Venus herself comes from a grand historical tradition, the rags represent impermanent trends that have been cast away. And yet the title suggests some link between the two. This is not Venus with some rags, but Venus of the Rags. The link is also made visually - Venus holds a cloth that subtly connects her to the mound. The clearest effect of this link is a debasement of Venus's ideal beauty by the vulgar materiality of the rags. She seems to be surrounded and almost submerged by them, as if beauty is being smothered by material reality.

Venus of the Rags suggests the gap between cultural myths such as ideal beauty and their actual realization. The implication is that beauty is not an innate quality, but rather something that is applied through commodities and thus supports a debased, materialistic society. Indeed, the statue itself is also a material object, and so it is suggested that material application is not external to the concept of beauty, but actually always within it. Pistoletto thus refuses to allow beauty any independence – he displays how beauty's roots lie instead within social control and material ends.

Venus of the Rags 1967, 1974 | Marble and textiles 212 x 340 x 110 cm (83½ x 133¾ x 43¼ in)

SIGMAR POLKE

BORN Ole'snica, Silesia (formerly East Germany now in Poland), 1941

He and his family moved to Thuringia in East Germany in 1945 and to West Berlin in 1953. He studied at the Kunstakademie Düsseldorf (1961–67). He had his first solo show at the René Block Gallery, Berlin (1964). He taught at Hamburg's Academy of Fine Arts (1977–91). Polke was awarded the Golden Lion at the Venice Biennale (1986). He had a solo show entitled *Sigmar Polke: History of Everything* at the Tate Modern, London (2003–04). He died in 2010.

SEE ALSO Kippenberger,

Rauschenberg, Richter, Warhol, Pop Art

Unlike American Pop Art, with its characteristically slick, polished style and focus on consumption, the works of Sigmar Polke are more concerned with the processes of production than with products themselves. I Don't Really Think About Anything Too Much (2002) is a painting of a printed photograph of a woman at a rifle range. The image is enlarged to expose the elements from which it was produced. The dots of the "Ben Day" printing process resemble the bullet holes in the depicted target. The implication is that, while the dots imply their own process of production, the reference to American gun culture indicts the image's role in the production of violence. This comparison can also be reversed; those who "shoot" photographs of events and distort history into iconic images profit from tragic events as much as those who deal in weapons.

Given this emphasis on causes, it might seem add that Polke often considered chance effects in his work. His series Printing Mistakes (1996–98) focuses on enlarged printing errors, which are beyond their producers' intentions. Similarly, Music from an Unknown Source (1996) consists of a number of gouache paintings partially formed by the uncontrolled dripping of paint. However, Polke's use of chance clearly becomes self-contradictory - the intentional construction of random events. The artist only used chance in order to negate it, and I Don't Really Think About Anything Too Much refuses "random" acts of violence as such. In opposition to the Conceptual Artists, who called for a withdrawal from traditional artistic practice. Polke demands that we view that practice conceptually and so understand the links between the structure of artworks and the structure of the world around us

l Don't Really Think About Anything Too Much 2002 | Mixed media on fabric 295 x 295 cm (116¼ x 116¼ in)

richard prince

BORN Panama Canal Zone, 1949

Richard Prince moved to Boston in 1954 and later to New York in 1973, having been refused entry to the San Francisco Art Institute. He quickly got a job working with photographs for Time-Life magazine and began to re-photograph images to create new artworks. He had his first solo show at the Artists Space, New York (1980) and many since, including Institute of Contemporary Arts, London (1983): Whitney Museum of American Art, New York (1992); and Kunsthalle Zürich (2002). His work appeared in the Venice Biennale (1998). He had a major retrospective at London's Serpentine Gallery and the Solomon R. Guagenheim Museum, New York (both 2008).

SEE ALSO Koons, Kruger, Levine, Sherman, Steinbach, Appropriation Art

Richard Prince's art is quintessentially American. Untitled (Cowboy) (1989) is a re-photographed Marlboro cigarette advertisement, with all traces of the brand removed. While an image of a cowboy riding across the plains on horseback served originally as the advertisement's background, Prince made it the entirety of his work. This draws our attention to the

brand name which has been removed. The mawkish image that remains was intended to instil notions of American masculinity into the cigarettes. Because we are aware of the removal of all Marlboro references, they actually have a constant presence. Although Prince has brought the background to the fore, the former foreground remains lurking "behind it" like the work's guilty secret.

While Untitled (Cowboy) can be seen as art's intervention into advertising, Pure Thoughts (2007) initially seems like

advertising's intervention into art. It was an installation created for the Frieze Art Fair, and consisted of a 1970 Dodge Challenger on a rotating disc, with a scantily dressed woman draping herself over it and catching the eye of passersby. While the work resembled a flagrant attempt at encouraging a purchase, it was actually distinguished from the rest of the fair's contents by the fact that it was not for sale. It thus parodied the fair's attempts to feign high-cultural aloofness when it was really nothing other than the consumer spectacle that Prince so bluntly presented.

What is common to these works is an interrelation of an object and its context, with careful attention being paid to everything's position within particular social and economic systems. Behind Prince's dry humour lies an investigation of the signs and symbols of American consumerism and their viral infection of global culture.

Pure Thoughts 2007

MARC QUINN

BORN London, England, 1964

He took up sculpture in 1984 and graduated from Cambridge University in 1986 where he studied History of Art. His first solo show was held at the Jay Jopling/Otis Gallery, London (1988). He is seen as a central artist in the Young British Artists group and was represented in the Young British Artists II exhibition at London's Saatchi Gallery (1993), as well as Sensation at the Royal Academy of Arts in London (1997). Quinn is well known for the work Self (1991), which is a portrait of his head sculpted from his own blood.

SEE ALSO Young British Artists

Marc Quinn's sculpture investigates the relationship between artistic images and their objects in reality. In *Garden 2* (2000) Quinn froze an entire garden, implying art's function as a preserver of particular historical moments. However, although this process preserved the plants aesthetically, it also killed them and so Quinn implies that art in general might have a similarly hostile relationship with its subjects.

The work Alison Lapper Pregnant (2005) has attracted particular interest because of its placement on the fourth plinth in London's Trafalgar Square from 2005 to 2007. With its use of marble and an idealized and lifelike style, the work pays homage to a sculptural tradition that originated in antiquity and which is also displayed in the square's other sculptures. But *Alison Lapper Pregnant* is formally very different from classical sculpture, which idealizes the human body. Lapper was born with no arms and shortened legs and she is pregnant in the sculpture. Although the work has some affinities with its traditional surroundings, the differences are actually quite jarring.

The unnerving effect of presenting a likeness of a pregnant, physically impaired woman for public view forces us to question our attitude toward the body. In today's society, bodily "imperfections" such as Alison Lapper's remain hidden in culture - they rarely appear in the media, and when they do they tend to be treated as freakish or pitiful. Alison Lapper Pregnant testifies to the exclusion that occurs in every image's declaration of "normality" and suggests that there is a large gap between the reality of the body and how we see it represented. Unlike in Garden 2, which can only preserve its contents by killing them, here Quinn brings an image of difference out of the shadows, swapping a rigid ideal for the realities of life.

Alison Lapper Pregnant 2005 | Marble 355 x 180.5 x 260 cm (139¾ x 71 x 102½ in)

NEO RAUCH

BORN Leipzig, Germany, 1960

He studied at the College for Graphics and Book Design, Leipzig (1981–90). His first solo show, entitled *Leipzig Secession*, was held at the city's Kroch-Hochhaus (1988). He had a solo show at the Deutsche Guggenheim, Berlin (2001), and his work was featured in the Venice Biennale in the same year. Rauch returned to the College for Graphics and Book Design as Professor of Painting and Graphics (2005). He had a solo show at the Metropolitan Museum of Art, New York (2007). He was awarded The Vincent van Gogh Award (2002).

SEE ALSO Polke, Richter

Neo Rauch's paintings are a distinct mix of the surreal and the everyday. He draws one from the other and allows both to unravel across his canvases. The dream-like quality of his works is created in a number of ways. *Silo* (2002) is spatially confusing – a tree branch on the left of the painting is cut off from the rest of the tree while a birdhouse appears to float slightly in front of it. Also, as in many Surrealist paintings, objects appear to be either in the process of a transformation or are split

into hugely different parts – the back half of a poodle emerges into the front half of a snarling, wiry-haired dog. Some sculptural forms to the bottom-left of *Silo* settle into what looks like a canal. All of this subverts our assumptions of material reality, and yet the people in the paintings seem normal and quite oblivious to their strange environment. If we are viewing this dream-world while awake, perhaps the

painting's inhabitants are actually asleep.

Rauch's painterly style has remained consistent throughout his career. One clear point of reference is Socialist Realism, the official style of Soviet Russia, which is suggested by Rauch's brushwork as well as his common depiction of workers, factories and fields. It is no coincidence that his appropriation of that style, used by the Soviet artists because of its approachability, is frozen into a confused state. If Socialist Realism was the projection of a dream onto the reality of society, then Rauch's paintings combine both dream and reality in a composition of disassociated parts.

Silo 2002 | Oil on canvas 210 x 300 cm (82½ x 118 in)

ROBERT RAUSCHENBERG

BORN Port Arthur, Texas, 1925 DIED Captiva Island, Florida, USA, 2008

After serving in the U.S. Navy, Robert Rauschenberg enrolled at Kansas City Art Institute (1947). He studied briefly in Paris before returning to the United States to study under Josef Albers at Black Mountain College, North Carolina (1949). He had his first solo show at New York's Betty Parsons Gallery (1951). He had his first retrospective at the Jewish Museum, New York (1963). Rauschenberg was awarded the Prize for Painting at the Venice Biennale (1964).

SEE ALSO Dine, Johns, Polke, Warhol, Pop Art

Robert Rauschenberg is among the most influential of recent artists. In 1950s' America his work provided a clear route away from the dominance of Abstract Expressionism. He is best known for his "combines", which included paint and assorted everyday objects and images. Although he subsequently moved more toward printing and painting, his technique continued to include the same logic of combination. Unlike Abstract Expressionist works, which are infused with the producer's emotions, Rauschenberg's art is more archival, formed by an interaction with the world. In Untitled (1964), images of President John F. Kennedy relate to the fact that his assassination took place a year earlier, while another image refers to the space race that was then at its height. Rauschenberg's work clearly responds to its surroundings, and in doing so opens the door to Pop Art and other subsequent approaches. It is worth noting that the elements of the work are not linked in any single way - links are allowed to be made but they are never declared explicitly.

Rauschenberg also opened up his work in a more literal, physical sense. *Pilgrim* (1960) combines oil paint, pencil, cloth and paper, and a chair is incorporated into the work by being partially painted. The work seems to encroach physically upon its surroundings and by extension to draw them into itself. Rauschenberg made artwork permeable, and therefore seems to have paved the way for art's inclusion of its physical surroundings, seen in Minimalism and, more recently, in Installation Art.

Untitled 1964 | Print

PAULA REGO

BORN Lisbon, Portugal, 1934

Rego studied at the Slade School of Art, London (1952–56). She returned to Portugal, but eventually settled in London in 1976. She had her first solo show at SNBA, Lisbon (1965). Having been originally well known for semi-abstract collage, she turned to a naturalist style of painting in the 1980s. She was nominated for the Turner Prize (1989). She had a major retrospective at Tate Liverpool (1997) and another at Tate Britain, London (2004–05).

In the 1960s Paula Rego made chaotic, semi-abstract collages that presented fragments of narrative but forced viewers into providing the links themselves. Despite shifting to naturalistic painting, Rego has continued to imply stories that she never fully tells. She reveals the inadequacy of history and the secrecy that prevents us from gaining direct access to the past.

Rego's The Policeman's Daughter (1987) shows the daughter polishing her father's boot. Although she is working obediently she also silently rebels, thrusting her arm into the boot as if to do violence to it and symbolically to her father. Rego includes many signs of the daughter's repression. She faces away from the light and the outside is represented only by a window through which her cat peers nervously, as if waiting for something awful to happen. The boot also seems symbolic of violent repression but, again, the lack of a clear narrative is characteristic of Rego's work.

Rego's style situates her within a history of "realist" painters, but she uses that style to comment on history. Her paintings commonly document an underlying repression that sits outside accepted narratives. While traditional paintings presented women in their domestic role. here that role is shown as a function of the male domination of society. And yet the policeman's daughter participates in her own domination, rebelling against its symbol while still maintaining the thing itself. The moments captured in Rego's paintings always insinuate a set of relationships that go beyond the boundaries of any one work. She draws the viewer into a process of implication that traces lines between personal moments and public history.

The Policeman's Daughter 1987 | Acrylic on paper on canvas 213.5 x 152.5 cm (84 x 60 in)

AD REINHARDT

BORN Buffalo, New York, 1913 DIED New York City, NY, USA, 1967

Ad Reinhardt studied painting at the National Academy of Design. He had his first solo exhibition at Columbia University's Teachers College (1943). Before that he earned a living as a commercial artist. He was a member of the American Abstract Artists group (1937–47). Reinhardt had a major exhibition at the Jewish Museum in New York City (1966). In 1970 his black paintings were shown together at the Marlborough Gallery, New York City. As well as a painter he was also a lecturer, a writer and a cartoonist.

SEE ALSO Judd, LeWitt, Richter, Abstract and Representational Art

Despite being an American abstract painter, and a contemporary of the Abstract Expressionists, Ad Reinhardt's early work exemplifies so-called "Hard-edge Painting." That style used simple geometric patterns and was influenced by European artists such as Josef Albers; its lack of emotional expression was opposed to the more personal style of Abstract

Expressionism. From the early 1950s Reinhardt became embedded in his late style, the monochromes or "black paintings" for which he is best known. These arids and monochrome paintings. such as Abstract Painting (1960-66), can be considered pivotal in the history of modern painting, a bridge between the high modernism of the Abstract Expressionists and the more conceptual approach taken by certain later painters. While his earlier works used a variety of colours, these paintings contain only shades of grey and black. Reinhardt himself talked about this shift as an attempt to separate abstract painting from life at a time when abstract design was increasingly being used in popular culture. However, many observers have interpreted his works differently, as statements of the end of painting and its final realization as pure. monochrome surface. According to them, they represent an end to abstract painting's progression toward aesthetic purity and suggest that painting itself has become obsolete. Whether or not it was Reinhardt's intention, this interpretation led into conceptual painting. His work takes part in a discussion about its medium and thus becomes as much a dealer in concepts as in forms and hues. Although Reinhardt may have wanted to protect painting against outside influences, he seems to have taken away any claim it had to independence.

Abstract Painting 1960–66 | Oil on canvas 152 x 152 cm (59¾ x 59¾ in)

JASON RHOADES

BORN Newcastle, California in 1965. **DIED** Los Angeles, California, USA, 2006

He received a Bachelor of Fine Arts degree from San Francisco Art Institute (1988) and an MFA from the University of California, Los Angeles (1993). He has had solo exhibitions at MAGASIN Centre National d'Art Contemporain, Grenoble (2005); Portikus, Frankfurt (2001); Van Abbemuseum, Eindhoven (1998); and Kunsthalle Basel (1996), among others.

SEE ALSO McCarthy, Rauschenberg, Roth, Installation Art

Jason Rhoades's work exudes the kind of freedom, excess and glamour that is often associated with the West Coast of the United States. His large sculptures and room-filling installations are manic outputs of words, associations and objects. The installations bear some resemblance to Abstract Expressionist paintings, though they are executed in three-dimensional space and clearly take inspiration from a capricious society accustomed to surfing the Internet, stimulus overload and instant gratification. His work is often lewd and sexually explicit, at times humorous, at other times vaguely offensive. His first work

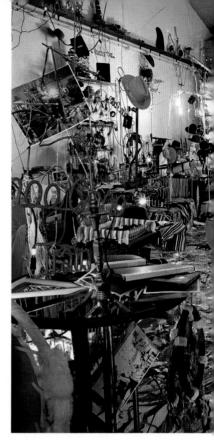

to claim critical and public attention was Swedish Erotica and Fiero Parts (1994), which included the artist's car as well as various assemblages held together with staples, glue, paperclips and other flimsy materials. Works such as this show the influence of artists Robert Rauschenberg and Dieter Roth, as well as Rhoades's mentor and occasional collaborator, Paul McCarthy.

In 2006, shortly before his untimely death, Rhoades completed the final instalment of a trilogy of works that

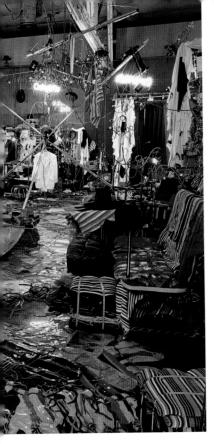

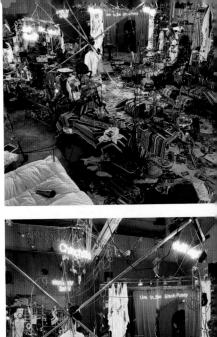

includes Meccatuna (2003), My Madinah. In pursuit of my ermitage (2004) and Black Pussy (2006). The final work consists of 360 idols and represents the figures once held in the Ka'bah, before they were destroyed after the Prophet Muhammad declared that there is only one God, who cannot be depicted in material form. The installation also includes various interpretations of the word "vagina", spelt out in black and ultraviolet lights. The project grew out of Black Pussy Soirée Cabaret Macramé, a series of ten private social events orchestrated by the artist, which took place in his studio in Los Angeles in early 2006 and included many of the elements that later featured in the exhibit *Black Pussy*.

Black Pussy

2006 | Mixed media installation including wire metal shelving, neon glass, dreamcatchers, cowboy hats, Chinese Gonshi stones, hookah pipes, camel saddle footstools, vegetables and other items Approximate dimensions: 275 m² (2960 sq ft)

GERHARD RICHTER

BORN Dresden, Germany, 1932

He studied at the Dresden Art Academy (1952–56). He had his first solo show at the Mobelhaus Berges in Düsseldorf (1963). He was chosen to represent Germany in the Venice Biennale (1972). There was a major retrospective of his paintings entitled *Forty Years of Painting* at the Museum of Modern Art, New York City (2001). He completed a stainedglass window for Cologne Cathedral in 2007. He had a solo show at the National Portrait Gallery, London (2009). He has won an number of awards including the Wolf Prize (1994/5) and the Praemium Imperiale (1997).

SEE ALSO Beuys, Kippenberger, Polke, Reinhardt, Tuymans, Warhol

Gerhard Richter is one of the foremost painters of his generation. Much of his work deals with loss: the loss of history, certainty and ultimately life itself. *Onkel Rudi* (1965) is a painting of a photograph, a technique often used by Richter. The photograph is of the artist's deceased uncle, who was an officer in the Nazi SS, the primary perpetrators of the Holocaust. The blurring of the photograph blocks our perception, symbolizing the unbridgeable gap between the present and this horrific past. The work evokes a multiple sense of loss: of a family member, of history and of the millions killed in the Holocaust. Furthermore, these losses are contradictory: how can we mourn Uncle Rudi and the others who were responsible for the murders? This complete detachment is emphasized by Richter's approach to painting; he seems incapable of emotionally expressive work, instead simply reproducing cold documents.

The endless cycle of loss continues in Betty (1988), a portrait of Richter's daughter, although again derived from a photograph. Betty faces away from us into what looks like a black void although the background is actually one of Richter's dark abstract paintings. She seems incapable of confronting us, and the muted painting is equally unlikely to communicate with her. This sense of absolute separation is a comment on both contemporary society and contemporary art, which will inevitably fail to match the scale and the monstrosity of Hitler's Final Solution, Richter's art ultimately laments its own demise and constantly returns to the absolute darkness of his early paintings.

Betty 1988 | Oil on canvas 102 x 72.5 cm (40¼ x 28½ in)

BRIDGET RILEY

BORN London, England, 1931

She studied at London's Goldsmiths College (1949–52) and at the Royal College of Art (1952-55), After starting her career in the 1950s with a style of painting that was primarily influenced by Impressionism, in 1960 she began making the Op Art for which she is best known. She had her first solo show at London' s Gallery One (1962). She had an exhibition at the Museum of Modern Art, New York (1966) and the Hayward Gallery, London (1992). She represented Britain in the Venice Biennale (1968). winning the International Painting Prize. and was awarded the Kaiserring der Stadt Goslar (2009).

SEE ALSO Craig-Martin, Abstract and Representational Art

Bridget Riley is the best known exponent of Optical or Op Art, a style of painting that emerged in the 1960s. Op Art is well exemplified by *Movements in Squares* (1961), which is solely constructed from black and white geometric forms. By reducing her pictorial range, Riley allows her spatial constructions to take precedence. The simplicity of her forms also reminds us constantly of the illusions in her works. Even if the work appears to curve inward, we are always aware that it must be flat and still. Riley simultaneously constructs and deconstructs her works, and, rather than apprehending them all at once, we have to perceive them in a gradual process of unfolding.

In later works, such as *Paean* (1973), Riley introduced colour. *Paean* consists of vertical lines of various different hues. By confronting us as an overwhelming whole, with all the parts conflicting and overshadowing each other, the work initially frustrates our ability to pick out any one line or colour. Only gradually do patterns and individual elements begin to assert themselves, and even then only tentatively, as they fluctuate and refuse to settle. Again, such work can only be viewed over time.

In relation to her contemporaries, the Minimalist sculptors, Riley's work could be seen as emerging into the reality of real time and space, except for the fact that there remains a disjuncture in her art between the work's optical unfolding and its actual physical nature. Ultimately, Riley's work still seems to battle with painting's separation from reality, which can be overcome only with further illusion.

Pean 1973 | Acrylic on canvas 290 x 287.5 cm (114¼ x 113 in)

PIPILOTTI RIST

BORN Grabs, Switzerland, 1962

Pipilotti Rist studied commercial art, illustration and photography at the Institute of Applied Arts in Vienna. Austria, and audiovisual communications at the School of Design in Basel, Her work was shown at the Venice Biennale (1997), where she was awarded the Premio 2000 prize. She has exhibited at the Kunsthalle, Vienna (1997); Art Gallery of New South Wales (1998); Solomon R. Guggenheim Museum, New York (1998); KW Institute for Contemporary Art, Berlin (1998); Metropolitan Museum of Modern Art. Tokyo (2000); Contemporary Arts Museum Houston (2006-07): and Museum of Modern Art, New York (2008). She lives and works in Zürich.

SEE ALSO Paik, Video Art

Pipilotti Rist is an illustrious video artist. Since the 1980s, she has created groundbreaking fusions of music, sculpture, performance and film. Rist has been at the boundaries of video art since her first critically acclaimed piece, *I'm Not The* *Girl Who Misses Much* (1986), which featured her dancing before the camera only partially clad. Her works often have a pseudo-psychedelic quality and possess the seductiveness of popular culture.

Dream-like video pieces are projected in large scale across multiple screens. The videos contain surreal alterations of colour, speed and sound. Often the work features a human body, and the pieces can be understood to relate to issues of gender, sexuality and the relationships between individuals and their bodies. On the surface, the videos maintain an infectious happiness and simplicity, imbued with bright colours and abstract patterns. However, they also suggest a strong feminist agenda and complex psychoanalytical interpretations.

Rist's work has been exhibited in unusual locations. *Open My Glade* (2000) appeared on a giant video screen in New York's Times Square. Every fifteen minutes past the hour, the screen featured a one-minute video segment by Rist. For the 51st Venice Biennale (2005), she made *Homo sapiens sapiens*, consisting of giant projections onto the baroque ceiling of the San Stae church. Below, visitors watched from specially constructed viewing beds. The work transformed the interior of the church into a dreamy psychedelic playground.

[Right] *Homo sapiens sapiens* 2005 | Audio video installation, view in the Chiesa San Stae, Venice

[Right] Homo sapiens sapiens 2005 | Audio video installation (video still)

MARTHA ROSLER

BORN New York City, NY, USA, 1943

In 1965 Martha Rosler was awarded a Bachelor of Fine Arts degree from Brooklyn College and in 1974 she received a Master degree in Fine Arts from the University of California, San Diego. She had her first solo exhibitions at the University of California, San Diego in 1973, and since then has consistently worked in various media. After the 1970s she returned to Brooklyn and became a Professor at Rutgers University. Between 1998 and 2000, a retrospective of her worked entitled Positions in the Life World was shown in five European cities as well as New York City.

SEE ALSO Fraser, Kruger, Sherman, Feminism, Performance Art, Video Art

Martha Rosler's work tends to imply links between everyday activities and wider political issues, especially with relation to gender. *Semiotics of the Kitchen* (1975) looks at the connection between women and their allotted domestic role. In the course of the six-minute video Rosler progresses through the alphabet, presenting a kitchen utensil beginning with every letter and miming an action with each. These actions are often violent, such as stabbing the air with a knife or hitting a table with a tenderizer. Her violent gestures, combined with her constantly straight-faced demeanour, seem to imply repressed anger and silent desperation.

From "U" onwards Rosler abandons utensils and mimes the letters with her body. This suggests that perhaps the piece is less about the meanings that she evokes than about the way in which they attach themselves to the individual and become our only means of communication. Rosler's apparent inability to communicate through any means other than the tools with which society has equipped her the metaphorical chains of her domestic slavery – suggests that she cannot communicate without being channelled down the routes that society allows her. More generally, we can also understand the work as questioning traditional notions of artistic expression, since Rosler demonstrates that our expressive tools tend to favour some individuals over others. By demonstrating connections between everyday activities and our potential as political agents, Rosler's work functions to reveal our status within the social arena. That is to say that she allows us to find our political feet and that in doing so, she also provides them with a direction.

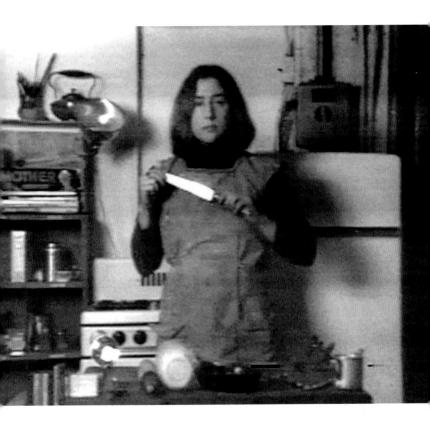

Semiotics of the Kitchen 1975 | Video installation 6 min 12 sec

DIETER ROTH

BORN Hanover, Germany, 1930 **DIED** Basel, Switzerland, 1998

Dieter Roth began an apprenticeship as a commercial artist (1947) and trained at a commercial art school in Bern. Switzerland (1948–49). In the early 1950s Roth began to work on non-commercial forms of art. His first solo show was organized by the Museum School of Art in Philadelphia (1964). He worked in a variety of media, including painting, sculpture, video, drawing, installation and books. From 1976 he produced a series of paintings and drawings in collaboration with Richard Hamilton. His first public exhibition in the United States took place at the Eugenia Butler Gallery, Los Angeles (1970) and the Museum of Modern Art in New York held a retrospective in 2004.

SEE ALSO Doig, Freud, Hodgkin, Abstract and Representative Art

Dieter Roth's art tended to be in a constant state of transformation. He is well known for the sculptures he created from food, such as *Portrait of the Artist as Birdseed Bust* (1968), a self-portrait cast in

chocolate and covered in birdseed. Roth placed the original sculpture in the open air, where it was pecked apart by birds. The work's fate mirrored our consumption of art - we incorporate it into ourselves and therefore destroy it as a discrete object. That the work was a self-portrait emphasized that the transferral between the artwork and the viewer involves a personal connection between viewer and artist. In some of his other works, Roth left food to rot, such as in A Pocket-room (1968), which featured a rotting banana. Again, the destruction of the work is brought about through its transformation and distribution into the world.

Roth presented art as inherently temporal, played out over time through the activity of both artist and viewer. In Book (1958), he allowed the reader to rearrange the book's pages in any way they saw fit. So while the raw material is still provided by the artist, there is also an acceptance that the viewer will inevitably restructure the work in its reception. The point is not that Roth's practice inaugurated a new way of working, but rather that he rendered visible the nature of all artistic exchange. While his work might seem radical in its inclusion of time, it is only actually radical in its refusal to feign the eternal. Unlike traditional artworks which declare immunity to degradation over time and outside control, Roth's insert themselves within the flow of history and the reach of their viewers.

P.o.th.a.a.Vb (Portrait of the artist as Vogelfutterbüste) 1968/93 (Head of the "Self-Tower"), 1975 Solid milk chocolate 21 x 12 x 10 cm (81/4 x 43/4 x 4 in)

The original edition of 1968 was a mixture of chocolate and birdseed. It was meant to be put outside. For the 90th edition, Roth took the moulds again – his self-portrait as an old man – and made hundreds of heads for his chocolate towers.

THOMAS RUFF

BORN Zell am Hamersbach, Germany, 1958

Thomas Ruff has exhibited widely throughout the world. The exhibition Thomas Ruff: Photographs 1979 to Present (2001) started at the Kunstalle Baden-Baden, Germany, and toured to several venues across Europe and Scandinavia. Ruff has also had solo exhibitions at Museum für Moderne Kunst. Frankfurt am Main, Germany (1992); Musée d'Art Moderne et Contemporain, Geneva, Switzerland (2004); Moderna Museet, Stockholm, Sweden (2007); and Castello di Rivoli, Turin (2009). He exhibited in the German Pavilion at the Venice Biennale (1995). Ruff currently lives and works in Düsseldorf, Germany,

SEE ALSO Becher, Gursky, Richter, Struth

Thomas Ruff has been testing the boundaries of the photographic medium for over 20 years. He belongs to a generation of artists that includes Candida Hofer, Andreas Gursky, Thomas Struth and Axel Hutte. Studying under Bernd and Hilla Becher at the Academy of Fine Arts in Düsseldorf in the late 1970s and early 1980s, he was heavily influenced by the Bechers' Conceptual photographs of industrial structures. The Bechers favoured the black and white image but, like many in his generation, Ruff soon began working with colour photography, taken in well-defined series. He began his career with photographs of the interiors of German houses, the exteriors of buildings and portraits of friends. His portraits are taken face on, in very high resolution like identification shots, and are then enlarged to a larger-than-life scale.

Ruff stands out from his peers in the variety of methods he uses to create an image; these have included infrared lenses, hand-tinting and appropriation, among others. Ruff's work shares a close affinity with the paintings of German artist Gerhard Richter, whose softly blurred paintings are usually made with a photograph as the point of reference. After studying Richter's presentation of the naked human form, Ruff began to explore the genre of the nude. The photograph Nudes ru05 (2000) is taken from a pornographic image found on the Internet. Ruff enlarges such thumbnail images of only 72 dots per inch to a large scale. The low resolution makes Nudes ru05 incredibly pixilated and blurry to the viewer. The image's slightly indecipherable quality expresses the anonymity of internet pornography.

Nudes ru05 2000 | Laserchrome and diasec 150 x 110 cm (59 x 43 in)

ED RUSCHA

BORN Omaha, Nebraska, USA, 1937

Ruscha moved to Oklahoma City in 1941 and to Los Angeles in 1956 to finish his studies at the Chouinard Art Institute. The J. Paul Getty Museum, Los Anaeles, organized a retrospective of his drawings (1998). The Hirshhorn Museum and Sculpture Garden in Washington DC held a major retrospective of his work (2000), which travelled to the Museum of Contemporary Art, Chicago; the Miami Art Museum: and the Modern Art Museum of Fort Worth, Texas. He also had an exhibition at the Whitney Museum of American Art (2004), which travelled to two further cities in the United States, and a retrospective exhibition at the Hayward Gallery, London (2009). Ruscha represented the United States at the 51st Venice Biennale (2005).

SEE ALSO Conceptual Art, Pop Art

Ed Ruscha's work first came to the fore in the early 1960s. After studying painting during the height of Abstract Expressionism in the 1950s, Ruscha soon abandoned gestural brushstrokes for what would become his characteristically cool, minimal style. He was a progenitor of the Pop Art movement, and many of his early paintings

were precursors to Conceptual Art. Ruscha is perhaps best known for his close affiliation with the West Coast of the United States, and particularly Los Angeles, where he has lived since the 1960s. His subjects are often everyday vistas associated with the California landscape, which he elevates beyond their mundane status. For example, a now well-known work, *Standard Station*, *Amarillo*, *Texas* (1963), depicts a petrol station against a large expanse of open sky, recalling road stops on the sprawling West Coast highway system.

Often incorporating words and signs in

his paintings, Ruscha's work is also an investigation of mass media, image and text. *The Old Tech-Chem Building* (2003) shows an ominous-looking building against a fiery red sky, with only the words "Fat Boy" to distinguish it. The work is a bleak portrait of America's consumerist values and globalizing agenda. Although known principally as a painter, Ruscha has also made a number of influential photographic books. *Twentysix Gasoline Stations* (1963) and *Every Building on Sunset Strip* (1966), for example, were important contributions to the development of Conceptual Art-based photography in the 1960s and later. The Old Tech-Chem Building 2003 | Acrylic on canvas 123.5 x 278 cm (48½ x 109½ in)

TOM SACHS

BORN New York City, NY, USA, 1966

Tom Sachs grew up in Connecticut. He gained a degree in fine art from Bennington College, Vermont (1989). He had a show at the Mary Boone Gallery, New York (1999), where a bowlful of bullets was offered to visitors This led to the arrest of the gallery's owner, Mary Boone, for illegally distributing ammunition. Solo shows followed including at Fondazione Prada, Milan (2006). McDonalds was shown at Tomio Kovama Gallery, Tokyo (2004); Space Program at Gagosian, Beverly Hills (2006); and his large-scale Bronze Collection including Hello Kitty at Lever House, New York City (2008).

SEE ALSO Doig, Freud, Hodgkin, Abstract and Representative Art

Tom Sachs's *Prada Death Camp* (1998) is a model of a Nazi concentration camp constructed on a disassembled Prada shoebox. Controversy has surrounded the work, particularly due to its exhibition at the Jewish Museum in New York. While the work seems to be directed against Prada rather than Nazism, its critics have argued that Sachs therefore takes the Holocaust rather too lightly.

However, amid the controversy of its Nazi symbolism the actual object has been mostly forgotten. Apart from its subject, its most striking feature is its unfinished, amateurish look. The box has been heavily scuffed and its surface is quite different from the smooth, polished aesthetic we might expect from a Prada product. This visual betrayal of Sachs's labour implies the original object's concealment of its production process, and also the way in which companies like Prada tend to hide the realities of

their production chains. This technique is characteristic of Sachs's work and he calls it "bricolage". It draws comparisons between poor nations, in which a doit-yourself approach is an economic necessity, and rich nations, where it seems out of place.

Sachs's interest in craft has extended to a series of works in which he recreats famous pieces of modern design using assorted cheap materials, such as a version of Knoll furniture made from telephone books and duct tape. This approach is in clear opposition to the technological dreams that have dominated much modern design, and which have largely failed in their lofty ambitions. Sachs offers a refreshing alternative to both dry Conceptual Art and the cold Modernist machine-aesthetic, and in doing so questions both.

Prada Death Camp 1998 | Cardboard, ink, thermal adhesive 69 x 69 x 5 cm 27¼ x 27¼ x 2 in

DORIS SALCEDO

BORN Bogotá, Colombia, 1958

Doris Salcedo studied at the Universidad de Bogotá Jorge Tadeo Lozano and at New York University. She is a recipient of the Penny McCall Foundation Grant and the Solomon R. Guggenheim Foundation Grant. Solo exhibitions include the New Museum of Contemporary Art, New York (1998); Tate Gallery, London (1999); San Francisco Museum of Modern Art (1999 and 2005); and Camden Arts Centre, London (2001). She also participated in the 24th Bienal de São Paulo (1998); Documenta 11 (2002); and the 8th Istanbul Biennial (2003). She lives and works in Bogotá.

SEE ALSO Hatoum

Doris Salcedo works with domestic materials that have become charged with meaning through years of use. In the past she has used textiles and furniture from her native Colombia to relay the experiences of individuals living in turbulent social, political and economic conditions. Like the artist Mona Hatoum, Salcedo implies violence through her choice of materials, without always making explicit reference to it. For instance, the early work *Camisas* (1989) consists of a stack of clean, neatly

pressed white shirts that have been pierced through with an iron rod. The work was made in response to a massacre that occurred in Colombia in 1988, when banana plantation workers were dragged from their homes and killed. Often, Salcedo combines hard and soft materials to show fragility and vulnerability. In Untitled (1995), for instance, a wooden wardrobe is filled with set concrete. Salcedo often works with concrete, which also represents her desire to safeguard memories. Reacting in part to the human "disappearances" practised by the Colombian military, Salcedo has made a number of works that deal directly with the preservation of a collective consciousness.

Salcedo was commissioned in 2007 to make a work for the Turbine Hall of Tate Modern, London. The work, *Shibboleth*, consisted of a crack in the hall's concrete floor, 167 m (548 feet) long. The fissure suggested the borders and separation between Third and First World societies. Like many of her works, the crack also implied some kind of violent gesture or catastrophic event. Salcedo's work consistently forces the viewer to take an uncomfortable look at the injustices and failures of modern society.

Shibboleth 9 October 2007 – 24 March 2008 Tate Modern Turbine Hall

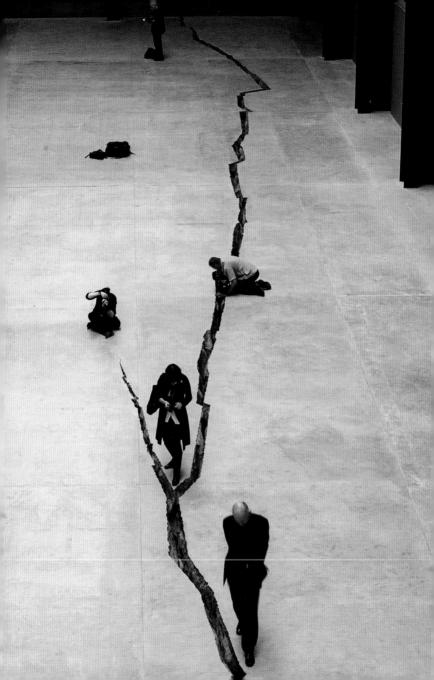

JENNY SAVILLE

BORN Cambridge, England, 1970

Jenny Saville gained a degree in Fine Art from Glasgow School of Art (1992) and studied at Slade School of Art, London (1992–93). She is generally associated with the Young British Artists group, mostly through her major patron Charles Saatchi, who bought an entire show of her work from the Cooling Gallery, London (1993). She was featured in the show *Sensation* at the Royal Academy of Arts, London (1997). She had a show called *Migrants* at the Gagosian Gallery, New York (2003).

SEE ALSO Doig, Freud, Hodgkin, Abstract and Representative Art

Jenny Saville's early work focused on her self-image. In *Plan* (1993), she painted herself as covered in contour lines. The huge size of the work, in which her own size is exaggerated, indicates her self-perception as ungainly and overweight. Rather than being a literal portrait of the artist's body, then, *Plan* is a representation of her bodily experience.

In her later work, Saville has turned to representing the body in its visceral reality. In another self-portrait, Reverse (2002-03), she swapped the neutral tones of Plan for reds and browns, indicative of flesh and blood. Her skin is cracked, as if to reveal hints of her insides. Indeed it is her body's openings that Saville emphasizes most, particularly the mouth, which is wet and slippery with saliva. However, the inside that is implied here is not the psychological one represented in Plan, but the more literal, physical interior. Saville's glazed expression makes her seem almost devoid of personality. simply an assemblage of meat and blood. Therefore, in Reverse we see a shift from a duality of inside and outside to a more purely carnal representation.

It is possible to understand *Reverse* in the context of the feminism of her earlier work. While in *Plan* she represented female self-perception, which is conditioned by a maledefined ideal of femininity, in *Reverse* she presents women as some feminists claim men see them – as vacant pieces of meat. Therefore there seems to be a continuity in Saville's work, which revolves around an understanding of the female body as a site for diverse interests and multiple perspectives. Reverse 2002–03 | Oil on canvas 213 x 244 cm (84 x 96 in)

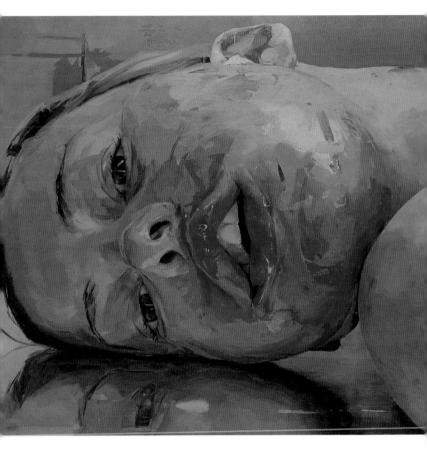

GREGOR Schneider

BORN Rheydt, Germany, 1969

He studied at the Düsseldorf Academy of Arts, Münster Academy of Fine Arts, and Hamburg Academy of Fine Arts, Germany. He has had solo shows at institutions around the world, including exhibitions at the Kunsthalle, Hamburg (2000); the Museum of Contemporary Art, Los Angeles (2003); Artangel, London (2004); Bondi Beach, Australia (2007); Milwaukee Art Museum, Wisconsin (2007); and Museo d'Arte Contemporanea Roma (2008). He showed in the German Pavilion at the Venice Biennale (2001). Schneider continues to live and work in Rheydt.

SEE ALSO Installation Art

Since 1985, Gregor Schneider has obsessively reconstructed the interior of his house in Rheydt, Germany. Through the construction of a series of chambers, walls, doors and rooms, the inside of the house, now known as *Haus ur*, is transformed into a claustrophobic maze of secret passageways and hidden spaces. Although the house itself has been seen by relatively few people, parts of it have been extracted and reassembled for exhibition. Schneider's manipulations of the domestic space are

almost always rife with sinister undertones. He is keen to point out repression and anxiety within "normal" society. In *Die Familie Schneider* (2004), the artist made the interior of two ordinary neighbouring houses in London's East End identical in every detail. Viewing was controlled such that visitors were permitted to enter only one at a time, first one house, then the other. Prior knowledge of the contents was limited. Each house was animated with identical repetitive and mundane performances: a woman washing up at the kitchen sink and a man masturbating in the shower upstairs.

In a bedroom a pair of legs protruded from a bin bag creating an intimation of perversity and distress. In all of Schneider's work there is great attention to detail, from the creation of particular smells to the manipulation of temperature.

In recent projects, Schneider has moved beyond the domestic space as a point of departure. He has drawn inspiration from a red light district in Germany, a religious centre in Mecca and the internationally deplored internment facility at Guantánamo Bay. *In Bondi Beach*, 21 *Beach Cells* (2007), Schneider brings his macabre aesthetic to the most unlikely of places, Sydney's sunny Bondi Beach. The construction of 21 identical cells on the beach, furnished with air mattresses and beach umbrellas, challenges the supposed freedom of Australia's beach culture and Western society at large.

Bondi Beach, 21 Beach Cells 2007 | Installation Each cell 4 x 4 x 2.5 m (13 x 13 x 8 ft)

thomas schütte

BORN Oldenburg, Germany, 1954

He studied at the Düsseldorf Art Academy (1973–81) under Bernd and Hilla Becher and Gerhard Richter, alongside such artists as Thomas Struth. He had his first solo show at the Haus Lange Museum in Krefeld, Germany (1986). He had a solo show at Kunsthalle, Bern which travelled to the Musée d'Art moderne de la Ville de Paris (1990). He had a trio of solo exhibitions at the Dia Center for the Arts, New York (1998– 99). He was awarded the Golden Lion at the Venice Biennale (2005).

SEE ALSO Becher

Much like his teachers, Berndt and Hilla Becher, Thomas Schütte produces art that highlights faulty attempts to eradicate differences in contemporary society. *Model for a Hotel* (2007) is constructed from Perspex. Its simple, quasi-futuristic forms and its matt colours mimic Modernist art and design, particularly that of the Bauhaus. The work was commissioned for London's Trafalgar Square, traditionally home to monumental sculpture, and it does not easily fit into that context – indeed, this disjuncture is the point of the work. While traditional monumental sculpture stamps the mark of particular individuals on a city, Schütte implies the shadows that lurk behind monuments of corporate architecture.

If Model for a Hotel presents an act of obscuring, then Big Spirits (1996) symbolizes the spectre of the obscured. Compared to Model for a Hotel's rational, geometric design, Big Spirits is bulbous, rotund and almost fluid, as if a process of formation has been arrested. The ghosts imply entities that will always escape the rationalizing approach ironically taken by Schütte's architectural models. While Model for a Hotel considers the enforcement of uniformity, Big Spirits insists upon the continuation of difference.

The subject of difference is also brought forward in United Enemies (1993–94), a series of sculptures each consisting of two figures strapped together. The "enemies" either confront each other aggressively or pull in different directions. They represent the reunification of East and West Germany that occurred in the early 1990s despite continuing differences between the two. Like *Big Spirits*, then, United Enemies criticizes processes of unification that really only paper over cracks without filling them in. The implication in both works is that lasting tensions threaten to collapse false attempts at unity at any moment.

Model for a Hotel 2007 | Perspex The Fourth Plinth Trafalgar Square, London

SEAN SCULLY

BORN Dublin, Ireland, 1945

Sean Scully's family moved to London in 1949 though he has lived and worked in the US since the mid-70s. He studied painting, first at Newcastle University and then at Harvard University. Cambridge, Massachusetts. He had a major retrospective at the Whitechapel Gallery, London (1989) and was nominated for the Turner Prize (1989 and 1993). The Hirshhorn Museum in Washington DC initiated a touring retrospective of the artist's work (1995). An exhibition of his work travelled from Fundació Joan Miró, Barcelona, Spain, to Musée d'Art Moderne in Saint-Étienne, France, and Museo d'Arte Contemporanea Roma, Italy (2008).

SEE ALSO Stella, Abstract and Representational Art

Sean Scully is one of the most significant abstract painters of his generation, he has also made prints, sculpture and ceramics, and has produced a vast body of drawings. Working almost exclusively with stripes and blocks of colour, Scully has developed a style of painting that is immediately recognizable. In early works he used masking tape to create a clean edge between bands of colour. More often, however, the colours have a soft, painterly edge that makes his work less authoritarian and more open-ended. Although Scully's paintings have an obviously geometric appearance, they are made with thick applications of oil paint that evoke the artist's process stroke by stroke. In this way, the paintings lie somewhere between works by Mark Rothko and Frank Stella, both important influences on the artist. But while Stella's work is known for its emotional coolness, reacting against the principles exalted by Abstract Expressionism a generation before, Scully's paintings imbue the canvas with feeling. For this reason, his works are often cited as emanating the kind of spiritual resonance that is associated with Rothko's oeuvre.

Scully's paintings are almost always executed to a very large scale, and are frequently diptychs. Around the beginning of the 1980s, he began experimenting with canvas inserts within his paintings. Each insert – itself a small painting – acts as a window within the work, or, more importantly, as a separate object. In many ways, Scully's paintings resemble architectural landscapes. In his *Wall of Light* series, begun in the 1980s, Scully refers to the stacks of horizontal and vertical bands of colour as "bricks", and it almost appears as though light is seeping through the gaps in the structure.

Wall of Light Light 1999 | Oil on linen 274.5 x 305 cm (108 x 120 in)

tino Sehgal

BORN London, England, 1976

Sehgal was born in London but grew up in Germany. He studied dance and political economy in Berlin and Essen. Though his work does not result in any tangible objects, he still produces a concept, which can be bought and sold, and Sehgal's work exists in the collections of many major institutions around the world, including Tate, London; The Museum of Modern Art, New York; and the Hamburger Bahnhof, Berlin.

Tino Sehgal is one of the most significant artists working today. Though he distances himself from the historical tradition of performance art, Sehgal is well known for creating artworks that are staged situations. His works exist exclusively on-site and in the moment, and are preserved only in memory. Sehgal does not allow any physical product, documentation or photograph to mark or record the occurrence. The artist produces the work by conceiving a set of instructions which involve the human voice and body. He then works with 'interpreters'-usually actors, volunteers or dancers-to carry out the instructions for the duration of the exhibition. In the staging of his work in

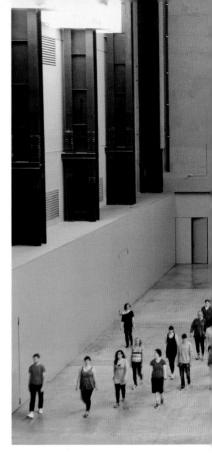

museums and galleries, it is often difficult to distinguish participants in the work from museum staff and members of the public.

Sehgal is interested in the interaction between art and spectators. In the work *This is So Contemporary*, shown in the German pavilion of the Venice Biennale in 2005, participants posed as gallery guards before breaking out into spontaneous chants around visitors. Similarly, in the work *This Objective of That Object* (2004), people who seem to be

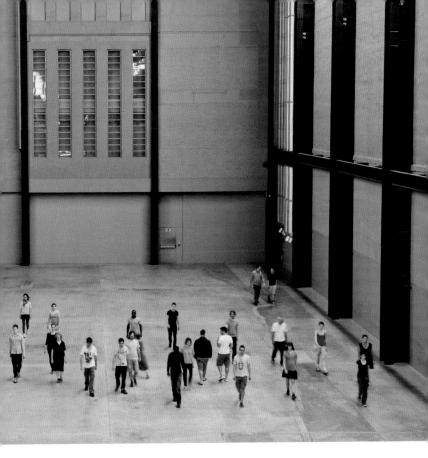

gallery visitors suddenly assume formation and begin discussing the work, and other visitors in the room. *This Objective of That Object* was the first in a trilogy of exhibitions by Sehgal that unfolded over three annual shows from 2004 to 2007 at the Institute of Contemporary Arts, London. Other works by Sehgal such as *Kiss* (2007), which consists of two 'lovers' acting out, in continuous succession, the embrace of famous artworks such as Rodin's *The Kiss*, have engaged with aspects of art history. In 2012 Sehgal presented *These Associations* at London's Tate Modern. The work involved over fifty participants who used conversation and movement to inhabit the Tate's large, cavernous Turbine Hall.

These Associations 24 July – 28 October 2012 Tate Modern Turbine Hall, London

RICHARD SERRA

BORN San Francisco, California, 1939

He received a Bachelor's degree in English from the University of California (1961) and a Master's degree in fine art from Yale University, Connecticut (1964). Serra had his first solo exhibition at the Leo Castelli Warehouse, New York (1969). He had a solo exhibition at the National Museum of Modern Art, Paris (1984). He had a solo show at the Museum of Modern Art, New York (1986) and a major retrospective there entitled *Richard Serra Sculpture: Forty Years* (2007). Although he is primarily known as a sculptor, he has also worked with video.

SEE ALSO Andre, Christo and Jeanne-Claude, Judd, De Maria, Morris, Smithson, Minimalism

Richard Serra is among the most important contemporary sculptors, with work ranging from Post-Minimalist and process-based work in the 1970s to his more recent colossal structures. The recent works actually sit somewhere between sculpture, installation and architecture; they are either sculptural environments that viewers can enter, or quasi-architectural interventions into

given spaces. Open-Ended (2007–08) is maze-like and spatially confusing. In places its walls encroach upon viewers as they walk through it, and its internal length seems to defy its exterior size. Serra's technique is a progression from works such as *Tilted Arc* (1981), which was a huge metal wall that intervened into a plaza in New York, forcing a renegotiation of a habitual architectural space. While that work attempted to reconfigure a given space, *Open-Ended* is a total space in itself.

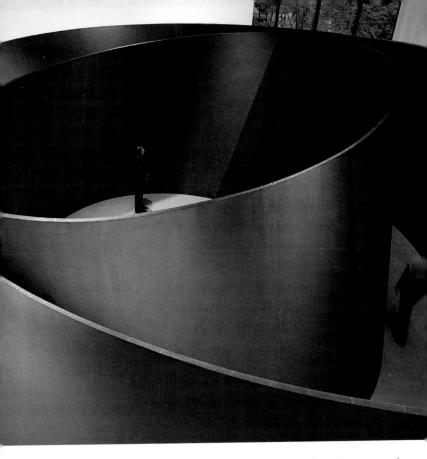

From 1968 to 1970 Serra made a number of Splash pieces, sculptural forms created when Serra splashed molten lead into junctions between a wall and a floor. In these earlier works he allowed the materials to define their own form, but in more recent works he has determined his viewers' activities through his objects. The recent work is a transition away from purely material processes, but it still retains sculpture's character as a gradually unfolding process that occurs either through physical formation or through movement of the viewer. In this sense, then, all of Serra's work appears to refer back to Minimalism, although he has applied Minimalist logic to create something able to function as an all-encompassing installation and compete with urban architecture.

Forty Years 2007 | Installation view of the exhibition Richard Serra Sculpture: Forty Years, MoMA, NY

CINDY SHERMAN

BORN Glen Ridge, New Jersey, 1954

She graduated from the State University of New York at Buffalo (1976) and moved to New York City the following year. She had her first solo show at the Contemporary Arts Museum, Houston (1980). She had a major exhibition at the Whitney Museum of American Art, New York (1987). She directed the film *Office Killer* (1997), and in the same year the Museum of Contemporary Art, Los Angeles, staged a retrospective of her work. A show of her work was held at the Serpentine Gallery, London (2003).

SEE ALSO Goldin, Kruger, Levine, Morimura, Appropriation Art, Identity Politics

Cindy Sherman masquerades under many guises in order to present masquerade itself as the foundation of identity. Her series Untitled Film Stills (1977–80) is a collection of black and white photographs that mimic stills from Hollywood movies. They always falsely imply a narrative. In Untitled Film Still #21 (1978), for example, Sherman stares anxiously out of the frame as if menaced by some unseen threat. Here, as in all her works, the photograph acquires meaning through difference with the others in its series, with her repetition of the same devices revealing their untruth. Also, we know that these are all images of Sherman, so their difference marks them all as fake. The identities depicted are only lent meaning by their context and do not appear to have any strong connection to Sherman herself.

Sherman's work targets the image as well as identity. In her series *History Portraits* (1989–90), she recreated famous paintings in photographs. The works reveal their trickery through the use of excessive make-up and clearly visible prosthetics. The point is to highlight the normally invisible modifications of reality that always occur in the process of image making.

Sherman's series *Clowns* (2004) seems to follow logically on from her earlier photographs, but there is one crucial difference. While previously she presented her characters as pure surface, her clowns imply some internal malevolence or sadness behind their external amusement and joy. Rather than just focusing on our outward definition and self-definition, Sherman seems to have turned to the relationship between this mask and the reality of the self.

Untitled 1989 | Colour photograph 105.5 x 84 cm (41½ x 33 in)

YINKA SHONIBARE

BORN London, UK, 1962

In the 1980s Shonibare studied at the Byam Shaw School of Art, London, and later graduated from London's Goldsmiths College (1991). He has had numerous solo exhibitions at institutions including Camden Arts Centre, London (2000): Tate Britain (2001); Kunsthalle Vienna. Austria (2004); and the Museum of Contemporary Art, Sydney, Australia (2008). Shonibare has participated in a number of group exhibitions, including the Venice Biennale (2001 and 2007) and Documenta 11, Kassel, Germany (2002). He was nominated for the Turner Prize (2004). He was made a Member of the Order of the British Empire (MBE) in 2005.

SEE ALSO Post-Colonialism

Yinka Shonibare is one of the most innovative contemporary artists working today. Creating sculptures, installations, videos and photographs, Shonibare explores issues of national and cultural identity. Born in London, England, to Nigerian parents, Shonibare moved to

Nigeria at a very young age and remained there until leaving to attend art college in the United Kingdom. His work has always been informed by the feeling of having two national heritages and cultural identities. Unlike much of the feminist and black art of the 1960s and 1970s, which also addressed issues of identity, Shonibare's work has a keen sense of humour and theatricality. Some of his installations and sculptures include briahtly coloured fabrics. The textiles resemble African garb, but are in fact usually purchased by the artist in the markets of Brixton, a culturally diverse area in south London. Shonibare uses the fabrics to makes dresses and canvases.

Shonibare's work also draws upon the history of Western art, confounding distinctions between high and low art. as well as Western and non-Western art Many of his photographs and installations are carefully constructed recreations of canonical English paintings and literary works. Borrowing from Gainsborough and Hogarth, amongst others, Shonibare questions the legacy of colonialism in a supposedly post-colonial world. In Diary of a Victorian Dandy (1998), Shonibare took a series of photographs of himself performing as a Victorian dandy. Having a black man take the role of what was nearly always a wealthy white man, Shonibare challenges the issue of race in Victorian England and in the world today.

Diary of a Victorian Dandy: 03.00 hours 1998 | C-type print 183 x 228.5 cm (72 x 90 in)

SANTIAGO SIERRA

BORN Madrid, Spain, 1966

He received a Bachelor degree in Fine Arts from the Universidad Complutense, Madrid (1989). Sierra has had numerous solo exhibitions at institutions including Kunstwerke, Berlin (2000); Ikon Gallery, Birmingham, England (2002); Kunsthalle Wien, Vienna (2002); CAC Malaga, Spain (2006); and Centro Cultural Matucana, Santiago de Chile, Chile (2007). He has lived and worked in Mexico City since 1995.

SEE ALSO Minimalism, Land Art, Performance Art

Santiago Sierra is known for making controversial, thought-provoking work. His practice questions the effects of different social, economic and political systems on individual lives. Returning often to the subjects of capitalism, exploitation and the meaning of labour, Sierra's work always assumes a critical perspective. Formally, it resonates with Minimalism, Land Art and the Performance Art of the 1960s and 1970s. Sierra first came to international recognition after his contribution to the Spanish Pavilion at the 50th Venice Biennale in 2003. Sierra chose to blockade the entrance to the

pavilion with bricks, refusing entry to everyone except those who could produce a valid Spanish passport. The piece demonstrated a surprising assumption of control, representing the power structures at play in contemporary society.

Much of Sierra's work is performance, which is usually documented on video. The artist employs people to add a humane dimension to the socio-economic policies and practices that govern

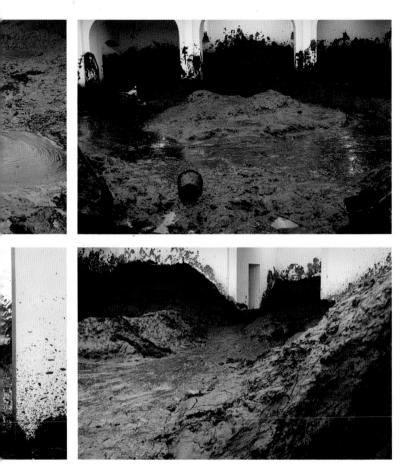

everyday lives. In one instance, Sierra paid a group of workers a minimum wage to push a block of concrete around a gallery. The work represents the plight of migrant and immigrant workers. The experience of watching it is painful and gives the feeling of complicity in wrongdoing. In another work, *House in Mud* (2005), created at the Kestner Gesellschaft in Hannover, Germany, Sierra filled the museum with 400 tons of mud. The work is an illustration of an important part of the city's history: in the mid-1930s, as part of an unemployment relief scheme, workers were hired to create a man-made lake. Sierra's work questions the value of human labour, while pointing to practices that exploit the disenfranchised.

House in Mud 2005 | Material Kestnergesellschaft, Hannover, Germany

LORNA SIMPSON

BORN New York City, NY, USA, 1960

She received a Bachelor's degree in photography from the New York School of Visual Arts (1983). She received a Master's degree in visual arts from the University of California, San Diego (1985), and in the same year had her first solo show, entitled *Gestures/ Reenactments*, at the Alternative Gallery, San Diego. She won the Whitney Museum of American Art Award (2001), and had an exhibition at that museum in 2002 and 2007. She had a self-titled solo show at the Irish Museum of Modern Art, Dublin (2003).

SEE ALSO Ofili, Mutu, Nauman, Shonibare, Feminism, Post-Colonialism, Video Art

Lorna Simpson makes photographs and films that seek to draw invisible processes into the visual field. *Corridor* (2003) consists of two films, projected side by side, which juxtapose the everyday activities of an escaped slave in 1860 and a black woman in 1960. The escaped slave is spatially confined. She also peers fearfully outward, demonstrating that her physical constriction has been incorporated into her mental attitude. The modern woman, meanwhile, seems spatially free but her image is constantly reflected back to her by mirrors. She fills her plentiful leisure time with the creation of a decorative facade, a defensive barrier against the outside world. While Simpson does not deny progress, the freedom of either of these women is questioned. In both cases, freedom from external constraint is dependent on internal policing.

Waterbearer (1986) contains a photograph of a black woman with her back turned to us. An accompanying text informs us that she witnessed some crime. but her account was not heeded. Therefore the woman, whose face is invisible, was denied a voice and completely disempowered. If, in this work, Simpson is trying to shed light on the invisible and to speak for the voiceless, in Corridor we see the ways in which external expressions can become part of a process of self-constriction. Simpson's work is therefore a progression from Conceptual works that tear open the structures of images and language, such as those of Bruce Nauman. While Nauman and his contemporaries have unravelled the power of the visual and the linguistic, Simpson attempts to redistribute the power, to bring that which was previously hidden before our eves.

[Above] Corridor (Night), 2003 Digital chromogenic print mounted to Plexiglass 68.5 × 183 cm (27 × 72 in)

[Below] Corridor (Day), 2003 Digital chromogenic print mounted to Plexiglass 68.5 x 183 cm (27 x 72 in)

robert Smithson

BORN Passaic, New Jersey, USA, 1938 DIED New Mexico, USA, 1973

Smithson was killed when his plane crashed in Texas during a photographic trip. An exhibition of his drawings toured to venues around the world, including New York Cultural Center: San Francisco Museum of Art; and the Whitechapel Gallery, London (1974-77). A show of his work toured to Walker Art Center Minneapolis; Museum of Contemporary Art, Chicago; and Musée d'Art moderne de la Ville de Paris amonast others (1980-84). Smithson was recently the subject of a retrospective organized by the Museum of Contemporary Art, Los Angeles, which toured to Dallas Museum of Art, Dallas; and Whitney Museum of American Art, New York (2004-05).

SEE ALSO De Maria, Minimalism, Land Art

Robert Smithson is often described as the most influential artist of recent times. He is known for making provocative and groundbreaking work, particularly from the mid-1960s to the early 1970s. He began his artistic career by making collages, but by 1964 he had started to experiment with Minimalist forms, using simple

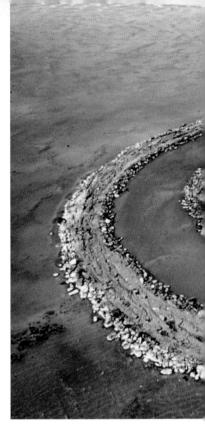

geometric shapes to create sculptural works. Engaging many of the ideas associated with Minimalism, but resisting total alignment with the movement, Smithson embarked upon a series of works that became known as non-sites and earthworks. The non-sites involved collecting material from a rural place and exhibiting that material in the gallery. The works often combined natural materials with the industrial materials of Minimalism, as in the non-site *Corner Mirror with Coral* (1969). The earthworks actually reversed this idea; instead of bringing part of the

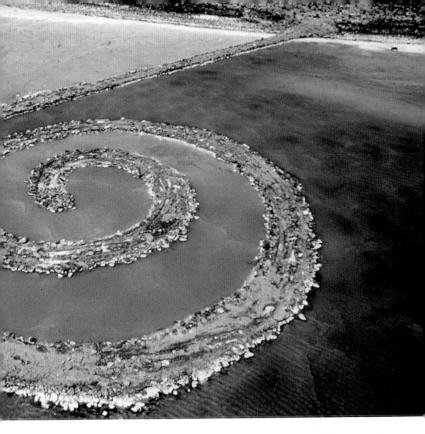

land into the art space, they created art in the land. Smithson's most famous earthwork is *Spiral Jetty* (1970), a monumental sculpture extending into Utah's Great Salt Lake in the United States. The jetty was constructed using black basalt rocks and earth collected from the site.

Smithson's work in the natural landscape was an attempt to circumvent New York's gallery system. Alongside Smithson, artists such as Walter De Maria, Nancy Holt and Michael Heizer came to define what became known as the Land Art movement. In his short career, Smithson used language, earth, mirrors, quarries and a variety of unconventional materials to make art. He made maps, proposals, drawings, films, and photographs. His interventions in the natural landscape redefined the meaning of sculpture. Smithson was also a prolific and well respected writer, and frequently contributed to a number of art publications, including Artforum.

Spiral Jetty

April 1970 | Great Salt Lake, Utah Black rock, salt crystals, earth, red water (algae) 1 x 4.5 x 457 m (3½ x 15 x 1500 ft)

NANCY SPERO

BORN Cleveland, Ohio, USA, 1926 DIED New York City, NY, USA, 2009

In 1949 Spero graduated from the School of the Art Institute of Chicago with a Bachelor's dearee in Fine Art. The Torture of Women was first shown in 1976 at A.I.R Gallery, Brooklyn – a gallery devoted to women artists, of which she was a founding member. In 1987 she had a mid-career retrospective which travelled, among other places, to Chicago's Museum of Contemporary Art and the New Museum of Contemporary Art in New York City. In the same year she also had a show at London's Institute of Contemporary Art. In 1992 she had a solo show at the Museum of Modern Art in New York City, In 2011 the Serpentine Gallery, London, staged the first major presentation of her work following her death. In 2006 Spero was made a member of the American Academy of Arts and Letters.

SEE ALSO Feminism, Identity Politics

Protest is always at the heart of Nancy Spero's art. In the late 1960s she made a series of paintings which protested against the Vietnam War. *F111* (1968) and *Chinese Bomb and its Victims* (1967) depict the deadly force of modern weapons. However as well as using dynamic, powerful lines, Spero also focuses on the victims' scorched bodies. Indeed her only moments of optimism, as in *Peace* (1968), are produced by death; the victims' ascend beyond this world of pain.

Elsewhere in this series, Spero links war and sexual politics. *Sperm Bomb* (1966), for example, compares explosions with ejaculation. This theme continues throughout her later work. In *The Torture* of *Women* (1974–76), Spero combined prints depicting female corpses with accounts of violence committed against women in South America. The fragility of the broken bodies is echoed by the delicacy of the work's paper support. Alongside the *War* series, the implication is that while violence is driven by men, it is often women who are the real victims.

Spero's work is an attempt to give voice to those who are never the protagonists but always the victims. Her recent sculpture Maypole: Take No Prisoners (2007) consists of a maypole, with a screaming head hung from each string. The heads, whose tongues protrude from their mouths, symbolize the communication of their suffering; a protest against their situation. The image of the tongue is constantly repeated in Spero's work and it always represents this power to communicate and thus to effect change. It is therefore also a symbol for her work in general, which confronts the forces of war and violence with an all-too-human scream.

haim Steinbach

BORN Rehovot, Israel, 1944

He and his family moved to the United States (1957), where he received a Masters of Fine Arts from Yale University (1973). In the early 1970s he was a painter, although some of his "paintings" were constructed using found objects. He later began to create installations and environmental works, and in 1979 he started to incorporate the shelving that became a hallmark of his practice. He had his first solo show at the Musée d'Art Contemporain, Bordeaux, France (1988). He has also been influential as a teacher, notably at the University of California, San Francisco, He now lives and works in New York

SEE ALSO Koons, Prince, Warhol

In his work since the late 1970s, Haim Steinbach has arranged objects on shelves. The arranged objects tend to be mass-produced commodities, and there is always a tension in his work between the anonymity of the objects and their deployment as art. Despite the objects' lack of individuality, Steinbach uses them as a means of individual creativity. We could take this as a comment on the nature of communication in general;

like Steinbach's objects, our vocabulary is generally created by others. Our communication is therefore never entirely our own, being partially defined externally.

Six Feet Under (2005) is a display of four kitschy ceramic sculptures. The work is centred around the repetition of feet. There is no definitive reason for this, but one of the most obvious associations to be made is with foot fetishism. We might then take this work as a materialization of sexual desire. Indeed, we can see

Steinbach's work in general as signifying the objectification of fundamental human activities – linguistic, sexual, interpersonal – with a questioning of how this impacts upon our individuality. We define ourselves by the objects that we possess, which are in turn defined by their creator and an external system of signification. Where Pop Artists felt the need to consider how popular imagery could fit within the canon of art, Steinbach considers how the individual can fit within the canon of popular culture. Six Feet Under 2005 | Mixed media 96.5 x 176 x 48 cm (38 x 69¼ x 19 in)

FRANK STELLA

BORN Malden, Massachusetts, USA, 1936.

Stella majored in history at Princeton University, also painting throughout his time as a student. After his graduation, he moved to New York (1958). He took part in the show entitled *Sixteen Americans* at the Museum of Modern Art, New York (1959–60) and in the same city had his first solo exhibition at the Leo Castelli Gallery (1963). He became the youngest artist to have a retrospective show at the Metropolitan Museum of Art, New York (1970).

SEE ALSO Andre, Flavin, Judd, Reinhardt, Abstract and Representational Art, Minimalism

The most immediately striking aspect of Frank Stella's work *Harran II* (1967) is its canvas, which departs from the square or rectangular shape that we might normally expect. The painting seems to be entirely orientated around the canvas, with curved lines used to emphasize its shape; the content of the work has been subordinated to its material support. This innovation seems to be a logical progression from the Abstract Expressionist style of the 1950s. While those artists stressed the materiality of paint through a variety of methods of application, Stella emphasizes the materiality of the work as a whole through the restructuring of its canvas. But Stella's approach was also radical because his orderly linear composition is entirely different from the exaggerated, expressive form of his predecessors. It seems that while the Abstract Expressionists were interested in a progression in the act of painting, Stella wanted to emphasize paintings as simply being material objects.

Stella's declaration of the status of his paintings as objects implies their existence

in three-dimensional, rather than twodimensional, space. It should therefore come as no surprise that he started making wall reliefs in the 1970s – transforming his materialization of painting into a direct engagement with three-dimensional form, while still retaining a fundamentally painterly format. Stella's retention of the painterly indicates that he did not intend to destroy or abandon the medium. Rather he invigorated it with new possibilities, allowing it to progress beyond the flatness of the gallery wall. Harran II

1967 | Polymer and fluorescent polymer paint on canvas

305 x 610 cm (120 x 240 in)

THOMAS STRUTH

BORN Geldern, Germany, 1954

Thomas Struth studied at the Academy of Fine Arts Düsseldorf (1973–80), He has had numerous olo exhibitions including P.S.1, Museum of Modern Art, New York (1978); Kunsthalle Bern (1987); Portikus, Frankfurt (1988); The Renaissance Society, University of Chicago (1990); St Louis Art Museum, Missouri (1993); ICA, Boston; ICA, London (1994); Sprengel Museum, Hannover (1997): Stedelijk Museum, Amsterdam (1998): The National Museum of Modern Art. Tokyo (2000); Museum of Contemporary Art, Los Angeles; Museum of Contemporary Art, Chicago (2003-04); Hamburger Bahnhof, Museum für Gegenwart, Berlin (2004); Museo del Prado, Madrid (2007); Family Portraits toured including De Pont Foundation. Tilburg and SK Stiftung Kultur, Cologne (both 2008): MADRE Museo d'Arte Contemporanea Donna Regina, Neapel (2008); and Museum of Cycladic Art. Athens (2009).

SEE ALSO Becher, Ruff

Thomas Struth is one of Germany's most respected photographers. His early works are urban landscapes, city scenes and

architectural structures. The black and white images reflect the objective stance of his teachers, and are documentary-like in their approach. Struth has captured cities in the United States, Europe and Asia, including New York, Milan, Naples and Tokyo. His images are not staged, and he avoids digital manipulation.

After spending some years capturing the urban environment, Struth began a series of domestic portraits, sometimes in colour. Although the subject matter is entirely different, Struth approaches his family portraits with the same

characteristically objective stance. Often the image captures the entire scene at hand, with the background acquiring as much emphasis as the subjects. He uses a long exposure time, which also forces his subjects into an unnatural stillness.

Struth is known for his wide range of subject matter. Alongside empty urban landscapes and family portraits is a series of images of wild Asian jungle. Struth has also made close-up photographs of flowers. For a more recent series he has taken photographs of visitors inside museums, churches and other cultural destinations. Audience 3 (Gallerie Dell'Accademia), Florenz (2004) is an astute observation of people in the act of looking. In this series, Struth's subject matter is the visitor, rather than the surrounding architecture or art. These works are often executed to a very large scale.

Audience 3 2004 | Florence | C-print 179.5 x 297 cm (70¾ x 117 in)

hiroshi sugimoto

BORN Tokyo, Japan, 1948

Sugimoto araduated from St Paul's University, Tokyo (1970), before graduating two years later from the Art Center College of Design, Los Angeles. Sugimoto has had numerous solo exhibitions, including Museum of Contemporary Art, Chicago (1994); Museum of Contemporary Art, Los Angeles (1994); Museo Guggenheim Bilbao, and Deutsche Guggenheim, Berlin (both 2000); Dia Center for the Arts. New York (2001); Serpentine Gallery, London (2003): and Mori Art Museum. Tokyo (2005). Sugimoto moved to New York in 1974. He lives and works in New York and Tokyo.

SEE ALSO Doig, Freud, Hodgkin, Abstract and Representative Art

Hiroshi Sugimoto is one of the most technically masterful photographers working today. Using a large-format camera and long exposures, Sugimoto captures his subject matter in intricate detail and with unrivalled intensity. Sugimoto's photographs, almost always gelatine silver prints, exploit the rich variety of shades of grey and black in the printing process. The formal composition of his images is matched by an equally considered conceptual approach. Inspired by the writings of André Breton, Sugimoto maintains a strong interest in Surrealism and Dadaism and his images resonate with the philosophy of each.

In 1976 Sugimoto began to photograph the diorama displays of natural history museums. His well-conceived images frame the scenes in such a way that they seem strikingly real. Sugimoto's assumption of artifice challenges the notion that photography is a representation of truth. In a similar vein, his series Portraits (begun in 1999) consists of photographs of waxworks of historical and contemporary figures, taken in museums. Since many of the waxworks are based on well-known paintings of the sitter, rather than the sitter himself, Sugimoto explores the layers of mediation in representation. Sugimoto's subject matter has also included movie theatres, Buddhist sculptures and twentiethcentury Modernist architecture. His most famous series, however, is Seascapes, an ongoing series of photographs of seas around the world taken from exactly the same vantage point. The images are serene musings on the natural landscape, as well as explorations of the notion of timelessness. The idea that the photograph is a record of the passing of time is an integral component of Sugimoto's work. This is most clearly illustrated in Sugimoto's images of movie theatres, where a single exposure can last the duration of a film.

U. A. Playhouse, New York 1978 | Gelatin silver print 119.5 x 149 cm (47 x 58¾ in)

SAM TAYLOR-WOOD

BORN London, England, 1967

Sam Taylor-Wood graduated from Goldsmiths College, London (1990) and had her first solo show at the White Cube Gallery, London (1995). She is often thought of as part of the Young British Artists generation. Taylor-Wood was nominated for the Turner Prize (1998). She became the youngest artist to have a solo show at the Hayward Gallery, London (2002), and was nominated for the Palme d'Or award at the Cannes Film Festival (2008). In 2009 she directed her first feature-length film, Nowhere Boy.

SEE ALSO Video Art, Young British Artists

Sam Taylor-Wood is a filmmaker and photographer whose work highlights gaps between appearances and reality. Her film *Still Life* (2001) features a bowl of ripe fruit that decays before our eyes. Its subject and style reference the painterly tradition known as "vanitas", which symbolically emphasizes time. The work implies that ownership of objects can provide only temporary and not eternal happiness. In her own work of vanitas, Taylor-Wood incorporates time by speeding up the fruit's decay. Self Portrait Suspended V (2004) is a photograph in which Taylor-Wood appears either to float or fall through the air. Either way, the image suggests a suspension of time. Perhaps this refers to photography's interruption of time, preserving a moment in image form.

Initially these works seem entirely opposed. While the former emphasizes time's inevitability, the other arrests it. Still Life documents resurrection as well as death. It is looped, so that once the fruit has fully decayed it appears ripe again. This suggests a more complex play between life and death, especially since the mould that signals the fruit's decomposition is itself alive. Although the title of the work Self Portrait Suspended V emphasizes time's suspension, it also suggests its own artifice. Taylor-Wood was suspended from a ceiling, but her supports have been digitally removed. Therefore, although these works appear to have specific approaches to time, they are ultimately ambiguous. Taylor-Wood presents the distortion of time, whilst emphasizing the fact that her work is only ever an image.

Still Life 2001 | 35 mm film/DVD Duration: 3 minutes 44 seconds

WOLFGANG TILLMANS

BORN Remscheid, Germany, 1968

Tillmans moved to England in 1990, studying at Bournemouth and Poole College of Art and Design. He became the first photographer to win the Turner Prize (2000). Tillmans has had many solo exhibitions at various institutions around the world, including Portikus, Frankfurt am Main, Germany (1995); Kunstmuseum Wolfsburg, Germany (1996); Chisenhale Gallery, London (1997); Museo Nacional Reina Sofía, Madrid (1998); Palais de Tokyo, Paris (2001); Museum of Contemporary Art, Chicago, which toured to Hammer Museum, Los Angeles and Hirshhorn Museum and Sculpture Garden. Washington, DC (2006-07); and Hamburger Bahnhof, Berlin, Germany (2008). Tillmans has lived and worked in London and Berlin since 2007

Wolfgang Tillmans is often credited with changing the presentation of photography in the gallery space. Rising to prominence in the early 1990s, after moving from Hamburg, Germany, to London, Tillmans became known for his considered approach to the way in which photographs are displayed. Grouping particular images together to elucidate certain connections, and printing his photographs at different sizes, depending on the gallery space, Tillmans creates installations out of images and encourages the viewer to enter the world he has photographed. His early images maintained many of the traditional categories of photography: landscape, portraiture and still life. Recently, however, he has experimented with abstraction, exploring the way light reacts with photosensitive paper. He also uses video as a medium, completing his first video piece. *Liahts*, in 2002.

Tillman's subject matter is usually mundane. He deliberately photographs from a position that anyone can achieve, maintaining an everyday perspective. He takes images of everything from clothes hanging on a hook to gay sub-cultures in London. Many of his photographs include friends, and although the compositions appear spontaneous, they are more usually carefully staged. In the work Adam, Vest and Cat (1991), Tillmans portrays his subject straight on. The image captures a particular street fashion, indicative of a certain era. Subtle details in the background, such as the pile of clothes on the floor and the ageing wallpaper, lend the viewer a glimpse into the life of the protagonist and, possibly, the artist. Tillman's images unveil what is intriguing, and often beautiful, in the world around us.

Adam, vest & cat 1991

RIRKRIT TIRAVANIJA

BORN Buenos Aires, Argentina, 1961

Born to Thai parents in Buenos Aires, Tiravanija studied at the School of the Art Institute of Chicago (1984–86) and then in the Whitney Independent Studies Program in New York. He had a solo show at New York's Museum of Modern Art (1997). Since 2001 he has taught at Columbia University, New York. He had work featured in the 50th Venice Biennale (2003). He was awarded the Hugo Boss Prize by the Guggenheim Foundation (2004). Tiravanija had retrospectives at Musée d'Art moderne de la Ville de Paris and London's Serpentine Gallery (2005).

SEE ALSO Acconci, Asher, Gillick, Relational Aesthetics

Despite the apparently loose, unstructured character of his works, Rirkrit Tiravanija has a very specific place within the canon of contemporary art. He is best known for environments such as *Untitled (Free)* (1992/2007), for which he moved a gallery's contents from its storage areas into its exhibition space. As he often does, he also cooked food and gave it away free to gallery visitors. Similarly, his Apartment series consists of recreations of his home in galleries, where he invites people to use each installation and its working facilities as they see fit. The open-endedness of these works places them within a trend toward viewer participation that began with Conceptual Artists such as Vito Acconci. At times they also bear a resemblance to the work of such artists as Michael Asher who intervene into gallery spaces to critique their economic function.

Tiravanija's work is radically different from that of his predecessors, however, because he consistently refuses to construct his participants' experience. As in his aift of food, he provides people with opportunities that they are free to take and manipulate as they choose. Since 1998 he has been involved in a project called The Land, in which rice fields have been developed by and for Thai farmers and artists. Again, this work is a gift on behalf of Tiravanija and his collaborators. Such acts of philanthropy initiate opportunities for interaction and collaboration that defv increasingly individualistic, profit-driven attitudes. Instead of merely providing users with commodities to be consumed. Tiravanija forces the users to produce the contents of the work themselves. In this way he nudges them into self-awareness, inviting them to enact and therefore internalize the values of the work.

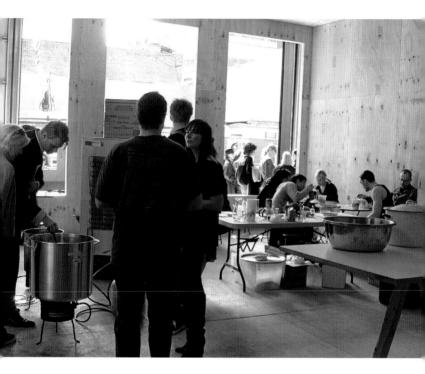

Untitled (Free) 1992 | at David Zwirner, New York 2007

LUC TUYMANS

BORN Mortsel, Belgium, 1958

Luc Tuymans studied fine arts at the St Lukas Institute, Brussels (1976–79), and at the Royal Academy of Fine Arts, Antwerp (1980–82). His first solo show, entitled *Josefine is not my woman*, was shown at Ruimte Morguen, Antwerp (1988). Tuymans had a solo exhibition at the Institute of Contemporary Arts, London (1995). His work was featured in the Belgian Pavilion at the Venice Biennale (2001). He also had a solo show at London's Tate Modern (2004).

SEE ALSO Auerbach, Bacon, Freud, Reinhardt, Richte

Luc Tuymans is a painter whose work turns aggressively against painting and images in general. *Body* (1990) is typical of his representations of people since the subject is partial and the face is absent, denying any psychological content. Black lines across the torso suggest a demarcation or an inscription. *Body* is amongst several of Tuymans's works based on medical images, and through its inscribing lines it seems to compare medical examination with image-making. Set against his refusal to deal with any emotional content, this could imply a violence within painting, an attack on its limitation of individuals to inadequate, finite forms and a measurement and mutation beyond their control.

Tuymans detects a tension between aspects of humanity that escape the image and those that are aggressively enclosed within it. In other works he finds a similar tension in relation to memory, and particularly our memory of the Holocaust. In Gas Chamber (1986) we are confronted with what could be the cellar of a house. Only after noticing the title do we realize the murderous function of the holes in the room's ceiling and the horror of its fleshy tones. Tuymans has painted the chamber as we might find it on a tour today. physically and emotionally empty. It is only via signposts like the title that we can access the terrible truth of the scene. The emptiness that Tuymans depicts is also an emptiness within ourselves, a gap where our emotional connection should be. While in Body we only see the image through its aggression, Gas Chamber demonstrates to us the impossibility of true representation. Therefore, while some hail Tuymans's works as a renaissance for painting, they may equally be seen as its executioner.

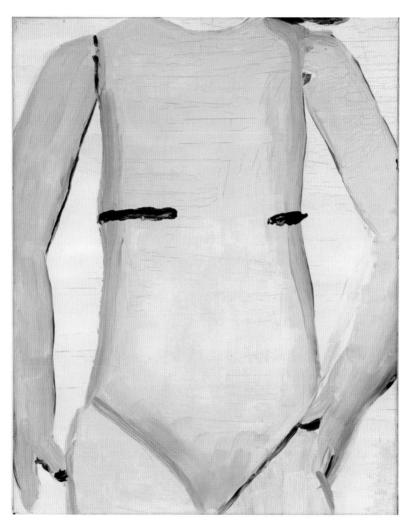

Body 1990 | Oil on canvas 49 x 35 cm (19¼ x 13¾ in)

BILL VIOLA

BORN New York City, NY, USA, 1951

Bill Viola received a bachelor's degree in fine arts from Syracuse University (1973). He worked as video preparator at the Everson Museum of Art (1972-4) and as an exhibition assistant to Nam June Paik and other artists. From 1974 he worked as technical director of Art/Tapes/22, a video art studio in Florence, Italy. While there he encountered the work of Bruce Nauman, Vito Acconci and other major video artists. He had a show entitled Bill Viola: Installations and Video Tapes at the Museum of Modern Art, New York (1987). He represented the United States of America at the Venice Biennale (1995). A show, Bill Viola: A 25-Year Survey, was organized by the Whitney Museum of American Art. New York (1997).

SEE ALSO Acconci, Nauman, Paik, Video Art

Bill Viola's videos seek to reconnect art with its traditional role as a bridge between the physical and the spiritual. His *Tristan Project* (2005–06) is a series of videos designed to accompany Wagner's opera *Tristan und Isolde*. It represents the two lovers' deaths as acts of sacrifice, necessary for their unity in another world. Tristan's ascent from the physical plane is depicted by water that first drips and then becomes a deluge, driving him upward and out of our view. The water utterly engulfs him, overpowering and carrying his limp body. Throughout the work, fire is juxtaposed with the water – the lovers' burning passion opposes their peaceful reconciliation. As they die, the fire that previously engulfed them dissolves into a fluid, indeterminate mass.

In Ocean Without a Shore (2007), figures emerge out of a dark void, approaching us by immersing themselves within a falling stream of water. Water, as a threshold between the physical and the eternal, thus becomes symbolic of artworks as sensual objects that evoke spiritual meaning. While many of Viola's contemporaries focus on the pure materiality of objects or their political significance, Viola reaches beyond these surfaces, delineating a point of transition. His works are almost always presented in slow motion, defying the speed of the contemporary world and our visceral demand for satisfaction. In his opposing of water and fire - and the final unity of Tristan and Isolde, intertwined under water - he implies that our burning desires inhibit our ability to reach beyond our bodies to the spiritual side of human existence.

Tristan's Ascension (The Sound of a Mountain Under a Waterfall)

2005 | Colour High-Definition video projection; four channels of sound with a subwoofer (4.1)

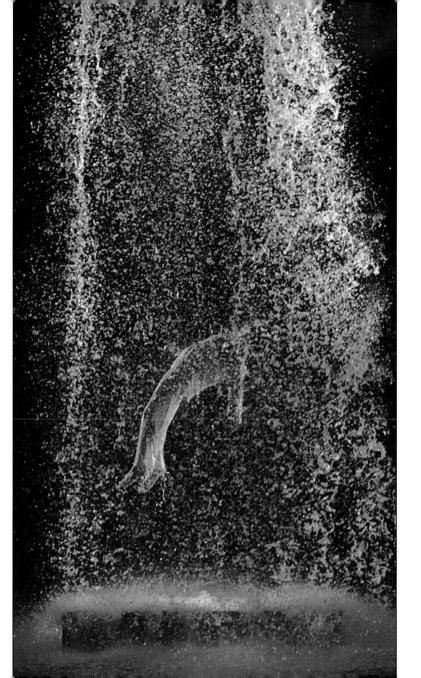

JEFF WALL

BORN Vancouver, Canada, 1946

Jeff Wall studied art history at the University of British Columbia, Vancouver (1964–70), and undertook postgraduate work at the Courtauld Institute of Art, London (1970–73). He has taught for many years at the University of British Columbia. Wall has been the subject of numerous solo exhibitions, including leff Wall: Figures & Places, Museum für Moderne Kunst, Frankfurt am Main. Germany (2001), and several retrospectives, including Jeff Wall at Tate Modern, London (2005–06), and leff Wall, which toured to the Museum of Modern Art, New York (2007); The Art Institute of Chicago (2007); and the San Francisco Museum of Modern Art (2008)

Jeff Wall is an important figure in the establishment of photography as an art form. He was also a pioneer of Photoconceptualism, a movement that emerged in Vancouver, Canada, in the 1960s and 1970s. In 1977, Wall made the first of his now well-known light-box pieces, which consist of large-scale photo transparencies mounted on light boxes. Wall devised this effect after seeing advertisements presented in the same way. Wall's back-lit transparencies often reference epic masterpieces of artists such as Eugène Delacroix, Diego Velázquez and Édouard Manet. Many of Wall's photographs are carefully staged and highly cinematographic. They are often recreations of a moment witnessed by the artist, and involve complex production teams of actors, set designers and digital editors.

In the 1990s, Wall began to investigate the still life, which he felt allowed for greater interpretive uncertainty. An Octopus (1990), for example, is an enigmatic depiction of an octopus on an empty table in a decrepit cellar – a startling scene that is full of narrative potential. In the early 1990s, Wall began to use computer digital montage techniques to construct his photographs, formulating both implausible and highly realistic scenes. In 1996, he made a series of large-scale, black and white photographs. Later on, he began to investigate the documentary photograph, and moved toward everyday scenes. Wall is also a prolific arts writer, and has written extensively on a number of Vancouver artists, including Rodney Graham, Ken Lum and Ian Wallace

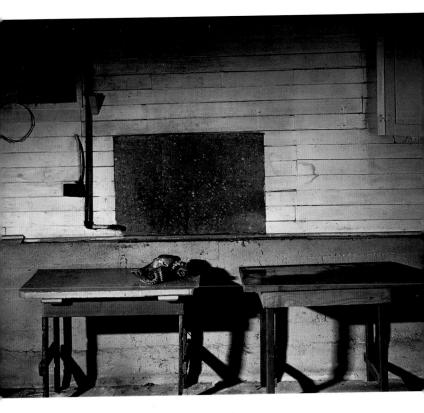

An Octopus 1990 | Cibachrome, light box 202 x 249.5 x 26 cm (79½ x 98¼ x 10¼ in)

MARK Wallinger

BORN Chigwell, England, 1959

Wallinger studied at the Chelsea School of Art and later at Goldsmiths College. He was a tutor at Chelsea from 1986. He was nominated for the Turner Prize (1995). A retrospective of his work, *Credo*, was held at Tate Liverpool (2000). He represented Britain at the 49th Venice Biennale (2001), and was also awarded the DAAD fellowship. He had a solo show at Kunstverein Braunschweig, Germany, in 2007. In the same year he won the Turner Prize for *State Britain*.

SEE ALSO Young British Artists

Mark Wallinger has been at the forefront of contemporary art since the 1990s. In 2007 he was awarded the Turner Prize for *State Britain*, a recreation of a display that formed around a peace campaigner protesting outside the Houses of Parliament in London. His work frequently investigates modern belief systems and ideas about secular and religious notions of faith. In 1999, he received critical acclaim, and public popularity, with *Ecce Homo*, a Christ like figure, which was the first commission for the empty fourth plinth in Trafalgar Square. The work was later included in the 2001 Venice Biennale. He

is well known for a piece entitled Angel (1997), a video of Wallinger walking backward down an upward-moving escalator, while reciting the opening lines of the Gospel of John in the King James Bible. The video is played in reverse.

At the beginning of his career, Mark Wallinger was closely associated with the Young British Artists (YBA) in the 1990s. Many of his earlier works investigate issues of class and nationalism. Wallinger often looked at sport, particularly horse

racing and its culture, as a means of understanding the uniquely British national sentiment. In 1994 and 1995, Wallinger made a series of paintings all entitled *Half-Brother*, followed in parenthesis by the names of two racing horses. The paintings depicted a hybrid horse, made from conjoining a rendition of the front half of one named horse with the back half of the other. Taking this idea one step further, in 1995 Wallinger purchased a racing horse and named it "A Real Work of Art". In this work, he sought to infiltrate art into the booking system, while simultaneously playing upon Marcel Duchamp's concept of the "ready-made".

State Britain 2007 | Installation, mixed media 43 meters, (141 ft)

ANDY WARHOL

BORN Pittsburgh, Pennsylvania, USA, 1928 DIED New York City, NY, USA, 1987

Born Andrij Warhola, he studied commercial art at the Carnegie Institute of Technology, Pittsburgh, graduating in 1949. He had his first solo show at the Hugo Gallery, New York (1952). He founded his famous studio, The Factory, in 1962. In 1968 he was shot and nearly killed by Valerie Solanas. He co-founded a celebrity magazine called *Interview* (1969), which continues to publish today. New York's Museum of Modern Art held a major retrospective of his work (1989). The Andy Warhol Museum opened in Pittsburgh in 1994.

SEE ALSO Hamilton, Koons, Lichtenstein, Oldenburg, Prince, Steinbach, High Art and Low Art, Pop Art

Andy Warhol is perhaps the most important and undoubtedly the most famous of all recent artists. Closely associated with Pop Art, he epitomizes its appropriation of popular images and techniques for the purposes of "high art". His *Marilyn* series (c. 1962–67), for example, inserts a celebrity from "low" culture into the high-art genre of portraiture. His use of silkscreen printing is also an import from commercial art. Furthermore, we could similarly take his famous *Brillo Box* sculptures (1964) or *Campbell's Soup Cans* (1962) as residing within the traditional genre of still life.

As well as breaking through the barrier between high and low art, Warhol also ruptured the surfaces of art and culture themselves. Initially this is meant literally; his screen-prints are marked by traces of their production process - matt colours, arainy textures and often scratches across their surface. His films also retain pockmarks, indicating the materiality of their reels. But Warhol's "rupturing of surfaces" also refers to his exposure of the underside of popular culture, represented in such works as 5 Deaths (1963) and his Electric Chair series (c. 1963-73). It is worth noting that the Marilyn series began shortly after Monroe's death. Although the movie star continues to live through Warhol's work, hers is now the life of an image. Our memory of her is absolutely determined by Warhol's production and her reception in the public sphere. Therefore Warhol is concerned, not only with a literal death, but also the death of an individual as she is devoured by the public. This is perhaps a metaphor for the death of art as it becomes consumed by popular culture. These confrontations have continued to reside at the centre of contemporary art, always in Warhol's shadow.

Marilyn Monroe (hot pink) 1967 | Colour screenprint

GILLIAN WEARING

BORN Birmingham, England, 1963

Wearing studied at the Chelsea School of Art, London (1985–87) and Goldsmiths College (1987–90), earning a Bachelor's degree in Fine Art. She had her first solo show at the not-for-profit art gallery City Racing, London (1993), and won the Turner Prize in 1997. She is often seen as part of the Young British Artists group, and was included in the show *Sensation* at the Royal Academy of Arts, London (1997). Wearing also had a show entitled *Mass Observation* at the Museum of Contemporary Art, Chicago (2002–03).

SEE ALSO Young British Artists

Gillian Wearing's Signs that Say What You Want Them to Say and Not Signs that Say What Someone Else Wants You to Say (1992–93) is a series of photographs in which Wearing allowed individuals to express themselves by writing signs to display to a camera. In one example, "I'm desperate", a successful-looking man wearing a suit defies our expectations by expressing his desperation. While his suit places him in a category that is provided by society, his sign seems to give him an opportunity for self-determination.

But this revelation of the private is never straightforward in Wearing's work. In Confess All on Video. Don't Worry You Will Be in Disguise. Intrigued? Call Gillian (1994), Wearing invited people to make confessions on camera behind various plastic masks. However, we cannot help but wonder whether these outlandish confessions, which include near-incestuous obsessions, crimes and infidelity, are anything more than performances for the camera. There is also an ambiguity to Wearing's role. Although she presents the works as documents of personal revelation, we inevitably ask how far they are prompted by her own intervention. So, rather than setting the public and private realms in opposition, Wearing displays all the ambiguities that exist between them. She is criticizing society's determination of the individual, while at the same time emphasizing her own determination of their self-revelations. If her work is an unmasking of the human condition, then it presents that condition as inherently relational – the self is only formed in its relations with other people.

"I'm desperate"

1992–93 | Colour photograph on paper Frame: 132.5 x 9 x 4.5 cm (52 x 3½ x 1¾ in) Support: 119 x 79 cm (46¾ x 31 in)

lawrence Weiner

BORN New York City, NY, USA, 1942

After leaving school, Lawrence Weiner moved through a number of jobs before eventually turning to art. He had his first solo show at the Seth Sieglaub Gallery, New York (1964). In 1968 he turned to language as the primary medium of his work, a move that made him one of the most important early Conceptual Artists. Since the 1970s, Weiner has often presented his linguistic works as wall installations. He had a show at the Institute of Contemporary Arts, London (1991). Weiner lives and works in New York and Amsterdam.

SEE ALSO Craig-Martin, Creed, LeWitt, Nauman, Conceptual Art

Since the 1960s, Lawrence Weiner has been an important exponent of Conceptual Art, a form of art-making that allows concepts to be artworks without requiring their realization as objects. In his 5 Figures of Structure (1987), Weiner wrote descriptions of five potential sculptures on the walls of a gallery. These appear to be precursors to objects, but in fact declare themselves as legitimate artworks in their own right.

Weiner's art, although it does not exist

in physical form, is still sensual, albeit in a radically new way. Although 5 Figures of Structure appears to be a purely linguistic work, it nonetheless evokes the physicality of a real construction in the viewer's imagination. In a sense, then, viewers are forced into the position normally occupied by the artist, since in reading Weiner's text they actually realize it as sensual in the same way that an artist might

AB + ANOTHER SLAB SET SLAB RESTING ON THE GROUND

TWO SLABS PLACED AGAINST EACH OTI TO FORM A FORM WITH ANOTHER SLAB ON THE GROUND

AB SET ABOVE THE GROUND EXPOSED En one slab set in line with 'r slab

normally realize it as an object. Doctrinal Conceptualism suggests that the sensual and the conceptual can be independent, but the viewer's experience of Weiner's work suggests otherwise. The two are always bound up in our approach to any work of art.

By enacting all of this through his viewers, Weiner reveals the role that they inevitably play in artistic production.

Furthermore by reconstituting the work within themselves, viewers reorientate themselves in relation to the work. Through their activity they themselves are changed.

5 Figures of Structure

1987 | Matt enamel-painted (black) lettering (Franklin Gothic Extra Condensed) on wall Height of letters approximately 30.5 cm (12 in) Overall dimensions variable

FRANZ WEST

BORN Vienna, Austria, 1947

He studied at Vienna's Academy of Fine Arts (1977–82). West has had work featured at the Venice Biennale on a number of occasions. He began to include elements of furniture in his work in the 1980s. He was included in the Documenta IX and X exhibitions in Kassel, Germany (1992 and 1997). He has been awarded several prizes, including the Sculpture Award of the Generali Foundation (1993). He had a solo show at the Museum of Modern Art, New York (1997). He had a show at London's Whitechapel Gallery (2003).

SEE ALSO Conceptual Art

Franz West is primarily known for his interactive sculpture. Auditorium (1992) consists of a number of sofas made from steel frames covered by old carpets. West's works include several similar chairs and sofas, and he invites viewers to sit in them. This encouragement of interaction opposes the way art is differentiated from useful objects and everyday activities. In this respect the works are like West's *Adaptives*, which he first made in 1974 and still makes today. These are ambiguous objects that viewers are

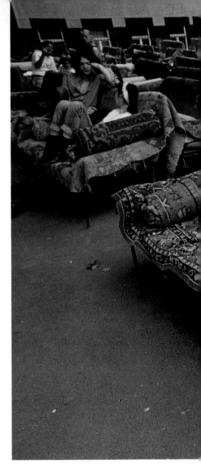

encouraged to handle and interact with, even though they have no clear intended use. Again, this encouragement of interaction breaks down the barrier between the viewer and the work. The awkwardness of the *Adaptives* complicates that interaction and forces participants to be wary of them in a way that they are not of other objects.

West's chairs also function symbolically. The artist is from Vienna, which was

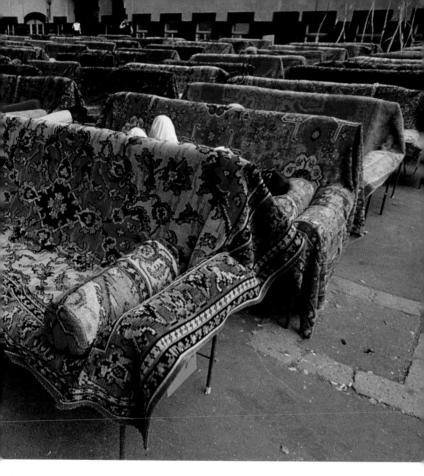

home to Sigmund Freud, the founder of psychoanalysis. All West's chairs reference Freud by alluding to the psychoanalyst's couch. The implication is that by sitting in the chair we become an object of analysis. Like the *Adaptives*, where much of the point is to watch others' vain attempts to find some use for the objects, the chairs turn viewers into viewed objects. While West critiques our relationship with art and objects in general, he also forces us into a position of self-awareness. In traditional works we can lose ourselves in the space of the artist's fantasy, but in West's sculpture we are faced with the realities of inhabiting real space and sharing it with others.

Auditorium

1992 | Iron, foam, carpets 72 parts, each 90 x 100 x 220 cm (35½ x 39½ x 86½ in)

RACHEL WHITEREAD

BORN London, England, 1963

Whiteread was educated at Brighton Polytechnic and London's Slade School of Art. She has had many solo exhibitions at institutions around the world, including shows at the Solomon R. Guggenheim Museum, New York (2002); Kunsthaus Bregenz, Austria (2005); and Museum of Fine Arts, Boston (2008–09). Whiteread exhibited in the British Pavilion of the Venice Biennale (1997), and received the Venice Biennale Award for Best Young Artist. She lives and works in London.

SEE ALSO Minimalism

The first woman to win the Turner Prize, in 1993, Rachel Whiteread is known for creating some of the most important works of contemporary art in recent times. Primarily a sculptor, Whiteread usually uses plaster or resin to create casts of "negative spaces", the areas in between, above, below and around objects. Often working with everyday items of furniture, such as a table or bath, Whiteread has also explored architectural spaces, sometimes casting an entire room. In the work *House* (1993–4), for which she won the Turner Prize, Whiteread cast the complete interior of a house in London. Scheduled for

demolition, the house was the last of a terrace of houses from the mid-nineteenth century. Whiteread's sculptures investigate the signs of living that are left behind in a space, or the marks of wear in an object after years of use. Her sculptures are a means of preserving personal memories and the history of objects and spaces. Throughout her career, Whiteread has fulfilled a number of now familiar public commissions. In 2000, she completed the Holocaust Memorial in Vienna, Austria The memorial consists of a concrete cast of many rows of shelved books. In 2002, Whiteread unveiled her project for the prestigious plinth commission in Trafalgar Square, London. The work was a large, and incredibly heavy, resin cast of the plinth on which it was placed. Again working with the casting of empty space, for a commission for the Turbine Hall. Tate Modern, London, Whiteread made over 14.000 models of the inside of cardboard boxes, made with clear, white polyethylene Embankment (2005). Stacked one on top of another, the boxes looked like a fantastical sugar-cube wonderland. However, as a monument of the empty spaces within boxes, the work also suggests the packing, storage, loss and decay of personal memories.

House 1993–4 | Mixed media Grove Road, East London Commissioned and produced by Artangel

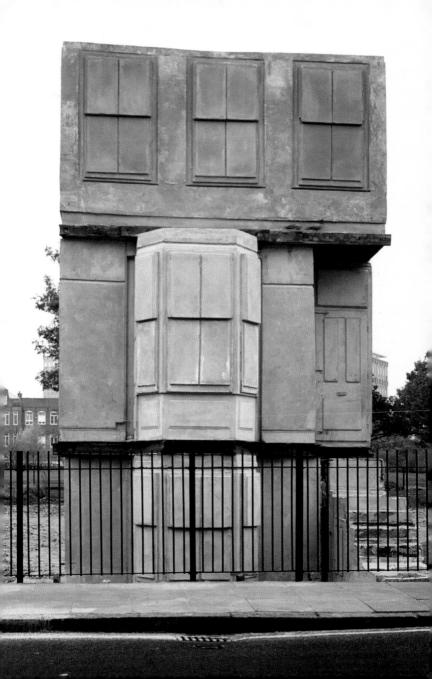

YUE MINJUN

BORN Daqing, China, 1962

In 1985 Yue Minjun graduated with a degree in Oil Painting at Hebei Normal University. Initially after graduating he taught drawing for North China Petroleum. In 1999 he had work featured in the Venice Biennale. He had a solo show at Chinese Contemporary in London in 2000. In 2007 he had simultaneous solo exhibitions at the Queens Museum of Art and the Asia Society in New York. n 2008 plans were announced for a Yue Minjun museum in China's Sichuan Province.

SEE ALSO Liu, Rauch, Zhang (Xiaogang)

The paintings of Yue Minjun are aggressive in their uniformity and painfully humourless in their incessant laughter. Yue Minjun's works such as *Noah's Ark* (2005) and *Untitled (Lady Liberty)* (2005) always include the same laughing figure, with his mouth wide open but his eyes sealed shut. In fact this is a self-portrait, but in its ubiquity it comes to represent the entirety of China's population. The figure's laughter clearly functions as a kind of social mask. He hysterically feigns amusement, but also refuses to open his eyes onto the world.

While this is preeminantly a comment on the enforced uniformity of contemporary Chinese society, Yue Minjun also aims similar accusations at the West. In paintings such as Infanta (1997), which is a manipulation of a painting by Velázquez, Yue Minjun replaces figures in well-known European paintings with his laughing Chinese man. We can similarly understand Untitled (2002), which represents a marble sculpture of the laughing man, as erroneously inserting him into the canon of European art. Yue Minjun thus implies the uniformity of Western culture by highlighting its exclusion of the East and its idealization of a European model of beauty.

Underlying these uniformities is always a latent violence. *Execution* (1995) features fake killings, with men pretending to point guns at a line of manically laughing figures. These mock murders belie the real violence of China's recent past and indeed that of events around the world. While Yue Minjun's figures outwardly imply amusement, their closed eyes reveal an inability to face up to the genuine horrors that underlie their social theatre. Although their masks never slip, we are always led to imagine the pain that must lie behind them.

Untitled (Lady Liberty) 2005 | Oil on canvas 170 x 140 cm (67 x 55 in)

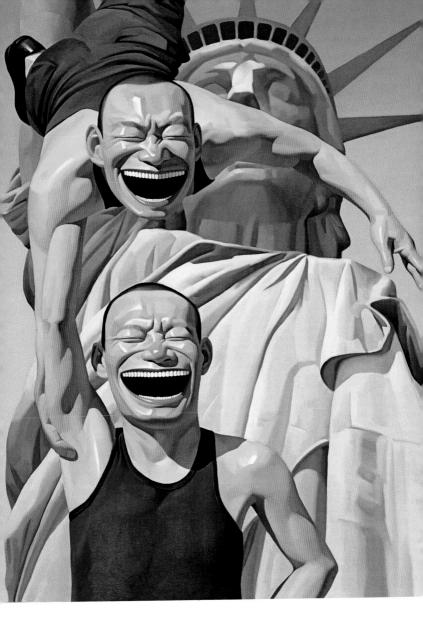

ZHANG HUAN

BORN He Nan Province, China, 1965

Zhang Huan received a Bachelor of Fine Arts degree from He Nan University (1988). His first solo show was held at that university in the same year, and he soon began to show internationally, including an exhibition at the Max Protetch Gallery, New York (1999). In 1992 he began to work as part of a group known as "Beijing East Village" after the group's own nickname for an impoverished area of that city. He had a show entitled Ash at Haunch of Venison, London (2007).

SEE ALSO Abramovic, McCarthy, Performance Art

In Zhang Huan's *To Raise the Water Level in a Fishpond* (1997), a crowd of Chinese workers were asked to stand in a pond; the volume of their bodies displaced and raised the water. The work thus affirmed the strength of collective action by visualizing how the workers' mere presence could cause effect on their environment.

Zhang Huan took a different approach in Family Tree (2000). A number of photographs document a calligrapher's gradual covering of Zhang Huan's face, first with his family tree and then with family stories and popular fables. His face ends up entirely black, as if his individuality has been submerged by his family history. The work suggests that Zhang Huan is nothing other than that history, despite the personal capacity he implied in his earlier work. Even if individuals can collaboratively produce change, we might wonder whether this is a free act or merely the product of their background.

Zhang Huan is a political artist, but not on a global scale. Instead he focuses on politics at the level of the individual and the community. Through the use of performance, he turns the individual into an artistic object. He demonstrates our potential to intervene, as well as our internal complexity. In Family Tree he shows our social determination and the impossibility of existing apart from our history. However, in To Raise the Water Level in a Fishpond he seems to imply that we ourselves are the force of social determination, the constituent parts of future history. As much as we are inseparable from social forces, those forces are inseparable from us, and so as much as we are controlled, we equally have the potential to control.

Family Tree 2000 | Chromogenic colour prints 127 x 101.5 cm (50 x 40 in)

ZHANG XIAOGANG

BORN Yunnan province, China, 1958

In 1982 Zhang Xiaogang graduated from the Sichuan Academy of Fine Arts. His first solo exhibition was held in 1989 at the Gallery of the Sichuan Academy of fine Arts. In that year his work was also included in *China/Avant-Garde* at the National Art Gallery in Beijing. He had work exhibited at the Venice Biennale in 1995. From 1998 to 2000 his work was featured in an exhibition called *Inside Out: New Chinese Art* which travelled across the United State, including stops in New York, San Francisco and Seattle. He currently lives and works in Beijing.

SEE ALSO Cai, Liu, Rauch, Yue

Zhang Xiaogang is a Chinese painter who presents a collision between public and private, inner life and the material conditions of the outer world. He is most famous for his *Bloodlines: Big Family* series (c1995–2006). These paintings derive from Chinese studio portraits of families from the time of the Cultural Revolution. They are permeated by strict uniformity. The figures are tied together by thin red lines: the 'bloodlines' which are symbolic both of familial connections and also, through their colour, of the Communist regime. However, *Little Graduate (From My Dream)* (2005) shatters the paintings' usual uniformity. This figure is naked from the waist down, an image from an anxiety dream. Zhang's Xiaogang's moment of embarrassing nonconformity implies the fear which holds any repressive regime in place. Although this fear never manifests itself on the blank faces of his figures, it erupts here in his unconscious.

The paintings are always scarred by blemishes, like the one on the cheek of the figure in Little Graduate (From My Dream). These marks resemble the degradation of a photograph which has been exposed to bright light. Here, they imply the age of the image, although of course this is not a painting of an actual photograph. The age of the image is also emphasised by Zhang Xiaogana's monochrome palette. Time is thus incorporated into the paintings, giving them a melancholy edge through reference to a lost past. However, as in the case of Zhang Xiaogang's dream, this is a past which continues to haunt the present. Like the latent fear which manifests itself in this painting, history continues to protrude through the chinks in ideology's armour. Therefore these images of China's past uniformity serve as moments of mourning which pierce its present.

Little Graduate (From My Dream) 2005 | Oil on canvas 200 x 160 cm (78¾ x 63 in)

THEMES AND MOVEMENTS

APPROPRIATION ART

This term describes a number of 1980s artists who used the appropriation of images, both from popular culture and also from the art world, as a means of social critique. While in some cases these artists directly re-presented images, they often made alterations in order to subvert the original. As well as performing social criticism of the specific images, this approach also asks questions about the nature of artistic authorship in general.

ARTE POVERA

Arte Povera is a term that was attached to a number of artists in the late 1960s, who attacked art itself through the use of cheap, second-hand materials and everyday objects. These artists, who were primarily Italian, sought to drag art down from its lofty social position and into the the gritty realities of contemporary society. This was an attempt to transform art into a revolutionary tool, rather than a participant in economic exploitation.

CONCEPTUAL ART

Conceptual Art, which first emerged in the late 1960s, assumes that ideas can be artworks as much as objects. Therefore although Conceptual Artists do often exhibit objects, these do not constitute the entirety of their production, which can only be understood alongside the concepts behind the objects. This approach has commonly led to the use of language or extended artistic processes in order to avoid placing the object at the centre of the artist's work.

INSTALLATION ART

While Minimalism embedded its objects directly within their surroundings, more recent artists have used these surroundings themselves as an artistic medium. This has allowed artists to create entire environments as works of art, thus bypassing the centrality of individual objects. It has also blurred the lines between artists and curators, with some artworks increasingly coming to resemble exhibitions.

INSTITUTIONAL CRITIQUE

This term refers to the approach of a number of 1970s Conceptual Artists who particularly turned their attention to the working of museums, galleries and other artistic institutions. Their key assumption is that artistic institutions, and indeed the art market in general, tend to dominate artworks. Therefore works of Institutional Critique seek to reveal the economic mechanisms underlying artistic production and circulation.

LAND ART

Following the influence of Minimalism, a number of artists became interested in integrating their work more fully into the world around them. They therefore created artworks within the natural landscape. Such works often comment on environmental issues and the relationship between man and nature. This approach also provided a means of escaping the influence of the art market as an alternative to Institutional Critique.

MINIMALISM

This term describes a trend among painters and sculptors in the 1960s and 1970s which blurred the lines between these two media. In opposition to the angstridden style of Abstract Expressionism they made frank, often geometric objects. These objects are not reliant on the emotions of an artist and through their simple forms they declare their objective existence within the gallery space. They therefore set up a direct physical relationship with their viewers' bodies, refusing the distance and separation which is often a characteristic of traditional art.

PERFORMANCE ART

Influenced by the diminishing importance of objects in Conceptual Art and the emphasis on the body in Minimalism, many 1960s artists directly used their bodies to create artworks. This approach was also used as a means of bypassing the art market, because they generally left no material object behind other than photo documentation. While performance art generally just involves using the body as a means of expression, some artists have blurred the lines between media by making themselves into living sculptures or using their body as a canvas or a means of applying paint. Some have also used self-harm as a means of altering the form of their body, as if to use it as a canvas.

PHOTOREALISM

Photorealism first emerged in the late 1960s, in opposition to abstract art's domination of painting. Photorealist paintings are always based on photographs and so although they seem almost implausibly life-like, they also generally reproduce photographic distortions. Therefore, as well as a simple return to representation, they also mark an interest in the mediation of reality by technology.

POP ART

Originating in mid-1950s Great Britain and then slightly later in the USA, Pop Art

incorporated the images and styles of popular culture into the canon of "high art". While this sometimes worked as a celebration of popular imagery, it could also serve as a means of criticising its increasing dominance.

RELATIONAL AESTHETICS

A term coined in the 1990s to refer to a trend towards highly participatory art that takes its form from the social relations of its participants. Artists often set up situations in which individuals are free to act as they choose, or present objects as the product of a relation between people. Relational Aesthetics is hugely influenced by Conceptual Art and continues its project of minimizing the object's importance.

VIDEO ART

Although artists had been experimenting with film throughout the 20th century, video art first became a common approach in the 1960s. In fact it is often distinct from film, because in its purest form video art involves no editing. Its use was influenced by the increasing availability of video cameras, which made them appear as a democratic way of making art, which could be used to critique traditional media. Video Installation is Video Art which incorporates the gallery space. This might involve the use of multiple screens, architectural elements, sculpture or some means of involving the viewer in the work.

YOUNG BRITISH ARTISTS

A loose group of artists who emerged in Great Britain in the early 1990s. The YBAs were originally centred around London's Goldsmiths College, but the term can also be applied to artists with no real connection to that institution. It is difficult to pick out any single common thread to their work, but they are best known for their often shocking, provocative approach.

PICTURE CREDITS

The publishers would like to thank the following sources for their kind permission to reproduce the pictures in this book.

9 Photograph by Kathryn Carr © The Solomon R. Guggenheim Foundation, New York; 11 greengrassi, London, Galerie Daniel Buchholz, Cologne, Galerie Giti Nourbakhsch, Berlin; 13 Acconci Studio: 14-15 Courtesv Mever Riegger, Photographer: Heinz Pelz; 16-17 Copyright Crystal Eye Ltd, Helsinki, Courtesy Marian Goodman Gallery, New York and Paris, © DACS 2009; 19 Rex Features; 20-21 Courtesy of Doug Aitken and 303 Gallery, New York; 22-23 Roman Mensing/artdoc.de; 24-25 Courtesy David Zwirner, New York; 27 © DACS, London/VAGA, New York 2009, Tate, London 2008; 29 Puck Film Production/The Kobal Collection; 31 Copyright © The Estate of Diane Arbus. LLC; 33 Roman Mensing/artdoc.de, LWL-Landesmuseum für Kunst und Kulturgeschichte (Westfälisches Landesmuseum); 35 © Tate, London/© the artist Courtesy of Marlborough Fine Art (London); 36-37 ©Tate, London 2008; 39 © Tate Modern, London, 2011; 41 © 2002 Matthew Barney, Photo: Chris Winget, Courtesy Gladstone Gallery, New York; 43 Courtesy, James Goodman Gallery, New York, USA, The Bridgeman Art Library, © Estate of lean-Michel Basauiat, All Rights Reserved. Used by Permission: 45 © Bernd & Hilla Becher/Tate, London 2008; 46-47 © 2009 Vanessa Beecroft, Courtesy of Massimo Minini & Galleria Lia Rumma; 49 © Tate, London 2008, © DACS 2009; 51 Courtesy: Marian Goodman Gallery, New York; 52-53 © Monica Bonvicini, Photo: Frederik Nilsen, © DACS 2009; 55 Courtesy Cheim & Read, Galerie Karsten Greve, and Hauser & Wirth, Photo: Allan Finkelman, © DACS, London/VAGA, New York 2009; 57 Copyright of the Artist and courtesy of Hales Gallery; 59 © Tate, London 2008, © DACS 2009; 61 © Glenn Brown. Courtesy of Gagosian Gallery. Photo credit: Prudence Cumina Associates Ltd; 62-63 Courtesy the artist and Hauser & Wirth Zürich London Photo: Mike Bruce; 64-65 Photolibrary/ Age Fotostock, © ADAGP, Paris and DACS, London 2009; 67 @ the artist; Courtesy, Timothy Taylor Gallery, London, © ADAGP, Paris and DACS, London 2009; 69t Seattle Art Museum, Gift of Robert M. Arnold, in honor of the 75th

Anniversary of the Seattle Art Museum, 2006. Exhibition copy installed at Solomon R. Guagenheim Museum, New York, 2008 during the exhibition Cai Guo-Qiang: I Want to Believe, Solomon R. Guggenheim Museum, New York, February 22-May 28, 2008 Photograph by David Heald © The Solomon R. Guggenheim Foundation, New York, Courtesy Cai Studio: 69b Photo by Tatsumi Masatoshi, Courtesv Cai Studio; 71 Courtesy Galerie Emmanuel Perrotin, Paris & Miami, © ADAGP, Paris and DACS, London 2009; 73 © Barford Sculptures Ltd Photographer John Riddy; 75 Courtesy Galerie Emmanuel Perrotin, Paris, Photo: Attilio Maranzano; 77t Mrs Florence M Schoenborn Fund, 585,1970. © 2008 Digital image, The Museum of Modern Art, New York/Scala, Florence; 77b The ludith Rothschild Foundation Contemporary Drawings Collection Gift, Acc, n:TR12112.334. © 2008, Digital image, The Museum of Modern Art, New York/Scala, Florence; 78-79 © The Estate of Helen Chadwick, Photo: New Art Centre, Roche Court: 80-81 © the artist, Photo: Stephen White, Courtesy Jay Jopling/White Cube (London); 83 Photo: Wolfgang Volz/laif/Camera Press © 1995 Christo; 85 Courtesy "The World of Lygia Clark" Cultural Association, Photographer Unknown: 87 Solomon R. Guagenheim Museum, New York Anonymous aift. 1999 99.5280/@ Francesco Clemente; 89 © Chuck Close, Courtesy PaceWildenstein, New York/ Photograph courtesy PaceWildenstein, New York; 91 © Tony Cragg/Tate, London 2008; 93 Collection Irish Museum of Modern Art Purchase, 2005/© Michael Craig-Martin. Courtesy of Gagosian Gallery. Photo credit: Prudence Cuming Associates Ltd.; 94-95 Courtesy the artist/Photo: Ellen Page Wilson; 97 Courtesy the artist/ Photo: Ellen Page Wilson; 98-99 The Bridgeman Art Library/Art Gallery of New South Wales, Sydney, Australia, © Richard Deacon: 100-101 Courtesy the artist, Frith Street Gallery, London and Marian Goodman Gallery New York/ Paris; 102-103 Artangel, Photo by Martin Jenkinson; 105 Courtesy Sprüth Magers, Berlin/London copyright: © Thomas Demand, VG Bild-Kunst, Bonn/© DACS 2009; 107 Courtesy: Marian Goodman Gallery, New York; 109 © Mark Dion/Tate, London 2008; 110-11 Courtesy of Victoria Miro Gallery,

Copyright the artist: 113 Courtesy the artist and David Zwirner, New York; 115 Courtesy the artist and Frith Street Gallery London; 117 Collection Irish Museum of Modern Art Purchase, 1994, Image Courtesy of Jimmie Durham and Irish Museum of Modern Art Photographer Denis Mortell; 119 © Eggleston Artistic Trust, Courtesy Cheim & Read, New York; 121 Photo: Andrew Dunkley & Marcus Leith, © Olafur Eliasson 2003; 122-123 Courtesy: Art Production Fund, York; Ballroom Marfa, Marfa; the artists Photo by: Lizette Kabré; 124-125 © the artist Photo: Stephen White, Courtesy lav lopling/White Cube (London); 127 © Peter Fischli David Weiss, Courtesy Sprueth Magers, Berlin/London; 129 Gift of Philip Johnson, Acc. N: 67, 1979. C 2008. Digital Image, The Museum of Modern Art, New York/Scala, Florence, © ARS, NY and DACS, London 2009; 131 Courtesy of the artist and Friedrich Petzel Gallery, New York; 133 Christies/© the artist; 135 © Tom Friedman. Courtesy Gagosian Gallery, New York; 137 Photo: Ben Westoby Courtesy White Cube; 138-139 Photo: Jan Bitter/Bitter Fotografie/© the artist; 140-141 Courtesy Gilbert & George: 142-143 Turner Prize, Tate Britain, London, Courtesy the artist & Corvi-Mora. London: 145 The Museum of Modern Art. New York. Gift of the Dannheisser Foundation © Robert Gober, Courtesy of Matthew Marks Gallery, New York: 147 © Nan Goldin; 149 "Oranges and Sardines: Conversations on Abstract Painting", November 9, 2008 -February 8, 2009, Installation at the Hammer Museum, Los Angeles; photo: Joshua White. © The Felix Gonzalez-Torres Foundation, Courtesy Andrea Rosen Gallery, New York; 151 © 2006 anna lena films; 152-153 © the artist, Photo: Stephen White, Courtesy Jay Jopling/ White Cube (London); 155 Courtesy the artist & Lisson Gallery; 157 © Subodh Gupta, Courtesy the artist. Arario Gallery and Hauser & Wirth, Photo: Mike Bruce; 158-159 Copyright: Andreas Gursky / VG Bild-Kunst, Bonn 2009, Courtesy Sprüth Magers Berlin London, © DACS, London 2009; 161 © Hans Haacke/VG Bild-Kunst. Courtesy of the artist and Paula Cooper Gallery, New York. Photo: Hans Haacke, @ DACS 2009; 163 © Richard Hamilton. All Rights Reserved, DACS 2009/Tate, London 2008; 165 © The Keith Haring Foundation. Used by permission; 166167 Photo: Philippe Migeat, Courtesy Centre Pompidou, Paris; 169 Museum of Modern Art, New York, gift of Anita and Charles Blatt, 1969, photo: Abby Robinson, New York, © The Estate of Eva Hesse, Courtesy Hauser & Wirth Zürich London: 171 Commissioned & produced by Artanael: 172-173 Courtesy of the artist and Stephen Friedman Gallery, London: 175 © Damien Hirst, All rights reserved, DACS 2009; 177 © David Hockney/Tate, London 2008; 179 © Howard Hodgkin. Courtesy of Gagosian Gallery; 181 Exhibition Details: Carsten Höller, 'Upside Down Mushroom Room', 2000. Installation view "Ecstacy: In and About Altered States", MOCA, Los Angeles, 2006 Courtesy of Fondazione Prada Collection, Milano, Photos; Dugaal Labs, © DACS 2009; 182-183 Solomon R. Guggenheim Museum, Gift of the artist, The Jay and Donatella Chiat collection; and purchased with funds contributed by the International Director's Council and Executive Members: Eli Broad, Elaine Terner Cooper, Ronnie Heyman, Dakis Joannou, Peter Norton, Inge Rodenstock, and Thomas Walther, 1996. 96.4499. Photograph by David Heald © The Solomon R. Guggenheim Foundation. © ARS. NY and DACS London 2009; 185 Photographer: Achim Thode Copyright 2009: Rebecca Horn/ VG Bild Kunst, @ DACS 2009; 186 187 Commissioned and produced by Artangel, Photo by Stefan Altenburger; 189 Copyright Hugna Yong Ping Courtesy Gladstone Gallery; 190-191 Courtesy: Marion Goodman Gallery, New York/Paris, © ADAGP, Paris and DACS, London, 2009; 193 @ Photo Scala, Florence, Dono dei Signori Robert C. Sculla. Inv.: 8.1958. © 2008. Digital image, The Museum of Modern Art (MOMA), New York, © Jasper Johns / VAGA, New York / DACS, London 2009; 195 Tate, London 2008, © Judd Foundation, Licensed by VAGA, New York/DACS, London 2009; 197 Collection of Kakkerei, Zollverein, Essen Germany Photo by Dirk Pouwels, Courtesy of Ilya and Emilia Kabakov, © DACS 2009; 199 Installation: Tate Modern, 2002-03, Photo: John Riddy, Courtesy: Tate; 200-201 © Alex Katz DACS, London/VAGA, New York 2009; 202-203 Photo credits: Peter Mallet, Copyright: Mike Kelley, 2009, Courtesy: The Frank Cohen Collection; 205t © Mary Kelly/Collection, Arts Council of Great Britain; 205b © Mary Kelly/ Collection Peter Norton Family Foundation; 207 © William Kentridge/ Tate, London 2009; 208-209 © Estate Martin Kippenberger, Galerie Gisela Capitain, Cologne; 211 © Per Kirkeby,

Courtesy Galerie Michael Werner Berlin. Coloane & New York: 213 © leff Koons; 214-215 Courtesy Cheim & Read, New York: 217 Collection The Broad Art Foundation Santa Monica, California Photo Courtesy Mary Boone Gallery, New York; 218-219 Courtesy of the Victoria Miro Gallery, Copyright The Artist; 221 Courtesy of Simon Lee Gallery, London; 222-223 Photograph by Ellen Page Wilson, Courtesy PaceWildenstein, New York, © ARS, NY and DACS. London 2009: 225 © Photo Scala, Florence, Gift of Richard Brown Baker, BA 1935 Acc. N: 1995.32.9 © 2007 Digital Image, Yale University Art Gallery/Art Resource, NY, © The Estate of Roy Lichtenstein/DACS 2009; 227 Courtesy Mary Boone Gallery; 228-229 © the artist/Hamburger Bahnhof Museum Fur Gegenwart Berlin 1996; 231 © the artist, Tate, London 2008/Sadie Coles: 233 Solomon R. Guggenheim Museum, New York Gift, The Robert Mapplethorpe Foundation, 1993 93.4304; 235 Photo by John Cliett. © Dia Art Foundation.; 237 Courtesy Electronic Arts Intermix (EAI). New York: 239 Photo by Ann-Marie Rounkle, Courtesy the artist and Hauser & Wirth Zürich London; 241 Copyright the artist, Courtesy Thomas Dane Gallery, London and Marian Goodman Gallery, New York and Paris; 243 Photos: Jan Bauer / Courtesy Contemporary Fine Arts, Berlin; 244-245 © the artist, Courtesy Jay Jopling/White Cube (London); 247 © Cildo Meireles/ Tate, London 2009; 248-249 Photo: Laurent Lecat - Stéphane Pons, Courtesy of the Artist et Galerie Marian Goodman. Paris / New York, © ADAGP, Paris and DACS, London 2009; 250-251 Keystone/Hulton Archive/Getty Images; 253 Courtesy of the artist and Roslyn Oxley9 Gallery, Sydney; 255 © the artist, Photo: Richard Learoyd; 257 Courtesy Yoshiko Isshiki Office; 258-259 Palais de Tokyo, site de création contemporaine/Kleinefenn; 260-261 Private Collection, Installation view London, Tate Modern, 2008; 263 Courtesy Gagosian Gallery © 2009 Takashi Murakami/Kaikai Kiki Co., Ltd. All Rights Reserved: 265 Photo: Bill Orcutt. Courtesy of the artist and Susanne Vielmetter Los Angeles Projects; 267 National Gallery of Australia, Canberra Purchased 1978, © ARS, NY and DACS, London 2009; 269 Copyright Shirin Neshat, Courtesy Gladstone Gallery, New York; 270-271 Photo: Eduardo Ortego, Courtesy the artist and Tanya Bonakdar Gallery, New York; 273 Copyright: Chris Ofili, Courtesy Victoria Miro Gallery, London; 275 Photo by Cesar Oiticica Filho, Courtesy of Projeto

Hélio Oiticica: 277 The Bridgeman Art Library/Art Gallery of Ontario, Toronto. Canada, C.2009 Claes Oldenbura; 278-279 Courtesy Marion Goodman Gallery, New York/Paris: 280-281 The Museum of Contemporary Art, Los Angeles, Purchased with funds provided by Eugenio López and the Jumex Fund for Contemporary Latin American Art; 283 © the artist, Lisson Gallery/© Tate, London 2009: 284-285 Photo Smithsonian American Art Museum/Art Resource/ Scala, Florence; 287 © Tate Gallery, London 2009/Courtesy of the Artist and Frith Street Gallery, London; 288-289 Courtesy Pilar Corrias Gallery, Photo Credit: Peter Mallet; 290-291 © ADAGP, Paris and DACS. London 2009: 293 Courtesy Victoria Miro Gallery, Copyright Grayson Perry; 295 Courtesy David Zwirner, New York and Regen Projects, Los Angeles: 297 Courtesy the artist/ Gavin Brown's enterprise; 299 © Tate Gallery, London 2009/Courtesy Fondazione Pistoletto; 301 © Sigmar Polke. Courtesy Michael Werner Gallery, New York and Berlin; 302-303 Courtesy Prince Studio, Photo: Polly Baden; 305 © the artist, Photo: Marc Quinn Studio Courtesy Jay Jopling/ White Cube (London); 306-307 © Neo Rauch courtesy Galerie EIGEN+ART Leipzig/Berlin an David Zwirner, New York, Photo: Uwe Walter / DACS 2009; 309 Private Collection / The Bridgeman Art Library © Estate of Robert Rauschenberg /DACS, London/VAGA, New York 2009; 311 Copyright the artist, photograph courtesy of Marlborough Fine Art (London) Ltd; 313 Solomon R. Guggenheim Museum, New York, By exchange, 1993 (93.4239). © ARS. NY and DACS. London 2009: 314-315 Courtesy Estate of Jason Rhoades; Galerie Hauser & Wirth, London and Zurich; David Zwirner, New York, Photography by Douglas M. Parker Studio; 317 © Gerhard Richter 2009/ Saint Louis Art Museum, Funds given by Mr. and Mrs. R. Crosby Kemper Jr. through the Crosby Kemper Foundations, The Arthur and Helen Baer Charitable Foundation, Mr. and Mrs. Van-Lear Black III, Anabeth Calkins and John Weil, Mr. and Mrs. Gary Wolff, the Honorable and Mrs. Thomas F. Eagleton; Museum Purchase, Dr. and Mrs. Harold J. Joseph, and Mrs. Edward Mallinckrodt, by exchange; 319 © Bridget Riley 2008. All rights reserved. Courtesy Karsten Schubert, London: 321t Courtesy the artist and Hauser & Wirth Zürich London, Photo: A. Burger, Zürich; 321b Courtesy the artist and Hauser & Wirth Zürich London; 323 Courtesy Electronic Arts Intermix (EAI), New York; 325 © Dieter

Roth Estate: 327 Courtesy David Zwirner. New York. @ DACS 2009: 328-329 @ Edward Ruscha Studio, Courtesv of Gagosian Gallery: 330-331 Private Collection, Courtesy Tom Sachs Studio: 333 Eyevine, Photo: David Levene / © the artist, Courtesy Jay Jopling/ White Cube (London); 335 © Jenny Saville. Courtesy of Gagosian Gallery; 336-337 © Gregor Schneider, © DACS 2009: 339 Courtesy Frith Street Gallery, 2008, Photo: James O'Jenkins, © DACS 2009; 341 Public Collection: Kunstsammlung Nordrhein-Westfalen, Düsseldorf, Germany; 342-343 © Photoshot; 344-345 © 2008. Digital Image, Lorenze Kienzle/The Museum of Modern Art. New York/Scala, Florence, Photo: Lorenz Kienzle, In2007.34. © ARS, NY and DACS, London 2009: 347 Courtesy of the Artist and Metro Pictures: 349 Courtesy of the artist. Stephen Friedman Gallery (London) and James Cohan Gallery (New York); 350-351 @ the artist, Courtesy Lisson Gallery; 353 Courtesy the artist and Salon94, New York; 354-355 © Estate of Robert Smithson / licensed by VAGA, New York, NY, Image courtesy James Cohan Gallery, New York Collection: DIA Center for the Arts, New York Photo: Gianfranco Gorgoni, © Estate of Robert Smithson/ DACS, London/VAGA, New York 2009; 357 © Nancy Spero, Courtesy Galerie Lelong, New York, © DACS, London/ VAGA, New York 2009: 358-359 © Haim Steinbach; 360-361 Solomon R. Guggenheim Museum, New York Gift, Mr. Irving Blum, 1982, 82.2976, © ARS, NY and DACS, London 2009; 362-363 © 2009, Thomas Struth; 365 C Hiroshi Sugimoto. Courtesy the artist and Gagosian Gallery; 367 © the artist, Courtesy Jay Jopling/ White Cube (London); 369 Images © Wolfgang Tillmans, Images courtesy of Andrea Rosen Gallery, NY; 371 Image Courtesy of the artist / Gavin Brown's enterprise, New York; 373 Courtesy Zeno X Gallery, Antwerpen; 375 © the artist, Photo: Kira Perov; 377 © Jeff Wall, Photo: Patrick Goethlen, Collection of the Fondation Cartier pour l'art contemporain, Paris; 378-379 As originally conceived and commissioned for the Duveens Commission at Tate Britain, 2007 © the artist, courtesy Anthony Reynolds Gallery, London, Photo: Dave Morgan; 381 Corbis, © The Andy Warhol Foundation for the Visual Arts /ARS, New York / DACS, London 2009; 383 Tate Picture Library / Tate, London 2009, courtesy Maureen Paley, London; 384-385 Lannan Foundation; Long-term loan. Installation at Marion Goodman Gallery, 1999. Courtesy Marian Goodman

Gallery, New York, © 2003 Lavrence Weiner/ Artists Rights Society (ARS), New York and DACS, London 2009; 386-387 © Franz West, Courtesy of Gagosian Gallery; 389 © Rachel Whiteread. Courtesy of Gagosian Gallery. Photo credit: Sue Omerod; 391 Courtesy AW Asia; 393 © Zhang Huan Studio, courtesy PaceWildenstein, New Yark; 395 © Fritz Kaiser Foundation / courtesy 8M MOCCA Collection

Every effort has been made to acknowledge correctly and contact the source and/or copyright holder of each picture and Carlton Books Limited apologises for any unintentional errors or omissions which will be corrected in future editions of this book.